PLANES ON FILM

Ten Favourite
Aviation Films

Colin M. Barron

Other Books by
Colin M. Barron

Running Your Own Private
Residential or Nursing Home

The Craft of Public Speaking

PLANES ON FILM

Ten Favourite
Aviation Films

Colin M. Barron

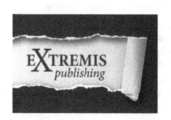

Planes on Film: Ten Favourite Aviation Films by Colin M. Barron.

First edition published in Great Britain in 2016 by Extremis Publishing Ltd., Suite 218, Castle House, 1 Baker Street, Stirling, FK8 1AL, United Kingdom.
www.extremispublishing.com

Extremis Publishing is a Private Limited Company registered in Scotland (SC509983) whose Registered Office is 47/51 Horsemarket, Kelso, Roxburghshire, TD5 7AA, United Kingdom.

A CIP catalogue record for this book is available from the British Library.

ISBN: 978-0-9934932-6-3

Typeset in Goudy Bookletter 1911, designed by The League of Moveable Type. Printed and bound in Great Britain by IngramSpark, Chapter House, Pitfield, Kiln Farm, Milton Keynes, MK11 3LW, United Kingdom.

Contents

PLANES ON FILM

Ten Favourite
Aviation Films

Colin M. Barron

Acknowledgements

Thanks are due to the following people: Simon Beck for his assistance with the chapter on *Flight of the Phoenix* and for supplying photos of the Fairchild C-82 Packet, and some of the aircraft used in *The Blue Max*, also Peter Arnold for clarifying details of the Spitfires used in *Reach for the Sky* and *Battle of Britain*.

How This Book Came About

I have always loved the cinema, and have had a lifelong fascination with aircraft – particularly those flown by the RAF during WW2. So it is no surprise that at the age of 59 I have finally got round to writing a book on my 'Ten Favourite Aviation Films'.

The first aviation film I ever saw (at the 'Gaumont' cinema in Greenock) was *633 Squadron*, when it was first released in August 1964. As a seven year-old I was enthralled by the amazing flying sequences and thrilled by Ron Goodwin's exciting music. But I came away from that viewing with a lot of unanswered questions. Where did they get all the Mosquitoes from? And what were these strange looking, square-fronted aircraft that were supposed to be Messerschmitt Me109s but obviously weren't? And was Cliff Robertson's character – Wing Commander Roy Grant – really dead at the end of the movie?

Not long after this pivotal experience I built my first Airfix model – which to an aviation enthusiast is the equivalent of losing your virginity. I recall it was a 1/72 scale Spitfire Mark IX moulded in light blue plastic and bought from Woolworths, and soon after this I saw further aviation films in the local cinema, on television and at the Greenock Arts Guild Junior Film Club.

One of the highlights of this era came in early October 1969 when I was taken to Glasgow by my parents one Friday evening to see the recently released epic *Battle of Britain* in 70mm colour. This was a revelation, as it was the first aviation film to have a lot of merchandise connected with it. There was a 'making of' book and TV documentary, and

several articles in aviation journals. *Airfix Magazine* had even previewed the film in its February 1969 issue, and a later edition had a cover illustration *in colour* from the film showing three Hurricanes in Polish markings flying in formation.

The plastic kit manufacturer FROG produced several paired kits (rather like Airfix's 'Dogfight Doubles') to tie in with the film and I bought one of these, which I recall was a Blenheim Mark I and Messerchmitt Bf109F.

But although I knew a lot about the filming of *Battle of Britain* I still wanted to find out more about the production of other aviation epics, and I had to wait till the late eighties when I visited London frequently and discovered *After the Battle* magazine. This publication – which is still being produced, by the way – used to feature detailed articles on the making of various war films. I bought up many back copies of this journal, plus old editions of publications like *Air Pictorial* which had contemporary features on aviation movies. I also made a habit of retaining copies of magazines like *Flypast*, *Aeroplane* and *Warbirds Worldwide* which had features on the making of a particular aviation film, and this large collection of journals – some originally published as far back as 1963 – formed the nucleus of the research material required to write this book. Thus when I first started to create this publication in the Spring of 2016, most of the reference material I needed already existed within the four walls of my house.

I would emphasise that this book contains my own personal choice of air pictures. As the subtitle says, it is my 'ten favourite aviation films', and is not based on a poll of aviation enthusiasts which might result in completely different films being featured. Furthermore, American aviation

4

enthusiasts would no doubt make different choices of films to their British counterparts, as some of the films featured in this book are not well known in the USA. Nonetheless, I hope you find my own choice of aviation movies to be both interesting and entertaining.

Colin Barron
July 2016

The Dambusters
(1955)

The *Dambusters* isn't just the aviation movie I admire most; it's my all-time favourite film. I first watched it in the Gaumont cinema in Greenock in 1966 at the age of nine, after seeing the trailer the previous week. Every frame of the film thrilled me, and I left the cinema with my chest puffed out with patriotic pride. Rather oddly, it wasn't shown on television until May 1971, sixteen years after its release. By comparison, *633 Squadron* had its first broadcast on BBC 1 in November 1970 – just six years after it first came out – while *Battle of Britain* had its UK TV premiere in September 1974, just five years after its cinema run.

I would not suggest that *The Dambusters* is a perfect film, though. It is riddled with numerous historical and technical inaccuracies, and some of the special effects seem rather unconvincing when viewed today. Nonetheless, the powerful performances of the leading actors – notably Richard Todd as Wing Commander Guy Gibson and Michael Redgrave as Barnes Wallis – combined with thrilling footage of low-level flying has made it a classic British film.

The 'Dambusters Raid' (or 'Operation Chastise' as it is more correctly known) on 16/17 May 1943 had a tremendous psychological impact. Coming just four days after Axis forces surrendered in North Africa, it gave the message that the RAF could strike anywhere with great accuracy and Winston

Churchill (who was in the USA at the time) used it for political capital.

In the short term, the breaching of the Mohne and Eder dams caused flooding of a large area of the Ruhr Valley and considerable disruption to industrial production. Even Hitler spoke of the devastation caused by the raid. 7,000 workers from the Organisation Todt (OT) had to be transferred from construction work on the Atlantic Wall defences to rebuild the dams, a job which took five months. In recent years revisionist historians have claimed that the Dams Raid had no lasting impact on the war effort and that it was really a greater disaster for the British than the Germans as eight experienced crews were lost.

The most recent historian to write a book about the raid, James Holland, takes a different view, however. In his 2013 book *Dambusters: The Race to Smash the Dams*, Holland claims that the Germans put tremendous effort into repairing the two breached dams because they were so important to them, and that this transfer of labour resulted in the Atlantic Wall defences being incomplete when the Allies landed in Normandy on 6 June 1944. It will be interesting to see whether the forthcoming remake of the *Dambusters* film by Peter Jackson reignites this controversy.

A film about the raid was first mooted as early as 1943, when Hollywood producer Howard Hawks was interested in making a *Dambusters* film – using models, as the Americans didn't have any Lancaster bombers. Both Barnes Wallis and Guy Gibson reportedly saw Roald Dahl's screenplay of *The Dam* (as it was to be called) and were appalled.

The story of the making of the 1955 *Dambusters* movie really started in 1951 when former RAF Spitfire pilot Paul Brickhill – who had been a POW between 1943 and 1945 –

wrote a book called *The Dam Busters* dealing with the wartime exploits of 617 Squadron. Brickhill's book drew partly on squadron and Air Ministry Records and also on what Guy Gibson had written in his own book *Enemy Coast Ahead*, which was published posthumously in 1946.

Brickhill's book could not reveal the exact scientific principle behind the 'bouncing bomb' (known as 'Upkeep'). All that could be said at the time was that the weapon bounced off the water and had to be released at a precisely calculated distance from the dam (about 1,300 feet) while the Lancaster aircraft was travelling at an altitude of 60 feet and an airspeed of about 230mph. Details of the 'Upkeep' weapon were classified until 1963, and the crucial facts that the bomb was effectively a cylindrical, rotating depth charge which was back-spun at 500rpm before release were kept secret until this date.

The book was a great success and, within two years, plans were made to make it into a film with shooting to start at the Associated British Picture Corporation (APBC) studios at Elstree, and on location, in the spring of 1954. The screenplay was by distinguished playwright R.C. Sheriff, who had served in the British Army in WW1 and was best known for his play *Journey's End* (1928) based on his wartime experiences. Incidentally, this play was the inspiration for another aviation movie, *Aces High* (1975), about WW1 flyers.

Richard Todd was the obvious choice to play Wing Commander Guy Gibson, as he had served with the Parachute Regiment in WW2 and had the correct military bearing for the role. He also resembled the late Wing Commander, particularly as regards height and build, though he was really too old for the part as Gibson was just 24 at the time of the Dams Raid and Todd was 35 in 1954 – something

9

which Gibson's widow Eve pointed out after seeing the film for the first time. Todd's flying kit for the film included a German *Schwimmvest* (lifejacket) and Boy Scout wristband, just as the real Gibson wore on operations.

The actor chosen to play Barnes Wallis was Michael Redgrave, who at 46 was nine years younger than Wallis was at the time of the Dams Raid. Other notable cast members included Nigel Stock – best known for playing Dr Watson in the BBC's *Sherlock Holmes* series (1964-68) which starred Peter Cushing in the title role – as 'Spam' Spafford, Gibson's bomb aimer; George Baker as F/Lt David Maltby; Henry Leech as Sq/Ldr Maudsley, and Bill Kerr as Fl/Lt Micky Martin. At that time Kerr was also appearing as the 'Aussie from Wagga Wagga' in the original BBC radio version of *Hancock's Half Hour*. For the role of Martin, Kerr had a handlebar moustache and 'chocks' fitted behind his ears to make them stick out more like those of the real Martin. Another notable cast member was Robert Shaw, then 27, in his first major film role as Sergeant John Pulford – Gibson's flight engineer.

The real stars of *The Dambusters* were of course the aircraft, four genuine Avro Lancaster bombers. In 1954, a few Lancaster GR3s were still being used by the RAF School of Maritime Reconnaissance at RAF St Mawgan in Cornwall. However, these were not available for filming, so four Lancasters were taken out of storage from 20 Maintenance Unit (MU) at Aston Down for use in the film. All of them were Mark VIIs, a late-war version of the Lancaster produced in 1945 by Austin Motors of Longbridge for operations against the Japanese mainland as part of the RAF's 'Tiger Force'. The dropping of the atomic bombs on Hiroshima and Nagasaki ended the need for the 'Tiger Force', and the Mark

VIIs were put into storage with some of them eventually being sold to the air arm of the French Navy (The 'Aeronavale').

The version of the Lancaster which took part in 'Operation Chastise' (the codename for the 'Dambusters' raid) was known as the B.III Type 464 Provisioning Lancaster, and differed considerably from a standard Mk. III Lancaster as the mid-upper turret and bomb doors were removed. Fairings were fitted to the front and rear of the bomb bay and the 9,250lb 'Upkeep' bomb was suspended between two v-shaped caliper arms and spun at 500rpm just before release by a hydraulic motor, via a belt drive. The power for this motor came from the hydraulic feed which operated the bomb doors and mid-upper turret in a standard Lancaster.

At the time the film was made, the exact shape of the bomb was a secret (it actually resembled an oversized garden roller) and so a large black wood-and-plaster construction looking a bit like an Edam cheese was bolted in place beneath the bomb bay. This was much larger than a real 'Upkeep' weapon.

Three of the Lancasters used in the film (NX673, NX679 and RT686) were converted to look like 'Upkeep' Lancasters, while a fourth (NX782) was kept as a standard Lancaster Mark VII and was used to represent Gibson's aircraft ZN-G during his time with 106 Squadron at RAF Syerston. In recent years, evidence has emerged that a fifth Lancaster Mark VII NX739 – then operated by the Aircraft and Armaments Experimental Establishment (AAEE) at Boscombe Down – was also employed as one of three camera aircraft used in the film.

The Mark VII Lancasters employed in *The Dambusters* had different armaments to those used in the raid. Although possessing the same FN-5A nose turrets with two 0.303in Browning guns as the Type 464 Provisioning Lancasters, they had Glenn Martin Type 250 CE23 mid-upper turrets with two heavy 0.50in Browning machine guns instead of the earlier turrets mounting two 0.303in weapons installed in most Lancasters. The three 'Lancs' used to depict 'Upkeep' carrying aircraft had these turrets removed, while NX782 retained its mid-upper turret. Mark VII Lancasters also had Fraser-Nash FN82 rear turrets with two 0.50in guns instead of the earlier FN20 turrets which carried four 0.303in guns. These FN82 rear turrets were not replaced on any of the film aircraft, though in studio-shot scenes of the rear gunners blazing away an FN20 turret with four 0.303in guns was used. The film aircraft were converted for their new role by a working party from the A.V. Roe Repair organisation based at Bracebridge Heath. As well as the deletion of the mid-upper turrets the bomb-bay doors were removed, as were the H2S radomes fitted to the ventral fuselage.

The 'Upkeep' aircraft – like most wartime Lancasters – had shrouds fitted over the exhaust stubs to mask exhaust flames during night operations, but these were not installed on the film aircraft, probably on grounds of cost. For the same reason, the four Lancasters used in the movie were not completely repainted. Their original colour scheme would have been light grey upperworks with the fuselage sides, and lower wings and tailplanes painted a satin black. A rough camouflage pattern was applied to all four aircraft (possibly using a darker shade of grey), and the red propeller spinners were left as they were. On film the spinners appear almost white in colour, whereas the real aircraft used in the raid had

black ones. Additionally, the film aircraft (being nine years old) had faded, stained, chipped and peeling paintwork whereas in reality the planes which took part in the raid were almost brand new, with the oldest aircraft being just five weeks old and the newest delivered from Avro on the day of the mission.

The principal camera aircraft for the production was an RAF Vickers Varsity WJ920 supplied by the Bomber Command Bombing School at Lindhome and flown by Fl/Lt Seowan. The Varsity was a twin-engined navigation trainer based on the post-war Vickers Viking civil airliner, which was itself derived from the wartime Vickers Wellington bomber. For its role as a camera ship, the Varsity was fitted with three cameras. One was installed in the nose, a second in the port side of the cockpit, and a third in the rear fuselage filming out the door aperture on the port side.

As the Varsity could not be used for rearward-facing shots, a second camera aircraft Vickers Wellington T.X MF628, flown by Fl/Lt 'Butch' Bird, was employed with a camera fitted in the rear turret. This plane was used for all head-on shots of Lancasters in the film. One of the Lancs was also fitted with a camera inside the nose compartment, filming through the perspex blister.

All the aircraft were flown to RAF Hemswell which was quite close to RAF Scampton, the base of 617 Squadron during the Dams Raid. Hemswell was also the location for the 1943 colour documentary *Night Bombers* about Lancaster operations, shot by Air Commodore Henry Cozens. Although it ceased to be an RAF airfield many years ago, many of the hangars and other buildings survive as it is now an industrial estate.

Filming of the aerial sequences started in April 1954 and continued until September. Five months were required, as blue skies were necessary in order for daytime filming to resemble night-time. By applying coloured filters to the cameras and filming in black and white, a 'day for night' effect was achieved. Unfortunately the summer of 1954 was a poor one with few sunny days, and bad weather disrupted filming just as happened during the shooting of *Battle of Britain* fourteen years later.

Normally RAF Hemswell was used for filming during the week and RAF Scampton at the weekends. All the Lancaster pilots normally flew the Avro Lincoln (the successor to the Lancaster), and were Flight Sergeant Ted Szuwalski and Flying Officer Dick Lambert of 97 Squadron and Flight Lieutenant Ken Souter and Flight Sergeant Joe Kmiecik of 83 Squadron. Eric Quinney of 83 Squadron replaced Dick Lambert later in the filming schedule. Only three flight engineers were required, as no more than a trio of Lancasters was airborne at any one time. These were Flight Sergeant Jock Cameron of 83 Squadron and Sergeants Mike Cawsey and Dennis Wheatley, both of 97 Squadron.

The film opens with a dramatic sequence in which the title lettering is superimposed on a shot of rolling clouds as seen from the rear turret of a Wellington MF628, to the accompaniment of Eric Coates' stirring title music. Apparently Coates's brilliant 'Dambusters March' was based on an unpublished work he had composed about a decade earlier to commemorate the Battle of El Alamein. The rest of the music in the film was the work of Leighton Lucas (1903-82), who later wrote the memorable title and incidental music for *Ice Cold in Alex* (1958).

A caption says 'Spring 1942', and the camera tracks down to reveal the garden of Barnes Wallis's house (actually a studio set) where the engineer is experimenting with a catapult device which bounces marbles off a bathtub full of water. Wallis's GP arrives to look at his daughter Elizabeth's throat (it is amazing that even in 1942 a GP would do a house call for a sore throat!).

At that point Wallis hears a large formation of RAF bombers flying overhead and strolls out the French windows to gaze at the planes. He mentions to his GP that the current British bombing strategy is like 'trying to kill a giant by firing hundreds of peashooters at his arms and legs instead of shooting a clean bullet through the head'.

Wallis then explains his idea about attacking German dams to his GP, pointing out that 100 tons of water are required to make one ton of steel. In fact it wasn't Wallis's idea to attack German dams, as they had been identified as a potential target by the Air Ministry before the war.

The next day Wallis meets an Air Ministry committee in London to explain his ideas, pointing out that he will need more time to carry out experiments. He subsequently performs a demonstration outdoors using large model dams at the Building Research Station at Garston, near Watford, in which he proves that a relatively small explosive charge placed against the dam wall at a depth of 30 feet will breach it. He envisages that a weapon containing 6,000 pounds of the new explosive RDX will be sufficient, well within the load-carrying capacity of the new four-engined Avro Lancaster bomber. (In fact, the final 'Upkeep' weapon used an explosive called 'Torpex', which was 42% RDX, 40% TNT and 18% powdered aluminium.)

Wallis is then given permission to use the Experimental Ship Tank at the National Physical Laboratory at Teddington, where he carries out tests involving the firing of spherical projectiles at high velocity (using a catapult) at the surface of the water, resulting in them bouncing and ultimately sinking while snug against the wall of a model dam. The young woman working the underwater cine-camera in these scenes is actually Mary Stopes-Roe, the daughter of Barnes Wallis, while Barnes Junior also appears as a technician in these shots. The tests go on for five months, much to the exasperation of officials at Teddington, and eventually Wallis has a meeting with an Air Ministry official at which he requests the loan of a Wellington bomber for further trials. The official is initially unhelpful, pointing out that Wellingtons are in great demand and asking for any information that might persuade the Air Ministry to hand one over. 'Would it help if you told them I designed it?' replies Wallis. A great scene, but not very accurate as Wallis did not actually design the Wellington bomber. He created the geodetic construction method used in that aircraft (and others such as the Wellesley and Warwick), but the actual design of the bomber was the work of a few people working for Vickers at Brooklands in Weybridge. Furthermore, Vickers had a few Wellington prototypes at Brooklands which were available for the testing of Wallis's weapon, so it was not necessary to borrow one from the RAF.

The next scene (filmed from the end of the runway at Hemswell) is of a Wellington Mark X MF628 flying towards the camera as it takes off. This is the same aircraft which was used as one of the three camera planes in the production, and as it only appears in this one brief scene it was left in its training colours of silver with yellow bands.

The Wellington, piloted by Vickers' most famous test pilot 'Mutt' Summers – played by Patrick Barr – then drops an early, half-size (46 inch) version of the 'Upkeep' weapon. Now we are looking at actual wartime footage of Wellington Mark III BJ995. As the weapon was still top secret at the time the film was made, the 'Upkeep' was disguised with a black spot painted on each frame of film to avoid revealing the fact that it was being back-spun.

The next scene is set at Brooklands, where 'Mutt' Summers and Wallis discuss the tests. In the background we can see a Fiat Topolino car, the exact type driven by Summers during the war.

Wallis and Summers subsequently meet Air Chief Marshal Arthur Harris (Basil Sydney), the chief of Bomber Command, and he agrees to view a reel of film showing the test drops. Harris is portrayed (quite incorrectly) as being initially sceptical about Wallis's weapon but then changing his mind and becoming quite receptive to the idea. This is completely incorrect, as Harris was totally opposed to Wallis's scheme to attack the German dams which he described as 'panacea targets'. Instead, Harris wanted all efforts to focus on his master plan to win the war by destroying German cities.

Wallis goes home despondent because he feels sure that his idea has been rejected, but his wife tells him that the Air Ministry had 'phoned earlier and want to see him the next day. The next morning Wallis travels to London expecting to give the Air Ministry a piece of his mind, but is told – to his surprise and delight – that the operation is going ahead in just two months' time. Wallis subsequently discusses the matter with Air Vice-Marshal the Hon. Ralph Cochrane (Ernest Clark) and 'Bomber' Harris, who feels that a new squadron should be formed to carry out the mission. Their choice of

Commanding Officer is Wing Commander Guy Gibson, the most experienced bomber pilot in the RAF.

Early the next morning a Lancaster lands at a grass airfield (supposedly RAF Syerston but actually RAF Kirton-on-Lindsey), and Gibson and his flight engineer Sgt Pulford (Robert Shaw) both utter their first line of dialogue: 'Rad Shutters auto'.

Curiously, one of the Lancaster's propellors (the starboard inner) is feathered, i.e. stopped, as the bomber comes to a halt. Gibson did in fact return from his last mission with 106 Squadron on three engines, but on that occasion it was the port outer engine which was shut down (not the starboard inner), so this is a 'goof' on the part of the filmmakers.

Gibson disembarks from the bomber via the rear door on the starboard side aft of the wing to be greeted by his black Labrador who is obviously pleased to see him. He is expecting a spell of leave after completing his third tour of duty, but is told that Air Vice-Marshal Cochrane wants to see him. Cochrane subsequently tells Gibson that he has been awarded a bar to his DSO, but also asks if he would be willing to do another operation as leader of a new squadron based at RAF Scampton.

Gibson accepts and asks his batman to pack his belongings for the move to Scampton where he sets about picking all the members of his new squadron. This is pure artistic licence, as most of the members of 617 Squadron were not selected by Gibson and were simply assigned to the Squadron. Some of these airmen were highly experienced while others were relative novices. The members of the newly formed 617 Squadron (at that time known simply as 'Squadron X') gather in the mess at Scampton, and one of

them gives Gibson's dog a pint of beer which he clearly enjoys drinking.

The first of the promised Lancasters arrive at Scampton and one, NX673 coded AJ-P, taxies past Gibson as another two are seen in the air. These should be standard unmodified Lancasters, as the first of the Type 464 models didn't arrive until 8 April, but they clearly lack bomb-bay doors and mid-upper turrets.

Gibson then addresses his crews in the briefing room, pointing out that they will have to practise low-level flying till they can do it 'with their eyes shut'. The next shot shows three Lancasters flying low over Lake Windermere with mock 'Upkeep' bombs under their bellies, a serious error since the first of the special bombs weren't delivered until just before the mission.

Gibson meets Wallis, who explains a little about the new weapon and shows him some film of the test drops of the bouncing bomb from a Wellington at Chesil Beach, near Weymouth. He explains that the 'Upkeep' will have to be dropped at an airspeed of about 240mph from a height of 150 feet. Gibson is subsequently shown models of the Mohne Dam and the others that will be attacked. He expresses surprise, because he thought the target would be the battleship *Tirpitz*.

Gibson is then invited to attend tests of the full-size weapon at Reculver using a De Havilland Mosquito bomber. This is another error, as this type of aircraft was only ever used to drop the smaller anti-shipping version of 'Upkeep' (known as 'Highball') and all the shots in the film of Mosquitoes dropping bouncing bombs are actually 'Highball' tests. Only Lancasters were used for tests of the full-size weapon, as this was the only aircraft the RAF possessed

which could carry it. Some footage of Lancasters carrying out test drops of 'Upkeep' exists, but was top secret when the film was made.

This initial test is unsatisfactory, as the bomb shatters. A rather disappointed Wallis wades into the water to recover the bomb fragments, while Gibson returns to Scampton where he decides to go into London by train with Group Captain Whitworth (Derek Farr) to see a show. While watching the theatre spotlights converging on some dancing girls, Gibson comes up with the idea of using such lights to determine the correct altitude for bomb release. This scene is a great piece of cinema, but is pure fiction since the idea of using spotlamps to calculate height at low altitude had already been worked out earlier in the war as an aid to Fleet Air Arm pilots carrying out night torpedo attacks. Benjamin Lockspeiser, Director of Scientific Research at the Ministry of Aircraft Production, is recognised as the inventor of this method for determining altitude.

Gibson returns to Reculver where he witnesses another unsuccessful test which ends with the bomb disintegrating. Wallis explains that he hopes to solve the problem by strengthening the casing, but that it would also help if the bomb-dropping aircraft could fly at the lower altitude of 60 feet. Gibson says this will be dangerous but he will see what he can do. In reality, another problem with the early 'Upkeep' bombs was that they were metal cylinders clad in an outer wood casing to make them spherical with flattened ends. The timber kept shattering on impact and eventually Wallis realised that he could dispense with the outer wooden casing and make the bombs cylindrical. Again this was something that was not portrayed in the film.

617 Squadron has some further practice flights at the new height of 60 feet, resulting in Gibson's aircraft almost crashing. 'This is bloody dangerous', comments his bomb aimer 'Spam' Spafford. In fact, for the film the over-water flying had to be done at 40 feet altitude not 60 feet, as the latter looked too high on screen. Most of these practice scenes were shot over Lake Windermere and other parts of the Lake District.

Meanwhile, a local poultry farmer – dismayed at the noise and vibration caused by the low flying aircraft – pens a letter complaining about the disruption to his routine. The farmer is played by Laurence Naismith, best known for playing Judge Fulton in the 1971 ITV series *The Persuaders* which starred Roger Moore and Tony Curtis.

The film implies that 617 Squadron only did its practice flights at night, when in reality some of them were carried out during the day using amber goggles for the pilot and bomb aimer and blue Perspex applied to the Lancasters' canopies: a system known as 'Two Stage Amber.' Again, this is a detail which is not featured in the film.

One of the Lancasters returns to Scampton with foliage wrapped round its tailwheel, something which did actually happen. Wallis returns to Scampton where he discusses the forthcoming test with 'Mutt' Summers. A Mosquito B.35 VR803 is parked behind him in post-war colours. In the far distance, some Avro Lincolns can be seen and apparently some post-war Canberra jet bombers as well.

The subsequent test at Reculver is successful, and the bomb bounces without breaking up. Everyone is delighted, and Wallis and Gibson have a congratulatory hug. On the way back to Scampton, Wallis is asked where he got the idea from; he says that Admiral Nelson once advocated skipping

cannonballs across the water for greater destructive effect, and may have used this technique during the Battle of the Nile. In fact, Nelson's invention was similar to the 'skip bombing' technique used to great effect by American B-25 aircraft against Japanese ships during the Pacific War.

Back at Scampton, Air Vice-Marshal Cochrane shows Gibson a simple bombsight that has been developed to enable bomb release to be made at the correct distance from the dam. Looking a bit like a coathanger, it consists of a wooden 'Y' with an eyehole and handle. Two nails are fitted at the extremes of the 'Y', and when they line up with the dam towers the correct distance for bomb release has been achieved. Again, this is an oversimplification, as some crews didn't like this bombsight and made two chinagraph pencil marks on the nose Perspex dome, with a piece of string being employed to ensure the correct position of their head when achieving alignment.

The next day, 617 Squadron tries out the new bombsight at the Derwent Water dam. Only one Lancaster, NX782, was used for this sequence (as evidenced by the fact that all the Lancasters in this scene have a mid-upper turret), and the same aircraft was filmed making repeated passes to give the impression of a whole squadron.

Gibson meets his pilots, and Maudsley suggests using stirrups to keep the front gunner's feet clear of the bomb aimer's head. The nose turret on a Lancaster was rarely used and was normally operated by the bomb aimer. As Gibson wanted it to be manned and firing during the attack, the displaced mid-upper gunner had to perform this task.

The members of 617 Squadron receive some ribbing from 57 Squadron crew as they haven't been on an operation for weeks, and a fight ensues. Meanwhile Gibson is informed

that the special bombs have started arriving and that the operation is on for the following night. A photograph published in Jonathan Falconer's 2005 book *Filming the Dambusters* shows that a scene was filmed portraying the bombs arriving at Scampton in trucks, but it does not appear in the final cut of the film.

We are then treated to some atmospheric scenes as the Lancasters are prepared for the forthcoming mission. Their petrol tanks are filled from fuel bowsers and ammunition belts (with 0.50in bullets rather than the correct 0.303in projectiles) are loaded onto the bombers. Leighton Lucas's music conveys a sense of mounting tension.

The crews gather at the briefing room at RAF Scampton (actually the Sergeant's Mess) as Eric Coates's theme music cuts into the soundtrack. The doors of the briefing room are closed by an RAF Military Policeman (played by Patrick McGoohan in his first film role) and Gibson gives a stirring speech to his crews as he stands with his hands on his hips. Meanwhile Gibson's black Labrador, unable to enter the briefing room to join his master, runs onto the road outside the main gate and is driven over by a passing motorist who fails to stop.

Meanwhile, Gibson – unaware of what has happened – continues his briefing and shows crews models of the Mohne and Eder Dams. However, no mention is made of the Sorpe Dam which was attacked unsuccessfully by two aircraft or the three other less important dams, the Diemel, Ennepe and Lister, which were also secondary targets. The film also implies that there was only a single wave of Lancasters involved in the attacks when there were in fact three. The Eder Dam was also not strictly speaking a Ruhr dam as it was on the River Fulda.

After the conclusion of the briefing the crews gather in the mess for a pre-raid meal of bacon, eggs and coffee. Wallis is so nervous that he refuses coffee, but Gibson insists he has some. After his meal Gibson, by now informed about the death of his dog, asks his crew chief to bury him at midnight close to his office at Scampton. According to his own account, Gibson made this request because he himself thought he would die at midnight during the raid.

The crews relax on the grass at Scampton in the warm spring sunshine until it is time to board their aircraft. As the crews travel to their Lancasters in several lorries and buses, the theme tune reaches a crescendo. Eleven WW2 vintage RAF vehicles were taken out of storage and loaned to the production for scenes such as this one. Gibson reaches his own aircraft AJ-G and asks his sergeant ground crew chief how the plane is. 'Bang on', he replies. This small part was played by a non-actor, RAF Corporal Tom Bailey.

As Gibson and his crew board their Lancaster AJ-G, a car drives up and Air Vice-Marshal Cochrane gets out to wish them luck. An Avro Lincoln is parked in the background as set dressing. The Lancaster's serial number ED932 (the true number of Gibson's aircraft) is visible in front of the rear door. This particular aircraft NX679 was the only one in the production to have a genuine 617 Squadron serial applied, as all the other aircraft retained their real serial numbers

Gibson makes his way to the cockpit with his Flight Engineer, Sergeant Pulford, and they begin a series of pre-flight checks before starting the engines. Rather than using a camera crane (as would be the norm nowadays), the scene was filmed with a camera mounted on top of a pantechnicon supplied by local removal firm Bullens. For this scene, an RAF flight engineer lay on the cockpit floor out of view of the

camera and started the engines – giving the impression that Richard Todd and Robert Shaw were doing it. Apparently Todd and Shaw eventually learned how to start up a Lancaster and eventually taxied one at 70mph.

The first three Lancasters (led by Gibson's aircraft) taxi to the end of the runway and start their take-off run. In May 1943 Scampton lacked concrete runways, so this scene was filmed at the grass airfield at RAF Kirton-on-Lindsey, probably using another Lancaster Mark VII NX739 as the camera aircraft. Shooting at Kirkton-on-Lindsey proved to be problematic, as the airfield was really too small for the safe operation of Lancasters and the Station Commander eventually asked for the bombers to leave his base as he was afraid that an accident would happen. Fortunately the essential footage was already 'in the can'.

The first three Lancs led by Gibson fly over Lincoln Cathedral as the next trio of bombers take off from Scampton. The Lancasters fly low over the North Sea as the setting sun reflects off the water. In his book *Flying Film Stars*, Mark Ashley suggests that the position of the sun relative to the aircraft shows that the Lancasters must be flying in an east-west direction, i.e. the wrong way. The scene raises other questions though. The first Lancaster took off from Scampton at 9.28p.m. Even allowing for the fact that the UK was on double summer time during the war years (i.e. GMT plus 2), sunset at Scampton would be at 9.52p.m. on the night of the raid, so by the time the Lancs were approaching the Dutch coast the sun should be below the horizon. Perhaps the low sun is supposed to be the moon as part of the 'Day for Night' filming, but if this is the case it is on the wrong side of the aircraft!

As the aircraft approach the Dutch coast, Sergeant Pulford notices that 'Martin is having a chat with Hopgood' (using Aldis lamps in the perspex bubble at the rear of the Lancaster's canopy to transmit Morse code). Gibson asks what they are saying, and is told that the following evening they are all going to 'get screechers', i.e. drunk. 'The biggest binge of all time', confirms Gibson.

The bombers cross the Dutch coast and, soon afterwards, one of the Lancasters AJ-B is hit by flak and crashes in flames (actually a rather unconvincing model). Gibson is a little shaken to see this, but continues the mission as planned. Then the aircraft are bracketed by searchlights. This was not a special effects or model shot but was done for real using an Army searchlight battery; an experience which the film pilots found quite disconcerting. The bombers' rear gunners fire at the searchlights with their four 0.303in Browning guns in an attempt to knock them out.

The bombers make their way to the first dam to be attacked (the Mohne) at low level, and at one point nearly hit some electricity cables strung between pylons, forcing them to open the throttles to climb above the obstacles. Gibson orbits the Mohne to get a good look and then starts his attack. The Mohne Dam and the surrounding countryside is actually a huge model 300 feet long by 150 feet wide created at Elstree studios. 28 giant fans were used to create realistic ripples in the water's surface.

Gibson carries out a perfect attack exactly as Wallis prescribed, and a huge column of water erupts from the dam wall courtesy of a rather clumsy bit of matte work. Miniature work involving water is reckoned to be the most difficult to achieve, as it cannot be scaled down and this is clearly evident in some of the effects shots in *The Dambusters*.

When the water subsides it is clear that the dam has not been damaged, and the second aircraft HJ-M, piloted by Hoppy Hopgood, makes its attack. Unfortunately the bomb is released too late, skips over the dam and destroys the power station. Hopgood's Lancaster is then hit by 20mm flak and explodes. AJ-P, flown by Micky Martin, subsequently attacks with Gibson flying his aircraft to one side of him to draw off some of the anti-aircraft fire.

The next Lancaster to attack is AJ-A, flown by Dinghy Young. This time both Martin and Gibson fly on either side of him, their nose turrets blazing away. Gibson even flicks his spotlights and landing lights on and off to attract enemy fire. Finally AJ-J, flown by Maltby, attacks, and the dam starts to crumble.

Gibson asks for the next Lancaster, piloted by Dave Shannon, to make its attack but tells him to 'skip it' when he realises a huge breach has been made in the Mohne Dam. He tells his wireless operator to send a message – the code word being the name of his late dog – indicating the successful breach of a dam, and tells all the crews who have dropped their bombs to go home and the rest to follow him to the Eder dam.

The Eder is surrounded by hills, making anti-aircraft guns unnecessary, and even the manoeuvrable Lancasters have difficulty making their attack runs. The first aircraft to attack, piloted by Dave Shannon, makes its approach too high for bomb release and then nearly crashes into a nearby hillside. The next Lancaster, Z-Zebra, releases its bomb too late. It skips over the dam and destroys the power station. Two more Lancasters attack and finally the Eder Dam is breached as well. Gibson's wireless officer sends the success signal to

Grantham, where Wallis, Harris and Cochrane are jubilant at the news.

As dawn breaks, the surviving Lancasters land at Scampton. Of the 19 aircraft which set out, five were shot down by anti-aircraft fire, two hit electricity cables and were destroyed and one pilot was blinded by searchlights while overflying a German airfield and subsequently crashed. One (AJ-H piloted by P/O Geoff Rice) returned to Scampton early after it flew too low over the sea, resulting in its bomb being ripped off, and another aircraft had to abort its mission after being damaged by anti-aircraft fire. These details were not shown in the film – all that was said was that eight Lancasters were lost – and the unsuccessful attack on the Sorpe in which two 'Upkeeps' were dropped on the dam by Lancasters flying across it was not depicted. The failed attack on the Ennepe Dam using a single bomb was also not portrayed in the movie.

The Lancasters taxi to dispersal and one of them, NX673 (AJ-P), has obvious flak damage to its starboard wing. The surviving crews are debriefed by intelligence officers.

Wallis speaks to Gibson about what has happened. He is appalled at the loss of 56 aircrew (in fact it was 53, as three survived as prisoners of war) and said he would never have started on his quest if he knew this was going to happen. Gibson reassures him that he knew all the crews personally and every one of them would still have gone on the raid even if they knew they would not be coming back. Wallis asks Gibson if he going to bed to sleep, and he replies that he some letters to write first.

The film had its premiere in May 1955. Demand for tickets was so high that two separate Royal Command performances were held at The Empire Cinema in London's

Leicester Square, with the first being held on 16 May – the twelfth anniversary of the raid – and attended by Princess Margaret. A special premiere was held for RAF personnel at Scampton on 20 May. The film went on general release in September that year.

After aerial filming was concluded, the three 'Upkeep' Lancasters were used in an episode of the BBC's *War in the Air* documentary series before being returned to Aston Down along with the fourth Lancaster NX782. All these aircraft were subsequently scrapped.

The Vickers Wellington MF682 used in the production did survive, though it was transferred to the Nash Collection of historic aircraft. After being stored at various locations it became one of the star exhibits at the RAF Museum, Hendon, when it opened in November 1972. By then it had been repainted in standard Bomber Command camouflage and eventually was refitted with a nose turret. At the time of writing it is not on view, as it is undergoing restoration and conservation work.

Dambusters: The Remake?

The first hint that a remake might be in the offing came in the late nineties, when a cinema special effects magazine mentioned that Mel Gibson's next film was to be a remake of *The Dambusters* using Lancaster bombers recreated with CGI. I noticed this, and sent the cutting to the late Robert J. Rudhall who at that time was assistant editor at *Flypast* magazine. Robert had a special interest in aviation films, and was eventually the author of two books and numerous articles about the 1969 film *Battle of Britain*.

Robert made some enquiries, and the following month *Flypast* reported that Mel Gibson's production company had

denied that a remake of *The Dambusters* was in the pipeline or that Mel Gibson was going to play Guy Gibson in a new version of the film.

That seemed to be the end of the matter, but then in 2005 rumours appeared in the aviation press that respected filmmaker Peter Jackson (who had just remade *King Kong*) was planning a new version of *The Dambusters*. Jackson initially refused to comment on these rumours, but then the following year he confirmed that he was indeed planning to make a new version of *The Dambusters* as he had bought the rights for a new film from Mel Gibson who had owned them for a few years. Whether Gibson seriously intended to make a new *Dambusters* film or star as Guy Gibson is not clear, but what is beyond dispute is that he did buy the rights before selling them to Peter Jackson.

More details began to emerge of the new film. The script was to be written by Stephen Fry and the film was to be produced by Paradine Productions, David Frost's production company. The director was to be Christian Rivers, a protégé of Jackson's. The budget was to be $40m and most of the filming was to be done in New Zealand.

Jackson had ten full-size steel and fibreglass replicas of Lancaster bombers constructed in China from a mould-master created in New Zealand. A partial-scale replica of a Vickers Wellington bomber was also built, possibly using the undercarriage of an Avro Anson.

Jackson also bought a lot of WW2 equipment for use in the film, including one of the actual AEC Matador fuel bowsers used at Scampton in 1943 and some German flak guns. Large models of the various German dams involved in the raid have reportedly been constructed as have full-size replicas of the 'Upkeep' weapons.

The film was originally scheduled for production as early as 2007, but since then there have been repeated delays, some of which have been caused by Jackson's decision to direct *The Hobbit* trilogy himself. The death of producer David Frost has also cast a shadow over the production.

In interviews, Jackson has confirmed that he does intend to make the film eventually, but the only question is when this will happen. If it does go ahead, it is likely that aviation sequences will be achieved using full-scale models, miniature work and CGI.

At the time of writing, there are just two airworthy Avro Lancasters in the world: PA474 with the RAF Battle of Britain Memorial Flight at Coningsby, Lincolnshire, and FM213 with the Canadian Warplane Heritage at Hamilton, Ontario. A third Lancaster, NX611, is in ground running, taxyable condition at the Lincolnshire Aviation Heritage Centre at East Kirkby, Lincolnshire, and is slowly being restored to airworthy status. All three could theoretically be used in a new *Dambusters* film in some capacity, but obviously could not be employed in dangerous low-level flying as the four Lancasters were in the original 1955 film. But it will be interesting to see if this film does eventually get made and cinemas reverberate once more to the sound of Rolls-Royce Merlin engines and Eric Coates' famous theme tune.

The Dambusters (1955)
Technical Credits

Director: Michael Anderson
Screenplay: R.C. Sheriff; Based
on *The Dam Busters* by Paul
Brickhill and *Enemy Coast Ahead*
by Wing Commander Guy
Gibson VC.

Cast

Dr Barnes Wallis - Michael
Redgrave
Mrs Wallis - Ursula Jeans
GP - Charles Carson
Sir David Pye - Stanley Van
Beers
Dr W.H. Glanville - Colin
Tapley
Committee Members - Frederick
Leister, Eric Messiter, Laidman
Browne
Official, National Physical
Laboratory - Raymond Huntley
Official, Ministry of Aircraft
Production - Hugh Manning
Captain Joseph (Mutt) Summers
- Patrick Barr
Observer at Trials - Edwin Styles
Observer at Trials - Hugh Moxey
RAF Officer at Trials - Anthony
Shaw
ACM Arthur Harris - Basil
Sydney
AVM The Hon. Ralph Cochrane
- Ernest Clark
Group Captain J.N.H.
Whitworth - Derek Farr

Farmer - Laurence Naismith
Group Signals Officer - Harold
Siddons
BBC Announcer - Frank Philips
Wing Commander Guy Gibson -
Richard Todd
Flt/Lt R.D. Trevor-Roper -
Brewster Mason
Flt/Lt R.E.G. Hutchison -
Anthony Doonan
Flying Officer F.M. Spafford -
Nigel Stock
Fl/Lt A.T. Taerum - Brian
Nissen
Flt/Sgt J. Pulford - Robert Shaw
Pilot Officer G.A. Deering -
Peter Assinder
Squadron Leader H.M. Young -
Richard Leech
Squadron Leader H.E. Maudsley
- Richard Thorp
Flight Lieutenant J.V. Hopgood -
John Fraser
Flight Lieutenant W. Astell -
David Morrell
Flight Lieutenant 'Micky' Martin
- Bill Kerr
Flight Lieutenant D.J.H. Maltby
- George Baker
Flight Lieutenant D.J. Shannon -
Ronald Wilson
Flight Lieutenant L.G. Knight -
Denys Graham
Flight Lieutenant R.C. Hay -
Basil Appleby

Flight Lieutenant J.F. Leggo - Tim Turner
Flight Sergeant G.E. Powell - Ewen Solon
Guy Gibson's Batman - Harold Goodwin
Crew members (uncredited) - John Breslin, Edward Cast
RAF Officer - Richard Coleman
Tail Gunner - Peter Diamond
RAF Officer - Gerald Harper
RAF Pay Clerk - Arthur Howard
Collins - Lloyd Lamble
Flight Sergeant - Philip Latham
RAF MP - Patrick McGoohan
Waiter - Jack McNaughton
Barnes Wallis's daughter - Nina Parry
RAF Officer - Edwin Richfield

Production Crew
Music: Leighton Lucas
Director of Photography: Erwin Hillier
Film Editor: Richard Best
Casting: Robert Lennard, G.B. Walker
Art Direction: Robert Jones
Makeup Artist: Stuart Freeborn
Hairdresser: Hilda Fox
Director in Charge of Production: Robert Clark
Production Manager: Gordon Scott
Production Supervisor: W.A. Whittaker

Assistant Directors: John Street, Frederic Goode, Jeremy Summers
Scenic Artist: Bill Beavis
Assistant Art Director: Peter Glazier
Draughtsman: Wallis Smith
Sound Recordist: Leslie Hammond
Recording Director: Harold V. King
Dubbing Editor: Arthur Southgate
Boom Operator: Eric Bayman
Dubbing Crew: H. Blackmore, Cyril Brown, Len Shilton
Assistant Boom Operator: Hugh Strain
Sound Camera Operator: Jim Whiting
Special Effects: George Blackwell
Special Effects Photography: Gilbert Taylor
Optical Effects: Ronnie Wass
Aerial Photography: Erwin Hillier
Camera Operator: Norman Warwick
Electrician: Steve Birtles
Focus Puller: Chick McNaughton
Still photographer: Bob Penn
Clapper Loader: Kelvin Pike
Still photographer: Ronnie Pilgrim
Camera operator, second unit: Val Stewart

Clapper Loader: Brian West
Focus puller, second unit: Tony White
Assistant Editor: Philip Barnikel
Assembly Cutter: Joan Warwick
Musical Director: Louis Levy

Unit driver: Eddie Frewin
Continuity: Thelma Orr
Technical Advisor: Group Captain J.N.H. Whitworth
Production Secretary: Daphne Paice

List of Aircraft used in *The Dambusters* (1955) and current status (where known)

Aircraft Type	Serial Number	Film Codes	Fate
Avro Lancaster Mk.VII	NX673	AJ-P	Scrapped July 1956
Avro Lancaster Mk.VII	NX782	ZN-G	Scrapped July 1956
Avro Lancaster Mk.VII	NX679 (ED932 in film)	AJ-G	Scrapped July 1956
Avro Lancaster Mk.VII	RT686	AJ-M	Scrapped July 1956
Avro Lancaster Mk.VII	NX739	?	Scrapped Feb 1957
Vickers Wellington Mk.T.X	MF628	None	RAF Museum, Hendon
D.H. Mosquito B.35	VR803	None	Presumed scrapped
Vickers Varsity Mk.T1	WJ920	None	Fire Fighting Practice Aircraft, RAF Finningley, October 1974

Notes: Wellington MF628, Varsity WF920 and Lancaster NX739 were all used as camera aircraft.

Wellington MF628 also appears briefly as an 'Upkeep' trials aircraft.

Six Avro Lincoln B.IIs also appear in the background in some shots, doubling for Lancasters.

Reach for the Sky
(1956)

Rather like *The Dambusters* (1955), *Reach for the Sky* (also based on a book by Paul Brickhill) has become a much-loved film in the UK. First shown on BBC 1 about a decade after it was first released, it has been repeated on TV many times since. It is not the most accurate or realistic aviation film ever made, and its low-budget depiction of events over southern England in the summer of 1940 can hardly be compared to the spectacle of the hugely expensive *Battle of Britain* (1969).

Nonetheless the central theme of the film – that of a fit, active man losing both legs and overcoming terrible disabilities to become one of the highest-scoring RAF aces of WW2 – has made it resonate in public consciousness. In addition, Douglas Bader's numerous battles with the bureaucrats of the RAF and the Air Ministry give the film great emotional appeal.

I have always loved this movie since I first saw it at the age of nine in 1966, and recent events in my own personal life have made it even more poignant. In May 2011 my dear wife Vivien suffered a devastating stroke at the age of just 55 which left her semi-paralyzed, partially-sighted, and unable to speak or read properly. Four years later I also fell seriously ill when I had a near-fatal heart attack at the age of 58. I spent four months in hospital including several weeks in intensive care, and had two cardiac operations to repair a hole in my

heart. For the first two months I hovered between life and death. As well as being doubly incontinent, I was unable to walk due to muscle wasting and had to learn this skill again and – as I lay in my hospital bed – I often thought of some of the hospital scenes in *Reach for The Sky*. Indeed, one of the first things I did when I finally got home was to watch a copy of the film on DVD as I knew it would inspire me to make a full recovery.

In 1954 former Royal Australian Air Force (RAAF) Spitfire pilot Paul Brickhill wrote a book, *Reach for the Sky*, which dealt with Douglas Bader's life. Brickhill had previously penned *The Dam Busters* (1951) and *The Great Escape* (1950), which were also made into highly profitable films.

Reach for the Sky was a great success, selling 175,000 copies within a few months of publication, and the Rank Organisation (based at Pinewood Studios) announced its intention of making a film adaptation. The director chosen to helm the project (and who subsequently also wrote the screenplay) was Lewis Gilbert, who had already made two highly acclaimed war movies: *Albert RN* (1953) and *The Sea Shall Not Have Them* (1954). The producer was Daniel Angel, who himself was physically affected as a result of childhood polio and so had a special interest in the way disabled people were portrayed in films.

One of the first problems facing the production team was the creation of a workable script. Brickhill's original book was 372 pages long and covered a period of about 20 years in Bader's life from 1928 onwards. In addition, it mentioned a huge number of individuals who had known Bader. To include them all would result in a script 1,000 pages long and a film which ran for 10 hours.

The only solution was to combine several characters into one person and simplify certain incidents. Unfortunately the real Douglas Bader – who had met Lewis Gilbert and Daniel Angel – would have none of it, and objected strongly to the way the film depicted events in his life. The producers had their way though, and the character of 'Johnny Sanderson' (played by Lyndon Brook) was an amalgamation of several people. In addition Sanderson provided a voice-over during certain parts of the film.

Another problem was how to successfully portray the legless Bader and his unique gait. Laurence Olivier was approached about the role but declined on the grounds that it would be impossible for any actor to portray a legless person authentically. He suggested that Bader play himself, an idea which Gilbert and Angel rejected. The next person to be suggested for the role was 30 year-old Richard Burton, whose career was on the up. Eventually he too declined as he had been offered a part in *Alexander the Great* at five times the salary.

Eventually the role was offered to 41-year-old Kenneth More, who had served in the Royal Navy during WW2 and had already made a few successful pictures including *Genevieve* (1953), *Doctor in the House* (1954) and *The Deep Blue Sea* (1955).

More met Bader at Gleneagles Hotel, Auchterarder in Perthshire, and they played a game of golf which Bader won, much to More's surprise. The two spent a few hours together during which More got an impression of Bader's personality, with his drive, aggression and irascibility being key features.

Gilbert's original plan for recreating the unusual gait of a legless person had been to use the real Bader in long shots and those filmed from behind in order to achieve accuracy.

Unfortunately this proved impossible after Bader resigned from all involvement with the movie after seeing initial 'rushes' of Kenneth More impersonating him. Gilbert solved the problem by using an almoner at Roehampton Hospital – who had suffered identical amputations to Bader and also wore tin legs – as Kenneth More's double throughout the production. Thus all long shots of 'Bader' in the film plus those taken from behind were actually of the almoner (the identity of whom remains unknown to this day). In some of these scenes More's voice was dubbed onto the soundtrack to further the illusion. In addition, More wore a contraption under his trousers – devised by technicians at Roehampton Hospital – to lock his knee and ankle joints in order to help him simulate Bader's walk, though eventually he did not need to use it.

The script called for scenes set during the Dunkirk evacuation, the Battle of Britain and fighter sweeps into France in 1941, so it was clear that a large number of aircraft would be needed for the production. Unfortunately in 1955 the producers could not find any airworthy Spitfires which looked anything like those used in 1940 and 1941 (which would have been Mark Is, IIs or Vs). The only ones the RAF still had in any quantity were Mark XVIs. This was a late-war development of the Mark IX which had an American Packard-built Merlin 266 engine with a two-stage, two-speed supercharger instead of the Merlin 66 of the Mark IX. In addition, the ten Mark XVIs used in the film had the later 'low back' fuselages, and bubble canopies, similar to those fitted to the North American P-51D Mustang.

The only alterations made to these film aircraft were the refitting of 20mm Hispano cannon and elliptical wing tips in place of their original clipped wings. Moreover, they

retained their original grey/green late war camouflage instead of the 'spinach and sand' scheme used in 1940, though as the film was made in black-and-white this was hardly noticeable. Only four of the Spitfires (RW352, SL574, TE358, and TE456) – which were supplied by Number 3 Civilian Anti-Aircraft Cooperation Unit (CAACU) at Exeter – were airworthy, with the other six (RW345, SL745, TB293, TB885, TE288 and TE341) being used as static set dressing. TE341 was later taken to Pinewood Studios for cockpit shots. In his 2014 book *Flying Film Stars*, Mark Ashley claims that an eleventh non-flying Mark XVI Spitfire TB863 – which was owned by MGM film studios – was also used in the production.

The producers were less successful in finding Hurricanes, as only three were available for filming. Only one of these – LF363, a Mark IIC owned by the RAF and based at Biggin Hill (now known as the 'Battle of Britain Memorial Flight' and based at Coningsby) – could fly, and the two others Mark I, P2617 (now owned by the RAF Museum) and a Mk IIC (whose identity remains unknown) were used as static props. Mark Ashley (in *Flying Film Stars*) has claimed that in fact Mark I L1592 (owned by the Science Museum) was used as a taxying aircraft in the production rather than this Mark IIC. A non-flying replica Mark I Hurricane was also created by the art department for the production, and was used both at the principal filming location at RAF Kenley (which also doubled for Cranwell, Duxford, Tangmere and Coltishall) and for cockpit shots at Pinewood Studios. Another airworthy Hurricane Mark IIC PZ865 (which was the last Hurricane ever built) was at that time owned by its manufacturer, but could not be spared for *Reach for the Sky* as it was being used as a 'chase plane' during the testing of Hawker Hunters.

For scenes set in the twenties and thirties, a number of vintage aircraft were obtained from various sources. The Shuttleworth Collection at Old Warden supplied an Avro 504K, E3404, used in the scenes where Bader learns to fly, and an Avro Tutor K3215 which was going to fly in the film but had to be used only as a static prop because of engine problems.

Shuttleworth also provided the camera aircraft for the film – a Bristol F.2B Fighter, D8096 – which was fitted with a 35mm camera on the Scarff ring in the rear cockpit in place of the usual Lewis gun. The F.2B also appears as background 'set dressing' in early scenes in the film.

No airworthy Bristol Bulldogs were available in 1955, but the Science Museum provided the sole surviving example K2227 which was used for ground scenes, and also served as a pattern for the creation of a static replica which was used in the scene of Bader's fateful crash in 1931. Ironically, Bulldog K2227 was restored to airworthy condition in the late fifties but then crashed during an aerobatic display at Farnborough in 1964. The final aircraft used in the film was Spartan Arrow G-ABWP, which appears as a background prop in scenes set at Reading Aero Club at Woodley Aerodrome.

The film opens with the titles superimposed on a close-up of the Gnome rotary engine of Avro 504K, E3404, being started up. The stirring title and incidental music is by John Addison (1920-98), a prolific British film composer who also happened to be Douglas Bader's brother-in-law. Apart from *Reach for the Sky*, Addison's most famous score was probably for *A Bridge Too Far* (1977) – Richard Attenborough's film about the ill-fated 'Operation Market Garden' in 1944.

The Avro takes off and flies over nearby countryside where the pilot (and flying instructor) Flying Officer W.J.

'Pissy' Pearson (Michael Gough) spots an 18-year old Douglas Bader, wearing a suit and bowler hat, racing towards Cranwell (where he is due to begin his induction into the RAF) on his Douglas motorcycle. Bader looks up at the low-flying plane, momentarily loses his concentration and goes off the road. He is unhurt though his bowler hat is ripped.

The next scene is set at RAF Cranwell, where a group of new RAF cadets (including Bader) are standing to attention. In the background is the Shuttleworth Collection's Bristol Fighter D8096 which took the aerial footage in the previous scene. Bader receives a bollocking on account of his damaged bowler hat and meets Johnny Sanderson for the first time. In these early scenes set in September 1928, a 41-year-old Kenneth More is playing an 18-year-old Bader.

Bader soon has his first flight in the same Avro 504K we saw earlier, with Pearson as his flying instructor. The cockpit scenes were shot at Pinewood Studios using a non-flying replica that was also used as background set dressing at RAF Kenley, which incidentally portrayed several airfield locations in the film. This first flight doesn't go too well, as Bader botches his initial attempt at landing the plane. However, after six-and-a-half hours of flying he makes his first solo and becomes a proficient pilot.

That night Bader goes out with some of his fellow cadets. The four of them, all sitting on Bader's motorbike, crash at the entrance to Cranwell. Their antics are witnessed by a policeman who threatens to charge Bader either with not having a working light on his bike or not being in control of it. While Bader keeps the policeman occupied one of his fellow cadets uses a spanner to loosen a nut on the policeman's bike, causing him to crash.

Bader is subsequently summoned to appear before Air Vice-Marshal Frederick Halahan (Walter Hudd), who berates him for not applying himself to his studies as he only came 19th (out of 21 cadets) in a recent exam. 'We don't want schoolboys: we want men', says Halahan.

The next scene is set at RAF Kenley in 1930, where Bader is introduced to the RAF's new Bristol Bulldog fighter and is specifically warned about performing low-level aerobatics in the aircraft by his CO Harry Day (Michael Warre), as it has poor directional stability. 'Rules are for the obedience of fools and the guidance of wise men', says Day. He informs Bader that two 23 Squadron pilots have already been killed performing aerobatics in the Bulldog.

Bader does not take the warning seriously and later we see him going dancing with his girlfriend Sally (Beverley Brooks). He seems free of all worldly concerns. By this time he is a keen aerobatic pilot who has performed at the annual Hendon Air Day and is already preparing for the next one in 1932.

On 14 December 1931 Bader visits Reading Aero Club at Woodley Airfield, where a civilian pilot goads him into giving a display of low-level aerobatics in his Bulldog. Bader is initially reluctant because of previous warnings about the dangers, but goes ahead. This scene was actually filmed at Denham Airfield which is near Pinewood Studios. Initially the display goes well, but then Bader scrapes the port wing of his aircraft against the ground and the plane crashes.

This scene was created entirely with miniature work and looks better than anything that could be done today with CGI. The model Bulldog used in this sequence was built by John Stears (1934-1999) who later did the special effects for eight James Bond films and the first (1977) *Star Wars* movie.

Stears was a keen aeromodeller and was also responsible for the highly realistic crash landing of a model Messerchmitt Bf109E at the beginning of *The One That Got Away* (1957). The miniature Bf109 created for that production was apparently capable of flight and survived into the nineties when it was restored by Stears and auctioned off for charity.

Although IMDB records Stears' career as starting in 1963 with *Call Me Bwana*, he is believed to have worked on an uncredited basis on a number of 1950s British films which featured miniature work including *Carve Her Name with Pride* (1958) directed by Lewis Gilbert and *A Night To Remember* (1953) about the RMS *Titanic*, the latter of which starred Kenneth More. For a few years from 1955 onwards, Stears worked for Shawcraft Models in Uxbridge who built miniatures and props for many British films of the period. They were also responsible for building props for the first few seasons of *Doctor Who*, including the original four Daleks, the 'Moonbase' from the 1967 Patrick Troughton story of the same name, the Vickers VC-10 airliner-cum-spacecraft from *The Faceless Ones* (1967), and parts of the original Cyberman costumes.

The scene ends with a dazed Bader lying in the wreckage of his Bulldog. This was created by breaking up the full-scale replica, which was also used for the scene where the aircraft's port lower wing scrapes the ground. As Bader is dragged from the wreckage the camera lingers on a pair of shoes lying neatly beside the wreck. This is not artistic licence, as a photo taken at the time clearly shows Bader's shoes lying in this position.

Bader is rushed to the Royal Berkshire Hospital, where surgeon Mr J. Leonard Joyce (Alexander Knox) carries out an emergency amputation of Bader's right leg. His left leg is also

badly crushed and its viability is in doubt. He has additionally suffered some fractured ribs and minor facial injuries.

His parents visit the hospital and talk to Joyce, who explains he had to amputate the right leg above the knee and may soon have to take off the left leg as well – though hopefully this will be below the knee. Bader's mother gives consent for this to be done.

During these scenes, Johnny Sanderson's voice provides a running commentary on what is happening: 'Douglas was like a man on the edge of a precipice. For two days and two nights, Douglas endured terrible pain. Then one morning the pain left him. He was slipping away from life.'

Suddenly Bader hears a nurse in the corridor outside telling a visitor to be quiet. 'There's a boy dying in there,' she says. 'Dying? We'll see', says Bader to himself. Suddenly the pain starts again.

This was one scene I thought of when I myself was close to death in October 2015 following a heart attack. As I slipped in and out of consciousness as a result of seizures brought on by my myocardial infarction, I heard some doctors talking about me in the corridor outside. 'Don't bother too much about rescuscitating this one,' one said. 'He's got a damaged left ventricle'. But like Bader, I made a miraculous recovery.

Some time later Johnny Sanderson visits Mr Joyce, who confirms that Bader has made a good recovery from his amputations but will face serious problems in adapting to his disabilities. He does not yet know that both legs have been removed to save his life. Sanderson agrees to break the news to him.

Sanderson enters Bader's hospital room, where he is lying in obvious agony. He tells Sanderson that his left leg

hurts like hell and he wishes they would cut it off. 'As a matter of fact, they have', says Sanderson. 'Then why does it hurt so much?' asks Bader.

Nurse Brace (Dorothy Alison) visits Bader, who tells him that some friends (including his girlfriend Sally) will be visiting. Harry Day, Don, Tommy and Sally subsequently call on Bader. Harry Day has some good news. A Board of Enquiry has exonerated Bader from all blame for the crash. He is pleased and says he has to fly again.

Later Nurse Brace sees Bader trying to walk using a peg leg and crutches. He falls. Then he receives a letter from Sally telling him she is dumping him and is going to South Africa with her mother for three months. Brace consoles him saying that he is probably better off without her. Bader recalls reading in the newspaper about one of his RAF colleagues, Johnson who had been killed in a flying accident. He wishes he were dead like him.

Brace scolds him for his attitude, saying that a lot of people (i.e. the medical and nursing staff) had worked very hard to get him well again and he should be ashamed of himself for saying such a thing. She then tells Bader that there is some good news as the RAF Court of Enquiry has decided not to take any action against him following his crash.

Soon Bader is able to walk round the hospital using crutches, and later still he is ready to leave. He thanks Nurse Brace for effectively saving his life, and says goodbye to the other nurses including Nurse Nichols and Sister Thornhill (Anne Leon) and his surgeon Mr Joyce.

Well on the way to recovery, Bader proposes going for a drive with his fellow patients John Peel (Jack Watling) and Vic Streatfield (Nigel Green). Peel has a broken leg, and Streatfield a fractured arm in plaster, but Bader thinks that

45

between the three of them they should be able to operate the Bentley which has a hand throttle. After a fast hair-raising drive – during which Bader nearly hits a pantechnicon – the three airmen pull in to the Pantiles tearoom on the A30 at Bagshot for some refreshment.

The three choose a table and order cream teas. They are served by one of the waitresses, Thelma Edwards (Muriel Pavlow), who inadvertently leaves her pencil on the table. Bader takes it over to her and engages her in conversation. When he rejoins his colleagues he announces that he is going to ask her out one day.

The next scene is set at the Ministry of Pensions Hospital in Roehampton where Robert Desoutter (Sidney Tafler) is assessing Bader for a pair of artificial legs. He says that six months have now passed since the accident (which means that it must be June 1932). Tafler was director Lewis Gilbert's brother-in-law, and appeared in several of his films including *The Spy Who Loved Me* (1977) in which he played the unnamed Captain of the supertanker 'Liparus'.

Bader tries on a pair of artificial legs and finds that he cannot move. 'It's impossible', he says. Desoutter reassures him that these early difficulties are normal, but professes the opinion that Bader will never walk without a stick. Bader asserts that he will learn to walk without one and Desoutter tells him to move by cracking his right stump forward like a whip. The prosthetics expert realises that he needs to take half an inch off the right leg, and eventually Bader manages a few steps before collapsing.

This was the second scene in *Reach for the Sky* which paralleled my own predicament in late 2015 as I struggled to learn to walk again, first with a Zimmer and then eventually unaided. I was determined that I would eventually march out

of the Forth Valley Royal Hospital under my own steam and without using a stick and, on 30 November 2015, I did so.

After receiving his new artificial legs Bader returns to the Pantiles tearoom in the hope of meeting Thelma. She arrives with a young man who then bids her farewell and kisses her. Bader asks Thelma if that is her boyfriend but she tells him he is her cousin. Bader then asks her out on a date and she accepts. He returns to the ward at Roehampton Hospital where he shows off by walking to his bed. A hospital orderly suggests he applies sticking plaster to his stumps and Bader agrees.

Bader and Thelma go on their first date. They have dinner and even dance together though Bader finds this difficult because of his artificial legs. He asks Thelma to wish him luck at Kenley.

The next day he returns to RAF Kenley where he meets his old batman Bates (Harry Locke) and his old CO Harry Day. He asks Bates to throw out his old rugby boots which he will have no further need for. Day takes Bader for a flight in an Avro 504K. He invites him to fly the aircraft from the rear cockpit and Bader does so, indulging in some aerobatics. It is clear that he can still fly a plane with considerable skill.

Soon after this he is seen by Wing Commander Hargreaves (Raymond Francis), who tells him that the Central Flying School has done a report on his case. He is clearly able to fly, but as there is nothing in King's Regulations covering his very unusual circumstances he can only be offered a desk job, with the alternative being retirement from the RAF and a disability pension.

Later Thelma and Bader discuss his predicament while standing on a footbridge. He is adamant that if he cannot fly

again he will leave the RAF. Bader says he has 'no money, no job, no legs'. Thelma points out that they do at least have each other.

Bader takes a job with the Asiatic Petroleum Company (later re-named Shell), which he finds extremely boring. He is reprimanded by his boss for writing letters which are too abrupt. However, he takes up golf, though his first attempts end with him falling. He gets married to Thelma in a registry office wedding on a soaking wet day.

Then, on 3 September 1939, Britain declares war on Germany. Bader sees this as his chance to get into the RAF. He is adamant that he must fly again. Initially it looks as though the RAF will only give him a desk job but, following a letter from the Central Flying School and the personal intervention of his old colleague Air-Vice Marshal Halahan, he is allowed to rejoin the RAF as a fighter pilot.

The film then moves forward in time to May 1940. By this time Bader is flying Spitfires with 19 Squadron at Duxford. The news comes through on the radio that the Germans have invaded the Low Countries. Bader is pleased because, after months of the 'phoney war', he can finally 'get at them'.

A shot of Spitfires and Hurricanes waiting at dispersal follows, accompanied by John Addison's music which gives the impression that something is going to happen. At 3.00a.m. Bader is woken to be told that his squadron is to take off at 4.00a.m. to provide air cover for the Dunkirk evacuation (Operation Dynamo). Bader asks for a cup of tea to be sent in and puts on his artificial legs.

Some newsreel footage of vessels crossing the English Channel is intercut with studio-shot scenes showing Bader in his Spitfire cockpit and one shot depicting his point of view.

As he looks down we can see ships passing beneath the wing of his aircraft, which has 20mm Hispano cannon protruding from its wing leading edges.

This is a 'blooper', because not only was it inaccurate to use Mark XVI Spitfires but Bader was opposed to the use of 20mm cannon as he believed them to be ineffective. Even in the summer of 1941 when his squadron had converted to Spitfire Mark Vbs with two cannon and four 0.303 in Browning machine guns, Bader insisted on flying a Spitfire Va with an armament of eight 0.303 guns.

Bader's assertion that small-calibre machine guns were more effective than cannon was entirely incorrect. In fact in Wing Commander W.R. 'Dizzy' Allen's book *Who Really Won the Battle of Britain?* (1974), it was pointed out that the 0.303 rounds used by RAF fighters in 1940 were really too small to cause serious damage to aircraft, particularly German bombers. There were numerous cases of such aircraft making it back to France with up to 300 bullet hits. Allen suggested that the RAF would have downed far more aircraft in 1940 if their Spitfires and Hurricanes had been fitted with a battery of just four 0.50 in machine guns which had greater range and hitting power than the 0.303s. The 20mm cannon which were eventually fitted to Spitfires and Hurricanes in 1941 had even greater range and hitting power than the 0.50in machine guns.

19 Squadron at Duxford did receive the first cannon-armed Spitfires in September 1940 (the Mark Ib), but the guns proved unreliable as they frequently jammed. The problem was caused by the need to install the weapons lying on their side because the wing of the aircraft was so thin. The issue was eventually solved in the Mark Vb Spitfire by fitting blisters in the upper wing which enabled cannon to be mounted upright.

Bader returns to Duxford after his first sortie over Dunkirk to learn that the CO of 19 Squadron (Johnny Sanderson) has been shot down. Some time later, he is told that he is to take command of 242 Squadron at Coltishall, consisting mainly of Canadians, who have had a rough time in France. The members of the squadron are initially sceptical about Bader as they cannot see how a man with tin legs can do the job effectively.

Bader enters the aircrew hut at Coltishall (not named as such in the film), where he discovers the Canadians are lying about listlessly and are obviously lacking in discipline. In addition, they don't seem to be taking him seriously. He realises that a demonstration of his flying skills is required, so he storms out of the hut and asks the ground crew to start up his Hurricane. Bader takes off and gives a spirited flying display. At one point he flies his aircraft upside down close to the ground. The Canadians are impressed.

Hurricane LF363 was used for these scenes, which appear to have been partly shot at RAF Biggin Hill as evidenced by Biggin's famous 'bump' which appears in some shots. A studio miniature was used in the scenes where Bader flies upside down for the simple reason that real Hurricanes couldn't do this.

After his impromptu flying display, Bader returns to the crew hut where he berates the Canadians for their lack of discipline and sloppy dress. He wants them to wear shoes, a shirt and tie when not flying, and eschew roll-neck sweaters and flying boots in the mess. The Canadians point out that they lost most of their kit in France, and had to scrounge for food and sleep under the aircraft. Bader apologises for his remarks and assures them that if they visit the tailor's shop in

Norwich, they can get new uniforms which will be paid for by the RAF.

There is another problem, however. Although the squadron has 18 new Hurricanes, it has no spares or tools. Bader asks why new parts cannot be obtained and is told that the 'channels are clogged'. 'Well we'll ruddy well have to unclog them!' he says angrily. Bader then 'phones an RAF functionary and gives him a piece of his mind. He is told that any new request for spares must wait three months because that is what the regulations say. Before slamming down the receiver, Bader blasts the bureaucrat for his obsession with 'forms and toilet paper' and says he might as well send a telegram to Goering telling him not to invade for three months.

I love this scene, because it mirrors my own experiences of dealing with the petty bureaucrats who play such a key role in local government and the NHS. When I was in hospital recovering from a heart attack I was told that the nurses couldn't cut my toenails or fingernails for me because they would need to go on a special training course first and then do a 'risk assessment'.

Bader subsequently sends a telegram to 12 Group, telling them that 242 Squadron is operational regarding pilots but non-operational as regards aircraft. This annoys a lot of people in the RAF hierarchy, but eventually Bader gets his way and a convoy of Bedford QL trucks and 'Queen Mary' transporters loaded with tools and spares arrives at Coltishall. Bader is delighted, and tells Warrant Officer West (Michael Ripper) to send a signal to Group to confirm that 242 Squadron is now fully operational.

The Canadians are impressed. 'Legs or no legs, I've never seen such a mobile fireball', says one. That evening, the

squadron celebrates in the mess and then become more sombre when they hear Churchill on the radio saying that the 'Battle of Britain is about to begin'.

Some newsreel footage of bombing then follows as 242 Squadron relax in their wicker chairs at dispersal while listening to the radio. At a party in the mess that evening they learn that Johnny Sanderson has survived as a prisoner of war. Two new squadron members Pilot Officers Nicholson and Jones arrive as Bader reassures Thelma about his invincibility: 'I've got an engine in front, armour plate behind and tin legs beneath', he says.

The next day 242 Squadron are at dispersal when they are scrambled to intercept a formation of 70 plus aircraft approaching North Weald. This is the only Hurricane scramble sequence in the film, and required careful editing to disguise the fact that only one airworthy aircraft was used. In some shots the Hurricane replica was employed, being towed by an unseen vehicle. Some footage from *Angels One Five* (1951) was also edited into this sequence, for the shot where five Hurricanes take off in line abreast formation. For the scene where five Hurricanes climb to meet the enemy aircraft, another clip from that film was used. Unfortunately it had to be flipped over to produce a mirror image, as the Hurricanes in the earlier film flew from right to left – the opposite of what was required for *Reach for the Sky*.

The subsequent air battle uses a mixture of newsreel footage and miniature work. The archive footage includes some familiar gun-camera film showing a Focke-Wulf 190 (which didn't enter service until 1941) being shot down. The film was reportedly taken by a North American P-51D Mustang in 1945. Gun camera film was of poor quality in 1940 which explains why film from later in the war was used.

Some model work also features in the sequence which again is the creation of the late John Stears. In 2009, seven minutes and 24 seconds of rushes of these miniature aircraft suspended on invisible wires appeared on YouTube with the title '1941 Scale Model Special Effects', but they are clearly from *Reach for the Sky* as they feature Mark XVI Spitfires with bubble canopies – and also the sequence of Bader's Hurricane flying inverted – in its entirety. Some of these shots look as good as (or better than) what could be achieved today with CGI, but there are others which are a bit unconvincing like the scenes showing Messerschmitts wobbling on wires. Another weakness of the 'fly by wire' method is that planes can only make flat turns and more realistic banking manouevres cannot be simulated.

After the air battle in which his squadron has achieved 12 confirmed kills and several probables, Bader lands his bullet-riddled Hurricane. As he climbs out the cockpit which is drenched in glycol from the punctured cooling system, he asks for the plane to be made flightworthy in 30 minutes. Warrant Officer West says this will be impossible.

Bader believed that the key to success in the Battle of Britain lay in 'Big Wings' of up to five squadrons which could knock down large numbers of German bombers. This tactic was supported by Air Vice-Marshal (AVM) Leigh-Mallory, chief of 12 Group, but not by AVM Keith Park of 11 Group which bore the brunt of the fighting in the battle. Park felt that a better tactic was to attack the German formations with single squadrons since 'Big Wings' took too long to form up and such large numbers of fighters tended to get in each other's way.

The controversy over 'Big Wings' continues to this day and was re-examined in the 1969 film *Battle of Britain*. The

view of the majority of historians is that Bader and Leigh-Mallory were mistaken in their claims for the success of this method and that Bader's views were all to do with his ego and his desire to play a bigger part in the battle. However, back in 1940 the 'Big Wing' concept was implemented by Leigh-Mallory and Bader himself eventually led the 'Duxford Wing' of five squadrons.

In the spring of 1941 Bader is moved to Tangmere, where he commands a wing of Spitfires which are involved in fighter sweeps into Europe. Sergeant Williams gives him some files to look at and Bader responds by dropping them in a wastebasket: a scene which symbolizes Bader's distaste for needless paperwork and bureaucracy.

Meanwhile, Thelma is concerned at the strain on her husband who has been on ops for so long, and suggests a holiday. Bader says he will consider this. The action then shifts to the events of 9 August 1941 (though this date is not mentioned on screen), when Bader flew his last mission. During a fighter sweep over Northern France Bader collides with a Messerschmitt Bf109 which is flying parallel to him. The impact shears off his Spitfire's fuselage aft of the cockpit and the fighter enters an uncontrollable dive at 400mph. Bader jettisons the cockpit canopy, but cannot exit the aircraft because one foot of his artificial leg is jammed beneath the seat. Eventually Bader's efforts to extricate himself cause the straps holding on his artificial leg to break and he manages to leave the aircraft and successfully open his parachute. As he descends to earth, a Bf109 flies past him but does not open fire.

The film (and the book which inspired it) both state that the cause of Bader's accident on 9 August was an accidental collision with a Bf109. But in recent years doubts

have been cast on this version of events. The Germans have always believed that Bader had been downed by a Messerschmitt Bf109 of JG26, but in 2006 aviation historian Andy Saunders examined the evidence and concluded that he was in fact the victim of friendly fire as he had probably been shot down in error by Flight Lieutenant 'Buck' Casson of 616 Squadron who thought he was attacking a Bf109.

Bader lands and is captured by German soldiers who take him to the nearest hospital at St Omer, near Abbeville airfield. Meanwhile back in England Thelma is distraught. Bader has gone missing and there is no news. Could he be dead? Suddenly the 'phone rings and she learns that he has been taken prisoner. She is overjoyed. One problem though is that he needs a replacement artificial leg and the Germans ask for a new one to be parachuted on to the airfield at Abbeville.

Bader is recovering in a French hospital bed and asks the German hospital doctor if he can have his legs back. He agrees. Soon after Bader is given a meal of soup and bread and discovers a handwritten note which tells him that someone will be waiting in the street outside every night from 12 midnight to 2.00a.m. Bader destroys the note by putting it in his pipe and lighting it. That night he escapes through a window using bedsheets knotted together to create a makeshift rope.

He is met by a Frenchman working for an evasion line, and the two walk 3km to a safe house where Bader is given food and coffee. The next day German troops arrive in a VW Kubelwagen, a staff car and a truck. Curiously, the Kubelwagen has SS number plates through the troops are regular Wehrmacht soldiers.

Bader hides in some hay in an outhouse, but is swiftly discovered. The German officer arresting him (Anton

Diffring) speaks good English and Bader compliments him on this. The officer explains that he lived in Streatham, London for II years before the war. Bader claims that the couple who lived in the house didn't know he was there (though in reality this didn't stop them being arrested later).

Bader is told that he will be taken to St Omer for questioning before being moved to Germany. In reality (though this was not depicted in the film) he was also entertained by German Luftwaffe ace Adolf Galland at Abbeville airfield and they became lifelong friends. At one point during his visit to the aerodrome, Bader was allowed to sit in the cockpit of a Messerschmitt Bf109. He briefly considered starting up the plane and escaping to England in it. Unbeknownst to him, Galland had a pistol pointing at him all the time he was in the pilot's seat.

Bader is subsequently moved from one prison camp to another in view of his repeated attempts to escape and ends up at the infamous Colditz Castle near Leipzig where he remained until liberated by American troops on 15 April 1945.

He returns home to England, where he is reunited with Thelma after nearly four years apart. Bader is keen to be posted to the Far East to see further combat, but the war ends before he can do so. However, on 15 September 1945 he takes off from RAF North Weald and leads a formation of 300 aircraft over London to celebrate the 5th anniversary of the Battle of Britain. The voiceover from Johnny Sanderson informs us that it was a 'story of courage... a victory of a man's own spirit'.

Reach for the Sky had its premiere at the Odeon in Leicester Square in London on 5 July 1956 in the presence of Prince Philip, and was a great success both critically and commercially. It made a great deal of money, and effectively

launched the career of Lewis Gilbert who went on to direct a series of highly profitable films including *Alfie* (1965), *You Only Live Twice* (1967), *The Spy Who Loved Me* (1977), *Moonraker* (1979) and *Educating Rita* (1983).

Having walked out on the film during production, Douglas Bader also declined to attend the premiere. Much later though, Lewis Gilbert discovered that Bader had gone to see the film at the Odeon in Southampton with a few friends and had told the cinema manager how much he had enjoyed it. Interviewed by Eamonn Andrews on *This is Your Life* many years later, he was asked what he thought of the film. He replied that at the time he felt he was too close to it but now he didn't think it was too bad. Lewis Gilbert happened to see this on TV and danced a jig round the room!

In later years Bader mellowed and became a champion for the rights of disabled persons. He was one of several advisors on the big-budget production *Battle of Britain* (1969). Also working on the film in a similar capacity was his old foe (and now friend) General Adolf Galland.

Bader was given a knighthood in June 1976 and died on 5 September 1982.

The Curious Coincidences which Link Douglas Bader and Guy Gibson

In researching this book I have been struck by the number of coincidences which link Douglas Bader and Guy Gibson. They are as follows:

- They both went to the same school, St Edwards in Oxford, and were in the same house (Cowell).

- Both were featured in books written by Paul Brickhill.

- Both of these books were made into black and white British war movies: *The Dambusters* (1955) and *Reach for the Sky* (1956).

- Both Douglas Bader and Guy Gibson were portrayed in these films by actors who were really too old for the part. In some scenes Kenneth More, aged 41 was portraying an 18-year-old Bader, while Richard Todd was 11 years older than Gibson was at the time of the Dams Raid.

- Both actors portrayed their characters as much nicer than they were in real life. Both Bader and Gibson were reportedly very difficult to get on with.

- Both Bader and Gibson had views that would be considered very right-wing by today's standards. Bader supported apartheid and Ian Smith's regime in Rhodesia.

- Both men considered a career in politics as a Conservative MP. Bader even wanted to be Prime Minister.

- Both were victims of friendly fire. As described above, Bader was almost certainly shot down by mistake by a fellow RAF pilot. Guy Gibson's final flight was on 19 September 1944 when his Mosquito crashed near Steenburgen, Holland. In recent years, evidence has emerged that he may have been shot down in error by Sgt. Bernard McCormack, the rear gunner of a Lancaster, who mistook his Mosquito for a German Junkers Ju88 night fighter.

Reach for the Sky (1956)
Technical Credits

Director: Lewis Gilbert
Screenplay: Lewis Gilbert, with
additional scenes by Vernon
Harris; based on a book by Paul
Brickhill.

Cast

Douglas Bader - Kenneth More
Thelma Bader - Muriel Pavlow
Johnny Sanderson - Lyndon
Brook
Turner - Lee Patterson
Mr Joyce - Alexander Knox
Nurse Brace - Dorothy Alison
Harry Day - Michael Warre
Robert Desoutter - Sydney Tafler
'Woody' Woodhall - Howard
Marion-Crawford
Peel - Jack Watling
Streatfield - Nigel Green
Sister Thornhill - Anne Leon
AVM Hugh Dowding - Charles
Carson
AVM Leigh-Mallory - Ronald
Adam
AVM Halahan - Walter Hudd
Crowley-Milling - Basil Appleby
Police Constable - Philip
Stainton
Flight Sergeant Mills - Eddie
Byrne
Sally - Beverley Brooks
Warrant Officer West - Michael
Ripper
Civilian Pilot - Derek Blomfield

Bader's Mother - Avice Landone
Prison Camp Adjutant - Eric
Pohlmann
Flying Instructor Pearson -
Michael Gough
Bates - Harry Locke
Warrant Officer Blake - Sam
Kydd
Wing Commander Beiseigel -
Ernest Clark
Tullin - Frank Atkinson
Lucille – Balbina
Orderly - Michael Balfour
Man Listening to Radio - Trevor
Bannister
German Doctor - Victor
Beaumont
Squadron Party Guest - Ernest
Blyth
Canadian Pilot - Roland Brand
Cadet Mason - John Breslin
Peter - Peter Burton
Civilian Pilot - Peter Byrne
Hall - Paul Carpenter
Cadet Taylor - Hugh David
Cyril Borge - Stringer Davis
Gilbert Petit - Guy Du Monceau
RAF Bugle Player - John Dennis
German Officer - Anton Diffring
Air Ministry Doctor - Basil
Dignam
Nurse - Patricia Fox
Wing Commander Hargreaves -
Raymond Francis
Madame Hiecque - Alice Gachet

Canadian Pilot - Philip Gilbert
Lorry Driver - Fred Griffiths
Don Richardson - Alexander
Harris
Drill Sergeant - Frank Hawkins
Walker - Charles Lamb
Adrian Stoop - Jack Lambert
Tommy - Barry Letts
Sergeant Williams - Philip
Levene
Jones - Jeremy Longhurst
German Officer - Richard
Marner
Pantiles Customer - Roger
Maxwell
Canadian Pilot - Ronan O'Casey
Monsieur Hiecque - Rene Poirier
RAF Batman - Clive Revill
Squadron Leader Edwards -
George Rose
Wounded Sergeant - Barry Steele
Limping Officer - John Stone
Mechanic - Drek Sydney
British Pilot - Jack Taylor
Hilda - Pamela Thomas
Pearson - Russell Waters
RAF Corporal - Patrick
Westwood
Batman at Duxford - Ian
Whittaker
Woodhall's Assistant - Gareth
Wigan
Cadet - Howard Williams

Production
Producer: Daniel M. Angel
Associate Producer: Anthony
Nelson

Music: John Addision

Cinematography
Director of Photography: Jack
Asher
Film Editor: John Shirley
Art Director: Bernard Robinson

Make up Department
Makeup artist: Robert Lawrence
Hairdresser: Pearl Orton

Production Management
Production Manager: Hugh
Attwooll

Second Unit/Assistant Directors
Second Unit Director: James Hill
Assistant Director: Basil Keys
Second Assistant Director: Kip
Gowans
Second Assistant Director:
Geoffrey Helman
Third Assistant Director: Gino
Marotta
Assistant Director: Pat Marsden

Art Department
Draughtsman: Charles Bishop
Assistant Art Director: Vernon
Dixon
Draughtsman: Roy Dorman

Sound Department
Sound Recordist: Gordon K.
McCallum

Sound Recordist: John W. Mitchell
Sound Editor: Arthur Ridout
Sound Camera Operator: Ron Butcher
Assistant Boom Operator: Roy Charman
Sound Recordist: Terence Cotter
Boom Operator: Danny Daniel
Dubbing Assistants: Graham Harris and Christopher Lancaster
Sound Editor, Second Unit: Archie Ludski
Sound Camera Operator: Basil Rootes

Special Effects
Bryan Langley
Bert Marshall
Bill Warrington

Visual Effects
Camera Operators, Model Unit: James Bawden and Bernard Ford
Models: Frank George, John Stears and Bill Warrington

Camera and Electrical Department
Camera Operator: Harry Gillam

Focus Puller, Second Unit: James Devis
Camera Operator, Second Unit: David Harcourt
Focus Puller: John Morgan
Stills Photographer: Charles Trigg

Costume and Wardrobe Department
Dress Designer: Julie Harris

Editorial Department
Second Assistant Editor: Michael Edmonds
First Assistant Editor: Peter Flack

Music Department
Orchestra Director: Muir Matheson

Other Crew
Production Controller: Arthur Alcott
Continuity: Shirley Barnes
Technical Advisor: Group Captain H.M.A. Day
Production Secretary: Teresa Bolland
Assistant Continuity: Doreen Merriman

List of Aircraft used in *Reach for the Sky* (1956) and current status (where known)

Aircraft Type	Serial No	Role	Current Status
Avro 504K	E3404	Flying	Shuttleworth Collection, Old Warden
Avro 504K	D7560	Static	Science Museum, London
Avro Tutor	K3215	Static	Shuttleworth Collection, Old Warden
Bristol F.2B	D8096	Camera ship Set Dressing	Shuttleworth Collection
Bristol Bulldog	K2227	Static	RAF Museum, Hendon
		(wore fake serial K2496 in film)	
Hawker Hurricane I	P2617	Static	RAF Museum, Hendon
Hawker Hurricane I	L1592	Taxyable	Science Museum, London
Hawker Hurricane IIC	LF363	Flying	Airworthy with BBMF, Coningsby
Spartan Arrow	G-ABWP	Static	Airworthy

List of Supermarine Spitfires used in production (all were Mark XVIs)

Aircraft Type	Serial No	Role	Current Status
Spitfire XVI	RW345	Static	Scrapped May 1956
Spitfire XVI	RW352	Flying	Scrapped 1957
Spitfire XVI	SL574	Flying	Air & Space Museum, San Diego, USA
Spitfire XVI	SL745	Static	Scrapped May 1956
Spitfire XVI	TB293	Static	Scrapped May 1956
Spitfire XVI	TB885	Static	Under restoration to flying condition in UK
Spitfire XVI	TE288	Static	RNZAF Museum, Wigram, New Zealand
Spitfire XVI	TE341	Cockpit Shots	Scrapped at Pinewood Studios, 1956
Spitfire XVI	TE456	Flying	Auckland War Memorial Museum, NZ
Spitfire XVI	TE358	Flying	Scrapped April 1957

Flight of the Phoenix
(1965)

Elleston Trevor (1920-1995) was a prolific British novelist and playwright. Born Trevor Dudley-Smith, he eventually changed his name to Elleston Trevor (though he had nine other pen-names) and wrote more than 50 novels plus articles and plays. He is best known for writing the series of *Quiller* spy thrillers (using the pseudonym 'Adam Hall'), including *The Berlin Memorandum* which was filmed as *The Quiller Memorandum* starring George Segal in 1966. Nine years later the BBC produced a short-lived TV series, *Quiller*, with Michael Jayston in the titular role.

In 1964 Trevor wrote *The Flight of the Phoenix*, a harrowing tale about a cargo plane which crashes in the Libyan desert. Against all the odds – and while suffering from thirst, dehydration and desert sores – the crew build a single-engined aircraft out of the wreckage of the freighter and fly to safety. In writing the story, Trevor may have been influenced by the real-life story of the *Lady Be Good* – a USAAF B-24 Liberator bomber which crashed in the Libyan desert on 4 April 1943 following a serious navigational error and lay undiscovered until 1958. This incident formed the basis of the TV movie *Sole Survivor* (1970) starring William Shatner and Richard Basehart, and *King Nine Will Not Return* (1960), an episode of *The Twilight Zone* TV series. Both of these productions used a B-25 Mitchell aircraft instead of a B-24 as the former were more readily available.

In 1965 a film adaptation of Trevor's book was made by 20th Century Fox with James Stewart – who had already expressed an interest in acquiring the film rights – in the lead role as veteran pilot Frank Towns. This was an inspired choice, since Stewart was not only an accomplished actor but a highly experienced pilot as well, having gained his private pilot's licence in 1933 and a Commercial Pilot Certificate in 1938. During WW2 he was a highly decorated bomber pilot, flying mainly B-24 Liberators and went from the being a private to a colonel in just four years. He remained an officer in the US Air Force Reserve until 1968 and even flew as an observer on a B-52F (No 57-149) 'Arc Light' bombing mission over Vietnam on 20 February, 1966.

Stewart had already made several aviation pictures when he was cast as Frank Towns, including *The Spirit of St Louis* (1957), a recreation of Charles Lindbergh's flight from the USA to Paris in 1927; *No Highway in the Sky* (1951), about a new airliner design which suffered from metal fatigue, and *Strategic Air Command* (1955), best remembered for its dramatic colour footage of giant Convair B-36 Peacemaker bombers.

The real star of *Flight of the Phoenix*, though, was the aircraft featured in it: the Fairchild C-82 Packet. Designed during WW2, the C-82 prototype first flew on 10 September 1944, and only a few of the 223 examples built would enter service before the war ended. Designed to succeed wartime transports such as the Curtiss C-46 Commando and Douglas C-47 Skytrain, the C-82 had a tricycle undercarriage with a nosewheel and a high wing which enabled freight loading at truck-bed height, rear clamshell loading doors, and a 'twin boom' layout with the tailfins and tailplane mounted at the rear of each boom.

Several other aircraft have featured a 'twin boom' layout, including the French Nord Noratlas, the British Armstrong-Whitworth Argosy and American C-119 'Flying Boxcar' transports. The latter was a more powerful development of the C-82. The most famous and successful twin-boom aircraft would undoubtedly be the Lockheed P-38 Lightning fighter, 10,037 of which were built and which saw extensive service in WW2. It was particularly effective in the Pacific theatre, and the USAAF's two top aces of the Second World War – Richard Bong (40 kills) and Thomas McGuire (38 kills) – both achieved all their victories against Japanese planes while flying the P-38.

In his 1964 novel, Elleston Trevor describes the crashed aircraft as a 'Salmon-Rees Skytruck Mark IV'. There is no mention of it being a Fairchild C-82 Packet, though there was an improved version of the C-82 (created by Steward-Davis of Long Beach, California) which was called a 'Skytruck', so this was possibly where Trevor got the name from. One possible reason why Trevor came up with a fictional name for the aircraft was probably to avoid legal complications, as aircraft manufacturers of the period weren't keen for their products to be depicted crashing, whether in books or in films. This is clearly evident in one of Stewart's earlier aviation films, *No Highway in the Sky* (1951), the plot of which involves a new airliner – the 'Rutland Reindeer' – being prone to metal fatigue in the tail section. The plane (depicted with miniatures and a full-scale mock-up built around a Halifax bomber) looks like no other which has ever flown with swept back wings, four liquid-cooled engines and two sets of tailplanes attached to the fin.

At the time the film was made (1965), the Steward-Davis company was the world leader in the supply and

maintenance of the C-82 aircraft, which was already becoming obsolete. A total of four C-82s were used in the filming. Only one, N6887C, was airworthy and was actually a 'Jet-Packet' created by Steward-Davis with a J30-WE jet engine mounted in the dorsal position to improve performance. The three others were N4833V, which was used to depict the crashed freighter at the filming location in Yuma; N53228, which was employed in a similar capacity for night-time scenes shot at Studio 6, Fox Studios in Culver City, and an unidentified C-82 which was used for cockpit interior shots at the Fox Ranch in Malibu, California.

Allied Aircraft of Tucson, Arizona provided parts, such as wings and booms, from a scrapped C-119 'Flying Boxcar' aircraft to portray the 'Phoenix' aeroplane which is gradually constructed during the film. These came from a former US Marine Corps R4Q-1 version of the plane, Bu No. 126580.

The film opens with a black screen which is then replaced by a view of the burning hot sun rising above the sand dunes. A Fairchild C-82 Packet takes off, the 'Arabco Oil' logo visible on the port side of the nose.

On board the aircraft, all is not well as the pilot Frank Towns (James Stewart) has been informed that the radio and voltage regulator are not working. Towns leaves his seat to inspect control linkages at the rear of the plane while his navigator Lew Moran (Richard Attenborough) takes over the controls. As Towns is checking out the control cables a sandstorm appears. He returns to the pilot's seat and opens the throttles to try and climb above the storm. The carburettor of the port Pratt & Whitney R-2800 engine fills with sand and the motor fails. Towns lowers the undercarriage and prepares for a crash landing. These early

scenes are the only miniature shots in the entire film and are very convincing, though the wires supporting the model are visible.

Now the titles appear with each one accompanied by a 'freeze frame' of the action; a common stylistic trend in the 1960s. The C-82 makes a hard landing on the sand dunes, and the impact causes some oil drums and equipment to break free killing some passengers and injuring another. Everyone exits the aircraft rapidly, perhaps fearing it is going to burst into flames, but it doesn't. They bury the dead passengers, marking the spot with a crude wooden cross.

One of the passengers, Army officer Captain Harris (Peter Finch) wonders how long it will be before they are rescued. In the meantime, he suggests using some of the aircraft's petrol to create flares and smoke to attract attention. Meanwhile, back in the cockpit Towns records in his log that the cause of the crash was 'pilot error'.

After consulting Dr Renaud (Christian Marquand), Captain Harris suggests rationing the water to one pint a day, just enough to sustain life providing they rest, keep in the shade and don't exert themselves. This will enable their meagre water supply (held in a tank inside the plane) to last 10-11 days.

Scotsman 'Ratbags' Crow (Ian Bannen) asks what food is available, and Harris replies that there is a plentiful supply of pressed dates on board the plane. Towns is sure that a rescue plane will arrive, though he concedes that it may have problems finding them as they were 130 miles off course.

Trucker Cobb (Ernest Borgnine) has a small hand-held transistor radio and Towns grabs it from him, hoping that he can use it to find out what is going on. Suddenly he can't hear anything because of interference from a battery-operated

electric razor used by Heinrich Dorfmann (Hardy Kruger) who is standing in the aircraft's doorway shaving. Towns explodes with anger, the first of many arguments he has with Dorfmann during the film.

Suddenly another sandstorm brews up and everyone has to retreat inside the plane, closing both the rear clamshell fuselage doors and the main hatch on the port side of the fuselage. As everyone waits for the storm to abate some soothing music comes on the radio – namely 'Senza Fine' (Italian for 'Never Ending'), aka 'The *Phoenix* Love theme', sung by Connie Francis. Cobb takes the radio over to the injured Gabriel (Gabriel Tinti) in the hope that it will console him.

Eventually the storm passes and everyone goes out of the plane again. Dorfmann walks round the crashed C-82 making notes. Suddenly a high-flying aircraft appears overhead. The smoke pots are lit but the aircraft continues on its way as the crew are flying too high to see anyone on the ground. The experienced Towns estimates its altitude as 35,000 feet.

Captain Harris has come up with a plan to save everyone. He is going to march to civilization taking Sergeant Watson (Ronald Fraser) with him. Moran is sceptical as the daytime temperature is 120 degrees Fahrenheit in the shade, but Harris says he plans to rest by day and walk at night when it will be cool.

Towns points out that as the Captain is right-handed, his right leg will be more developed than the left giving him a tendency to walk in a large circle. He also explains that compasses would be unreliable in the area because of nearby magnetic mountains. However Harris is convinced his plan will work and he prepares to depart.

At this point Dorfmann announces that he believes it would be possible to build a new aircraft out of the wreckage of the old one and fly everyone out. Towns explodes with anger, saying 'Are you trying to be funny?'

Cobb gives his radio to Gabriel and announces that he wants to go with Harris but the Captain doubts whether he is fit enough for the task. Around the same time, Sergeant Watson stages a fall in the doorway of the aircraft and pretends to have a sprained ankle in order to avoid going on the march.

Moran talks to Dorfmann and discovers that he is an aircraft designer, and that his scheme is perhaps not as crazy as Towns thought. Carlos gives his pet monkey to Mike Bellamy (George Kennedy) and sets off with Harris to seek help. Sometime later Sergeant Watson realises that Cobb is missing and has presumably gone into the desert after Harris. He runs round the aircraft to tell Towns, momentarily forgetting that he is supposed to have a sprained ankle. Towns notices this and sets off to rescue Cobb.

Meanwhile, Dorfmann expresses the opinion that they have everything they need to create a new aircraft, but they will need a great pilot. He has doubts if Towns is the man for the job but Moran defends him, saying that he has flown planes which were 'just bits and pieces'. Dorfmann responds angrily, opining that Towns has 'remembered everything but learned nothing'.

Out in the desert, Towns finds Cobb's dead body. He is brought back to the crash site for burial. Later, Towns and Moran have a discussion in the cockpit of the C-82. After learning that Dorfmann is an aircraft designer, he agrees to talk to him about the feasibility of creating a new plane from the wreckage.

Towns and Dorfmann then have a chat about what will be involved. The plan entails severing the starboard wing outboard of the engine, hauling it over the fuselage, and attaching it to the starboard side of the port engine nacelle which will have to be cut from the inner portion of the wing. As the undercarriage has been destroyed in the crash, skids made from 'H' section steel will be fitted.

Towns will be in the cockpit for the flight out, with Dorfmann in a separate compartment behind him, while all the other men will lie on top of the wing protected by fairings. 12 days will be required to complete the project and the most difficult part (cutting and moving the wing) will have to be done that night before the mens' condition weakens.

Towns is concerned about some of the practicalities of the project, as he believes that it will be impossible to put an injured man (Gabriel) on top of the wing and there won't be enough water to cover the construction period. Dorfmann replies that Gabriel is only likely to live a few days so there will be no problem. Although Dorfmann is correct in what he says, Towns is shocked by his apparent callousness. Dorfmann also points out that the plane is carrying several gallons of anti-freeze in drums which can be distilled to provide additional water.

This is an interesting plot point. In Elleston Trevor's original novel, the 'Salmon-Rees Skytruck Mark IV' had two liquid-cooled engines from which it was possible to extract coolant for distilling. The type of engine was never specified in the book, though to have a similar output to the 2000 horsepower Pratt & Whitney R-2800 of the C-82 it would need to be something like a Rolls-Royce Griffon V12. In the film, the 'Skytruck' is obviously powered by air-cooled radial

engines so the screenwriter Lukas Heller got round this problem by having the aircraft carry some anti-freeze – though why anyone would need it in the desert is never made clear.

Towns also doubts whether the new aircraft built from wreckage will be able to stand the vibration of a 2,000 horsepower engine. This is a fair point. Another plot error I have often wondered about is the fact that Dorfmann's plan would involve severing the main spar at two points. Aircraft normally have one or more main spars (basically thick metal beams) to support the wings. In the world of aircraft restoration it is generally accepted that an aeroplane with a severed main spar cannot fly again unless a new spar is found or manufactured, as broken spars which are welded together simply aren't strong enough to be used in a flying aircraft.

However, it is something that the majority of the cinema-going public would be unaware of. As director Brian J. Hutton once said about the anachronistic inclusion of a 1947 Bell 47 helicopter in the WW2 movie *Where Eagles Dare*: 'They'll never notice in Nebraska'.

Towns and the other passengers continue their discussion with Dorfmann about the feasibility of his plan. Dr Renauld says it may be worth proceeding with the plan to give the men something to do, while Moran points out that even if there is only a 1 in 1000 chance of the scheme working it is worth a try.

Dorfmann rigs up a hand-operated generator in the cockpit to keep the batteries charged, enabling lights to be set up around the plane to facilitate work at night. He then creates a simple apparatus to distil the anti-freeze. Crow watches as he uses sand to prevent a metal pipe from breaking

when he bends it. 'Why didn't you lot win the war?', he muses. 'I wasn't involved', replies Dorfmann.

As work continues, Sergeant Fraser hears a noise and discovers Captain Harris lying in sand dunes near the plane, but he runs back to the crash site without telling anyone. Meanwhile, the men haul the severed starboard wing over the fuselage using winches. Eventually Captain Harris cries out and is discovered and brought back to the plane where he recovers.

The next day, Gabriel – realising there is no hope of him surviving the ordeal – slits his wrist and is discovered by Captain Harris. He is buried near the crash site beside the bodies of the others who have died.

As Dorfmann implores the men to work harder, Towns announces that he has discovered that someone has been stealing water from the tank. Dorfmann admits he did it because he was working when others were sleeping. When Towns asks him why he did it, he replies that if he had asked for the extra water he would have refused his request. 'You're damn right I would', snaps Towns, leading to another disagreement between the two men.

Towns and Moran have another discussion about the prospects of them surviving the ordeal. Towns points out that the crash might not have happened if the alcoholic Moran had checked the engineer's report on the radio instead of going to his bunk to finish another bottle. He says he is a 'second rate navigator working for a fifth rate outfit'. Moran storms off, his feelings obviously hurt.

Later, Towns finds him inside the plane furiously working the hand-powered electric generator. 'Come on, you drunken bum – get back to work', says Towns. Moran laughs, their disagreement over.

The men continue their work on the plane, attaching the previously severed starboard wing to the right side of the port engine nacelle. Standish (Dan Duryea) paints the words 'The *Phoenix*' on each side of the rear fuselage using a pot of black paint.

Captain Harris smells something in the air and goes off to investigate. He discovers some Arabs on the other side of the rise who are unaware of the plane. Harris speculates that they may be a raiding party and suggests he goes to meet them as they may be able to help them. He asks Sergeant Watson to accompany him. The cowardly Watson refuses and Dr Renaud goes instead.

Sometime later, Crow says he can see something over the rise. Towns investigates and discovers the dead bodies of Harris and Renaud, plus a lame camel. He shoots the camel. Watson announces that Harris is dead, obvious glee evident on his face. Towns punches him and he falls to the ground. Watson collapses onto the sand and, soon after, starts to have hallucinations of an Arab dancing girl.

Afterwards, as Dorfmann discusses the layout of the passengers on the wing, Towns suggests that they test the engine to make sure it will start. Dorfmann says it should do so provided all sand has been cleaned out of the carburettor, but that it would be unwise to test it as the vibration will strain the airframe. Also, they have just seven Coffman starter cartridges left and four or five might be needed to start the engine.

Dorfmann responds angrily, saying that Towns 'behaves as if stupidity was a virtue', and goes off in a huff. Towns remains adamant that the engine should be test-run and asks for some of the men to help him pull the propeller through (a common prerequisite to starting a large radial

piston aircraft engine, as it spreads oil throughout the engine preventing damage; oil tends to pool in the lower cylinders due to gravity). None of the men volunteers to do this, as they realise Dorfmann is correct in what he says.

Later Towns talks to Moran as they sip a little water together, and he concedes that Dorfmann was right in everything he said and that was really what annoyed him so much. Moran goes to Dorfmann with some water and he finally agrees to complete work on the plane, as they only have enough water for one more day and if they don't fly out soon they will die.

Towns and Moran chat with Dorfmann in the fuselage of the C-82 where Towns discovers a catalogue which shows all the planes Dorfmann has designed. To his horror he discovers that Dorfmann has only ever created model aircraft, with the largest aircraft he has been responsible for being the *Adler* – a glider with a two-metre wingspan.

As Dorfmann goes to check on the control linkages in 'The *Phoenix*', Towns and Moran discuss the latest revelation. 'He builds toy aeroplanes', reflects Towns. Moran agrees it would be best if the others didn't know and then laughs hysterically at the situation.

They go outside to speak to Dorfmann, who is working on harnesses which the men can wear to pull 'The *Phoenix*' into position. Moran says he shouldn't mention to the others about being a 'toy plane designer'. Dorfmann responds testily, pointing out that a toy plane is something that you 'wind up and it runs along the floor' whereas model aircraft were flying 50 years before the Wright Brothers first flew (in 1903). Since they have no pilot they have to be stable, and (according to Dorfmann) in 1851 Henson and Springfellow created a rubber-powered aircraft which flew 600 metres before encountering

an obstruction. The next morning, Towns emerges from the C-82 wreck clutching his leather flying gloves and seven Coffman starter cartridges. Dorfmann advises him to throttle back as soon as the engine starts, to minimise stress on the airframe. Towns climbs into the cockpit of 'The *Phoenix*', puts on his gloves and inserts the first Coffman cartridge into the starter tube. He slides the cover shut and fires the first cartridge. There is a loud bang, the propeller turns a few revolutions and then stops. The first attempt to start the engine has failed.

This engine-starting sequence is one of the most exciting points in the film, but it is totally fictitious. The Coffman starter (aka a 'shotgun starter') was developed as one of a number of ways of getting an aero engine to start up, and involved an explosive cartridge (looking like a shotgun shell) being placed in a metal tube and then ignited. The resulting explosion produced a surge of high-pressure gas down the tube which turned the crankshaft. It was used in a number of aircraft including some versions of the Supermarine Spitfire, the Chance-Vought F4U Corsair, and even early jets such as the Armstrong-Whitworth Sea Hawk.

It was, however, never used in the Fairchild C-82 Packet which employed an electric starter, similar to that in a car, powered by a huge 24-volt battery in the nose of the aircraft. The C-82's successor, the Fairchild C-119 'Flying Boxcar' (used in the 2004 remake of the film), also used an electric starter.

Nonetheless, the 'Coffman starter sequence' does provide a few moments of exciting cinema even though it may be totally inaccurate. After the first failed attempt to start the engine, Towns tries three more cartridges without success. The men become increasingly anxious. Towns then announces

that he is going to use one cartridge, ignition off, to clean out the cylinders. Dorfmann forbids him to do this but Towns ignores him and fires the cartridge. There is a loud bang and a plume of black smoke comes out the exhaust.

Towns now puts the sixth cartridge into the tube and prepares to fire up the engine as Dorfmann attempts to climb up the ladder onto the plane, requiring him to be restrained by Moran. The cartridge fires and the propeller turns a few times. It looks as though the engine is not going to start up, but Towns works the throttle and the fuel primer and coaxes the engine into life. Slowly, the engine picks up revs and starts running normally. The men who, a moment before, were consumed with anxiety are now jumping for joy.

Dorfmann tells Towns to throttle back to reduce the revs to reduce vibration but Towns replies with the words: 'Right, Mr Dorfmann: start pulling'. The six men put on their harnesses and with the last of their energy haul 'The *Phoenix*' to the top of a nearby hillock from where it can slide down to start its take-off run along a dried-up river bed.

The men climb onto the top of the port wing using a ladder, and the monkey goes with them in a bag. Dorfmann stands behind Towns in a compartment behind the cockpit while the others lie flat on the wings behind a crude windshield.

Towns revs up the engine of 'The *Phoenix*' as it makes its take-off run. It soon becomes airborne, then bumps back on the ground. Towns applies more throttle, pulls back on the stick, and 'The *Phoenix*' leaves the ground. Flying low over the crash site Towns heads for an oil-drilling facility at an oasis.

A while later, 'The *Phoenix*' flies past an oil-drilling site and (off camera) makes a safe landing. The men race for a

pool of water and jump in, splashing water everywhere. Towns and Dorfmann walk slowly towards the pool. They have been saved.

The flying sequences in the last few minutes of the film are very realistic, and involved two separate aircraft to portray 'The *Phoenix*'. The original *Phoenix* (known as the Tallmantz Phoenix P-1) was commissioned by Tallmantz Aviation (who were responsible for the flying sequences in the film) and designed by Otto Timm.

The base aircraft for 'The *Phoenix*' was a North American AT-6 Texan with an R-1340 engine, and fitted with the outer wings of a Beech C-45 Expeditor. The fuselage aft of the cockpit was scratch-built using plywood over a tubular steel framework, and designed to look as though it had been constructed from the boom of a Fairchild C-82 Packet.

The original undercarriage of the AT-6 was not used. Instead, fixed skis were fitted with the wheels of the AT-6 mounted behind them to allow a take-off from a hard runway. The tailwheel came from an L-17 Navion.

The stunt pilot for these scenes was 61-year-old Paul Mantz, who had been flying in movies since 1930. One of his most famous stunts was a belly landing of a Boeing B-17 Fortress for *Twelve O'Clock High* (1949), footage of which which was re-used in many other aviation films including *The Thousand Plane Raid* (1969) and *The War Lover* (1962).

After construction, the Phoenix P-1 was given a Certificate of Airworthiness as an experimental aircraft and was placed on the US civil register as N93082. Paul Mantz first flew the aircraft from Yuma International Airport, Arizona on 29 June 1965 and discovered that it was barely airworthy. The R-1340 engine – which developed just 550

horsepower – made the 4,550lb plane underpowered, particularly as it had a fixed, heavy skid undercarriage which caused a lot of drag and dummies on the wings which decreased lift. It also had a tendency to fly nose down, requiring Mantz to tie back the control column with a bungee cord and fit lead weights in the rear fuselage. There were particular problems at the filming location for the take-off sequences, Buttercup Valley in Arizona – 17 miles from Yuma airport – as the high ambient temperature caused the air to be less dense, thus providing less lift to the aircraft and decreasing available engine power.

Early on the morning of 8 July 1965, Mantz made a series of passes in 'The *Phoenix*' for the benefit of the cameras at the filming location. The intention was to carry out a series of 'touch and gos' which (with careful editing) could be made to look like take-offs. 65-year-old stuntman Bobby Rose was standing in the rear cockpit doubling for Hardy Kruger. Mantz's partner in Tallmantz Aviation, Frank Tallman, was originally going to be the pilot for these scenes but could not participate as he had recently lost a leg in a go-kart accident.

The first two passes went without incident, but then the second unit director Oscar Rudolph requested a third. This time things went badly wrong. Mantz dived too steeply as he approached the valley floor, resulting in the skids hitting the ground. The rear fuselage fractured behind the wing and detached completely as the front end of the aircraft cartwheeled several times, ripping off the engine in the process. Mantz died instantly from severe head injuries, while Bobby Rose was thrown clear and survived with a broken shoulder and pelvis.

In an article in the May 2016 issue of *Aeroplane* magazine, author and aviation historian Simon Beck listed six

factors which may have contributed to the crash: namely that the aircraft was not adequately powered to perform the flying required; high ambient air temperatures causing lower air densities (again hindering the *Phoenix*'s performance); Mantz's alleged consumption of alcohol (which Mantz's associates have strongly disputed); a misjudged approach with an unintended touchdown; a rigid skid undercarriage (which lacked shock absorbers), and possible existing airframe damage due to a previous hard landing on 2 July. The 1967 accident report cited alcohol impairment (from autopsy blood tests) and structural failure (of the joint between the main fuselage and boom assembly) due to an inadvertent touchdown as the main contributing factors toward the crash.

Although the footage of the Phoenix P-1 which was captured before the crash could be employed in the film (in fact four individual shots were used), the producers still lacked a few essential shots to complete the film. In order to achieve this, a North American O-47B observation plane owned by the Ontario Air Museum was converted to resemble the Phoenix P-1. The original designer of the O-47 came out of retirement to oversee the conversion work which was carried out at North American's factory at Palmdale, California.

To turn the O-47B into a '*Phoenix*' lookalike, extensive work had to be carried out including the removal of the canopy and the fitting of skids plus a new fin and rudder to resemble that on a C-82 boom. As with the original Phoenix P-1, dummies were fitted to both upper wings. The O-47 retained its retractable undercarriage (in addition to the skids), which was operated as usual during filming.

Wally McDonnell was the pilot of the O-47B and found that in its reconstructed form it was hard to fly with the same

nose-down tendencies as the P-1. The main problem was a lack of lift caused by the positioning of the dummies on the upper wing surfaces, and this was subsequently improved by altering their position.

On 3 November 1965, director and producer Robert Aldrich and his crew arrived at a quarry location at Pilot's Knob, Arizona for one day's filming to get the final shots they needed to complete the film. Stuntman Bobby Rose had by then recovered from his injuries and was able to reprise his role as Hardy Kruger's stand-in.

The next day, Wally McDonnell made ten passes over the quarry which was standing in as an oasis and drilling site in Libya. No scene of the 'The *Phoenix*' landing was shot (probably because it was considered to be too dangerous). Instead the plane is seen disappearing over a rise and, soon after this, Towns and his fellow survivors arrive at the oasis.

Flight of the Phoenix had its premiere on 15 December 1965 and went on general release in early 1966. Although it received much critical acclaim it was not a box-office success, but it has become a cult classic.

The 2004 Remake

In 2004, a new version of *Flight of the Phoenix* went on general release. Whereas the original was a character-driven drama which focused on the ongoing tensions between the survivors and their desperate need to complete the plane before their water runs out, the new version was more of an action-adventure.

The director was John Moore, best known for action films such as *Behind Enemy Lines* (2001) which starred Owen Wilson, and the fourth film in the *Die Hard* series – *A Good Day to Die Hard* (2013) – which saw Bruce Willis reprising

his role as John McClane. This time, the aircraft which crashed was a Fairchild C-119 'Flying Boxcar' – the successor to the C-82 – which was more streamlined and had more powerful engines, but had the same twin-boom layout which was essential to the plot.

Filming was carried out in Namibia which was standing in for the Gobi Desert, and there were a number of changes compared with the original. Scottish actor Tony Curran, who had appeared in *Pearl Harbor* (2001) and the ITV1 series *Ultimate Force* (2002-2005), played a Scotsman called Rodney who was the equivalent of Ian Bannen's character 'Ratbags Crow' in the original. The aircraft designer (now called Elliott) was portrayed by Giovanni Ribisi, and there was a woman amongst the survivors: oil worker Kelly Johnson (Miranda Otto). Incidentally, in real life 'Kelly Johnson' was the designer of the Lockheed P-38 Lightning, which had a twin-boom layout. In the new version, the lead role of Frank Towns was played by Dennis Quaid, who like James Stewart was a qualified pilot.

It wasn't a bad film, but most people would agree that it wasn't as good as the original. There is no real sense of tension in the movie, and the survivors don't look as though they are slowly dying of thirst, dehydration, sunburn and desert sores. There is also a scene where a song plays in the background but, instead of Connie Francis's sublime 'Senza Fine', it is the far less subtle 'Hey Yah' by Outkast!

The opening scene is even more dramatic than the original, as during the sandstorm sequence one of the C-119's propellors detaches and slices its way through the fuselage thanks to some nifty CGI. However, critics were quick to point out the many implausibilities in the plot of the new version – particularly the scene where the '*Phoenix*' is

completely buried by a sandstorm and then excavated without any apparent damage using a single shovel!

The climax of the movie is different from the 1965 version. After a very similar Coffman starter sequence, the *Phoenix* makes its take-off run while being pursued by Mongolian bandits on horses and heading towards a cliff. It is all a bit like *Raiders of the Lost Ark* (1981).

For this scene the producers briefly considered building a lightweight flyable '*Phoenix*' using carbon fibre, but in the end the sequence was achieved using a combination of a radio-controlled model plus CGI. In my view, though, the definitive version of Elleston Trevor's book will always be the 1965 original which – while being a box-office failure – has taken its place in history as one of the truly great aviation films.

.

Flight of the Phoenix (1965)
Technical Credits

Director: Robert Aldrich
Screenplay: Lukas Heller, based on a novel by Elleston Trevor

Cast

Frank Towns - James Stewart
Lew Moran - Richard Attenborough
Captain Harris - Peter Finch
Heinrich Dorfmann - Hardy Kruger
Trucker Cobb - Ernest Borgnine
Ratbags Crow - Ian Bannen
Sergeant Watson - Ronald Fraser
Dr Renaud - Christian Marquand
Standish - Dan Duryea
Bellamy - George Kennedy
Gabriele - Gabriele Tinti
Carlos - Alex Montoya
Tasso - Peter Bravos
Bill - William Aldrich
Farida - Barrie Chase
Arab Singer (voice only) - Stanley Ralph Ross

Production Credits

Producer: Robert Aldrich
Associate Producer: Walter Blake

Music

Composer: Frank DeVol

Cinematography

Director of Photography: Joseph F. Biroc
Film Editor: Michael Luciano
Art Director: William Glasgow
Set Decorator: Lucien Hafley
Costume Design: Norma Koch
Makeup Artists: Edwin Butterworth, Terry Miles, Jack Stone, William Turner and Frank Westmore
Makeup Supervisor: Ben Nye
Body Makeup: Dee Manges

Second Unit and Assistant Directors

Assistant Directors: Alan Callow, Cliff Coleman and William F. Sheehan
Second Unit Director: Oscar Rudolph
Construction Co-ordinator: John LaSalandra
Property Master: John Orlando
Special Effects: Johnny Borgese
Visual Effects: L.B. Abbott and Howard Lydecker

Stunts

Stunt pilot: Paul Mantz
Stunt double for Hardy Kruger: Bobby Rose
Stunts: Ted Mapes

Aerial Unit

Aerial Supervisor/Chief Pilot:
Paul Mantz (Tallmantz Aviation
Inc)
B-25 Camera Pilot: Frank Pine
(Tallmantz Aviation Inc)
Helicopter Camera Pilot: James
Gavin (Mercury General
Helicopters)
C-82 Crew: Earle Bellotte & Don
Dinoff (Steward-Davis)
FAA Coordinator: Both Thayer
(Steward Davis)
0-47 Phoenix Pilot: Wally
McDonnell (Contract hire)

Camera and Electrical Department

First Assistant Camera: Red
Crawford
Gaffer: Homer Plannette
Still Photographer: Phil Stern
Assistant Camera: Ronald Vidor

Music Department

Orchestrations: Albert
Woodbury
Musician (Guitar): Laurindo
Almeida
Musician (Violin): Victor Arno
Conductor: Frank De Vol
Musician (Accordion): Carl
Fortina
Orchestrator: Gil Grau
Music Copyist: Wally Heglin
Orchestrator: Jerrold Immel
Musician (Piano): Artie Kane
Musician (Trombone): Richard
Nash
Orchestrator: Jack Pleis
Musician (Piano): Urban
Thielmann
Musician (Piano): Raymond
Turner

Transportation Department

Drivers: Chris Haynes and Frank
Khoury
Script Apprentice: Adell Aldrich
Dialogue Supervisor: Michael
Audley
Script Supervisor: Robert Gary
Aerial Sequences: Paul Mantz
Main Title: Don Niehaus
Dialogue Supervisor: Robert
Sherman

Aircraft used in *Flight of the Phoenix* (1965) and current status (where known)

Aircraft Type	Registration No	Status (1965)	Status (Current)
Fairchild C-82A Packet	N6887C	Flying	Scrapped 2005
Fairchild C-82A Packet	N4833V	Desert Wreck (Yuma)	Scrapped 1972
Fairchild C-82A Packet	N53228	Desert Wreck (Fox Studios)	Scrapped 1972
Fairchild C-82 Packet	Unknown	Cockpit scenes	Scrapped 1965
Fairchild R4Q-1	Bu No 126580	Phoenix replica (non – flying)	Scrapped 1965
Tallmantz Phoenix P-1	N93082	Flying Phoenix	Crashed 1965
North American o-47B	N4725V	Second Phoenix	Planes of Fame Museum, Chino, California
N.A. B-25J Mitchell	N1042B	Camera Ship	Airworthy, William Glover, Mount Pleasant, Texas.
Beech Bonanza	Unknown	Tallmantz Support Plane	-
Piper PA-23 Apache	N3131P	Mantz liaison aircraft	Registration expired 2012

Aircraft used in *Flight of the Phoenix* (2004) and current status where known

Aircraft Type	Registration No	Status (2004)	Status (Current)
C-119G	N15501	Flying aircraft	Airworthy, Lauridsen Collection, Buckeye Municipal Airport, USA
C-119F	N3267U	Desert Wreck	Scrapped
C-119F	Bu No 131691	Phoenix prop	Scrapped
C-119F	Bu No 131700	Phoenix Prop	Scrapped

85

Tora, Tora, Tora
(1970)

Almost 50 years after it was made, *Tora, Tora, Tora* remains the most accurate and spectacular reconstruction of the attack on Pearl Harbor on 7 December 1941 ever committed to celluloid.

Almost 70 WW2 vintage aircraft were used in the production, which took four years to make – including two years of pre-production, several months of filming, and 18 months of editing and post-production. The effort made by the filmmakers to achieve authenticity puts this movie in a league of its own. It is certainly far better than the dreadful *Pearl Harbor* (2001), which cost a fortune but was reviled by critics, historians, aviation enthusiasts and the general public alike for its trite, clichéd plot and multiple historical and technical inaccuracies.

In 1966, 20^th Century Fox chief executive Darryl F. Zanuck first considered the possibility of a film about Pearl Harbor. His previous big war picture, *The Longest Day* (1962), had received much critical acclaim and did well at the box office. The only problem was that the ongoing Vietnam War had turned American popular opinion against the glorification of military actions.

This had an effect on the film, as great efforts were made to explain why Japan attacked Pearl Harbor. The Japanese action was precipitated by Roosevelt's decision to impose an oil blockade on the country in retaliation for its

barbaric and unjustified invasion of China. Japan was faced with two options: withdraw from China and make peace with the USA, or else seize natural resources from elsewhere in the Pacific basin, which would entail war with the USA and Britain. Unfortunately they chose the latter option.

Some earlier movies such as *From Here to Eternity* (1953) had featured scenes of the Pearl Harbor raid, but this was the first time that an entire film was to be devoted to the attack. Right from the start it was agreed that to achieve authenticity and balance the film would be a Japanese/American co-production, and *Tora, Tora, Tora* is really two films which have been carefully edited together – one made in Japan, the other in Hawaii and mainland USA.

The biggest problem facing the filmmakers in both Japan and the USA was a lack of suitable WW2 aircraft to participate in the production. This particularly affected Japanese planes which were almost an extinct species. Only a few Mitsubishi A6M2 *Zero* fighters were left, and none were in airworthy condition. Two Aichi D3A1 *Val* dive bombers were found in museums, but neither could fly, and not a single example of the Nakajima B5N2 *Kate* torpedo bomber existed.

One solution briefly considered by 20th Century Fox was to scour the Pacific islands for wrecked Japanese aircraft which could be restored to airworthy condition. But it was soon realised that five derelict planes would be needed to produce one flyable one and the cost involved would be astronomical. Such aircraft restorations can also take years (or even decades) to complete, so this was not a practical strategy.

Eventually the filmmakers turned to a solution that had been used since the earliest days of the cinema; namely, converting an existing type of aircraft. The production's aviation advisor Jack Canary realised that two types of WW2

vintage American training planes, the AT-6 Texan (known to the British and Canadians as the 'Harvard') and the Vultee BT-13 'Vibrator', which were still available in reasonable numbers, could be modified to look like the Japanese types which took part in the attack.

Canary envisaged that AT-6 Texans could be turned into *Zeroes*, Vultee 'Vibrators' could be modified to look like *Val* dive bombers, and the *Kates* could be created using the front end of an AT-6 mated to the rear fuselage of a BT-13.

Eventually a total of 31 replica Japanese aircraft were created in California for the Pearl Harbor scenes, consisting of twelve Zeroes, ten Vals and nine Kates. The aircraft were acquired from all over the USA, and 12 of the AT-6s came from surplus RCAF stocks. Tragically, Jack Canary was himself killed while ferrying a BT-13 to California for conversion.

Two companies at Long Beach, California were given the job of modifying the airframes. Steward-Davis (who had supplied the C-82 Packet aircraft featured in the 1965 film *Flight of the Phoenix*) constructed the *Val* replicas, and also built the 400 plastic bombs and 100 fibreglass torpedoes used in the film. These fake munitions were carefully weighted to fall like the real thing.

Another firm, Cal-Volair, was responsible for creating the *Zeroes* and *Kates*. They also took a plaster cast of a genuine American Curtiss P-40E fighter, which was used to create 30 non-flying fibreglass replicas that could be blown up during strafing scenes.

Using engineering drawings prepared by Robert Brukhart, Steward-Davis constructed ten *Vals* at a cost of $18,000 per aircraft. Starting with a stock BT-13, newly constructed sections were inserted in front of and behind the

89

cockpit to increase the length of the fuselage by a few feet. A seven foot fibreglass dorsal fin was added to the vertical stabiliser, and a horizontal stabiliser leading-edge addition was added along with four-foot fibreglass wing tips to create an approximation of the elliptical wing of a *Val*.

The design of the *Val* was heavily influenced by the German Junkers Ju87 *Stuka* (including the fitment of a fixed, spatted undercarriage), and so large wheel pants were replicated in fibreglass. Fake cowl flaps were added to a modified AT-6 cowling. Each of the *Vals* was refitted with a 600hp Pratt & Whitney R-1340-AN-1 engine instead of the BT-13's original 450hp R-985 Wasp Junior. One *Val* had a geared R-1340 with a three-bladed propeller fitted instead of the usual two-bladed one.

A standard AT-6 has a rather unusual feature: the engine is ungeared, causing the propeller blade tips to exceed the speed of sound. This resulted in an exciting and unique 'rasping' sound which is ideal for war films.

The *Val* replicas had a large wing-to-fuselage fillet fitted, which boosted performance by ten knots. An aft-facing gunner's position was also installed in the rear cockpit under a remodelled canopy. Working bomb racks, including a fake under-fuselage 'trapeze' assembly (which in the real aircraft allowed a 551lb bomb to be dropped during a near-vertical dive without hitting the propeller), were also manufactured and fitted.

Another Long Beach firm, Cal-Volair, carried out most of the aircraft conversions for the film; they were responsible for the 12 *Zeroes* and 9 *Kates* used in the Hawaiian filming, as well as the construction of conversion kits which were shipped to Japan to allow 21 AT-6s to be altered to look like Japanese planes for scenes set on the carrier *Akagi*.

The *Zero* was the easiest of the three Japanese aircraft to recreate, as the conversion work required was not as great as for a *Val* or *Kate* and the cost involved was only $12,000 per plane. The original canopy was removed, the rear cockpit covered with a fairing and a new canopy installed which was similar to that on a real *Zero*. A deck was fitted over the engine cowling and two dummy 7.7mm machine guns installed, as were two mock 20mm cannons in the wings. These guns could be fitted with strobe lights to simulate a real firing weapon. New fibreglass wing tips and an addition to the dorsal fin were added. Landing gear fairings and tail hooks were also affixed, and one *Zero* was fitted with a geared R-1340 engine and a three-bladed propeller.

The most difficult conversion carried out by Cal-Air was the creation of the nine *Kate* torpedo bombers used in the film at a cost of $23,000 per unit. This work was carried out at the company's two workshops at Long Beach and Oxnard, California.

Two fuselage extending 'plugs' were added to the hybrid *Kate* aircraft, which was created from the front end of an AT-6 mated to the rear of a BT-13. These two extra sections, one in front of the cockpit and one behind, added seven feet to the length of the aircraft. This stretched fuselage allowed an elongated canopy to be fitted and a total of three seats were installed, two facing forwards and one to the rear in what was now the gunner's compartment.

As with the *Zero* and *Val* conversions, a single aircraft was fitted with a geared R-1340 engine and three-bladed prop in place of the usual two-bladed AT-6 propellor. Other additions included fake cowl flaps, operating tailhooks and two-and-a-half foot wing tip extensions. At least one *Kate* was

modified to have folding wings, though this is not apparent in the final cut of the film.

While construction of replica Japanese planes continued, the producers obtained several genuine American aircraft for the filming. At the time of the Pearl Harbor attack the defending US fighters would have been Curtiss P-36 Hawks and P-40B Warhawks. No airworthy P-36 or P-40B aeroplanes could be found, so the producers used instead two of the later P-40E models (known to the British as the 'Kittyhawk'). These were N1207V, which had recently been sold to a new owner by the Tallmantz Collection at Orange County Airport and was leased for use in the film, and ex-RCAF 1064, which was owned by Gil Macy of Monterey, California.

N1207V was also used as the mould master for the 30 fibreglass replica P-40s used in the production, and carried the tailcode '27-15P' in the film. The other P-40, RCAF 1064, had been fitted with a four-bladed prop, and a replacement Allison V-1710 engine was installed complete with a more accurate three-bladed airscrew.

A production line was set up at a hangar at Ford Island at Pearl Harbor to complete the construction of the P-40 replicas. The fibreglass sections were bolted to a steel framework and Beech C-45 outer wing panels were attached. Brand new spare AT-6 landing gears and genuine P-40 tailwheel assemblies were fitted to the replicas, two of which were fitted with Allison V-1710 V12 engines to enable them to be taxyed at speed with realistic spinning propellors.

Six PBY Catalina flying boats were also sourced in California for use in the production. One PBY-5A, N6108, was fully airworthy, while the other five were derelict examples which were destroyed during filming.

Five B17G Flying Fortresses operated by Aircraft Specialties of Mesa, Arizona, (which used them to dowse forest fires) were loaned to 20th Century Fox for use in the film. Each aircraft was fitted with a dummy dorsal turret shell and was repainted in a 1941 paint scheme and markings. Aircraft Specialties was also contracted to maintain all the vintage aircraft used in the production, including the 30 replica Japanese planes. This work was carried out under the supervision of the late John King, and reportedly included seven engine changes.

A single rare Douglas SBD Dauntless (actually a land-based A24A version) N9142H, tail number 42-60817, was also located for use in the production. Though some air-to-air footage was taken of this aircraft, none made it into the final cut of the film.

The US military co-operated fully with the production, and many off-duty servicemen played the part of soldiers, sailors and airmen. As most of the buildings at Pearl Harbor hadn't changed much since 1941 the original locations could be used. These included the Naval Air Station at Barber's Point, Ford Island, and Wheeler Field. Ford Island was later redressed as Hickam Field.

The largest set constructed in Hawaii for the film was a huge replica of the stern of the USS *Arizona* adjacent to a full scale mock-up of the mast of the USS *Tennessee*. This amazing construction, built on two barges to make it moveable, was also redressed to become the stern of the USS *Nevada*. It cost $1.5 million, a huge sum in 1968, and included a fibreglass replica of a Vought OS2U Kingfisher floatplane mounted on the stern. The only inaccuracy was that the US roundel on the fuselage of the aircraft lacked a red dot in the centre of the white star, as was the norm in 1941. A few

months later, all Allied aircraft in the Pacific theatre had the red part of their roundels deleted to avoid them being wrongly identified as Japanese planes which carried red 'meatball' markings.

The production also required a large number of period vehicles, and eventually 25 cars and 55 military vehicles were found in Hawaii and restored in the same hangar at Ford Island where the P-40 replicas were being assembled. The located military vehicles included command cars, ambulances, weapons carriers, buses, motorcycles and trucks of all kinds. These were repainted as Army or Navy vehicles according to the demands of filming.

The director chosen for the American sequences was Richard Fleischer, whose most famous work was probably the Disney Movie *20,000 Leagues Under the Sea* (1954). He also directed many other films including *Fantastic Voyage* (1966), *The Boston Strangler* (1968), *Soylent Green* (1973) and *Conan the Barbarian* (1984).

The original director of the Japanese scenes was Akira Kurosawa. However, just a few weeks into production it was clear that he felt uncomfortable about making the film, and he was replaced by Toshio Masuda and Kinji Fukasaku. This meant that the movie had to be recast and scenes reshot, as the original director had cast 15 Japanese industrialists – all non-actors – in key roles.

The film opens with a breathtaking scene (set in August 1939) of three silver *Kate* replicas overflying the Japanese battleship *Nagato* as it lies at anchor. This is not a special effects shot, and no miniatures or matte paintings were used. Instead, we are looking at a full-size replica of the *Nagato*, 660 feet long: the largest film set ever constructed in Japan. It was a technical masterpiece on a par with the

SPECTRE base inside a volcano created by Ken Adam for the Bond movie *You Only Live Twice* in 1966. Although it was constructed of plywood and built on scaffolding which was erected at low tide in Kagoshima Bay, it looked just like the real thing with every detail reproduced including flags, anti-aircraft guns and a replica of a Nakajima E8N2 *Dave* floatplane.

A caption informs us that the American Pacific fleet was 'attacked and partially destroyed' by Japan on Sunday December 7, 1941. Again, this is entirely accurate, as the majority of the American battleships sunk at Pearl Harbor were refloated, repaired and refitted and played a role in the later stages of the Pacific War. This was possible because they were sunk in shallow water (40 feet). Had they been lost far out at sea then salvage would have been impossible.

Admiral Yamamoto (So Yamamura) boards the *Nagato*, where he discusses the proposed Pearl Harbor attack with Lieutenant Commander Mitsuo Fuchida (Takahiro Tamura). Vice-Admiral Zengo Yoshida (Junya Usami) tells him that he (Yamamoto) has been made Commander-in-Chief of the Pacific Fleet.

Meanwhile, the Japanese Prime Minister Prince Fumimaro Konaye (Koreya Senda) discusses the ongoing dilemma facing Japan. Army hotheads are demanding an alliance with Germany, but the Americans are furious at this ongoing dialogue. Clearly Japan has to make the decision to either withdraw from China and make peace with the USA or else seize natural resources (such as oil) from elsewhere, which would involve war with the United States.

The next scene shows Japanese ambassador Saburo Korusa (Hisao Toake) signing the Tri-Partite Pact in Berlin in September 1940, making Japan a part of the Axis. Jerry

Goldsmith's pounding incidental music underlines the significance of this development.

Back in Washington, Cordell Hull (George Macready) – the US Secretary of State – and Henry L. Stimson meet the Japanese ambassador to discuss the diplomatic crisis, while at US Navy Headquarters Lieutenant Colonel Kramer (Wesley Addy) shows Colonel Bratton (E.G. Marshall) how Japanese messages sent using the *Purple* code are being decoded using two electric typewriters connected via an electronic gizmo; a process similar in principle to that used at Bletchley Park in the UK to unravel the mysteries of the German *Enigma* decoding machines. Intelligence information produced by Bletchley Park was known as *Ultra* intercepts while the American equivalent depicted in the film was called *Magic*.

Colonel Bratton is shown a board which displays the names of the 12 people who are privy to *Magic* decrypts, and is dismayed to observe that it does not include 'Hap' Arnold – head of the Air Corps. Ever since the Second World War there has been much controversy about how much American Intelligence knew about Japanese intentions. This has even led to conspiracy theorists – such as Robert Stinnett, who in 2001 published a book called *Day of Deceit* – suggesting that President Franklin D. Roosevelt knew of the forthcoming attack (or even provoked it) and did nothing in order to ensure America's entry into the war. They have pointed to the fact that all the battleships damaged or destroyed at Pearl Harbor were 'World War One junk', while the newer vessels – including the three all-important aircraft carriers – happened to be elsewhere during the raid. What is beyond dispute is the fact that the Allies' double agent Joan Pujol Garcia ('Garbo') tipped off the head of the FBI, J. Edgar

Hoover, about a possible Japanese attack on Pearl Harbor but his warnings were ignored.

Back in Japan, Navy aircrews led by Lt Commander Fuchudi of the *Akagi* are rehearsing a torpedo attack at Pearl Harbor in a scene reminiscent of the 'practice' sequences in *The Dambusters*. Three of the *Kate* replicas built in Japan were used in these scenes. Japanese Navy officers discuss the difficulties of using torpedoes in the shallow waters of Pearl Harbor. Eventually the problem was solved by fitting special fins which allowed the torpedoes to run at a depth of 35 feet.

Now we return to Pearl Harbor, where some US Navy officers go ashore from the USS *Arizona*. This spectacular view was created by combining footage of the full-size mock-up of the stern of the *Nevada/Arizona* with a highly realistic matte painting which adds the front of the ship and other vessels in the background.

Admiral Kimmel (Martin Balsam) overflies the harbour in a Consolidated PBY flying boat as four of the B-17s used in the production pass behind him going in the opposite direction. As Kimmel surveys the scene from the starboard blister window of the PBY he expresses some concerns about the vulnerability of his ships to air attack, particularly by torpedo aircraft. He recalls the successful attack by the British Fleet Air Arm on Italian battleships at Taranto in November 1940 (the aircraft involved were actually Fairey Swordfish torpedo bombers which also crippled the German battleship *Bismarck* in May 1941, allowing it to be destroyed by Royal Navy battleships). It is pointed out to Kimmel that torpedoes need a depth of 75 feet of water to work properly and Pearl Harbour is only 40 feet deep.

Back in Japan on the *Nagato*, the successful Taranto attack is also being discussed by Japanese naval officers

including Yamamoto. Commander Minoru Genda (Tatsuya Misha) lands his *Zero* on the *Akagi,* another huge set built in Japan near the *Nagato*. The full-size replica is entirely accurate apart from the island (superstructure), which is on the wrong side. Most aircraft carriers have their island on the starboard side because planes in trouble tend to veer to port. The only exception to this rule were the majority of Japanese carriers used in WW2 (including the *Akagi*), which had islands on the port side.

The likely reason that the full-size *Akagi* replica had an island on the 'wrong' (i.e. port) side was so that footage shot on it could be integrated with that filmed on the USS *Yorktown*, which portrayed the Japanese carrier in other scenes and had a conventional starboard island. Interestingly, some other films and TV series which have used American carriers (usually the USS *Lexington*) to portray Japanese ones have solved the problem by flipping the film over to give a mirror image. The same technique was used in James Cameron's 1997 movie *Titanic*, which employed a full-scale replica of the RMS *Titanic* that was only fully constructed on the starboard side.

Genda climbs out of his new *Zero* (which has a silver finish rather than the off-white colour of the US-built replicas used in other scenes in the film). He announces that it is a 'Type 21 Zero with folding wingtips', enabling more aircraft to be taken on board a carrier. When asked if it is better than a Spitfire or Messerschmitt he replies 'definitely', as he has seen both in combat over London.

Genda's assertion is not correct. The *Zero* could out-turn all Allied fighters of the period providing the speed of the engagement was kept low, and it had an amazing range of about 1,000 miles with a belly drop tank fitted. But it was

very lightly constructed and lacked armour protection and self-sealing fuel tanks, making it very vulnerable to attack. Even a single o.5ocal hit in its petrol tank could cause a *Zero* to explode in a massive fireball. It was slower than the contemporary Curtiss P-40B and Spitfire Vb, and the latest Messerschmitt Bf109F out-performed all three aircraft. The Focke-Wulf 190A was better than any of these aircraft with its 408 mph top speed and armament of four 20mm cannon plus two 7.9mm machine guns, and was probably the best fighter in the world at the time of the Pearl Harbor attack.

Back at Pearl Harbor, the two airworthy P-40Es used in the production fly past the control tower in a splendid air-to-air shot taken from the production's Bell Jet Ranger helicopter. Lieutenant-General Walter C. Short (Jason Robards) surveys the scene from a window and expresses concern that all the dispersed US aircraft are vulnerable to sabotage from some of the 130,000 Japanese people on the island. He orders all the planes to be parked close together in the centre of the airfield to make them easier to guard, even though it will put them at great risk in the event of an air attack.

In Japan, Admiral Yamamoto is discussing the forthcoming attack on Pearl Harbor and declares that six carriers will be needed, deploying *Zero* fighters, *Val* dive bombers and *Kate* torpedo bombers (some of which can carry bombs instead).

In Hawaii, Admiral Kimmel ponders the need for ongoing aerial surveillance of the waters around the islands. This will entail a full 360 degree search involving 180 B-17s, which is more than exist in the whole of the USA.

Meanwhile, out at sea Admiral Halsey (James Whitmore) is on board the carrier USS *Enterprise* and views

the dismal results of some dive-bombing practice by US Navy pilots. They keep missing a towed target, much to Halsey's dismay. These shots appear to have been achieved using some of the *Kate* replicas, though as they are in long shot they can pass for US dive bombers. This was probably the scene which the Douglas SBD Dauntless was acquired for, though the resulting air-to-air footage was never used.

Over in Hawaii, US soldiers are attempting to set up a radar station on a mountain top, but are told they need permission from the National Park Service. General Short says he will try to get this.

Back in Japan, Admiral Yamamoto learns that his country has now invaded Indo-China, making war inevitable. In Washington, Colonel Bratton learns about this from an intelligence report and General Short in Hawaii is advised to take 'precautionary measures'.

The US troops in Hawaii go on alert, and there are several scenes of convoys of GMC 'Deuce-and-a-Half' trucks leaving Schofield Barracks and aircraft being moved around airfields. The American troops wear tin hats similar to those used by the British, as the more familiar GI helmet wasn't introduced until mid-1942.

In Japan, the military are still arguing over whether the attack on Pearl Harbor should proceed. Yamamoto had concerns about the attack as he knew about the vast industrial capacity of the USA and was certain that after a year or so the Pacific War would turn in America's favour; a prediction which proved correct.

Another training sequence featuring three *Kate* replicas follows, and then the action switches back to Hawaii where the Americans have installed their radar on a hilly slope looking out to sea. It is not the perfect location, but the best

that can be achieved under the circumstances. Another snag is that there is no radio set or telephone at the site, so if the soldiers do spot anything they will have to walk a mile down the road to the nearest gas station to report their findings by 'phone.

Back at Pearl Harbor, two airmen – Second Lieutenants Kenneth Taylor (Carl Reindel) and George Welch (Rick Cooper) of the 47th Pursuit Squadron – are instructed to fly their P-40s to a local dirt airstrip at Halleiwa and await instructions, as their commanding officer is concerned about their vulnerability to air attack.

In Washington, the Japanese Embassy has not responded to compromise proposals made by Hull. In Japan at Hittakopu Bay on 26 November, Yamamoto briefs his colleagues on the forthcoming attack.

Meanwhile, Colonel Bratton views the latest intelligence reports and concludes that Japan is going to attack US forces somewhere in the Pacific on 30 November. As the American military ponders over what to do, the Japanese task force steams towards Hawaii in bad weather – a sequence achieved using 40-feet-long models in the 20th Century Fox water tank. Thirty highly detailed ship miniatures were created for the film.

At Pearl Harbor, General Short is told to 'take appropriate precautions', and squadrons of US Navy fighters are sent to Midway and Wake Islands while Admiral Halsey decides to take his carriers out to sea on a scouting mission. When asked what he plans to do if he encounters a Japanese vessel, he says that if he 'sees as much as a Sampan near us I'll blow it out the water'.

In Washington, the Japanese Embassy prepares to receive a 14-part message from Tokyo as its carrier task force

steams towards Hawaii. The Japanese ships can now pick up Hawaiian music on their radios. On the hangar deck of the *Akagi*, the *Kate* crews practice acquiring American ships in their bombsights using rolling rubber mats pulled under the aircraft. The aircrew are shown silhouettes of the principal American warships they will attack.

In Hawaii, Lieutenant Kermit A. Tyler (Jerry Cox) is told to report to the Pearl Harbor Intercept Centre at 4.00a.m. on the morning of Sunday 7 December, while back in Washington intelligence analysts are poised to intercept the final part of the 14-part Japanese message. The Japanese diplomatic staff have been told to destroy all their documents and cypher machines after receiving the final part of the message, suggesting that an attack is imminent though the Americans have not twigged that Pearl Harbor is the target. Colonel Bratton is so concerned that he tries in vain to contact General Marshall.

In the cinema version of the film there is an intermission at this point, and following it the action really begins. The *Akagi* (and the other five Japanese carriers) are brought into the wind to allow its air group to take off, another shot achieved with miniatures. In a scene filmed on the *Akagi* set in Japan, the Navy pilots start their radial engines. The aircraft in the foreground all appear to have three-bladed propellors, while in the background there are some unmodified AT-6s painted in Japanese markings. As the first aircraft rolls forward for take-off there is a seamless cut to footage shot off San Diego on the USS *Yorktown* as the 30 replica Japanese planes take off from the carrier deck while the sky lightens in the east. At first the Japanese planes appear almost as silhouettes with just a faint blue glow from their exhaust flames but, as the first rays of the sun appear above

the horizon, details of the planes – such as canopy framing – appear.

As all the planes get airborne while the sun rises, they form up and fly past the mast of the USS *Yorktown* which has been bedecked with Japanese flags. It is a truly breathtaking sequence which must rank as one of the greatest aviation scenes ever filmed for the cinema. In the audio commentary for the DVD of the film, director Richard Fleischer says that one reason they used the USS *Yorktown* was because she didn't have a 'diagonal runway' like modern carriers. In fact, this is untrue. When the USS *Yorktown* was first launched in 1943 as one of the *Essex* class carriers, she did not have an angled flight deck (to give it its correct technical term) but one was installed when she was refitted in 1955, and it is clearly visible in one of the aerial shots.

After participating in the carrier take-off sequences the replica aircraft flew to San Diego Naval Air Station and were then re-embarked on the USS *Yorktown*, which took them to Hawaii to participate in the filming there.

In Washington, General Marshall reads the final part of the Japanese communique while in the waters off Pearl Harbor the American destroyer USS *Ward* spots a periscope. The warship opens fire with its forward 3-inch turret gun and the second round blows a hole in the conning tower of a Japanese midget submarine. The vessel crash dives, severely damaged, and the *Ward* attacks with two depth charges. The USS *Ward* (which in reality had four funnels) is played by the USS *Finch*, a single-funnelled destroyer built in 1943. An accurate model of the *Ward* with four funnels was constructed for the film but never used. At the time it was not known if the destroyer had actually sunk the submarine or merely damaged it, but in 2001 the craft attacked by the *Ward*

(a Ko-Hyoteki class two-man midget submarine) was found by divers who confirmed that two large shell holes resulting from the *Ward's* gunfire had caused the loss of the Japanese boat.

Captain John B. Earle (Richard Anderson), the Chief of Staff of the 14th Naval Division, is shaving in his bathroom when receives a 'phone call from Lieutenant Harold Kaminski (Neville Brand), informing him of the USS *Ward's* attack on a Japanese submarine close to Pearl Harbor. Earle dismisses Kaminski's report, saying he needs 'confirmation'.

The huge Japanese air armada continues on its way to Pearl Harbor, and the aircrews notice that the sunbeams projecting through holes in the clouds remind them of their national flag: the 'Rising Sun'. One of the aircrew of a *Kate* picks up a Honolulu radio station and 'rides the beam' to take them to Hawaii. Meanwhile, Major Truman H. Landon (Norman Alden) – supposedly leading a formation of twelve B-17s (actually just five) – listens to the same radio station as he heads towards Pearl Harbor.

On Hawaii, just before the end of their shift at 7.00a.m., two American soldiers manning the radar station have detected the incoming Japanese strike force. One of them (Private Elliott) 'phones Lieutenant Kaminsky to inform him, but he tells the soldier not to worry about it. Kaminsky has assumed the blips are the incoming B-17s.

As the Japanese planes approach Hawaii, Yamamoto is told that an official declaration of war will be made 30 minutes before the attack. Meanwhile, a telegram has arrived in Hawaii from Washington warning of a possible attack but – as it is not marked 'urgent' – it is put in a pigeon hole to await collection.

By now the Japanese force is overflying the island of Oahu on its way to Pearl Harbor, where they encounter a

single yellow civilian Boeing Stearman two-seater biplane crewed by a female instructor Cornelia Clark Fort (Jeff Donnell) and her pupil Davey (Hank Jones). The Japanese aircrew are astonished at this sight but do not attack the civilian plane. Fort takes control of the plane and dives for safety.

As the Japanese aircraft approach Pearl Harbor, Fuchida comments that the American anti-aircraft batteries haven't fired a shot. He asks for the radio message 'Tora, Tora, Tora' ('Tiger, Tiger, Tiger') to be sent back to the flagship to signify that total surprise has been achieved.

Just before 8.00a.m., as the Americans are starting to raise the Stars and Stripes on the stern of the USS *Arizona* and the Navy band starts to play the National Anthem, the Japanese planes attack with bombs, torpedoes, and cannon and machine gun fire.

Within minutes the Americans are firing back with whatever weapons can be brought to bear. One problem during the real attack was that the ships weren't at battle stations, prepared for an attack, and much of the anti-aircraft ammunition was in padlocked lockers, delaying the American response.

One *Val* flies over an American shore installation at low level, prompting one US Navy officer to say he is going to get his number and report him for a safety violation. The *Val* then drops a 551 pound bomb which explodes, much to the American's surprise.

Interestingly, one technical inaccuracy in the film is that none of the *Vals* execute true dive-bombing. Instead they carry out low-level horizontal bombing. In a true dive-bombing attack the aircraft is put into a near-vertical dive, viewing the target through a special sight (in the case of the

Val, this was a small telescope mounted in front of the windscreen). At a pre-determined height (usually about 2,000 feet) the bomb was released from an extendable cradle under the belly of the aircraft, allowing the weapon to drop clear of the propeller arc. An effective dive bomber must not plunge too fast, which is the reason that most were fitted with air brakes to slow them down. Once the bomb has been dropped, the pilot has to pull out of the dive, resulting in huge g-forces which can cause a blackout. For this reason the German Junkers Ju87 *Stuka* was fitted with an automatic mechanism to make the aircraft climb after bomb release, even if the pilot was unconscious.

In the early stages of WW2 dive-bombing was the only true precision bombing method, but it was only effective in conditions of air superiority as the aircraft involved were vulnerable to fighters as they pulled up slowly from their dives. During their attack, they also made perfect zero-deflection targets for anti-aircraft guns.

Furthermore, dive-bombing aircraft had to have their structures strengthened to withstand the g-forces involved. This would have been the reason that the *Val* replicas in *Tora, Tora, Tora* never carried out true dive-bombing attacks, as their airframes would not have been strong enough to take the stresses involved. Incidentally, two of the replica Japanese aircraft – one *Val* and one *Kate* – crashed during filming, resulting in the death of the *Val* pilot while the *Kate* pilot escaped with minor injuries.

As the Americans do their best to fight back with the few anti-aircraft guns that can be brought into action, the Japanese continue their attack. *The* USS *Arizona* is badly hit and capsizes, while the USS *Nevada* attempts to get under way.

As there are no airborne American fighters to engage in combat, the *Zeroes* strafe Wheeler Field and the other airfields. One by one the P-40s blow up in a series of spectacular explosions. Some of the American pilots try to take off, but are hit by cannon and machine gun fire from the *Zeroes*.

One P-40 taxying at speed is hit and veers to the left, plowing into a line of parked fighters. This scene proved more dramatic than intended. Two of the fibreglass P-40 replicas were fitted with Allison V-1710 engines to spin their propellors and enable them to taxi. They could even be steered by remote control through applying the brakes to one or other wheel. On the day of filming, one of the P-40s went out of control and hit the line of fighters at a different spot from that intended. A huge explosion resulted and the stuntmen seen running from the scene were genuinely afraid of being killed. They didn't need to act.

As the carnage continues, the B-17s attempt to land but cannot fight back against the strafing *Zeroes* as their guns are packed in grease. One of the Fortresses develops a problem with its landing gear as its starboard wheel is stuck in the 'up' position, and thus has to make a one-wheeled landing. This did not happen during the real attack, but was a genuine incident which occurred during filming. After one of the B-17s (N620L) reported problems with its undercarriage, it was told to circle the field to use up fuel while cameras were set up and smoke pots ignited. Once the Fortress had burned off most of its gasoline it made a gentle, controlled landing which was filmed by several cameras. Later, some air-to-air footage was shot showing one of the B-17s flying with only its port wheel down and coming in to land. This was carefully edited into the finished film to produce a highly realistic sequence

which never happened during the Pearl Harbor attack but was felt to be worth including in the film.

As the attack reaches its climax a spent bullet comes through a window and nearly hits Admiral Kimmel, who expresses a wish that it had killed him as he feels responsible for what has happened.

As the Japanese *Zeroes* destroy the remaining P-40s, Lieutenants Taylor and Welch 'phone Haleiwa airfield and tell the groundcrew to get their two P-40s started and their engines warmed up. The two pilots race to the satellite field in a convertible and take off.

Meanwhile, the heavily damaged USS *Nevada* is beached to one side of the main channel without blocking it; an amazing feat of seamanship which allowed her to be salvaged and refitted.

By this time, Lieutenants Taylor and Welch have gained altitude and attack some *Kates* which are protected by *Zeroes*. After a quick burst of machine-gun fire one of the *Zeroes* is hit, followed by a *Kate*. The damage to the *Zero* is depicted by a studio shot showing a line of holes appearing in the fuselage. The demise of the *Kate*, though, is portrayed by an actual pyrotechnic charge exploding on the side of the aircraft; a piece of realism not previously seen in the cinema.

Close-up shots of the American fighters firing their guns appear to have been shot in the studio using modified P-40E replicas, with all glass and perspex removed from the canopies to avoid reflections from studio lights and a front projection process used to depict the background. The P-40Bs deployed at Pearl Harbor had two 0.50cal Browning guns mounted in the upper engine cowling firing through the propeller, plus four 0.30cal Brownings fitted in the wings. However, the later P-40E (the type used in the film) had a

different gun configuration consisting of six 0.50cal Brownings in the wings.

The P-40 replicas used in the studio shots had their gun arrangement altered to that of the earlier 'B' models, with two cowling guns plus four more in the wings. However, the latter weapons don't look like those in a P-40B, as in real examples of this type the four 0.30cal wing guns project about a foot in front of the leading edge and are close together, while those in the studio shots are quite widely spaced and hardly projecting at all as they are largely faired in by the metal 'pimples' which project from the leading edge of the wing. Close study of the DVD of the film using freeze-frame shows that the four-gun layout was achieved by blanking off the middle 0.50cal gun position on each wing. The guns also appear to be oxy-acetylene gas weapons, as used in *633 Squadron* and other aviation films.

Tora, Tora, Tora was one of the first American movies to use front projection for scenes such as this. Prior to this, the options were to use a 'blue screen' method (which often resulted in a matte line around the actors) or back projection, which was often unconvincing as the background footage was often dimmer and of poorer quality than that in the foreground. Front projection was first used in the Japanese film *Matanga: Fungus of Terror* in 1963. Its widespread use in mainstream films followed the invention of the reflective material 'Scotchlite' by the 3M company in the 1960s. This is the technology used in reflective car number plates and cinema screens. The first big-budget picture to use it was *2001: A Space Odyssey* (1968) (particularly for the 'Dawn of Man' sequences), and it was also used extensively in *Where Eagles Dare* (1969) and *On Her Majesty's Secret Service* (1969).

As the Japanese attack continues, several PBY flying boats are destroyed. A Japanese *Zero* is hit by machine gun fire, and the pilot dives into an American hangar in the first kamikaze attack of WW2. This stunt did not involve any miniature work, and was done for real using a *Zero* replica on a chute. The resulting carnage inside the hangar was filmed by an unmanned camera and included the destruction of a B-25 Mitchell modified with a single fin instead of the usual twin tail. Many aviation buffs have wondered why the B-25 was altered to represent a non-existent type, but a letter published in *Flypast* magazine in 1992 suggested that it may have been representing a Douglas A-20 twin-engined light bomber and that was the reason for the unusual conversion.

The Japanese aircraft return to their carriers, but are denied permission to refuel and rearm for a further strike against Pearl Harbor. In Washington, Secretary Hull berates the Japanese ambassador for their country's duplicity prior to the attack. As the raid comes to an end the non-urgent telegram sent to Pearl Harbor to warn of a possible attack is finally read by the military commanders.

Admiral Halsey returns to Pearl Harbor in the USS *Enterprise* (actually the USS *Iwo Jima*), where he views the carnage. Meanwhile, Yamamoto is less than jubilant about the attack as he realises that the Americans will be angered at the fact that the raid started before a declaration of war had been made. 'I fear that all we have done is to wake a sleeping giant and fill him with a terrible resolve', he says.

Principal shooting on *Tora, Tora, Tora* finished in the spring of 1969, but a further 18 months of post-production work and editing followed. The film was released on 23 September 1970 and received mixed reviews. Some critics didn't like its dramatic documentary style and found the first

half of the movie to be boring. Most aviation and military enthusiasts loved the film for its accuracy and attention to detail, and it made almost $30m in the USA against a production cost of $25m.

After the film was completed, 20th Century Fox hung onto its fleet of replica Japanese planes for a couple of years before selling them off. Some were returned to their original configuration but most remained as mock Japanese warbirds. 14 of the 28 replicas which survived the filming are still airworthy in the USA. The Commemorative Air Force (formerly known as the Confederate Air Force) flies eleven of the former *Tora, Tora, Tora* aircraft as a key part of their Pearl Harbor re-enactment at airshows. Three other ex-*Tora* replicas are also active on the US airshow scene, and one of the *Zeroes* used in the film was operated by the Old Flying Machine Company at Duxford in the UK for a few years in the 90s.

Some of the replica Japanese aircraft created for the film have turned up in a number of films and TV shows including *Midway* (aka *Battle of Midway*), *The Final Countdown*, *Pearl Harbor*, *War and Remembrance* and *The Black Sheep Squadron*, while footage from the movie has also been re-used in many productions. For *War and Remembrance*, some of the Kate replicas created for *Tora, Tora, Tora* were painted to represent US Navy Douglas Devastator torpedo bombers.

Pearl Harbor
In 2000, filming started on *Pearl Harbor*: a large-budget Hollywood epic directed by Michael Bay which included a recreation of the attack on the US base. There were also scenes depicting an RAF Eagle squadron fighting German

Heinkel 111 bombers over England in the summer of 1941(!) and the Doolittle Raid on Tokyo in April 1942.

Unlike *Tora, Tora, Tora,* the film was not a dramatized documentary but centred around a love triangle involving Evelyn Johnson (Kate Beckinsale) and two pilots Rafe McCawley (Ben Affleck) and Danny Walker (Josh Hartnett). The producers' idea was that this would be a 'film with a heart' which would draw in audiences attracted to the emotional core at the heart of the movie. *Pearl Harbor* appears to have been inspired by the success of James Cameron's *Titanic* (1997), which also featured a love story set against a backdrop of dramatic historical events. It additionally features some scenes which are similar to those in *Top Gun.*

Twenty-eight aircraft were used in the production, including four Spitfires, a Hurricane, a Sea Hurricane, two Hispano Buchons, four P-40s, three *Kate* replicas, three *Val* reproductions, three *Zeroes,* and four B25s. The *Vals* and *Kates* were ex-*Tora* aircraft, but the *Zeroes* were the genuine article. One of them was owned by the 'Planes of Fame' museum at Chino, California, and the two others were 'Flight Magic' *Zeroes* built in Russia using derelict airframes, a lot of new parts, and American Pratt & Whitney R-1830 engines. The 'Planes of Fame' *Zero* is the only one still flying with its original Sakae engine.

Despite all the hype, the film was given the thumbs down from critics and the general public alike when it was released in 2001. Unlike *Tora, Tora, Tora,* much of the action was created with horribly cartoony CGI. One has only to compare the scene where *Zeroes* strafe P-40s in *Tora, Tora, Tora* with its CGI-created equivalent in *Pearl Harbor* to see what I mean.

Perhaps one day Hollywood will make another very accurate film about Pearl Harbor. But is there really any need since the 1970 original achieved near-perfection?

Tora, Tora, Tora (1970)
Technical Credits

Directors: Richard Fleischer
(USA sequences), Kinji Fukasuka
(Japanese sequences), Toshio
Masuda (Japanese sequences).

Screenplay Credits
Screenplay: Larry Forrester,
Hideo Oguni, Ryuzo Kikushima
and Akira Kurosawa (Japanese
scenes - uncredited).

Book Sources:
Tora, Tora, Tora by Gordon W.
Prange
The Broken Seal by Ladislas
Farago

Cast
Admiral Kimmel - Martin Balsam
Admiral Yamamoto - So
Yamamura
Henry Stimson - Joseph Cotton
Commander Genda - Tatsuya
Mihashi
Lt Colonel Bratton - E.G.
Marshall
Lt Commander Fuchida -
Takahiro Tamura
Admiral Halsey - James
Whitmore
Admiral Nagumo - Eijoro Tono
Lt Commander Kramer - Wesley
Addy
Ambassador Nomura - Shogo
Shimada

Lt Commander Thomas - Frank
Aletter
Prince Konoye - Koteya Senda
Frank Knox - Leon Ames
Admiral Yoshida - Junya Usima
Captain John Earle - Richard
Anderson
Foreign Minister Matsuoka -
Kazuo Kitamura
General George Marshall - Keith
Andes
Admiral Stark - Edward Andrews
Lieutenant Kaminsky - Neville
Brand
Mrs Kramer - Leoro Dana
General Tojo - Asao Uchida
Cordell Hull - George MacReady
Major Truman Landon -
Norman Alden
Captain Theodore Wilkinson -
Walter Brooke
Lieutenant George Welch - Rick
Cooper
Doris Miller - Elven Havard
Miss Ray Cave - June Dayton
Cornelia (Flying Instructor) - Jeff
Donnell
Davey (Student Pilot) - Hank
Jones
Colonel Edward F. French -
Richard Erdman
Lt. Colnel William Outerbridge -
Jerry Fogel
Kameto Koroshima - Shunichi
Nakamura

Lieutenant Kenneth Taylor - Carl Reindel

Rear Admiral Bellinger - Edmon Ryan

Saboru Kurosu - Hisao Toake

General Short - Jason Robards

Rear Adm. Tamon Yamaguchi - Susumu Fujita

Adm. Koshiro Oikawa - Bontaro Miake

Read Adm. Ryunosuke Kusaka - Ichiro Ryuzaki

Capt. Harold Train (USS California) - Karl Lukas

Lt Laurence Ruff (USS Nevada) - Ron Masak

Rear Adm. Chuichi Hara - Hiroshi Nihonyanagi

Lt Cmdr. Shigeharu Murata - Toshio Hosokawa

Rear Adm. Takijiro Onishi - Toru Abe

Eugene Dooman - Harold Conway

Captain Logan C. Ramsey - Dick Cook

Lt. Kermit A. Tyler - Jerry Cox

Edward Crocker - Mike Daneen

Captain Arthur H. McCollum - Francis De Sales

Major Gordon A. Blake - Dave Donnelly

French's Subordinate - James B. Douglas

Col. Kendall J. Fielder - Bill Edwards

Lt Col Carroll A. Powell - Dick Fair

Lt Col William H. Murphy - Charles Gilbert

Lt Mitsuo Matsuzaki - Hishashi Igawa

Army Officer - Lex Johnson

Major John Dillon - Robert Karnes

Civilian Officer - Kenner G. Kemp

Japanese Embassy Officer - Akira Kume

George Street (RCA Honolulu) - Dan Leegant

Read Adm. John Newton - Ken Lynch

Col. Walter C. Philips - Mitch Mitchell

Japanese Pilot - Hideo Murota

Destroyer Captain - Steve Pendleton

Vice Adm. William S. Pye - Walter Reed

Radio Operator - John Henry Russell

Sailor - Dan Savino

Cmdr. William H. Buracker - Robert Shayne

Brig. Gen Howard C. Davidson - Edward Sheehan

Ed Klein (Telegraph Operator) - Tommy Splittgerber

Cmdr. Maurice E. Curts - G. D. Spradlin

Japanese Midget Sub Crewman - Hiroshi Tom Tanaka

Maj. Gen. Frederick L. Martin - Larry Thor

Captain on Flight Line, Hickam - George Tobias
Officer at Signing of Pact - Arthur Tovey
Desk Sergeant - Bob Turnbull
Brig. Gen Leonard T. Gerow - Harlan Warde
Ambassador Joseph C. Grew - Meredith 'Tex' Wetherby
Ens. Edgar M. Fair - David Westberg
Private Joseph Lochard - Bruce Wilson
Adm. James O. Richardson - Bill Zuckert

Producers
Associate Producers (Japan): Keinosuke Kubo, Otto Lang, Masayuki Takagi and Elmo Williams
Producer (uncredited): Richard Fleischer
Executive Producer (uncredited): Darryl F. Zanuck

Original Music
Music: Jerry Goldsmith

Film Editing
Pembroke J. Herring
Shinya Inoue
James E. Newcom

Art Direction
Richard Day
Jack Martin Smith
Taizo Kawashima

Yoshiro Muraki

Set Decoration
Walter M. Scott
Norman Rockett
Carl Biddiscombe

Make Up
Makeup Artist: Layne Britton
Make-up Supervisor: Daniel C. Striepeke

Art Department
Art Crew: Tsukasa Kondo
Construction Supervisor: Ivan Martin
Production Illustrator: Joseph Musso
Assistant Art Director: Jack Senter

Sound Department
Sound Recordists: James Corcoran, Herman Lewis, Theodore Soderberg, Murry Spivack, Shin Watarai and Douglas O. Williams
Supervising Sound Editor: Don Hall

Special Effects
Mechanical Effects: A.D. Flowers, Johnny Borgese, Greg C. Jensen, Glen Robinson

Visual Effects
Special Photographic Effects: J.B. Abbott, Art Cruickshank,

Edward Hutton, Howard
Lydecker
Miniature Construction
Supervisor: Gail Brown

Stunts

Lightning Bear
Jerry Brutsche
Steven Burnett
Everett Creach
Vince Deadrick Snr
Chad Evans
J. David Jones
Charlie Picerni
Rock A. Walker

Camera and Electrical Department

Photographers (Japan): Osama
Furuya, Shinsaku Himeda,
Masamichi Satoh
Director of Photography (USA):
Charles F. Wheeler
Still photographers: Mal Bulloch,
Doug Kirkland, Sterling Smith,
Tamotsu Yato
Cinematographer, Second Unit:
David Butler
Assistant Camera, Second Unit:
Thomas Del Ruth, Rexford L.
Metz
Assistant Camera: Dave
Friedman
Gaffer: William Huffman
Assistant Camera: Tom
Kerschner
Camera Operator: Jack Whitman

Costume Department

Wardrobe: Ed Wynigear
Wardrobe Supervisor: Courtney
Haslam
Set Wardrobe: Michael Butler

Music Department

Orchestrator: Arthur Morton
Musician (samisen): Robert Bain
Musician (drums): Larry Bunker
Musician: Gene Cipriano
Composer (Japanese music):
Alexander Courage
Supervising Music Editor:
Leonard A. Engel
Conductor: Jerry Goldsmith
Music Copyist: Wally Heglin
Musician (piano): Artie Kane
Musician (bass): Milton
Kestenbaum
Musician (viola): Virginia
Majewski
Orchestrator: Billy May
Musician (clarinet): Ted Nash

Transportation Department

Picture car coordinator
(Washington): George Hamlin
Driver: Chris Haynes

Miscellaneous Crew

Air operations: Jack Canary
Technical Advisors (Japanese
scenes): Kuranosuke Isoda,
Tsuyoshi Saka, Kameo Sonokawa
and Shizuo Takada
Dept of Defense Project Officer:
E.P. Stafford

Production Coordinator:
Theodore Taylor
Script Supervisor: Duane Toler
Production Coordinator: Maurice
Unger
Air Operations: George Watkins,
Arthur P. Wildern Jr.
Boeing B-17 Pilots: Bill Benedict,
George Burnette, Don Clark,
Don Fletcher, Bill Groomer,
Davie Haines, Allen Mosley,
Gary Pylant, Sam Steele and Jim
Stumpf
Chief Pilot: J. David Jones
Technical Advisors: Robert
Buckhart, Minoru Genda and
Konrad Schreier Jr
Production Assistant: Randee
Lynne Jensen
Production Auditor: Gaines
Johnston
Caterers: Dominic Santarone and
Ruth Santarone

Unit Publicist: Ted Taylor
Story Consultant: Yasuji
Watanabe
Army Affairs Coordinator: B.H.
Watson

**Second Unit Director or
Assistant Director**
Assistant Directors: David Hall,
Hiroshi Nagai, Elliott Schick,
Shunsuke Kariya and Harrold
Weinberger
Second Unit Director: Ray
Kellogg

Production Management
Unit Production Managers:
Stanley Goldsmith, William
Eckhardt, Masao Namikawa,
Jack Stubbs and Richard D.
Zanuck

Aircraft Used in *Tora, Tora, Tora* (1970) and current status (where known)

Kate Replicas

Base aircraft	Civil Registration	Current Status
Harvard Mk IV	N1264	Chiang Mai, Thailand; Status unknown
Harvard Mk IV	N2047	Commemorative Air Force (CAF)
AT-6D	N7062C	Japanese Bomber LLC, Atlanta
AT-6D	N6438D	Takai Hiroyosu, San Jose, CA
SNJ-5	N3242G	CAF
SNJ-5	N3725G	CAF
SNJ-5	N7130C	CAF
SNJ-5	N3239G	Amjet; Geared Engine, 3 -bladed prop
Unknown	Unknown	Crashed during filming and destroyed

Zero Replicas

Base aircraft	Civil Registration	Current Status
Harvard Mk IV	N15796	Olympic Jet, Olympia, Washington State USA
Harvard Mk IV	N12048	Destroyed; hangar fire, 12/06/94; Geared Engine, 3 bladed prop
Harvard Mk IV	N15795	Crashed 11/08/91 at Airshow, Grove, USA
Harvard Mk IV	N15799	CAF
Harvard Mk IV	N15798	Now VH-ZRO; Australia, Gary Cooper
Harvard Mk IV	N9097	CAF
Harvard Mk IV	N7754	Snyder Steven, Richland, Washington State,USA
Harvard MK IV	N4447	CAF
Harvard Mk IV	N15797	CAF
Harvard Mk IV	N7757	American Aeronautical Foundation
Harvard MK IV	N296W	Challenge Publications
SNJ-5	N7986C	Rudy Frasca, Urbana, Illinois

Val Replicas

Base aircraft	Civil Registration	Current Status
BT-13	N63163	Civil Registration cancelled, 20/01/95
BT-13A	N67208	CAF
BT-13	N65837	Charles Angel, Kingswood, Texas

BT-15	N27003	CAF
BT-15	N56336	CAF
BT-15	N22009	CAF
BT-15	N56478	Unknown
BT-13	N56867	Laird Aviation, Lemoyne, Pennsylvania
BT-13	Unknown	Lost During Filming

In addition, a tenth Vultee Valiant was converted to a Val and given the serial N18102, though no further details are known of its subsequent fate.

B-17 Flying Fortresses

Type	Civil Registration	Current Status
B-17F	N17W	Museum of Flight, Seattle
B-17G	N621L	Destroyed in crash, July 1975
B-17G	N3193G	Yankee Air Force, Belleville, Michigan
B-17G	N620L	Destroyed in crash, 12/07/1973
B-17G	N9563Z	Martin Aviation, Santa Ana, Orange County, California, USA

B-25 Mitchell

Type	Civil Registration	Current Status
B-25J	N9754Z	Destroyed during filming

Curtiss P-40E Warhawk

Type	Civil Registration	Current Status
P-40E	EN1207V	John McGuire, War Eagles War Museum, Santa Teresa, NM, USA. Now N95JB. Static.
P-40E	N151U	Static. Pacific Aviation Museum, Pearl Harbor, Hawaii

Douglas A-24A

Type	Civil Registration	Current Status
A-24A	N15749	Airworthy, Tillamook Air Museum, Oregon

Boeing PT-17 Stearman Kaydet

Type	Civil Registration	Current Status
PT-17	N34307	Unknown

Consolidated PBY Catalina Flying Boats

Type	Civil Registration	Current Status
PBY	N6180	Unknown

Also four derelict Catalinas, identities unknown, were destroyed during filming.

Replicas constructed in Japan

21 AT-6 Texans were used during the filming in Japan. Details are as follows:

Japanese-built Zeroes

Base Aircraft	Serial Number	Civil Registration
North American T-6G Texan	JASDF 52-0030	-
North American T-6G Texan	JASDF 72-0158	-
North American T-6G Texan	JASDF 72-0175	-

Japanese-built Kates

Base Aircraft	Serial Number	Civil Registration
North American T-6G-NH- Texan	JASDF 72-0151	N6522
North American T-6G –NH Texan	JASDF 72-0159	N6524
North American T6G-NH Texan	51-14675	N6526
North American T-6G-NH-Texan	51-14679	N6529
North American T6G-NH-Texan	51-14706	NN6520

As can be seen, no Val replicas were built in Japan. The remaining 13 T-6G Texans were painted in Japanese markings and used as background set dressing on the *Akagi* set.

The Commemorative Air Force

The December 2011 issue of *Aircraft Illustrated* lists 11 Japanese aircraft replicas currently flown by the Commemorative Air Force (CAF), formerly known as the Confederate Air Force. They are as follows:

Zero replicas

Harvard IV	N4447
Harvard IV	N9097
Harvard IV	N15799
Harvard IV	N15797
AT-6B	N11171
SNJ-5	N9020C

Val Replicas

BT-13A	N67208
BT-13A	N56478

Kate Replicas

SNJ-5	N3242G
SNJ-5	N3725G

It should be noted that two of the Zeroes, N11171 and N9020C were apparently not used in *Tora, Tora, Tora* and were presumably constructed in more recent times. The following ex-*Tora, Tora, Tora* aircraft are also on the US civil aviation register, and are not part of the CAF *Tora, Tora, Tora* display team:

Zeroes

Harvard IV	N60DJ (formerly N296W)
Harvard IV	N7754

Val

BT-13A	N56336

Kate

SNJ-5	N6438D

Dark Blue World
(2001)

Dark Blue World (or *Tmavomodry Svet* to give it its Czech title) is not a well-known aviation film as far as the general public is concerned. It only gained a limited release in the UK and, though it came out on DVD on 2002, it hasn't had re-runs on TV in way that films like *Reach for the Sky* and *The Dambusters* have.

The film is, however, held in high regard by aviation enthusiasts. In his 2014 book *Flying Film Stars*, Mark Ashley praises the film as one of the greatest aviation movies ever made. What makes the film so excellent is the way that original aerial footage, out-takes from the 1969 film *Battle of Britain*, replica aircraft, radio-controlled models, miniature work and CGI have been blended to produce a visual masterpiece. Ashley also commends the filmmakers for their excellent use of CGI, saying that the production features the best use of this technique in any aviation movie to date. I would completely concur with this view.

The Czech film industry has previously shown great creativity when making aviation movies. For the 1968 film *Nebestt jezdci* (*Riders in the Sky*), an accurate replica of an RAF Vickers Wellington bomber was created using a Soviet Lisunov Li-2 transport plane No 23442209, OK-GAD (a Russian version of the Douglas C-47), with the geodetic fabric-covered structure of the Wellington built over its existing metal fuselage at the Aero Vodochody works. The

bomber had working front and rear gun turrets and could taxy with turning airscrews – though, to prevent the propeller tips striking the widened fuselage, slots were cut in the outer skin.

A German/Czech co-production, *Dark Blue World* makes an interesting contrast with Michael Bay's *Pearl Harbor*. Both were filmed in 2000 and released the following year. The two movies feature Spitfire sequences and two out of the four Spitfires used in *Pearl Harbor* also appeared in *Dark Blue World*. Also, the two productions feature a 'love triangle' as a key part of the plot.

There the resemblance ends. *Dark Blue World* had a budget of $10m; *Pearl Harbor*, fourteen times that. Michael Bay's overblown and inaccurate movie was almost universally reviled by the critics, general public and aviation enthusiasts alike, and featured really atrocious cartoon-like CGI. For example, the scene of a CGI-created Aichi D3A 'Val' dive bombing the USS *Arizona* looked like something out of a *Bugs Bunny* cartoon rather than genuine aerial footage (one almost expected the bomb to have 'ACME' written on the side of it!). *Dark Blue World*, though, is an example of what can be achieved with a little money and a lot of imagination and creativity.

Apart from a couple of sea scenes which were shot in South Africa, the entire production was filmed in the Czech Republic in the spring and summer of 2000. The Old Flying Machine Company (OFMC), based at Duxford near Cambridge, was contracted to supply Spitfires for the production. A total of three Spitfires were used: namely Mark V EP120 (owned by the Fighter Collection at Duxford and flown by Nigel Lamb), Mark VIIIc MV154 (piloted by Robs Lamplough) and the OFMC's own Mark IX MH 434. The

latter aircraft had already appeared in numerous films and TV productions including *The Longest Day* (1962), *Operation Crossbow* (1965), *Battle of Britain* (1969), *A Bridge Too Far* (1977) and London Weekend Television's *Piece of Cake* (1988), to name but a few.

Although the Mark IX Spitfire MH434, piloted by Ray Hanna, was flown to the filming location at the former Soviet air base at Hradcany, it never flew in the movie and only appeared as a static aircraft. Why this happened is not clear, though it is possible that it developed a technical problem preventing its full participation in the production. Fortunately director Jan Sverak – who had previously helmed the highly acclaimed Academy Award winning film *Kolya* (1996) – managed to use the two remaining airworthy machines to great effect and the impression given throughout the film is that a whole squadron of Spitfires was used. In addition to the genuine aircraft, GP Replicas supplied a number of fibreglass replica Spitfires. Two of these were fitted with lawnmower engines to spin their propellors and were used in taxying scenes.

Digital (rather than film) cameras were used throughout the production, making computer effects easier. One technique employed throughout the film – which is known as 'layers in progress' – enabled the number of aircraft on screen to be multiplied. Thus in one scene we see two Spitfires taxying as two more take off and another pair buzz the airfield, while a further four are parked in the background. All this was achieved with different shots of the same two aircraft which were joined together by computer. A similar technique was used in *Night Flight* (2002), a BBC film in which a line-up of Avro Lancaster bombers waiting to take off was created by sticking together different shots of the

same aircraft: the taxyable but (as yet) non-airworthy Lancaster Mark VII NX611 at the Lincolnshire Aviation Heritage Centre at East Kirkby.

A large number of out-takes from the 1969 film *Battle of Britain* were also used, supplied by a firm called 'World Backgrounds'. For some reason, many hours of unused footage from this production have survived in film vaults and have turned up in a number of feature films and documentaries over the years. The producers of *Dark Blue World* improved these clips by cleaning them up digitally, adding additional smoke, debris and fire effects, and in some cases adding or deleting aircraft and altering code letters to suit the demands of the scene.

To facilitate the use of these clips, the three genuine Spitfires and the fibreglass replicas were painted in correct 1940 colour schemes of dark green and dark earth ('spinach and sand') camouflage with sky undersurfaces and white code letters. Codes used by RAF fighters in 1940 were actually light grey, but those employed in the 1969 *Battle of Britain* film were made of white self-adhesive Fablon which could be changed between shots and showed up better on film, so the aircraft in the newer film were marked accordingly. Thus Frantisek's Spitfire was marked AI-A while Karel's was AI-H, to match the AI-prefix codes used on most of the *Battle of Britain* Spitfires.

The film opens with a shot of the titles against a sky background. Then there is an amusing scene as Frantisek Slama (Ondrej Vetchi) entertains his girlfriend Hanicka Pecharova (Linda Rybova) in a Czech training biplane as it sits on the ground. As Frantisek sits in the rear cockpit, he pulls back the stick causing the front joystick to move in the same direction, as the aircraft has dual controls.

The aircraft used in these scenes – which looks a bit like a DH Tiger Moth – is a German-made Platzer Kiebitz UL, a modern (1984) recreation of the 1927 Focke-Wulf S.24 Kiebitz which was never used by the Czech Air Force but is representative of types of that era.

The action then shifts to Mirov Prison in 1950, where Frantisek is an inmate. In 1948 the Communists took power in Czechoslovakia, and immediately imprisoned pilots who had flown for the RAF in WW2 as they were regarded as possible traitors; a policy which was symptomatic of Stalin's paranoia. Frantisek is being treated by a fellow inmate, Dr Blaschke (Hans-Jorg Assmann), who is a former SS man as evidenced by the tattoo on his wrist.

Now we are back to March 1939, where Frantisek flies at dangerously low level over a railway station in his biplane trainer as his girlfriend Hanicka and dog Barcha (who happened to be Ondrej Vetchi's real pet) watch. The aircraft lands at Olomouc airfield, where the pilots are anxiously awaiting developments as the Germans prepare to occupy their country.

On 15 March, as snow is falling, German troops march into Czechoslovakia without any military opposition and German troops arrive to take over the airfield. Ober-Leutnant Hesse (Thure Riefenstein), the Wehrmacht officer leading the military contingent, inspects a hangar containing five biplane trainers. One is the Kiebitz seen earlier while the other four are Aero C-104s, Czech-built versions of German Bucker Bu.131 Jungmann trainers, all painted in authentic pre-war Czech livery and markings. The hangar is closed and padlocked, and the Czech pilots are advised to go home. Frantisek and his young colleague Karel Vojtisek (Krystof Hadek) subsequently decide to flee the country on a

motorbike and sidecar. Frantisek's dog Barcha tries to follow them but is told to go home.

The action then shifts to England in the summer of 1940, where the RAF is battling it out with the Luftwaffe. Two Spitfires chase Messerschmitt Bf109s around the sky and some used 0.303in cartridge cases fall to the ground. On a huge lawn in front of a country house, the Czech pilots are being taught formation flying using bicycles fitted with radios and small wooden elliptical wings complete with RAF roundels.

The pilots find this exercise frustrating, but are soon transferred to an unnamed RAF base where they are introduced to real Supermarine Spitfires. Hradcany airfield stands in very well for a wartime RAF station, and the attention to detail is excellent with authentic uniforms and correct period vehicles. The only thing which spoils the illusion are the hills in the background, which don't look like the terrain in South-East England.

An RAF Sergeant explains to the pilots the importance of inflating their personal dinghy slowly to stop it exploding. The Czech pilots are then given English lessons in a classroom on the airfield and find the vagaries of the English language quite confusing. Some 1/72 scale aircraft recognition models are hanging from the ceiling. These include a Short Stirling and also an American P-38 Lightning, TBM-3 Avenger and Douglas C-47 Dakota, none of which had entered service in 1940.

Frantisek expresses his concern to Wing Commander Bentley (Charles Dance) that his pilots have so far not seen any action, but things are about to change. As some Spitfires return from a sortie, Karel has some nose art painted on his plane using one of his stash of soft-porn photos as a guide. Another airman is given a wet shave outdoors by an RAF

sergeant using an open razor but is cut on his neck because he keeps talking.

Soon the Czechs get a chance to show what they can do as 'Blue Section' of four aircraft is scrambled to intercept enemy aircraft flying at 12,000 feet on their way to bomb RAF North Weald. The Czechs spot nine Heinkel 111s flying below and dive to attack. Unfortunately the RAF formation is 'bounced' by some Messerschmitt 109s. Tom Tom sees a 109 in his rear view mirror, guns blazing, and is hit. His aircraft crash dives into the English Channel off Dover before he can get out. It is a marvellously executed sequence using enhanced clips from *Battle of Britain* combined with original footage. The dramatic shot of the Messerschmitt in Tom Tom's mirror was achieved using a four metre long model of a Hispano HA-1112 MıL 'Buchon', carefully painted and marked up to look like those used in *Battle of Britain*, which was supported by a horizontal pole painted blue so that it could be erased by computer.

Karel returns to base with his Spitfire badly shot up, its canopy shattered. Meanwhile, Tom Tom's body is washed ashore near Dover. The brief shot of him lying dead on the beach as the waves lap over him was actually shot in South Africa.

The Czechs visit the plotting room and are asked to leave as they are making too much noise. Soon after this, Frantisek and Karel are scrambled to intercept a lone intruder heading for Sheffield. The shot of their two Spitfires flying past the cliffs of Dover is an unused clip from *Battle of Britain* (just before the Stuka attack sequence) and originally featured three aircraft. One aircraft was deleted by computer to create the required scene.

Frantisek and Karel rapidly catch up with the bomber, a single Heinkel He-111H. Karel attacks first but is hit by return fire from the bomber's dorsal gun position and his plane dives to earth in flames. Frantisek does not see him bale out, and thus assumes he has been killed. He then attacks the Heinkel himself and brings it down. He reports by radio that he has destroyed 'one Junkers' (a script error).

That evening the Czech pilots have a rather unappetising meal of fish, Brussels sprouts and carrots. An alarm goes off, and the pilots are told to leave the mess and disperse their planes as a bombing raid is imminent. One pilot is determined to finish his meal before carrying out this task.

While this is happening, Karel – who has survived bailing out of his Spitfire – turns up at an English country house. Susan (Tara Fitzgerald) lets him in. Karel explains that he is a Czech pilot who has been on two missions and has shot down one plane. Susan dresses his wound. Meanwhile German bombers are pounding the RAF base. There are some spectacular scenes as Spitfires are taxyed to safety against a background of orange fireballs.

Back at Susan's house, Karel is told that her husband Charles is in the Royal Navy and has been missing for a year. She shows him a picture of his ship. Karel points out that his name is the Czech equivalent of 'Charles'. Tara says that she does not have a telephone in the house but her neighbours (the Mortons) do, and she will 'phone the RAF base to let them know that he is safe. Karel says there is no need to inform them straight away. In the meantime, back at the RAF base a Spitfire pilot is helped from his machine just before it blows up.

Tara allows Karel to stay the night and offers him a pair of Charles' pyjamas. They kiss passionately and Tara

realises she has made a mistake as Karel is too young for her (Krystof Hadek was only 17 when the film was made).

The next morning Karel and Susan have breakfast along with six children who happen to be staying in her house. Susan explains that they are not her own children but are evacuees, moved from London because of the risk of bombing. Later that day, Karel returns to the RAF base and goes to a dance with two of the WAAFs.

The next scene is set in 1950. Frantisek is scrubbing a toilet clean. One of his colleagues suggests escaping. The former SS doctor produces a bottle and he and Frantisek have a drink.

Then it is back to 1940, where Karel and Frantisek visit Susan. A bee has stung one of the evacuees (Beth) and Frantisek suggests vinegar as a remedy. He applies a vinegar-soaked cloth to the area. Frantisek explains it is a worse tragedy for the bee as they always die after stinging, unlike wasps.

It is a well-known fact that bees can only sting once before dying, whereas this is not the case for wasps. However some people forget this, including Winston Churchill who in 1942 commented on the American aircraft carrier USS *Wasp's* second successful delivery of Spitfires to Malta on 9 May by saying: 'Who said a wasp couldn't sting twice?'

Karel tells Susan that Frantisek has a girlfriend called Hanicka, over in Czechoslovakia. Later, back at the mess Honza is playing the piano. Their colleague Sysel has died and they are commemorating this sad event. The next scene is in Mirov Prison in 1950, where Honza has his left eyebrow stitched up by the doctor after being beaten up.

The action then moves back to the war years as Karel receives a 'Dear John' letter from Susan. He is clearly upset

and discusses his romantic problems with Frantisek. He is clearly infatuated with Susan, though she clearly doesn't feel the same. Later, although it is a foggy day, Susan drives to the RAF base. But she hasn't come to see Karel. Instead it is Frantisek she wants to meet.

Wing Commander Bentley briefs the squadron on their next mission: to escort Bomber Command aircraft returning from an attack on Brest on the French coast. The squadron take off and head to France. One of their number has to return early due to engine problems, but soon the pilots come across a solitary B-25 Mitchell bomber. It has a highly polished natural metal finish and has no markings other than RAF fin flashes. The aircraft is actually the well-known 'Flying Bull' B-25 Mitchell N6123C based in Austria and owned by the company which produces 'Red Bull' energy drinks.

Originally the producers had intended to use the 'Duke of Brabants' B-25 N320SQ which was based in the Netherlands and has WW2 Free Dutch markings, including olive green camouflage, but it went unserviceable at the last moment and the 'Flying Bull' B-25 had to be used instead. The Mitchell also doubled as a camera platform though some aerial shots were also achieved with a camera fitted under the wing of Spitfire MV154.

The Mitchell is clearly in trouble as it is under attack from four Messerschmitts. Its port engine is smoking and the tail gunner is valiantly blazing away with his twin 0.50in Brownings. These scenes were executed using a combination of footage of the real aircraft, a CGI recreation and a large miniature. Director Jan Sverak played the part of all the crew members of the B-25 and this was added to footage of the miniature by computer. The Czech pilots attack the

Messerschmitts and Karel shoots one down. Later, the bomber lands safely at its base.

Following their mission, Karel and Frantisek chat about Susan. Frantisek tells Karel that Susan had come to see him but he sent her away. Afterwards, Frantisek visits Susan at her house and they begin a sexual relationship. When Frantisek returns to the airfield later Karel notices that one of the brass buttons from his RAF uniform jacket is missing. An RAF Sergeant sows on a new button as he sings the well-known wartime ditty 'Hitler has only got one ball,' the instrumental version of which (The 'Colonel Bogey March') was later immortalized in the film *Bridge Over the River Kwai* (1958).

Karel and Frantisek take off on a fighter sweep over Northern France. The date is not mentioned but we can assume it is summer 1941 as RAF Fighter Command was by then implementing a questionable policy of 'leaning into Europe' resulting in the loss of huge numbers of aircraft and pilots including such luminaries as Wing Commanders Douglas Bader and Bob Stanford-Tuck.

The pair fly low over the French countryside and soon come across a German goods train which they decide to attack. This sequence was the most expensive in the whole production, and cost the same as the entire budget of Jan Sverak's previous film *Kolya*. No miniatures were used; just a real train with the explosions and debris enhanced by computer. Each Spitfire used in the production cost $10,000 per hour to fly, so even one pass by two aircraft could be hugely expensive.

The train is defended by a twin-barrelled automatic flak gun on a flat car, but the two pilots press home their attack using their twin 20mm Hispano cannon and four 0.303in

Brownings. The train explodes in a fireball, but Karel's plane is hit and a film of oil forms on his windscreen as his engine stutters to a halt. Karel just manages to clear some trees and belly lands his Spitfire in a meadow.

This sequence is a masterpiece of special effects. A four-metre-long model of a Spitfire sliding down a ramp was used to depict the aircraft crash landing, and the supporting pole and ramp was later deleted by computer. After the aircraft had come to a standstill, one of the full-size glass fibre replicas was used to depict the burning, crashed plane.

Karel quickly unfastens his harness and runs away from the Spitfire, which is starting to burn fiercely. Soon some German soldiers arrive in a VW *Kubelwagen* and a *Kettenrad* motorcycle half-track and question some peasants who are standing near the wreckage. By this time Karel has got rid of his RAF uniform and is dressed as a farm worker to avoid detection.

Frantisek, who has been circling, waits until the Germans have left and then lands his plane on the field. The actual landing was shot on the edge of Hradcany airfield as it was too dangerous to land a real Spitfire in a short field. Frantisek keeps his engine running as he taxies over to Karel and asks him to get into the cockpit, sitting on his lap. It is a tight squeeze, but the two pilots manage it. Frantisek takes off and flies back to England.

Such pick-ups involving two pilots squeezing into one cockpit did actually happen in WW2, particularly in the Western Desert, and a similar scene involving a Hurricane features in the pre-credit sequence of *Battle of Britain* (1969).

One of the replica Spitfires was used to create this sequence. For the scene where the aircraft apparently 'flies' with two pilots in the cockpit, the structure supporting the

full-size model was deleted by computer creating a highly realistic effect.

Some time later, Frantisek visits Susan at her house. His left arm is in a sling following injuries sustained in the strafing attack. Two of the children eat watermelon on tables in the garden. Susan explains that she will have to keep them as their parents are now dead.

As Frantisek is visiting, Karel overflies the house and – looking down – sees Frantisek's car outside. He realises what has happened, and that evening he sets off for Susan's house on his motorbike in the middle of a storm. As he drives down a country lane a bolt of lightning strikes the ground some distance away. This was not a special effect, but a real lightning strike which happened during shooting and was captured on film. Karel arrives at Susan's house and, looking through the window, sees her and Frantisek together, naked. He now knows for sure that he has stolen Susan from him.

Karel returns to the mess at the RAF base where he starts drinking and smoking heavily. Honza plays the song 'Dark Blue World' on his piano, and Karel sings along realising the words reflect his own predicament.

The next day Karel tries to pick a fight with Frantisek, accusing him of stealing Susan from him. Later, during an air battle, Frantisek sees tracer rounds flying past his aircraft. He looks in his mirror, sees Karel's Spitfire, and assumes he is shooting at him.

The film moves forward again to 1950. Machaty (Oldrich Kaiser) has suffered a brain haemorrhage.

Then it is back to the war years again, where Wing Commander Bentley shows Frantisek some gun-camera footage which proves that Karel was actually firing at a Messerschmitt Bf109 which was behind him. Far from trying

to shoot him down, Karel had actually saved his life. This black-and-white gun-camera film looks authentic but was created by CGI for this sequence.

Frantisek goes over to the mess and apologizes to Karel, in front of his colleagues, for his unfounded accusation. He then tells him to stop drinking and staying up all night as it will affect his performance. Later, one of the Czech airmen – Bedrich Mrtvy (David Novotny) – is buried.

The squadron is assigned to escort American B-17 Flying Fortress bombers (which means it must now be 1943), and two clips from the 1990 film *Memphis Belle* are used to illustrate this. The first shows two Fortresses flying just above one another; the second is an unused outtake similar to the well-known shot filmed from vertically above, depicting five B-17s crossing the English coast. For its use in *Dark Blue World*, the clip was doctored with the addition of two extra B-17s, contrails streaming from the engines and some CGI Spitfires flying above the Fortresses.

By this time, RAF fighters in the European theatre were painted in a new camouflage scheme of dark green and dark grey upper surfaces and light grey bellies. The fuselage roundels and fin flashes were also different to those used in 1940. However, these new colour schemes were not applied to the Spitfires used in *Dark Blue World* – probably because it would have meant that clips from *Battle of Britain* could not be used for these later sequences.

One of the shots in this sequence, showing eight Spitfires crossing the coast, was actually an unused shot from *Battle of Britain* which was filmed over the South of France as part of the French filming. It was never used because the French coast looked so different from England.

The engine of Frantisek's Spitfire conks out and he is forced to bail out. Unfortunately he inflates his dinghy too rapidly, and it bursts leaving only his Mae West to keep him afloat. Circling above, Karel realises what has happened. He can't call for assistance because his radio has been damaged by a bullet hit, so he comes up with a plan: he will start inflating his own dinghy and throw it to Frantisek. As he tries to do this while flying at low level he loses control of his aircraft and his starboard wingtip hits the sea. The Spitfire crashes and sinks rapidly. This sequence was shot using a radio-controlled model and is utterly convincing. Frantisek is distraught that his friend has been killed, but then the still-inflating dinghy from Karel's plane breaks the surface. Frantisek swims towards it. He has been saved by Karel's sacrifice. The whole of this sequence was filmed in South Africa, which is a good place to go if you are looking for big waves. For the same reason the storm sequences in *Ryan's Daughter* (1971) were also shot there.

Much later, Frantisek visits Susan's house and finds that she is now looking after her husband Charles who is in a wheelchair. After being missing for a long time he has been found.

Frantisek pretends that he is lost and asks if it would be OK to continue down the road. Susan replies that the road has now been repaired and all the potholes have been fixed. It is her way of saying their relationship is over and she sees her future with Charles. At the end of the war Frantisek returns to Czechoslovakia and is reunited with his girlfriend Hanicka and dog Barcha.

Five years later, as an inmate at Mirov Prison, he imagines himself flying his Spitfire with Karel as his wingman.

The sun sets behind the two aircraft, but in a way – though Karel is dead – he will always be with him.

Dark Blue World premiered in the Czech Republic on 17 May 2001 and in the UK on 13 November 2001. It garnered generally positive reviews though it was not a financial success, grossing only $2,300,00 worldwide. Nonetheless, it is a film that is greatly appreciated by aviation enthusiasts.

Dark Blue World (2001)
Technical Credits

Director: Jan Sverak
Story and Screenplay: Zdenek
Sverak

Cast

Frantisek Slama - Ondrej Vetchy
Karel Vojtisek - Krystof Hadek
Susan Whitmore - Tara
Fitzgerald
Wing Commander Bentley -
Charles Dance
Jan Machaty - Oldrick Kaiser
Bedrich Mrtvy - David Novotny
Hanicha Pecharova - Linda
Rybova
Railwayman Kanka - Jaromir
Dulava
Tom Tom - Lukas Kantor
Jura Sysel - Radim Fiala
Jan Gregora - Juraj Bernath
Vilha Houf - Miroslav Taborsky
Doctor Blaschke - Hans-Jorg
Assmann
German Officer Hesse - Thure
Riefenstein
English Teacher - Anna Massey
Major Skokan - Viktor Preiss
RAF Instructor - John Warnaby
Vrba Vlastik - Peter Burian
Pavlata (Armourer) - Cestmir
Randa
Corporal Pierce - Jeremy Swift
WAAF Jane - Sophie Wilcox
Mrs Brett - Caroline Holdaway

WAAF Sally - Charlotte
Fairman
Susan's Husband - William
Scott-Masson
Pub Landlord - Jiri Labus
Bustik (Prison Guard) - Jan
Dvorak
Pecharova - Daniela Kolarova
Beth - Ashley Clish
Jeanette - Annie Vesela
David - Lexie Peel
Projectionist - Filip Renc
Ann - Blaise Colangelo
Mary - Sienna Colangelo
WAAF - Rhian Heppleston
WAAF - Lucy Fillery
WAAF - Amy Huck
Radio Operator - William
McEnchroe
Telephone Operator - Noel le
Bon
Radio Operator - Jeff Tyler
German Motorcyclist - Martin
Dostal
English Mechanic - John Comer
German Motorcyclist - Frantisek
Vyskocil
Rear Gunner Captain - John
Norton
Pilot Cerny - Filip Cervinka
Indian RAF Member - Zdenek
Sverak

Production

Line Producer (Germany):
Massoud Abedi
Producer: Eric Abraham
Line Producer (South Africa):
Genieveve Hofmeyr
Co-producer: Werner Koenig
Producer (Czech TV): Jarolslav
Kucera
Co-producer: Domenico Procacci
Producer: Jan Sverak
Associate Producer: Ed
Whitmore
Music: Ondrej Soukup
Cinematography: Vladimir
Smutny
Film Editing: Alois Fisarek
Casting: Sona Tichackova and
Ivan Volicek
Production Design: Jan Vlasak
Art Direction: Vaclav Novak
Costume Design: Vera Mirova
Key Hair Stylist: Zdenek Klika
Makeup Artist: Ivana
Langhammerova

Production Management

Production Manager (South
Africa): Leigh Clarke
Production Managers: Jo Farr
and Martin Korinek
Production supervisor
(Germany): Hannah Richardson

Second Unit and Assistant Directors

Third Assistant Director: Karel
Brezina
Second Assistant Directors:
Nikola Hejko and Vaclav Motti
First Assistant Director: David
Rauch

Art Department

Construction Manager: Roman
Bandas
Stand-By Prop Man: Zbynek
Chvojka
Construction Stand-By: Karel
Elckner
Key Prop Man: Marcel Hana
Stand-By Prop Man: Milan
Janostik
Construction Stand-By: Jaroslav
Janovsky
Construction Assistant (Czech
Republic): Rudolf Kinsky
Construction Manager: Pavel
Krejci
Stand-By Prop Man: Tomas
Lehovec
Art Department Coordinator:
Oldrich Oliva
Construction Designer (Czech
Republic): Pavel Rample
Construction Stand-By: Martin
Stefka
Property Master: Karel Vanasek
Construction Manager: Ing.
Milos Volpalensky
Stand-By Prop Man: Stepan
Zacios

Sound Department
Sound Engineer (Cinemasound): Viktor Ekrt
Foley Engineer: Ivo Heger
Boom Operator: Tomas Lylo
Sound Designer: Zbynek Mikulik
Sound Mixer: Pavel Rejholec
Boom Operator: Petr Styblo

Special Effects
Camera Operator: Petr Hojda
Video Operator: Jan Hojzler
Best Boy: Zdenek Janacek
Special Effects Designer: Milos Kohout
Special Effects Supervisor: Jaroslav Kolman
Loader, Special Effects (Czech Republic): Michal Kudlacek
Gaffer, Special Effects Unit (Czech Republic): Jaroslav Novak
Electrician, Special Effects Unit: Petr Pavlicek
Grip, Special Effects Unit: Milan Petrolin
Focus Puller, Special Effects Unit: Ivan Simunek
Focus Puller, Special Effects Unit: Jakub Simunek
Special Effects (South Africa): Antony Stone

Visual Effects
Film Grader: Vladimir Altman
3D Animator/Inferno Compositor: Ales Diabac
Inferno Compositor: Miro Gal

Optical Effects: Ivan Hatak
Inferno Compositor: Helena Keslova
Visual Effects Designer: Milos Kohout
Digital Effects Production: Petr Komrzy
Digital Effects Coordinator: Vit Komrzy
Optical Effects: Pavel Kryml
Model Coordinator: Jiri Krystof
Visual Effects Supervisor (UK): Dennis Lowe
Engineer (Replica Spitfire): Lukas Maly
Engineer (Replica Spitfire): Zdenek Maly
Engineer (Replica Spitfire): Jiri Mikes
Inferno Compositor: Jan Malir Jr
Model Makers: Miroslav Manda, Petr Tax and Rodek Tresnak
3D Animation: Jaroslav Maty
Inferno Compositors: Viktor Muller, Jaroslav Polensky and Jiri Sabata
Digital Film Technologies: Martin Sladky and Pedek Svodoka
3D Animation/Inferno Compositor: Zdenek Urban
Inferno Compositor, Head of Digital: David Vana

Post Production
Model Maker: Jindrick Zimak
Stunt Rigger: Jindrich Klaus

Stunt Coordinator: Ladislav
Lahoda
Stunts (South Africa): Antony
Stone
Stunts: Ryan Stuart

Camera and Electrical Department

Gaffer: Jaroslav Betka
Director of Photography (Second
Unit): Ramunas Greicius
Still Photographer: Jiri Hanzi
Assistant Camera: Karel Havelka
Key Grip (South Africa): Terry
Hoffman
Loader: Miroslav Hunt
Best Boy: Josev Jancar
Loader: Karel Kaliban
Video Operator (South Africa):
Justin Kirschner, Ricardo
Koopman and Jan Merhaut
Assistant Grip (South Africa):
Majiet Nasmie
Loader (South Africa): Bruce
Newton
Pilot (Camera Helicopter):
Frederic North
Electrician: Petr Prochazka
Aerial Camera Operator: Martin
Sacha
Grip: Jaroslav Sinkule
Best Boy Grip (South Africa):
Jimmy Slabbert
Key Grip: Radim Stefan
Best Boy: Petr Stejskal
Clapper Loader: Adela Valkola
Generator Operator: Vratislav
Vosicka

Electrician: Frantisek Wirth
Focus Puller (South Africa):
Justin Youens
Focus Puller: Valclav Zajicek

Casting Department

Casting Director (UK): Doreen
Jones
Casting Assistant: Lida
Matusinska
Casting Assistant: Magda
Tichackova

Costume and Wardrobe Department

Costume Assistant: Milena
Adamova
Costume Assistant: Nada
Chrastova
Assistant to Wardrobe
Supervisor: Miroslav Fantys
Costume Assistant: Karolina
Jirova
Wardrobe (South Africa): Mila
Meter
Costume Assistant: Patricia
Soptenkova
Costume Assistant: Jitka Svecova

Editorial Department

Assistant Editors: Adam Dvorak
and Ivan Frossl
Post-Production Technical
Supervisor: Ivo Marak
HD Colourist: John Dowdell

Location Management
Location Managers: Jakun Bily, Jakub Exner and Michael Mares
Location Scout: Jan Pachi
Location Manager: Martin Pavek
Location Manager (South Africa): Mick Snell

Music Department
Music Mixer: Juraj Durovic
Conductor: Adam Klemens
Concert Master: Antonin Pergler
Music Administrator: Josef Pokluda

Transportation Department
Driver (South Africa): Craig Banks
Transport Facilities: Jan Diouhy
Driver (South Africa): Anton Geldenhuys
Unit Driver: Jiri Janda
Unit Driver: Bohumil Kindl
Transport Facilities: Vaclav Kindl
Action Vehicles: Jozef Ovrada
Unit Driver: Jiri Rafti
Unit Driver: Miroslav Roxer
Unit Driver: Frantisek Rys
Transport Facilities: Petr Stasak
Unit Driver: Martin Visvader

Miscellaneous Crew
Head of Production (Helkon Media): Massoud Abedi
Spitfire Mechanic: Adrian Ayres
Public Relations: Magda Bicikova
Unit Publicist: Jan Bobrowska

Production Coordinator: Klara Bukovska
Helicopter Pilot: Petr Cerny
Production Assistant: Renata Cihulkova
Accounting Assistant: Lenka Cintalanova
Caterer (South Africa): Shane Eades
Historical Consultant: Frantisek Fajti
RC Model Aircraft Pilots: Pavel Fenci, Jaroslev Hovorka and Bohumil Sova
Floor Runner: Michaela Francova
Spitfire Pilots: Ray Hanna, Nigel Lamb and Robs Lamplough
Public Relations: Tomas Hoffman
Production Assistant (UK): Tom Hooper
Technical Advisor (Military Aircraft): Zdenek Hurt
Unit Nurse: Jirina Kabatova
Helicopter Pilots: Harold Kaprielian, Luc Malhomme, Tim Price, Frederick North, Emil Remenec, Petr Cerny and Gert Uys
Floor Runner: Nina Knezkova
Production Accountant: Johnanna Kohtz
Other Period Aircraft Pilots: Charley Koidl, Reinhard Roetzer, Jiri Koubik, Maximilliam Walch, Ladislav Mackerle and Daniel Ungerer

B-25 Pilot: John Romain
Catering: Jaroslava Kozakova
Assistant to Director: Helena
Krystofova
Production Coordinator (South
Africa): Natascha Leite
Historical Consultant: Antonin
Liska
Production Assistant: Marketa
Makova
Production Accountant: Tracey
Malone
Floor Runners: Milan Malak and
Monika Petru
Unit Publicist: Charles
McDonald
Assistant to Producer: Vaclav
Motti
Cashier: Markeva Mutlova
Making of Documentary: Alice
Nellis
Production Accountant: Eva
Nietschova

Catering: David Pesaut and Eda
Raban
Technical Advisor (Military
Aircraft): Miroslav Petru
Production Secretary (UK):
Caroline Raymond
Script Associate: Vaclav Sasek
Script Associate (Translation):
Jitka Scoffin
Production Consultant
(Germany): Tilo Seiffert
Historical Consultant: Malcolm
Smith
Production Secretary: Renata
Sodomova
Boat Coordinator (South Africa):
Grant Spooner
Screenplay Translator: Paul
Wilson
Continuity: Petra Zachova
Production Assistant: Jarka
Zajickova

List of Aircraft used in *Dark Blue World* (2001) and current status (where known)

Aircraft Type	Serial Number	Supplied by	Current status
Platzer Kiebitz	12K	Unknown	Unknown
Aero C-104S	3K	Unknown	Unknown
Aero C-104S	Unknown	Unknown	Unknown
Aero C-104A	8K	Unknown	Unknown
Aero C-104A	6K	Unknown	Unknown
Supermarine Spitfire LF.Vb	EP120	The Fighter Collection Duxford, UK	The Fighter Collection Duxford, UK
Supermarine Spitfire HF.VIIIc	MV154	Robs Lamplough Duxford ,UK	Robs Lamplough Duxford, UK
Supermarine Spitfire HF.IXb	MH434	OFMC, Duxford	OFMC, Duxford
North American B-25J	N6123C	Flying Bulls, Austria	Flying Bulls, Austria
Spitfire Mk.II replica	P5411	GB Replicas Ltd	Extant. Czech Republic
Spitfire Mk.II replica	R6811	GP Replicas Ltd	Extant. Czech Republic
Spitfire Mk.II replica	R6813	GB Replicas Ltd	Extant. Czech Republic
Spitfire Mk.IX replica	Unknown	GB Replicas Ltd	Destroyed during filming
Spitfire Mk. IX replica	N3317	GP Replicas Ltd	Extant, Cornwall

The Blue Max
(1966)

As you will have noticed, this book is biased towards WW2 movies – particularly those featuring the RAF – and this reflects my own personal interests, as I have never enjoyed most of the films made about the First World War. *The Blue Max*, though, is an exception, as (in my view) it is one of the most exciting movies ever made about aerial warfare.

A lot of people share this view. When the film was first shown on BBC 1 in the early 1970s, reviewer Philip Jenkinson (writing in the *Radio Times*) said that he hadn't been so excited by flying since seeing *Hells Angels* (1930).

The Blue Max has a lot to commend it. Filmed long before the invention of CGI, the film was made entirely using real aircraft and full-scale mock-ups without any miniature work whatsoever. No matte work or glass paintings were employed, and all special effects were done entirely 'in camera'. The scene where two Fokker DR-1 Triplanes take it in turn to fly under the arches of a bridge was done for real, and was just as dangerous as it looked.

The screenplay for *The Blue Max* was written by David Pursall, Jack Seddon and Gerald Hanley from an adaptation by Ben Barzman and Basilio Franchina, which was itself based on a novel by Jack D. Hunter (1921-2009) – a writer who had a life-long fascination with WW1 aviation and who was an intelligence officer with the U.S. Army in

Germany just after the end of WW2. Hunter had originally learned German purely so he could read *Der Rote Kampflieger* (*The Red Battle Flier*): the memoirs of the German air ace, Baron Manfred Von Richtofen.

Hunter had previously worked as a journalist, and was also interested in watercolour painting and making model aircraft. In 1962 he wrote his first novel, *The Blue Max*, over a period of seven months. His preferred writing method was to take a nap from 7.00pm to 10.00pm, when he would awaken and work on his manuscript for four hours – writing in longhand so as not to disturb his family.

Hunter's novel was rejected by nine publishers but was eventually accepted for publication in 1964, and went on to sell 255,000 copies in the Corgi paperback edition alone. Within a few months the rights were bought by 20th Century Fox, who intended to make a film of the book in the Republic of Ireland in the late summer of 1965.

The script called for a squadron of authentic German biplane fighters and an equal number of British aircraft who could oppose them. Very few original WW1 aircraft existed; most of these were in museums in a non-airworthy condition, and would not be able to stand the stresses of aerial filming.

The solution was to build a number of replicas of German and British warplanes, backed up by several De Havilland DH.82 Tiger Moths and SV-4 Stampes which could be painted in British or German markings according to the demands of the scene.

Two replica British SE5as powered by six-cylinder 200hp Gypsy Queen 3 engines were built for the movie by Miles Marine and Structural Plastics Ltd of Shoreham, while Bitz Flugzeugbau of Augsburg, West Germany constructed two Fokker DR-1 triplanes from original blueprints. These

were entirely accurate, except for the engines which were Siemens-Halske SH-14 radials instead of the original Oberursel rotaries.

Rotary engines were popular in the early days of aviation, and are in effect a type of radial engine in which the cylinders spin along with the propeller, enhancing cooling. The main disadvantage of a rotary engine is that this large lump of spinning metal at the front of the aircraft works like a gyroscope, making changes in direction more difficult. Thus a rotary-engined aeroplane is harder for the pilot to control.

Two Pfalz D.III reproductions were constructed for the movie. One of those was built by Doug Bianchi of Personal Plane Services (PPS) at Booker and was based on a converted De Havilland Gypsy Moth with two extra (fake) engine cylinders added to make the Gypsy Major engine look like the original aircraft's six-cylinder Mercedes motor. The other Pfalz was an all-wood replica built from scratch by Vivian Bellamy of the Hampshire Aero Club.

Rousseau Aviation of Dinard, France built three replicas of Fokker DVIIs powered by six-cylinder 200hp Gypsy Major engines, while a French Caudron C276 Luciole played the part of both a British RE.8 reconnaisance aircraft and its unspecified German equivalent. A Morane Saulnier MS230, a French-built aeroplane with a parasol wing dating from 1929, appears as the new experimental German monoplane at the end of the movie, while several D.H. Tiger Moth and Belgian SV-4 Stampe trainers were used in the background in many shots to increase the numbers of aircraft seen on screen.

Filming in France was ruled out as the original locations of WW1 battles were now marred by modern structures such as factories and electricity pylons, plus there

was considerable atmospheric pollution. Instead, the producers chose to make the film in the Republic of Ireland which offered a number of advantages such as low labour costs, clear natural light, unspoiled rural landscapes and interesting cloud formations.

A total of 11 pilots took part in the flying; namely Ken Byrne, Tim Clutterbuck, Pat Cranfield, Tim Healey, Peter Hillwood, Joan Hughes, Darby Kennedy, Liam Mulligan, Roger Kennedy, Derek Pigott and Taffy Rich. Actor George Peppard learned to fly and gained his private pilot's licence prior to starting work on the movie. He even flew some of the replica German aircraft, but the film insurers soon grounded him.

Some of the pilots were from the Irish Air Corps, while the other civilian pilots had considerable experience of film flying. Derek Pigott in particular had flown a number of the spectacular recreations of early aircraft in *Those Magnificent Men in Their Flying Machines* (1965). Former Royal Canadian Air Force pilot and aircraft collector Lynn Garrison was responsible for gathering all the aircraft together. The director of the aerial sequences was Anthony Squire, who was later responsible for the stock car racing scenes in *On Her Majesty's Secret Service* (1969).

The director was John Guillerman, at that time best known for several Tarzan movies, who later directed a number of blockbusters including *The Bridge at Remagen* (1969), *The Towering Inferno* (1975), and *King Kong* (1976). The producer was Christian Ferry, while the executive producer was Elmo Williams who had previously been involved with *The Longest Day* (1962) and later worked on *Tora, Tora, Tora* (1970).

The principal location for the filming was Weston Aerodrome near Dublin, while Casement Aerodrome (then known as Baldonnel and the headquarters of the Irish Air Corps) was used for scenes towards the end of the movie. Studio scenes were shot at Ardmore Studios in Bray near Dublin.

The film opens with a view of a First World War battlefield. A caption reads '1916, Western Front'. There is a tracking shot of the battle-scarred landscape. Artillery shells explode and there is the rattle of machine guns. Infantryman Corporal Bruno Stachel (George Peppard) runs for cover and takes shelter in a shell crater, still clutching his rifle. As he lies there panting, he looks up at the sky and sees two biplane fighters engaged in a slow-turning dogfight, their machine guns chattering as they try to get on each other's tail. At that moment, Stachel decides he is going to retrain as a fighter pilot and get away from all the mud and filth.

As Jerry Goldsmith's powerful score begins, the titles appear including an image of the 'Blue Max' itself, a medal awarded to pilots who have achieved twenty kills. Jerry Goldsmith was one of the most prolific American composers of all time with a huge number of films and TV series to his credit including *Tora, Tora, Tora* (1970), five *Star Trek* films and the original theme to the TV series *The Man From UNCLE* (1964-68).

British composer Ron Goodwin – who had scored *633 Squadron* (1964) and the previous year had composed the music for *Operation Crossbow* (1965) and *Those Magnificent Men in Their Flying Machines* (1965) – was originally approached about doing the music for *The Blue Max*, but wasn't available as he was too busy.

The titles are shown against a background of rolling clouds, and then a caption informs us that it is now 1918. Another dogfight is in progress and soon comes to a conclusion. A biplane is hit and dives to earth. As it disappears behind a ridge there is an explosion. Unfortunately there is a technical error at this point, as the explosion occurs to the left of the point where the aircraft is supposed to have crashed. A common way of depicting an aircraft crashing and exploding in films is to get it to dive behind a hill, a ridge or trees and then detonate an explosion somewhere on a straight line between the camera and the point where the plane has disappeared from view. When this is done correctly it can be very convincing, as in the supposed crash of a Curtiss P-40E Kittyhawk in *Tobruk* (1967), George Peppard's next film, or the demise of a Stinson L-5 Sentinel in *Catch 22* (1970). Sometimes, though, the trick is obvious – as in *A Bridge Too Far* (1977), where an RAF Dakota is supposedly hit by German anti-aircraft fire and crashes in flames. Unfortunately in that particular shot, as the fireball clears the starboard wingtip of the Dakota can be seen as the aircraft climbs away. In the DVD and Blu-Ray releases this error has been corrected by editing out a few seconds of film.

Newly-trained pilot Bruno Stachel sits in a lorry as he is driven through a ruined French village. He takes a few swigs of cognac from a bottle and then throws it to a grateful German soldier. Stachel has clearly not forgotten what it is like to be an infantryman.

The truck eventually arrives at a German airfield. A couple of broken-up aircraft (which look like dismantled D.H. Tiger Moths in German colours) can be seen in the background. As Stachel dismounts from the lorry, eleven German biplanes arrive over the field and start to land. The

aircraft consist of the three Fokker DVII and two Pfalz D.III replicas with the six other planes being D.H. Tiger Moths and Stampes painted to represent German WWı aircraft.

Stachel is introduced to his commanding officer, Hauptmann Otto Heidemann (Karl Michael Vogler), who asks him about his previous experience. Stachel explains that he was in the army and reached the rank of Corporal. This differs from Jack Hunter's novel, in which a 19-year-old Stachel has just done his basic flying training without having first served in the Army. Heidemann asks him why he decided to become a pilot. 'To fly', replies Stachel. 'Are you a good flier?' asks Heidemann. 'I am comfortable', says Stachel.

Heidelman also asks about Stachel's background and discovers that his father works in a small hotel with five beds. The other pilots (who all have aristocratic backgrounds) are unimpressed with Stachel's family. This is one of the main themes of the film; the conflict between the chivalrous aristocrats who predominated in the WWı German air service, and their middle- and working-class colleagues.

Stachel goes to his room to wash, and Heidemann follows him there to continue his discussion. He asks Stachel what aircraft he trained on and is told that he learned to fly on 'out of date' Pfalzs. Stachel is appalled to discover that that is what he will be flying from now on, as the more modern Fokker DVIIs are reserved for the more experienced pilots. As Heidemann leaves, Stachel notices the 'Blue Max' medal round Heidemann's neck. It is obvious that he hopes to be awarded one eventually.

Stachel gets into the back of a truck with the other pilots and they drive to their Officer's Mess, which is a requisitioned private house in a nearby French village. When

he arrives at his destination he is assigned to room number 11, which was previously occupied by the now-deceased Mueller.

As Stachel opens his case and takes out his dress uniform, his fellow pilot Willi Von Klugermann (Jeremy Kemp) enters the room and tells him they don't bother to dress for dinner. Kemp and Peppard had previously starred together in the war movie *Operation Crossbow* (1965), which was directed by Michael Anderson – a film-maker whose most famous feature was *The Dambusters* (1955).

Stachel also removes a framed photo of Baron Von Richtofen from his case. The photo is monochrome, but the 'Blue Max' round Von Richtofen's neck is hand-tinted blue. Von Klugermann enquires whether Richtofen is Stachel's hero but he dismisses the notion, pointing out that Willi only needs to get two more kills to qualify for the medal.

The next day eleven aircraft are lined up on the airfield; the five Fokker and Pfalz replicas nearest the cameras, with the other six being Tiger Moths and Stampes in German colours. Stachel is about to fly on his first mission to attack some British observation balloons. He is instructed to fly behind and to the left of Fabian (Derren Nesbitt), an experienced pilot who has a Fokker DVII while Stachel has an old Pfalz D.III. Nesbitt is best known for playing SS Major Von Hapen in *Where Eagles Dare* (1969). He also had a long-running role in the ITV series *Special Branch* (1969-1974) in which he played Detective Chief Inspector Jordan.

The two pilots approach a British observation balloon. Realising the danger, the British ground crew attempt to winch down the balloon while the observer jumps out of his basket and parachutes to safety. The balloon is hit by fire from the German fighters and bursts into flames, but then two patrolling Royal Flying Corps SE5as dive to attack the

German machines. Fabian's Fokker is hit and starts to emit white smoke.

One of the SE5as then latches onto Stachels's Pfalz and they start to dogfight at treetop level. Eventually Stachel manages to turn the tables on his attacker. He gets behind the British aircraft and shoots it down. The two Spandau machine guns on Stachel's aircraft are not real weapons but are 'gas guns' which work using a mixture of oxygen and acetylene ignited by a spark plug. Though they vibrate realistically and eject spent cartridges they lack ammunition feeds, something which author Jack D. Hunter pointed out to the producers when he viewed initial 'rushes' of the film. Another technical error in the film – which was also noticed by Hunter – is that the style of German crosses on the aircraft is wrong for 1918, as all the planes in the movie wear the earlier style of 'flared' insignia rather than the 'Greek Crosses' which were in use by 1918.

The stricken SE5a hits the trees and explodes in flames as Stachel does a victory roll. At this point an image of the Jasta 11 blackboard (listing pilots' kills) is superimposed on the action. Heidemann has 30 kills, Willi Von Klugerman 20, Fabian eight and Stachel zero (his first kill being so far unconfirmed).

Stachel returns to base and reports what happened. There is no news of Fabian. Was he killed or did he survive a forced landing? Stachel is anxious that his own first kill should be confirmed but no-one (apart from himself) saw the SE5a crash. He asks why the Army can't search for the wreckage but is told that they have more important things to do.

He sets off with Corporal Rupp (Peter Woodthorpe) on a motorcycle with a sidecar to find the wreck but after searching all day in the rain they find nothing and are

eventually forced to return to the Officer's Mess as it is now dark. To rub it in, he learns that Willi achieved his 20th kill that day and is now eligible for 'The Blue Max'.

As he celebrates by drinking champagne, Willi also mentions that he has had three unconfirmed kills himself. As Willi sips his drink he tells Stachel that there is now a rumour in the squadron that he cares more about his first (unconfirmed) kill than about Fabian's death.

This is an interesting point, because in Jack Hunter's original novel Stachel is an even more unsavoury character than he is depicted in the film – possibly even being a psychopath. He drinks heavily, even drinking cognac from a bottle via a rubber hose while flying, and becomes sexually aroused when he shoots down an aircraft. Both of these aspects of Stachel's character were omitted from the film adaptation, as was Kettering's hobby of collecting pornographic photographs.

Willi tells Stachel that to gain a confirmed kill he must have witnesses, and volunteers to accompany him on his next mission. The next day the two pilots set off on patrol, Stachel flying a Pfalz D.III and Willi a Fokker DVII. Soon they spot a British RE.8 reconnaissance aircraft flying slowly beneath them and, using hand signals, Willi suggests to Stachel that he should attack it. The Germans dive down on the RE.8 (actually a French-made Caudron 276), and Stachel apparently kills the rear gunner with his first burst. Blood is splattered all over the rear gun position and the gunner has slumped out of sight. The defenceless pilot looks nervously over his left shoulder expecting a fatal burst of machine-gun fire at any moment.

But Stachel takes pity on him and, using hand signals, persuades the pilot to turn round and fly back to the German

airfield. The pilot, greatly relieved, complies with this request. At one point he starts to deviate from the correct course, and Stachel has to force him to alter his heading with a short burst on his guns and further hand signals.

As the two German aircraft with their captive RE.8 approach the airfield everyone stops what they are doing to watch this amazing sight. Suddenly the gunner in the rear of the RE.8 regains consciousness – he was not dead after all – and struggles to man his Lewis gun and point it at Stachels's aircraft. Stachel fears that he is about to open fire and fires a long burst into the British aircraft. It crashes on the airfield in front of the astonished onlookers. The Germans try to help the two crew members, but they are both dead.

Stachel lands his Pfalz nearby, climbs out and inspects the British aircraft. Using his knife, he cuts out a rectangle of fabric from the starboard side of the fuselage with the British aircraft's serial number (A8590). He now has 'confirmation'.

Later, the two British airmen are prepared for burial with full military honours; their coffins draped with Union Jacks, they are placed in the back of a military truck. Heidemann and Von Klugermann discuss the incident as they prepare to leave for the funeral. Heidemann clearly still has notions of chivalry. Von Klugermann says that Stachel was right to act as he did, as the rear gunner was about to open fire. Heidemann points out that the rear gunner was blinded, but Von Klugermann responds that this could have happened over the airfield.

They go to Stachel's room and tell him that they are going to honour the dead. Stachel initially refuses but finally agrees to go to the funeral after being told it is an order. 'There's something of the Cobra in you. We'll have to watch you', says Von Klugermann.

Later, Willi's uncle General Von Klugermann (James Mason) arrives at the airfield to present Willi with his 'Blue Max'. He shows great interest in the downed RE.8 and has a completely different take on things to Heidemann. 'Is he a good flier?' he asks. The General is accompanied by his much younger, beautiful wife Kaete (Ursula Andress), who at that time was regarded as one of the hottest actresses on the planet following her bikini-clad debut in *Dr No* (1962).

The entire squadron are lined up on the airfield as Major Holbach (Anton Diffring) reads Willi's citation. He is then presented with his medal. Later at a reception, Stachel is introduced to Major Holbach and General Von Klugermann. Both men realise that Stachel could be of great value to Germany for public relations purposes as he could be presented as a 'working class hero'.

Heidemann is dismissive of the idea, pointing out that Stachel is 'ruthless' and citing the incident with the British RE.8 as proof of his lack of chivalry. The General is non-plussed by Heidemann's remarks and points out that they are now living in 1918 with unrestricted submarine warfare, poison gas and the bombing of civilians all part of everyday life. In Jack Hunter's novel, Stachel is described as having 'The X-Factor' on a number of occasions, proof that this is not a modern expression as most people would assume.

Willi introduces Stachel to Kaeti and he asks her if she wants a drink. She asks for champagne and they dance together. General Von Klugermann then makes an important announcement – in a few hours the horizon will be lit up by 7,000 guns as the Germans start the greatest offensive in history. The defeat of Russia has released an extra million German soldiers for duty on the Western Front, making victory a certainty.

Later, Stachel is in his room when Kaeti enters. She has come into his room in error, as Stachels's room is next to Willi's. Stachel realises that Willi is having an affair with her, but flirts with her regardless. He has no champagne left, so he offers Kaeti some Schnapps which she finds disgusting. He then knocks on the connecting wall and Kaeti leaves to be with Willi.

The next morning the offensive starts, and as artillery shells explode amongst the British lines the German squadron takes off to provide tactical air support. They are now down to just nine planes, and each carries six small bombs under their wings. As the German infantry attack, their aircraft swoop down to strafe and bomb the British positions. The Tommies fire back with rifles and machine guns.

Six SE5as arrive overhead. The two nearest the camera are the authentic replicas built in England, while the four most distant aircraft are three D.H. Tiger Moths and a single Stampe SV.4. Four of the British fighters dive to attack, a dogfight ensues, and one SE5a is shot down in flames.

Once again we see the squadron scorecard (a blackboard) superimposed on the action as Stachel's personal score is changed from five to eight aircraft. Stachel returns from the battle and complains that his oil pressure is low. He is told that his plane 'wasn't built yesterday'.

Later, Stachel is on patrol in his Pfalz when he sees a single red Fokker DR-1 Triplane far below about to attack a lone SE5a. But it is a trap as the Fokker pilot hasn't spotted two other SE5as which are above and behind him. Stachel dives and manages to shoot down one of the SE5as which is about to attack the Triplane. Unfortunately he is hit by the other SE5a and his engine catches fire. He crash lands his Pfalz

in a field, and is lucky to get out just before the plane explodes.

The Fokker DR-1 then flies over the wrecked Pfalz a couple of times and the pilot waves to Stachel as a gesture of gratitude. Stachel makes his way to a German field hospital where his wounded left arm is treated and soon a lorry arrives to take him back to the airfield. Willi is in the back with a bottle of champagne to toast Stachel's 10th victory. 'What does it feel like to be shot down?' he asks. They then discuss Kaete, and Willi notes that Stachel has aspirations in that direction. 'If the impossible happens I will buy you a bottle of champagne', he says.

When the truck arrives back at the German base Stachel notices a red Fokker Triplane sitting on the grass. It is the same one he saw earlier and its pilot is none other than Germany's greatest ace, Baron Manfred Von Richtofen. Stachel is dumbstruck to meet his idol. 'I am honoured', he says. In Jack Hunter's book, Stachel is much more forthright with Von Richtofen, saying that he should remember to look over his shoulder before making an attack – a remark which Von Richtofen actually agrees with. He then invites Stachel to join his squadron which is to be equipped with the new Fokker monoplane, but Bruno declines the offer as he says he wants to prove himself in his existing squadron. Von Richtofen commends him for his loyalty and flies back to his own unit.

The next scene shows General Von Klugermann examining a model of the new monoplane fighter, supposedly a Fokker E.V but in reality a French 1929 Morane Saulnier MS.230 parasol wing aircraft. He discusses Stachel with Major Holbach and agrees that he should be brought to

Berlin as a public relations exercise involving 'special newspaper treatment'.

Later, Von Klugermann witnesses wind tunnel tests of a model of the new monoplane fighter. It is clear that the aircraft is inherently unstable and the wing struts are too weak for the wing loading. It will take three months to solve the problem, but Von Klugermann says that Germany hasn't that much time as the war will be lost by then; the pilots will just have to take their chances.

Stachel is brought to Berlin for a photo opportunity and is disturbed by what he sees. It appears that, as a result of the war going badly for Germany, order is breaking down and people are on the verge of rioting. These Berlin scenes were shot in central Dublin.

Stachel makes his way through the overcrowded corridors of the hospital. Beds, stretchers and wounded soldiers are everywhere. He is taken to a small single room where he is snapped by five newspaper photographers while he is apparently being treated by Heidemann's wife Elfi, who is a nurse.

General Von Klugermann arrives and tells Stachel that his wife would like to dine with him later. In fact he is referring to a formal dinner with a large number of guests at Von Klugermann's house. Eventually, at the end of the evening, the guests leave and Kaete is left alone in the house with her elderly manservant, Hans. Then she hears the sound of drums being played and, when she investigates, she discovers that Stachel is still in the house. He is drinking from a bottle of wine. Kaeti goes into her bedroom and closes the door. Stachel tells Hans to knock on Kaeti's door and tell her that 'he knows what she means'. Hans knocks on the door as instructed and Kaeti answers. She is surprised to see Hans as

she was expecting Stachel. Then he appears behind Hans holding a wine glass and a bottle. He enters Kaeti's bedroom, closes it behind him and their intimate relationship begins.

The next day Willi meets Stachel, who has brought a bottle of 1903 champagne. During the ensuing conversation Willi learns of Stachel's affair with Kaete and becomes angry. 'One of these days I am going to shake you up. Are you as good as you think you are? In and out of bed?'

In the cinematic version of this movie there is an intermission at this point with specially-composed music. After this, the action resumes as a single Fokker DVII lands on the German airfield and a rather shaken Heidemann climbs out. He reports seeing thousands of enemy troops on the move and almost continuous anti-aircraft fire. He also says that any replacement pilots the squadron is receiving are only half-trained.

Heidemann briefs his men and reports that the German offensive has failed and the enemy is counter-attacking. They are now out-numbered in the air and their reconnaissance planes are being shot down. He is going to lead a decoy mission while a German aircraft carries out a photo-reconnaisance mission over Amiens.

At 0800 two Fokker Triplanes take off, piloted by Stachel and Willi Von Klugermann. They are to escort the German reconnaissance aircraft (which is actually the same Caudron 276 which played a British RE.8 earlier in the film, although this time it is painted in German lozenge camouflage).

Unfortunately the German formation is spotted by five British SE5as which dive to attack. Stachel sees them and waggles his wings to warn his fellow pilots. Using hand

signals, he instructs the German reconnaissance plane to turn back for base while he takes on the attackers.

Willi and Stachel are now engaged in a dogfight with five British fighters. Both of Stachel's machine guns jam after firing two short bursts, but Willi shoots down two of the SE5as and then successfully downs a third on Bruno's tail. The other British fighters beat a hasty retreat.

Willi celebrates his triple victory by carrying out a perfect barrel roll as he flies beside Stachel. Then he sees a railway bridge below and, using hand signals, suggests to Stachel that they prove their skills by flying under the bridge. Von Klugemann starts off by flying under the main span of the bridge. Bruno tops him by piloting his DR-1 under one of the subsidiary spans which are much narrower. Willi follows suit and successfully flies through the smaller archway but then, on pulling up his Triplane, he hits a castle keep and is killed.

This 'flying under a bridge' scene is the highlight of the movie, and considerable planning went into its execution. The producers looked at a large number of bridges in Ireland before settling on the Carrigabrick railway viaduct at Fermoy, near Cork, which had been built in 1872. This was ideal, as it had a large main span plus smaller arches on each side which were just big enough to accommodate a Fokker Triplane with only four feet of clearance on each side.

In his book *Delta Papa* (1977), stunt pilot Derek Pigott devotes a whole chapter to the filming of *The Blue Max*, and much of it is concerned with the filming of this particular scene. Pigott realised that to carry out the stunt safely he needed to have the aircraft lined up correctly on each pass, and to achieve this two scaffolding poles were hammered into the ground beyond the smaller arch – one in a river bed and

the other in a field. All that Pigott had to do was ensure that the two poles were exactly lined up as he approached the bridge and the Triplane would pass through the exact centre of the arch. Some rehearsals were carried out at Weston Airfield using two scaffolding poles painted yellow, with an observer on the ground in the position of the arch giving feedback. Despite all these precautions, though, the stunt was still considered dangerous.

Eventually Pigott did 18 runs through the small arch plus 15 under the main centre span without mishap. Much credit for the success of this stunt must also be given to the pilot of the SA318C Alouette II camera helicopter, Gilbert 'Gilly' Chomat, who flew behind Pigott and then pulled up over the bridge at the last moment, giving the impression that the Triplane was ducking down under the bridge.

To complete the sequence, Pigott did four runs at the bridge with a fixed camera installed on the fuselage spine shooting the back of his head while he wore Stachel's and Willi's different leather flying helmets in turn. The sequence was thus shot from three viewpoints: from the camera helicopter behind the triplane, from the ground, and from behind the pilot's head. When the best footage from all three positions was combined by skilful film editing a truly thrilling scene resulted.

To underline the point that the sequence was real, sheep were placed in the adjoining field who would scatter when the planes approached. Eventually they became used to the aircraft and had to be dispersed by a shepherd. Despite all the enormous effort and risk involved in shooting these scenes, many people who have seen this sequence think it was done with models.

When he gets back to base, Bruno is 'economical with the truth' and tells Heidemann that Willi was flying too low and hit the trees. Karl then announces that two British planes have been reported shot down in sector nine and Stachel immediately claims them as his kills even when Karl subsequently points out that an armourer's report has shown he has fired only 40 rounds which is equivalent to two three-second bursts. 'Is your marksmanship that good?'

A few days later, Willi is buried with full military honours with General Von Klugemann and Kaete in attendance. Later, Stachel arrives at a hotel in the pouring rain to meet Kaete. No-one is manning the reception desk or even answering the bell, so Bruno makes his way up the stairs to Kaete's room.

She is just out of the shower. Her hair is wet and she is clad in two towels, one round her neck which covers her breasts and a second round her waist. Along with Sean Connery's bedroom scene in *From Russia with Love* (1963), this is probably the most famous 'towel scene' in cinema history. Many critics who viewed the film commented on the gravity-defying properties of the towel covering Andress's breasts. No matter what position she adopted, the towel remained firmly attached to her ample bosom. (There was obviously some toupee tape in there somewhere!) Another critic, on seeing these racy scenes, commented that the actress should really be called 'Ursula Undress!' After they have made love, Stachel indulges in some 'pillow talk' with Kaete and admits the truth about what really happened to Willi and how he had claimed two of his kills.

The next scene depicts the immediate aftermath of a British strafing attack on the German airfield by British Sopwith Camels. Hangars are on fire. Planes have been

destroyed. Heidemann tells Ziegel to clear up the mess while announcing that on the next mission, the squadron is to refrain from air combat as they have to conserve their planes and pilots in order to support the retreating German Army. The squadron takes off with 11 aircraft, including the last remaining Fokker Triplane flown by Stachel.

The squadron spots the advancing British Army and dives to attack as the soldiers return fire with rifles and machine guns. 1,100 extras supplied by the Irish Army were used in these ground battle scenes under the command of liaison officer William O'Kelly, and a set of a destroyed French village was built at Kilpedder, six miles from Ardmore on the East coast. As the squadron climbs for height after strafing the British positions, Stachel spots some British fighters and peels off to attack them against orders. One by one his colleagues follow until Heidemann is left on his own. A furious dogfight ensues and both sides suffer losses.

When the squadron returns to base Heidemann is furious with Stachel, as nearly half the squadron has been shot down. However, seven British planes have been destroyed in the engagement, three of them by Stachel which means he is now eligible for 'The Blue Max' as he has achieved 22 kills.

However Heidemann thinks differently and wants to have Stachel court-martialled for disobeying orders. Stachel replies by stating that Heidemann should get a desk job in Berlin as that is what his wife Elfi wants.

Later, Stachel receives orders to return to Berlin with Heidemann. As he is driven through the city he notices the population being fed at roadside soup kitchens. Heidemann has produced a report highly critical of Stachel's actions which has resulted in nearly half the squadron being lost but General

Von Klugermann thinks differently as he sees that Germany needs a hero in this time of crisis. He asks Heidemann to withdraw his report, resulting in him threatening to resign. Eventually he agrees to take a staff job in Berlin.

Von Klugermann has announced that the Crown Prince will present Stachel with the 'Blue Max'. After receiving his medal, Stachel will test-fly the new monoplane. Heidemann is told to be present.

Later, Stachel is taken to his hotel suite and Major Holbach says that he felt the press reception had gone well. Stachel is told to ring the hotel reception if he needs anything. Kaeti arrives at Stachel's hotel room saying they need to talk. She is going to flee to Switzerland the next day as she feels Germany is finished and wants Stachel to accompany her after he has been presented with the medal. Bruno is angry at this suggestion, saying that The Blue Max will only be worth 5 Marks in scrap value. 'In a few months you'll be afraid to wear it', replies Kaeti.

She is furious that he has refused her offer. 'Don't be angry; where's that aristocratic poise?' says Bruno. But this upsets her even more, and she knocks the drink he is offering her out of his hand as she storms out of the room.

The next day, the new Fokker monoplane (actually a Morane-Saulnier MS230 with its forward cockpit faired over to depict a single-seat aircraft) sits on the airfield as the military band plays. Stachel is presented with his 'Blue Max' and everything seems to be going to plan. Then Major Holbach whispers something in General Von Klugermann's ear. Some information has been received which he needs to hear.

The General goes to a nearby building on the airfield to use the 'phone. Through the windows a modern control

tower can be seen beside a flagpole, from which is fluttering an Irish flag. The General hears some disturbing information and asks that the Field Marshal 'phone him to discuss this.

In the meantime, he asks for Stachel to be kept out of sight and for Heidemann to carry out the initial test flight of the new monoplane. Elfi is concerned, because she thought that Stachel was going to fly the plane. She fears for her husband's life. Heidemann test flies the new aircraft for a few minutes, then lands somewhat shaken. The new plane is a death trap as the struts are too weak.

Meanwhile, General Von Klugermann finally speaks on the 'phone to the Field Marshal and learns that Kaeti has spilled the beans about Stachel falsely claming Willi's two kills in retaliation for him jilting her. Heidemann arrives and tells the General the truth about the new aircraft.

Von Klugermann sees a solution to his problem and orders Stachel to fly the plane. He wants to see some 'real flying'. Stachel walks to the monoplane as the crowds are cheering. He takes the plane up and engages in some spirited flying, including loops and high-speed dives.

As Von Klugermann stands in the office preparing to stamp Stachel's personal file, we hear the sound of the aircraft's wing collapsing followed by a shrieking noise as the plane dives to earth. The crash of the monoplane is depicted by an explosion on the periphery of the airfield as Von Klugermann stamps and signs the file. Stachel has died a hero, his honour intact.

The film's ending is different from the book, in which Heidemann – not Stachel – dies in the crash of the experimental aircraft, which is known as the *Adler* (*Eagle*). In Jack D. Hunter's novel, Stachel survives the war and even meets Hermann Goering. The character subsequently

reappeared in two sequel books, *The Blood Order* (1979) and *The Tin Cravat* (1981), though neither was filmed.

The Blue Max was released on 21 June 1966 and was a great success both critically and commercially, making $5m at the box-office. After the production of the movie was completed, all the unmodified D.H. Tiger Moths and Stampes were returned to their original owners while the entire collection of replica German aircraft and associated props was bought by Lynn Garrison and stored for a while at the Powerscourt Estate near Dublin. These replica aircraft were used in four other WWI movies: *Darling Lili* (1970), *Von Richtofen and Brown* (1971), *You Can't Win 'Em All* (1970), and *Zeppelin* (1971).

Sadly both the replica SE5as constructed for *The Blue Max* were destroyed in separate flying accidents within a month of one another. G-ATGW was destroyed on 18 August 1970 when it collided with an Alouette camera helicopter during the making of *Zeppelin*, resulting in the deaths of five people including aerial cameraman Skeets Kelly. Four weeks later, on 15 September 1970, the other Blue Max SE5a replica G-ATGV crashed at Weston Aerodrome during the making of *Von Richtofen and Brown*, causing the death of pilot Charles Boddington.

Following the making of *The Blue Max*, pilot Derek Pigott oversaw the construction of six further SE5a replicas based on Currie Wot aerobatic biplanes. These partial-scale reproductions were flown to Ireland where they were used in several films and TV commercials. Many of the replica German aircraft used in *The Blue Max* still exist, with some in airworthy condition, and full details are given in the listings which follow.

The Blue Max (1966)
Technical Credits

Director: John Guillerman
Screenplay: David Pursall, Jack
Seddon and Gerald Hanley
Adaptation: Ben Barzman and
Basilio Franchina, from a novel
by Jack Hunter

Cast
Lt Bruno Stachel - George
Peppard
General Count von Klugermann
- James Mason
Countess Kaeti von Klugermann
- Ursula Andress
Willi von Klugermann - Jeremy
Kemp
Heidemann - Karl Michael
Vogler
Holbach - Anton Diffring
Kettering - Harry Towb
Corporal Rupp - Peter
Woodthorpe
Ziegel - Derek Newark
Fabian - Derren Nesbitt
Elfi Heidemann - Loni von Friedl
Feldmarschall von Lenndorf -
Friedrich von Ledebur
Von Richtofen - Carl Schbell
The Orator - Alex Scott
The Crown Prince - Roger
Ostime
Pilot - Ray Browne
Pilot - Timothy Parkes
Pilot - Ian Kingsley

Production Crew
Producer: Christian Ferry
Executive Producer: Elmo
Williams
Music: Jerry Goldsmith
Cinematography: Douglas
Slocombe
Film Editor: Max Benedict
Casting: Stuart Lyons
Production Design: Wilfrid
Shingleton
Art Direction: Fred Carter
Hairdresser: Pat McDermott
Make-up Artists: Charles E.
Parker, John O' Gorman, Pat
McDermott, Tony Sforzini and
Jay Sebring
Production Manager: Rene
Dupont
Assistant Directors: Jack Causey
and Derek Cracknell
Aerial Unit Director: Anthony
Squire

Art Department
Plasterer: Brian Doyle
Production Illustrator: Joseph
Musso

Sound Department
Assistant Sound Editor: Richard
Best Jr
Sound: John Cox
Sound Editor: Chris Greenham
Sound: Claude Hitchcock

Sound: Bob Jones
Special Effects: Maurice Ayers,
Ron Ballanger, Karl Baumgartner
and Gerry Johnston
Pilots: Ken Byrne, Tim
Clutterbuck, Pat Cranfield, Tim
Healey, Peter Hillwood, Joan
Hughes, Darby Kennedy, Roger
Kennedy, Liam Mulligan, Derek
Pigott and Taffy Rich

Camera Department

Aerial Photographer: Skeets
Kelly
Photographer, Second Unit:
Donald C. Rogers
Camera Operator: Chic
Waterson
Focus puller, Second Unit: Mike
Fox
Camera Operator, Second Unit:
Ginger Gemmel
Camera Assistant, Aerial Unit:
Jimmy Stilwell

Wardrobe Department

Wardrobe Supervisor: Elsa
Fennell
Wardrobe Creator for Ursula
Andress: John Furniss

Editorial Department

Assembly Editor: Norman
Cohen
Assistant Editor: Elizabeth
Thoyts

Music Department

Conductor: Jerry Goldsmith

Transportation Department

Transportation Captain: Arthur
Dunne

Other Crew

Air Engineer: Johnny Maher
Production Liaison (Irish Army:
William O' Kelly
Runner: Willy Roe
Air Supervisor: Allen Wheeler
Continuity: Helen Whitson

List of Aircraft used in *The Blue Max* (1966) and current status (where known)

Aircraft Type	Registration	Current Status and Location
SE5a replica	G-ATGV	Destroyed 15/09/70
SE5a replica	G-ATGW	Destroyed 18/08/70
Fokker DR-1 Triplane replica	G-ATIY (EI-APW)	Patrick Garrison
Fokker DR-1 Triplane replica	G-ATJM (EI-APY)	Salis Collection, La Ferte Alais, France
Pfalz DIII replica (PPS)	G-ATIF	Peter Jackson's 1914-18 Trust, New Zealand
Pfalz DIII replica (Viv Bellamy)	G-ATIJ	Peter Jackson's 1914-18 Trust, New Zealand Omaka Aviation Heritage Centre, New Zealand
Fokker DVII replica	N902AC	Peter Jackson, Vintage Aviator, New Zealand
Fokker DVII replica	N903AC	Stampe & Vertongen Museum, Antwerp
Fokker DVII replica	N904AC	Southern Museum of Flight, Alabama
Moraine-Saulnier MS.230	N230MS	Kermit Weeks, Fantasy of Flight, Florida
Moraine-Saulnier MS.230	N230EB	Airworthy, Thomas Leaver, Florida
D.H. Tiger Moth	G-ANEW	Unknown
D.H. Tiger Moth	G-ANDM	Unknown
D.H. Tiger Moth	Unknown	Unknown
D.H. Tiger Moth	Unknown	Unknown
Stampe	G-ATIR	Unknown
Stampe	EI-ARE	Unknown
Caudron 277	EI-ARF	Rebuild to fly. Ken Kellet, Florida

633 Squadron
(1964)

L ike the film it was probably inspired by (*The Dambusters*), *633 Squadron* is a national institution in the UK. The theme tune by Ron Goodwin remains immensely popular more than 50 years after it was first composed, and the film crops up regularly on television. Indeed, the movie had it first showing on British television on 21 November 1970 as part of an evening of programmes to celebrate a year of colour broadcasts on BBC 1. It was the first British war movie to be made in both colour and Panavision.

The film was based on a 1956 novel by Frederick E. Smith (1919-2012), who had served in the RAF during WW2 and dealt with the efforts of a crack RAF squadron to destroy a supposedly bombproof heavy water plant in a Norwegian fjord by bringing down an overhanging cliff face using 4,000 lb 'earthquake' bombs. At the beginning of Smith's original novel, the squadron is flying American-made Douglas Boston light bombers, later converting to De Havilland Mosquitoes in order to carry out the dangerous mission.

For the film adaptation, screenwriters James Clavell (who later wrote *Shogun*) and Howard Koch (the scriptwriter of *Casablanca*) changed certain plot elements. 633 Squadron now flew Mosquitoes from the start of the film, as no Douglas Bostons were available, and the heavy water plant became a rocket fuel factory. 633 Squadron's commander was renamed Wing Commander Roy Grant, an American ex-Eagle

Squadron pilot, instead of Englishman Roy Grenville, and was played by Cliff Robertson – himself a keen aviator – who had portrayed the young John F. Kennedy in *PT-109* the previous year. Similarly, Greek American actor George Chakiris – who had recently starred in the film version of *West Side Story* (1961) – was cast as Norwegian Resistance Leader Erik Bergman, with Austrian actress Maria Perschy as his sister Hilde.

Distinguished former RAF bomber pilot Group Captain T.G. 'Hamish' Mahaddie was appointed as the film's technical advisor. His first involvement with aviation films was in 1954 when, as a serving RAF officer, he was involved in procuring four Avro Lancaster Mark VIIs for use in the film *The Dambusters*.

He had retired from the RAF in 1958, and set himself up as an independent aviation consultant to the film industry. His first task on *633 Squadron* was to find as many Mosquitoes as possible. Eventually, Mahaddie tracked down eleven examples which were owned by the No 3/4 Civilian Anti Aircraft Cooperation Unit (3/4 CAACU) at Exeter Airport. These aircraft were flown by civilian pilots and used to tow sleeve targets for Army, Navy and RAF anti-aircraft gunners.

Five of the Mosquitoes were fully airworthy, three were capable of taxying (and were ultimately destroyed in crash sequences) and the others could be used as airfield set dressing and for cockpit shots at MGM Borehamwood Studios. Two other ex-3/4 CAACU Mosquitoes, TT.35 TA634 and T.3 RR299, were airworthy but were not available for use in the production. TA634 had already been sold to Liverpool Corporation and was in Northern Ireland at the time of filming in the summer of 1963, while RR299 had

been purchased by Hawker Siddeley Aviation and was undergoing a major overhaul at the time *633 Squadron* was shot. Mahaddie purchased the airworthy aircraft, fully fuelled, for £75 each, while the non-airworthy planes were just £35-45 apiece. As part of the deal, 3/4 CAACU also gave the producers a large quantity of Mosquito spares which they were glad to get rid of. The film was originally scheduled to be shot in October and November 1962, but production was delayed until the summer of 1963 as the RAF was not finished with the aircraft until May of that year.

Of the five airworthy Mosquitoes, four were TT.35 versions – essentially B.35 bomber versions with target towing gear fitted. Once this had been removed, the aircraft returned to B.35 specification. This was the final version of the Mosquito bomber, and featured a pressurised cabin giving it a ceiling of 42,000 feet and a bulged bomb bay permitting the carriage of a 4,000lb 'cookie' bomb.

Mirisch purchased three of the airworthy Mosquitoes RS709, RS712 and TA719, and had them placed on the UK Civil Register as G-ASKA, G-ASKB and G-ASKC. One caveat was that ownership of TA719 would be transferred to Peter Thomas (who had established the new Skyfame Museum at Staverton, Gloucestershire) on 31 July 1963, something that caused problems later in the filming schedule. The other two airworthy Mosquitoes were B.35 TA639, by then owned by the RAF Central Flying School at Little Rissington, and T.3 TW117 which had been acquired by the RAF's storage facility at Henlow (the famous 'pickle factory') for inclusion in the future RAF Museum. Both were loaned to the Mirisch Corporation for the duration of filming.

TW117 had dual controls and was mainly used for pilot training. Indeed, close study of the final cut of the film reveals

that the producers never managed to get all five airworthy Mosquitoes aloft at the same time. There is only one shot in the whole film featuring four airborne Mosquitoes, and most aerial scenes only feature the three TT.35 Mosquitoes owned by Mirisch.

While Hamish Mahaddie was responsible for acquiring all the aircraft for the production, the co-ordination of the flying sequences was handled by Captain John Crewdson whose company Film Aviation Services Ltd had already received plaudits for its work on *The War Lover* (1962) and *From Russia with Love* (1963). Crewdson later appeared as the pilot of one of Draco's Bell Jet Ranger helicopters in *On Her Majesty's Secret Service* (1969).

Five pilots were employed to fly the Mosquitoes during the film: namely Captain John Crewdson, Flight Lieutenant John 'Jeff' Hawke RAF, Squadron Leader Graham 'Taffy' Rich (RAF retired), Captain Peter Warden, and Flight Lieutenant 'Chick' Kirkham RAF.

During WW2 the Mosquito was produced in a large number of variants. Bomber versions (including the B.35 versions used in the film) had a clear perspex nose and no armament, fighter versions had 'solid' noses mounting four Browning 0.303in machine guns and four 20mm Hispano cannon, while some night-fighter versions only carried the cannon because airborne interception radar occupied the compartment in which the machine guns were fitted in day-fighter versions. One of the most common versions was the F.B Mark VI fighter-bomber which combined some of the features of the fighter and bomber models, as it had a shortened bomb bay holding two 250 or 500 pound bombs, four cannon and a quartet of 0.303 machine guns.

In Frederick E. Smith's 1956 novel, he envisaged 633 Squadron as being equipped with a hybrid version of the Mosquito with the long bomb bay of the bomber version, two 0.303 machine guns and two short-barrelled 20mm cannon.

For the film, most of the Mosquitoes were fitted with four dummy 0.303 Browning gun barrels. Two different methods were used. The airworthy aircraft had a curved piece of material attached to the nose cone (using two nuts and bolts) to which four dummy machine gun barrels were fitted, while the non-airworthy machines had holes drilled in the perspex with machine guns poked through. To achieve the 'solid nose' effect, the nose cones and side windows were painted over.

The location chosen for filming was RAF Bovingdon, which became 'RAF Sutton Craddock' and was close to the MGM studios at Borehamwood, Herts. This had previously been used for the filming of *The War Lover* (1962) which starred Steve McQueen and Robert Wagner, and was utilised again for a number of films including *The Liquidator* (1965), *Mosquito Squadron* (1970) and *Hanover Street* (1979).

On arrival at Bovingdon, all the Mosquitoes were repainted in correct wartime day bomber camouflage of dark green and slate grey on the upper surfaces of the wings and fuselage and light grey undersides. Behind-the-scenes photos indicate that this work was done outdoors using rollers and brushes rather than by spraying. Spurious serial numbers were applied to the aircraft plus squadron codes with an HT-prefix. Wing Commander's Grant's machine was HJ898, squadron code HT-G for much of the film.

The aerial camera aircraft for the production was North American B-25J Mitchell N9089Z *Moviemaker II* which was flown from the USA by Gregg Board and Martin

Caidin (who later penned a number of aviation-related books, one of which – *Cyborg* – was adapted as the pilot of the successful 1975 TV series *The Six Million Dollar Man*, which starred Lee Majors).

The film opens with a pre-credit sequence (which was very much in fashion in the Sixties). A caption reads 'Norway 1944.' A German staff car is ambushed by Norwegian resistance fighters (known as the 'Ling'), who steal a briefcase full of secret papers. One of their number, Erik Bergman, escapes with the documents in a waiting aircraft. In real life this would have been a Westland Lysander or Lockheed Hudson of an RAF special duties unit (either 138 or 161 squadron based at Tempsford), but as neither type was available a civilian Miles M.38 Messenger 2A G-AKBO, registered to Dorran Construction Ltd of Perth and flown for the film by Neville Browning, was used instead.

As the Messenger takes off, several German soldiers arrive and fire their MP40 submachine guns at the departing aircraft. The sound of multiple machine pistols then merges with the first few bars of Ron Goodwin's amazing theme tune, and now we see the incredible title sequence of rolling clouds filmed from the rear turret of the B-25 camera plane. The red lettering of the titles, edged with black, contrasts perfectly with the white clouds. Marvellous stuff! The title sequence is almost identical to that used in *The Dambusters*, except this time it is in colour and widescreen.

Just after the title sequence ends a caption informs us that the 'story is inspired by the exploits of British and Commonwealth Mosquito aircrews during WW2.' This is entirely correct, as there never was a '633 Squadron' nor an attack on a Norwegian rocket fuel factory as depicted.

Instead, the story is based on a number of daring Mosquito missions during the war.

The next (rather shaky) process shot depicts twelve Mosquitoes in flight, achieved by multiplying an image of one 'vic' of three aircraft. Then we see three of them flying over 'The Black Swan', a pub next to the airfield as described in Smith's novel. As there was no such establishment next to RAF Bovingdon, 'The Three Compasses' at Elstree was used, and the resulting footage carefully edited in to make it seem that it was next to the airfield.

The first 'vic' of three Mossies beats up the airfield and then banks right in a steep climbing turn, Rolls-Royce engines screaming. The aircraft then land on the runway and taxi to dispersal. Though the initial process shot established that the squadron has twelve aircraft, only four can be seen in this sequence. This is a recurring problem in the film, as only three or four planes are seen in each shot rather than the twelve to eighteen that would have been the normal complement of a WW2 RAF squadron. The same issue was solved in *Memphis Belle* (1990) by using several cut-outs of B-17s plus large models (in one sequence) to increase the number of aircraft seen in shot.

The Mosquito pilots and navigators disembark from their aircraft and Grant immediately berates one of his pilots, the reckless Australian Flight Lieutenant Gillibrand (John Meillon), for breaking formation to strafe an ammunition train which has resulted in some flak damage to his Mosquito. However, he also tells Gillibrand that he is going to recommend him for a medal and, when it comes, he is going to 'stick it right on his tail'. Among the 24 actors playing the squadron's pilots and navigators are Johnny Briggs (Pilot Officer Jones) who played Mike Baldwin in *Coronation*

Street, and Edward Brayshaw (unnamed pilot) who portrayed the War Chief in the classic 1969 *Doctor Who* story *The War Games*.

Suddenly an RAF jeep arrives hooting its horn, and the driver – Squadron Leader Frank Adams (Michael Goodliffe) – informs Grant that he is to meet immediately with Air Vice-Marshal Davies (Harry Andrews). As Grant is driven off in the jeep, a Mosquito coded HT-M is towed into view by a 1951 Fordson tractor. In the far distance, some modern vehicles can be seen including a grey Land Rover station wagon (which wasn't produced until 1958). This is another problem with the film, as out-of-period aircraft and vehicles appear in the background in some shots though this is not noticeable on initial viewing.

Grant is taken for a briefing with Air Vice-Marshal Davies where he meets Royal Norwegian Navy officer (and 'Ling' member) Lieutenant Erik Bergman for the first time. Davies explains that the Germans have been building concrete structures all along the coast of France which are believed to be rocket launching pads. Up until now, no rockets have been fired because the Germans are awaiting deliveries of special rocket fuel from a factory in a Norwegian fjord.

No details are given about what type of rockets are involved. They can't be V-1s because these are cruise missiles; essentially pilotless planes powered by a pulse jet engine, fuelled by acetylene gas which can be manufactured at any chemical factory. Neither can they be V-2s, since they used a mixture of *B-Stoff* (ethanol and water) and *A-Stoff* (liquid oxygen), substances which were readily available in Germany. Frederick E. Smith's original idea of a heavy water plant in Norway was obviously inspired by the true story of the hydro-electric plant at Vemork, the only source the Germans

had of Deuterium (heavy water) which could be used to create atomic bombs, and which formed the basis of the film *The Heroes of Telemark* (1965).

The rocket fuel factory is protected from bombing by an overhanging rock, so the only way to destroy it is to fly up the fjord at an altitude of 200 feet and lob 4,000lb 'earthquake' bombs at the underside of the cliff causing it to disintegrate and collapse on the factory.

As the factory is protected by flak guns at the mouth of the fjord, the Ling has agreed to destroy these emplacements just before the attack begins, giving the squadron a clear run at the target. Grant is cynical about the chances of success but agrees to the mission. He carries out an initial practice bombing run on a valley in Scotland, Larig Ghru in the Cairngorms – which resembles the fjord – in which he engages in some humorous banter with his Cockney navigator 'Hoppy' Hopkinson. 'I thought you wanted to see Scotland,' says Grant. 'Not upside down!' quips Hoppy, played by Scottish actor Angus Lennie who had also starred in Mirisch's previous war move *The Great Escape* (1963).

Grant returns to RAF Sutton Craddock, where he expresses a desire to see photos of the overhanging cliff that the squadron is to bomb. None are available, so Grant asks one of the navigators – Bissell (who was an artist before the war) – to sketch a charcoal drawing of the rock. Bissell (Scot Finch) does the drawing to Grant's satisfaction, and tells Grant he is due to get married soon to one of the WAAFs – Mary Blake (Suzanne Farmer).

Meanwhile, the 'Ling' has discovered that the Germans have moved a convoy of flak guns 'a mile long' into the Schwarzfjord. The footage used to illustrate this comprises out-takes from the title sequence of *The Great Escape* (1963),

and shows a number of dark grey Luftwaffe lorries traversing an obviously Germanic landscape. None of them are towing AA guns, but at least they are genuine WW2 trucks – the vehicles for *The Great Escape* having been discovered in several West German scrapyards and restored for the film.

Word of this depressing development is passed to the RAF by the 'Ling' using their radio set. Davies and Bergman discuss this new problem, and Bergman says it will be difficult to find enough men to destroy all the enemy guns but that he will do the best he can.

The entire squadron now flies to the valley in Scotland, where they practice their mission. Gillibrand almost crashes his Mosquito into a rock face and Grant advises him (by radio) to pull up sooner. For these Scottish scenes, the three B.35 Mosquitoes RS712, RS709 and TA 719, all owned by Mirisch and registered as civil aircraft, were based at Dalcross Airport near Inverness. TA719 was specially fitted with zero-time Rolls-Royce Merlin engines to carry out the risky low-level flying. The RAF-owned aircraft were not allowed to participate in these scenes, as they were considered too dangerous.

While this section of the filming was being carried out, a problem developed which was caused by the transfer of ownership of TA719 from Mirisch to Peter Thomas of the Skyfame Museum on 31 July 1963. As a result of the filming schedule, TA719 was unable to participate in the official opening of the Skyfame Museum in Staverton, Gloucestershire on 31 August. An aggrieved Peter Thomas announced that the aircraft was to be grounded until an agreement could be reached with Mirisch over compensation for this oversight. Accordingly, the aircraft was flown back to Bovingdon by Captain Peter Warden while negotiations

started. Mirisch needed three Mosquitoes for the attack sequence, and the non-participation of TA719 was delaying filming at a cost of £6,000 a day. Eventually – after a meeting between Robert Relyea of Mirisch and Peter Thomas – a deal was agreed. This included a payment of £2,000 compensation to Skyfame for the non-appearance of the aircraft at the opening ceremony, and an undertaking that TA719 would only be flown by Captain Peter Warden for the duration of filming and would be cleaned and repainted once production had concluded.

After the squadron has taken part in its first training mission, the Mosquitoes land back at RAF Sutton Craddock and, as they do so, a number of Avro Anson Mark XIXs of the RAF Southern Communication Squadron can be seen in the background along with a few RAF Percival Pembrokes and some light aircraft.

The pilots and navigators disembark from their aircraft and, while they are doing so, a pair of German fighters – supposedly Messerschmitt 109s but actually Nord 1002 Pinguoins, the French-built version of the Messerschmitt Bf108B four-seat light aircraft – arrive overhead and start strafing the airfield. The Nords, F-BFYX and F-BGVU, are the very same aircraft which appeared as German fighters in *The Longest Day* two years before, and are fitted with strobe lights in the wings to simulate the appearance of blazing cannon. They are being flown by Martin Caidin and Jeff Hawke. This sequence was originally planned to be shot using two or three Hispano HA-1112 M1L Buchons (licence-built Me109s with Rolls-Royce Merlin engines) of the Spanish Air Force, but Hamish Mahaddie decided to use the Nords instead as the proposed leasing deal with the Spaniards would have been too expensive. In Smith's original novel, the

attacking planes were an entire squadron of long-range Messerschmitt 110s.

Explosions soon appear among the parked aircraft, which is odd as the Messerchmitts only carry cannon – not bombs and rockets – and Sutton Craddock's anti-aircraft gunners open fire with WWI- vintage twin Lewis guns.

One Messerschmitt kills the crew of a Mosquito which is taxying at speed, and the aircraft veers off the runway and collides with a Bedford QL fuel bowser resulting in a spectacular explosion. To achieve this highly-realistic sequence, Mosquito B.35 TA724 was fitted with a brace to prevent the tailwheel from castoring (it can be seen quite clearly in front of the tailwheel). Two sets of control wires were fitted to the brace, one working the throttles and the other the brakes, enabling a special effects man (Les Hillman) running behind the aircraft to control it remotely without any risk of being injured. All the same, it took three attempts to get the aircraft to hit the bowser, resulting in a fire which burned for hours.

The next scene is set that evening in 'The Black Swan', where the members of 633 Squadron enjoy a few drinks and relax despite having lost two of their colleagues that day. Bergman remarks to his sister Hilde that the men are 'drinking and very gay', a line that would produce chuckles in a modern audience. A rather inebriated Grant arrives accompanied by two WAAFs and is introduced to Hilde.

The next day the training continues and Pilot Officer Jones (Johnny Briggs) and his navigator are killed when one of their Mosquito's engines falters during the critical pull out after bomb release. Their Mosquito hits a rock face and is destroyed. The carnage is witnessed by Adams, who is

standing in front of a Series 1 Land Rover (which was first produced in 1948).

The next scene is set back in Sutton Craddock, where Grant burns a slip of paper printed with the names of P/O Jones and his navigator, using the pot-bellied stove in his room. Bergman arrives and informs him that he has to return to Norway to organise the resistance attack on the flak positions.

Grant offers to fly him in using his Mosquito, but his request is vetoed by Air-Vice Marshal Davies who points out that a 'Mitchell' (B-25) is to be used for the mission which will also include an arms drop to the resistance. Grant then offers to fly the Mitchell but Davies turns down his offer, informing him that he is now grounded till M-Day (the day of the bombing raid) as he is too valuable to be put at risk.

The action then moves to dispersal, where the Mitchell (the same aircraft used as the camera plane but with its serial number shortened to 'N908' and RAF roundels and tail flashes added) is being fuelled up in readiness for its mission. This scene was shot in daytime, but was then converted to a 'day for night' shot in post-production. Unfortunately the 2004 DVD release has this scene (and subsequent ones) presented in their original daytime glory. This makes the 'wrong' colour scheme of the Mitchell all the more evident, the top half of the aircraft being painted gloss white with a blue cheat line and the bottom half being left natural metal, giving the aircraft the appearance of a 1960s RAF Transport Command plane rather than a wartime bomber. Two things that would have greatly improved this scene (and made it more atmospheric) would have been the re-painting of the Mitchell in correct wartime camouflage colours, and filming it at sunset.

The Mitchell starts up and takes off with Bergman aboard, and Grant arranges a date with Hilde for the following day. Grant then runs her to 'The Black Swan', where Bissell and Mary have just got married. Again, it is clearly daylight but meant to be night-time as Grant's jeep has its headlights on.

A few hours later Bergman parachutes into Norway, courtesy of some stock footage previously seen in *The Red Beret* (1953). Like the previous two scenes, this is supposed to be set at night but appears as daytime in the DVD release. Just after landing, Bergman is challenged by his comrades and has to depart in a hurry as a German patrol has just arrived. The Germans are driving a crude replica of an Sd Kfz222 armoured car, apparently created for the movie using a British Humber scout car. The vehicle has its headlights and turret-mounted searchlight switched on, revealing that the scene is meant to be set at night.

The next morning, Bergman and his 'Ling' colleagues attempt to make contact with a neighbouring resistance group by driving to meet them in a captured German lorry – supposedly an Opel Blitz, but actually a Bedford OY with a modified bonnet. Why 'Ling' members would be driving an Opel Blitz with German camouflage (which would surely attract attention) is never explained.

The resistance members are ordered to stop at a German road block consisting of several soldiers and a six-wheeled armoured car (actually a British Army Alvis Saracen painted in German markings and fitted with an MG34 machine gun). Bergman tells his driver to slow down as if stopping, and then throws a Mills bomb (British hand grenade) at the German soldiers killing some of them.

The surviving German troops set off in hot pursuit using the Saracen, and after a few bursts of machine gun fire Bergman's driver is killed and the lorry overturns. A firefight ensues in which Bergman is captured and taken to Gestapo HQ in Bergen.

Meanwhile, Grant is enjoying a romantic date with Hilde. As the couple fish in Tykes Water by Tykes Bridge (a location used the previous year in *From Russia with Love* and in many films and TV series), the Mitchell flies over them as it returns from its long flight to Norway.

A few hours later, Grant returns to Sutton Craddock where Group Captain Don Barrett (Donald Houston) greets him with some bad news. Bergman has been captured by the Gestapo and is likely to be tortured to reveal details of the British plan. The only way to save the mission is for Grant to bomb Gestapo HQ in Bergen as soon as possible, killing Bergman in the process. Grant is anxious at the thought of killing his friend, but realises he has no other option and so he reluctantly agrees to Barrett's request. The just-married Bissell has volunteered be his navigator. Grant picks up the 'phone and asks to be put through to 'The Black Swan' to speak to Hilde, but changes his mind and puts down the receiver. Half an hour later Hilde hears the noise of a Mosquito starting up and looks out her window at 'The Black Swan' to see Grant's aircraft departing. Meanwhile, a Gestapo officer (Anne Ridler) bursts into Bergman's cell accompanied by two male colleagues. Bergman refuses to answer her questions and is hauled off for interrogation.

As dawn breaks, Grant's aircraft crosses the Norwegian coast. Soon they are over Bergen, where Hoppy identifies Gestapo headquarters. As they make their initial run over the target, the Mosquito is engaged by anti-aircraft

guns defending the area consisting of a four-barrelled 20mm Flak 38 and a triple-barrelled 20mm MG151 Drilling. Both appear to be acetylene-fuelled 'gas guns' rather than real blank-firing weapons. Grant attacks the AA positions using his four nose-mounted machine guns, and then turns the aircraft round to make a bombing run. He pulls a lever to open the bomb doors revealing four 500-pound general purpose bombs. As he crosses over Gestapo HQ (actually a set on the MGM back lot) for a second time, the bombs are released and hit the target resulting in huge explosions.

Grant exits the target area at low level and, as he does so, his Mosquito is hit by 20mm flak causing his plane to catch fire and wounding Bissell. Despite the damage Grant manages to limp home to RAF Sutton Craddock, where he prepares to make an emergency landing with his undercarriage down but possibly not locked. The smoking Mosquito makes a heavy landing on the runway, then veers onto the grass where its undercarriage collapses and the plane lands on its belly while swerving to one side. Grant gets out of his burning aircraft through the plexiglass escape hatch on top of the cockpit. As he does so his leather flying jacket catches fire and he has to roll on the grass to put it out.

He then tries to re-enter his aircraft to rescue the unconscious Bissell, and has to be physically restrained from doing so. By this time the fire has taken hold and it is clear that Bissell is being roasted alive. Eventually, the fire crew arrive and quench the flames with foam while other firemen smash the cockpit canopy with an axe and drag out the blackened and unconscious body of Bissell who is taken away by ambulance.

This is one of the most realistic scenes in the whole film. No model work or trick photography was used in the

sequence. Instead, on 8 August 1963 Mosquito B.35 RS718 (which was in taxyable but not airworthy condition) was filled with a small amount of fuel and taxyed at high speed across Bovingdon airfield by Captain John Crewdson. At the appropriate moment, Crewdson raised the undercarriage causing RS718 to collapse on the grass and swerve. The crash was filmed by two cameras, one of which was hidden in a camouflaged hide, enabling the sequence to be used later in the film to depict Grant's Mosquito crash landing in Norwegian territory after the raid. Originally, another Mosquito TA642 was scheduled to be used in this scene but had to be withdrawn when it suffered an undercarriage collapse for real on 1 August 1963.

Grant is debriefed on his sortie by Air Vice-Marshal Davies, who tells him that he is going to be recommended for a medal as his actions have probably saved the mission from cancellation. In view of what has happened, Davies also announces that the mission is to be brought forward to the next morning with take-off at 0330 hours.

As Grant leaves the briefing room, he bumps into Bissell's wife WAAF Mary Blake who is traumatised and tearful. 'How is a man going to be... without a face and blind?' she says.

That evening, as rain is falling, the special cylindrical earthquake bombs arrive at Sutton Craddock towed by a Fordson tractor to the accompaniment of sombre music by Ron Goodwin. Curiously, there are only six of them even though twelve will be required for the mission. They appear to be made of polished aluminium. Meanwhile, Grant is telling Hilde what has happened to Erik and how he was responsible for his death. Hilde is upset but thanks Grant for ending his suffering.

In the early hours of the morning Air-Vice Marshal Davies briefs the crews on the forthcoming mission using a model of the Schwarzfjord to show them how twelve bomb hits at 12 second intervals will bring down the cliff face on the factory. The call sign for the mission will be 'Everest', and the code word 'Vesuvius' is to be used to denote a successful attack. Hoppy asks what the factory makes and Davies replies that they will be told when they get back.

With the briefing completed, the crews move outside to their aircraft which are being 'bombed up'. This is another scene which should be 'day for night', but appears as daylight in the DVD release even though it is supposedly about 3.15a.m.!

A number of interesting things can be observed in this scene. The rearmost Mosquito has no nose guns. To the left side of the picture, a modern (i.e. late 1950s) white estate car can be seen in the background and the fuselage of Mosquito TV959 coded HT-P is visible in the background. The real reason for the dismantled state of this aircraft was that it was already being prepared for display at the Imperial War Museum in Lambeth, where it was mounted on a wall with its starboard wing removed to save space.

Group Captain Barrett asks Grant if he can fly on the mission even though he has not participated in any of the practice flights, and he agrees to his request saying that he can lead Red section. The squadron then takes off and heads for Norway. Shortly before the Mosquitoes cross the Norwegian coast, the 'Ling' (on their way to attack the flak gun emplacements) are ambushed by German troops and most of them are killed. A few of them survive the attack and unwittingly lead the Germans back to their cave hideout

where one resistance member manages to send an urgent radio message to the RAF warning them of what has happened.

The scenes of the Mosquitoes flying low over the North Sea were actually filmed over the Wash. Four Mosquitoes were originally scheduled to participate in this section of the filming, but one developed engine problems and so only one 'vic' of three planes was used.

Back at Sutton Craddock, Davies receives an urgent 'phone call telling him what has happened to the 'Ling'. He orders a radio message to be sent by Morse code to Grant's aircraft telling him that the 'Ling' has been destroyed and giving him permission to abort the mission. Grant calls up the other eleven crews and tells them that they are proceeding with the mission even though the enemy anti-aircraft guns are intact. Hoppy says that when he gets back he is going to recommend Grant for a medal, and when it arrives he is going to pin it 'right on his tail'.

Soon after this, the Mosquitoes enter the fjord, supposedly flying in four 'vics' of three aircraft although in reality only three planes were used with the same aircraft entering the fjord four times to give the impression of a twelve-plane squadron. Some pyrotechnics were set off to simulate AA shell bursts, and a view of the planes as seen over the gun barrels of a traversing MG151 Drilling triple 20mm gun was created in the studio using a blue screen technique. It is hardly surprising that none of the shells hit the Mosquitoes, since the gunners appear to be aiming directly at the planes instead of pointing their guns ahead of the target using the principle of deflection shooting (or 'lead' as it is sometimes known) which any competent AA gunner would be aware of. These scenes where shot in Loch Morar

on the North West of Scotland in August 1963 during the Scottish phase of the shooting.

The Mosquito pilots engage the German AA guns, which include the Flak 38 and MG151 we have already seen plus a twin MG34 machine gun mount. All of these strafing scenes appear to have been shot at the MGM studios at Borehamwood.

As the planes approach the target, some really terrible miniature work is evident. Although the factory and overhanging cliff look quite realistic, the shots of tiny Mosquitoes wobbling on visible wires are truly awful. In one shot, one of the model Mosquitoes (which were reportedly 1:48 scale) appears to have what looks like masking tape attached to its port wing and engine nacelle.

Some Messerschmitts (actually the Nords seen earlier in the film) appear overhead and attack the Mosquitoes. One is shot down by a Mosquito's nose guns in a very unconvincing effects shot, which looks as though they just stuffed a gunpowder charge into a very small model, suspended it in front of the camera and then blew it up. Another of the Messerschmitts is brought down by Gillibrand who, out of ammunition, suicidally rams the enemy aircraft. In the original novel this happened earlier in the story when Gillibrand smashes into a Messerchmitt Bf110 to stop it attacking Sutton Craddock.

Despite the losses inflicted by the Messerchmitts and anti-aircraft fire, the overhanging cliff is brought down and the buried factory explodes in an orange fireball. The two surviving Mosquitoes – piloted by Scott and Grant – attempt to fly out of the fjord, but both are hit by flak. Scott's aircraft is blown to pieces, while Grant's is severely damaged and he attempts to make a wheels-down landing on flat ground near

the fjord. In reality, a WW2 pilot would probably attempt a belly landing with the undercarriage up in such a situation. The crash of Grant's aircraft, involving the collapse of the undercarriage, is actually footage of RS718 crashing at Bovingdon on 8 August 1963 which we saw earlier, but filmed from a different angle and with a matte painting of Norwegian hills and forest added.

Grant's aircraft catches fire, and Hoppy climbs out the perspex escape hatch. This scene was shot using TA642, which was already damaged following its undercarriage collapse on 1 August. With the help of a local woodcutter, Hoppy breaks open the canopy and rescues Grant who is dragged clear of the wreckage. 'Where does it hurt?' asks Hoppy. 'All over', replies Grant, who then lapses into unconsciousness. It is not clear whether Grant has died or is just wounded. In Frederick E. Smith's original book, Grenville (Grant) survives the war as a POW and returns to Sutton Craddock.

Meanwhile, back in the operations room Davies hears the word 'Vesuvius' over the radio, indicating a successful mission. Adams is despondent, speculating that the entire squadron is dead. 'You can't kill a squadron,' says Davies, as the camera tracks back to reveal an airfield devoid of aircraft as Ron Goodwin's end title music reaches a climax.

633 Squadron was released with an 'A' certificate on 23 August 1964, and became one of the most successful British films of 1964. More than 50 years after it was made, it still crops up regularly on British television. One of the reasons for its success was the stirring martial score composed by Ron Goodwin – regarded as one of his finest works – which has been re-used in countless TV adverts and documentaries. In interviews, Goodwin claimed that he had some initial

difficulty coming up with the theme tune. Eventually he was inspired by the number '633', so he had six notes followed by three notes followed by three more. However, if you listen to the track it is actually six notes followed by three more, then six notes and three more, which would be '63 Squadron' and not '633 Squadron'. It's a great story, though; a bit like Terry Nation's doubtful claim that he got the name 'Dalek' from a set of encyclopedias on his bookshelf which had 'Dal-Lek' on their spine!

After filming was completed, Cliff Robertson tried to buy Mosquito TA719 but he was not allowed to do so. Robertson subsequently bought a Supermarine Spitfire IX instead (MK923), which had been used in *The Longest Day*. He continued to be an aviation enthusiast and keen pilot to the end of his life, and was airborne over New York in a light aircraft – at the age of 78 – when the Twin Towers of the World Trade Center were hit by hijacked airliners on 11 September 2001.

Frederick E. Smith wrote nine further sequels to *633 Squadron*. The first of those, *Operation Rhine Maiden*, was published in 1975, and the last – *Operation Safeguard* – came out in 2007. Although he sold the film rights to *Operation Rhine Maiden*, it was never made into a movie.

Mosquito Squadron (1970)

Although Frederick E. Smith wrote nine sequels to his 1956 novel *633 Squadron*, none of them were filmed. However, in 1968 Oakmont Productions – a low-budget subsidiary of Mirisch films – made another, similar film about an RAF Mosquito Squadron.

Oakmont had already made the low-budget war movie *Attack on the Iron Coast* (1968), which starred Lloyd

Bridges, and *Mosquito Squadron* was to be the second of six war pictures made by them, all with a budget not exceeding $1 million. Incidentally, *Attack on the Iron Coast* re-used some of Ron Goodwin's score from *633 Squadron,* while he was the composer for Oakmont's next war picture *Submarine X-1* (1969) – a film that was essentially a colour remake of the John Mills war movie *Above Us the Waves* (1955) about the Royal Navy's X-Craft midget submarines which starred a young James Caan.

Mosquito Squadron dealt with the exploits of the fictitious '641 Squadron' which was given the task of destroying an underground research facility near Chateau De Charlon, which produced 'V3 and V4' weapons, using 'Highball' bombs – the smaller version of Barnes Wallis's 'Upkeep' dambusting bomb – which could bounce on land. This weapon really existed, and the monochrome footage featured in the film of 'Highball' test drops on land is real wartime footage of a Mosquito B Mark IV releasing the weapon at the Ashley Bombing Range in the New Forest.

To save on costs, as much footage as possible was re-used from *633 Squadron* and the same location was employed – RAF Bovingdon, which was close to the MGM Studios at Borehamwood. Six Mosquitoes were used in the production. Four (RS712, RS709, TA634 and RR299) were fully airworthy, while a fifth – TA719 – was used in a static role. A sixth Mosquito, TJ118, was used for cockpit scenes shot at MGM Studios, Borehamwood.

RS712 was a Mosquito B.35 which had been owned by Group Captain T.G. 'Hamish' Mahaddie ever since it had been used in *633 Squadron* in 1963. It had remained at RAF Bovingdon for some years, and even appeared in the 1965 *The Avengers* episode *The Hour That Never Was.*

B.35 RS709 was also owned by 'Hamish' Mahaddie following the filming of *633 Squadron*, and was later sold to Peter Thomas of the Skyfame Museum as a replacement for TA719 which had been damaged in a crash in July 1964 at Staverton Airfield, Gloucestershire which followed a display of single-engine flying.

The damage to the port wing and engine nacelle of TA719 resulting from this accident meant that it would never fly again. It was used in a crash sequence at the end of the film and also appears as a static aircraft in a hangar scene.

Mosquito T.3 RR299 was owned by Hawker Siddeley (now British Aerospace) at Hawarden, and was one of two ex-No3/4 CAACU aircraft which was not used in *633 Squadron*, the other being TA634.

Mosquito B.35 TA634 was in Northern Ireland in the summer of 1963, which probably explains why it was overlooked for use in *633 Squadron*. After a narrow escape from being scrapped, Liverpool Corporation purchased the aircraft and it was stored in a hangar at Speke Airport until it was discovered by engineer Les Hillman, who had been tasked with surveying all the available potentially airworthy Mosquitoes in the UK. Hillman reported that the aircraft was in excellent condition and could be made airworthy again with a few weeks' work.

Hillman also looked at Mosquito T.3 TJ117, which had flown in *633 Squadron* and was in storage at RAF Henlow for use in the future RAF Museum but concluded that too much work would be needed to make her airworthy again. Finally, the nose and cockpit section of B.35 TW118 – which had been used in *633 Squadron* and had been stored at MGM film Studios in Borehamwood – was re-used in the new production.

All the Mosquitoes were gathered at RAF Bovingdon in June 1968, with camouflage and markings identical to that worn in *633 Squadron*. The squadron codes all had an HT-prefix to maintain continuity with the earlier film, and dummy nose guns were fitted to all the aircraft. The camera aircraft used in the production was Avro Shackleton MR.3 WR972, supplied by the Royal Aircraft Establishment and flown by Tom Sheppard. The four pilots employed to fly the Mosquitoes in this production were Taffy Rich, Neil Williams, Dizzy Addicott and Pat Fillingham.

The film opens with a pre-credits sequence lifted in its entirety from *Operation Crossbow* (1965), depicting V-1 flying bombs being launched from Northern France and landing in London. The score by Frank Cordell is almost as good as that done by Ron Goodwin for *633 Squadron*.

Then the film cuts to a magnificent title sequence of four Mosquitoes flying low over the water as they approach the French coast. This tops a similar sequence in *633 Squadron*, which only used three aircraft as one developed engine problems.

The Mosquitoes soon arrive at their target – V-1 launching ramps – and destroy them with 500 pound General Purpose bombs. The miniature work in this sequence (and later in the film) was done outdoors in Malta by a team of special effects men, including Kit West and Brian Johnson, under the direction of Les Bowie. Huge painted backdrops including real foliage were constructed for the sequence, and the model Mosquitoes were flown along wires with a converted bicycle being used to pull the miniatures on wires.

After attacking the target, the squadron is bounced by two Messerschmitt 109s (a sequence achieved using fairly small miniatures on wires) and the bomber piloted by

Squadron-Leader Scott (David Buck) is shot down in flames, apparently leading to his death.

The Mosquitoes return to their base where pilot Quint Munroe (David McCallum) is told that with the death of 'Scottie' he will be taking over as Squadron Leader. He is also given the job of informing Scott's parents about what has happened. Glasgow-born McCallum was by then a celebrity following his four-year stint in the TV series *The Man From UNCLE* (1964-68). Rather oddly, his character is supposed to be Canadian (as the word 'Canada' is on the shoulder of his uniform) but McCallum retains his usual British accent throughout the production.

Later, Munroe is instructed to carry out a photo reconnaissance of the Chateau De Charlon where the Germans are believed to be developing new V-weapons. Flying in the navigator's seat during the mission is intelligence officer Major Kemble (Robert Urquhart). This is a major inaccuracy in the film, as photo reconnaisance (PR) missions were usually carried out by a dedicated PR unit using modified aircraft.

Munroe buzzes the chateau at low level and takes many pictures. In reality, 'Charlon' was the Staff College at Minley Manor near Blackbushe in Surrey. The anti-aircraft defences include a twin 20mm Oerlikon gun and also an American M2 'Ma Deuce' 0.50 cal machine gun. The aircraft is hit and crash lands back at the RAF base, using footage lifted from *633 Squadron* of Grant's Mosquito crashing after the raid on Gestapo HQ in Bergen.

Kemble is killed, but the photos taken on the reconnaissance mission reveal that the Germans are developing new V-weapons in an underground laboratory close to the chateau. Munroe is summoned to London, where

he is told that he has been chosen to lead a mission to destroy Charlon using 'Highball' bouncing bombs.

641 Squadron subsequently practices with the new weapon using a wooden archway constructed on their airfield, but after one training mission two 'Messerschmitts' strafe the airfield (using footage of the two attacking Nord 1002 Pinguoins from *633 Squadron*). At the end of the attack, one of the German pilots drops a reel of film on the airfield which – when viewed – reveals that a large number of RAF POWs are being held at Charlon to deter attack. One of these 'human shields' is none other than 'Scottie', who has survived the crash of his aircraft though he apparently has amnesia caused by a head wound.

Wing Commander Clyde Penrose (Dinsdale Landen) orders the film to be stopped, and insists that the contents be kept secret from the rest of the squadron to avoid sapping morale. Flight Lieutenant Douglas Shelton (David Dundas) is outraged, and subsequently spills the beans in the mess. An added complication is that he is the brother of Beth, Scottie's wife, who is now romantically involved with Quint.

Incidentally, two scenes depicting Quint and Beth's romance were filmed at Tykes Water Bridge which was also used for similar shots (involving Cliff Robertson and Maria Perschy) in *633 Squadron*. The crashed German fighter which the couple discover in one of these scenes is believed to be a scrapped Percival Proctor, suitably painted and weathered.

Quint is anguished at the moral dilemma now facing him, as destruction of Charlon is likely to lead to the deaths of RAF aircrew – including Scottie, who has been like a brother to him. Eventually, he persuades Penrose and Hufford to agree that one of the 'Highball' bombs should be used to breach the walls at Charlon, allowing the prisoners to escape

with the assistance of the French Resistance. This part of the plot was obviously inspired by the real-life 'Operation Jericho', the breaching of the walls of Amiens prison on 18 February 1944.

The squadron sets off to attack Charlon, and are eventually successful when Flight Lieutenant Bannister (Michael McGovern) crashes his stricken Mosquito into the mouth of the tunnel, destroying the installation. This allows Munroe to use a 'Highball' to breach the wall, but his aircraft is hit and he belly-lands his plane (using footage from near the end of *633 Squadron* where Grant crashes his plane after completing his bombing mission). The scene where Munroe exits his burning Mosquito was shot in fields near MGM studios using the non-airworthy B.35 TA719.

Although his navigator Wiley Bunce (Nicky Henson) has been killed, Munroe is safe and soon discovers Scottie. A second Mosquito squadron arrives and completely destroys the Chateau. This scene was shot using a large photograph of the chateau which was mounted on hardboard as a 'cut out' and then apparently blown up using small flash charges in front of and behind the two dimensional 'flat'.

Suddenly, a German tank arrives and the French resistance tries to take it out using a bazooka. This is not accurate, as the Maquis was never supplied with bazookas during WW2 and – in any case – the type shown in the film is the post-war 3.5 inch 'superbazooka' rather than the M1 2.36 inch launcher which was used by American troops during WW2.

Many reviews of this film have stated that the tank used in this sequence was an M4 Sherman. In fact, it is an M5A1 Stuart light tank modified to look like a Panzer IV by the addition of a fake 75mm gun barrel in place of the usual

puny 37mm carried by this type of tank. The camouflage scheme is also wrong for a late-war German tank as is the swastika on the front glacis plate.

The German vehicles in the Chateau De Charlon sequences include American FWD HAR-1 trucks and M3 half-tracks, but an authentic VW Kubelwagen and Sd Kfz222 armoured car can also be seen.

A resistance member who is trying to stalk the tank with the bazooka is killed by machine gun fire. Scottie bravely grabs the rocket launcher and attempts to destroy the Panzer, but he is run over and the anti-tank round explodes destroying the tank but also killing himself in the process.

A few days later two Avro Anson XIXs painted in Green and Dark Earth camouflage taxi to the apron at 641 Squadron's base and discharge their passengers – including Munroe, who is reunited with Beth. These two Ansons belonged to the RAF's Southern Communications Squadron based at Bovingdon, the last to operate the type which was retired by the RAF on 21 June 1968 while *Mosquito Squadron* was being filmed.

For some unknown reason *Mosquito Squadron* was not released until November 1970 and even then it was a double bill with *I Start Counting* (1970). It was first shown on BBC 1 in December 1975 and has been repeated many times since. Though much criticised as a 'B-movie', it is still a film that is much enjoyed by aviation enthusiasts, containing as it does the last footage ever taken of four Mosquitoes flying together – something we will probably never see again. It also features unique wartime film of a 'Highball' being dropped on land. For that reason, the production has a special place in the history of aviation films.

633 *Squadron* (1964)
Technical Credits

Director: Walter Grauman
Screenplay: James Clavell and
Howard Koch, based on the novel
by Frederick E. Smith

Cast
Wing Commander Roy Grant -
Cliff Robertson
Lt. Erik Bergmann - George
Chakiris
Hilde Bergmann - Maria Perschy
Air Vice Marshal Davies - Harry
Andrews
Group Captain Don Barrett -
Donald Houston
Squadron Leader Frank Adams -
Michael Goodliffe
Flight Lt. Gillibrand - John
Mellon
Flight Lieutenant Scott - John
Bonney
Flying Officer Hoppy Hopkinson
- Angus Lennie
Flying Officer Bissell - Scot
Finch
Flying Officer Evans - John
Church
Barmaid at Black Swan Inn -
Barbara Archer
Lt. Nigel - Sean Kelly
Flight Lt. Singh - Julian Sherrier
Flight Lt Frank - Geoffrey
Frederick
Lt. Jones - Johnny Briggs

Production Crew
Producer: Cecil F. Ford
Executive Producer: Lewis J.
Rachmil
Executive Producer: Walter
Mirisch
Music: Ron Goodwin
Cinematography: Edward Scaife
Film Editing: Bert Bates
Production Design: Michael
Stringer
Make-up: Wally Scheiderman
and Tom Smith
Production Manager: Albert
Becket

Second Unit and Assistant Directors
Second Unit Director: Roy
Stevens
Assistant Director: Ted Sturgis
Second Assistant Director: Terry
Lens
Third Assistant Director: Roger
Simons

Art Department
Assistant Art Director: Norman
Dorme
Chargehand Dressing Prop:
Mickey Lennon
Draughtsman: Tony Rimmington

Sound Department
Sound Recordists: John Bramall and J.B. Smith
Sound Editor: Teddy Mason
Assistant Sound Editor: Timothy Gee

Special Effects
Tom Howard
Jimmy Harris
Garth Inns

Stunts
Aircraft Stunts: John Crewdson
Stuntman: Joe Powell

Camera and Electrical Department
Camera Operator: Jack Atcheler
Clapper Loader: Mike Drew
Additional Photography: John Wilcox
Gaffer: Steve Birtles
Still Photographer: Arthur Evans
Camera Operator: Geoff Glover
Focus Puller: Tony Spratling

Costume and Wardrobe Department
Wardrobe: Brian Owen-Smith

Editorial Department
First Assistant Editor: Peter Elliott
Second Assistant Editor: Martyn K.E. Green

Music Department
Conductor: Ron Goodwin
Score Remixer: Michael J. McDonald
Orchestrator: Brian Couzens
Music Editor: Bert Rule

Transportation Department
Transportation Chief: Eddie Frewin

Other Crew
Technical Advisor: Group Captain T.G. Mahaddie
Continuity: Connie Willis
Military Advisor: Sean Barry-Weske

List of Mosquitoes used in 633 *Squadron* (1964) and current status where known

Serial	Type	Film Serial	Film Code	Status (1963)	Status (Current)
RS712	B.35	RF580	HT-F	Airworthy	On loan to EAA, Oshkosh; Owner Kermit Weeks; May be restored to fly
RS709	B.35	HR113	HT-D	Airworthy	Museum of the USAF,
			HT-G		Dayton,Ohio
RS715	B.35	-	-	Cockpit scenes	Destroyed 1963
RS718	B.35	HJ662 HJ898	HT-G	Crashed	Destroyed 1963
TA639	B.35	HJ682	HT-B	Airworthy	RAF Museum, Cosford
TA719	B.35	HJ898	HT-G	Airworthy	IWM,Duxford
TA642	B.35	HX385	-	Crashed	Destroyed 1963
TA724	B.35	-	-	Crashed	Destroyed 1963
TV959	T.3	MM398	HT-P	Static Prop	AVspecs, New Zealand; Airworthy Restoration (for Flying Heritage Collection)
TW117		HR155	HT-M	Airworthy	Bodo Museum, Norway
TJ118	B.35	-	-	Cockpit scenes	DH Aircraft Heritage Centre

Other Aircraft used in 633 *Squadron*

North American B-25J Mitchell, *Moviemaker II*

Serial	Type	Film Serial	Film Code	Status (1963)	Status (Current)
N9089Z	N908	-	-	Camera Ship RAF Transport	Extant but non-airworthy at Booker

Miles Messenger 2A

Serial	Type	Film Serial	Film Code	Status (1963)	Status (Current)
G-AKBO	-	None	None	Appears in pre-credits sequence	Extant and airworthy in Cornwall

Nord 1002 Pingouin II (Messerchmitt Bf.108)

Serial	Type	Film Serial	Film Code	Status (1963)	Status (Current)
F-BFYX	-	None	None	Airworthy	Extant in Germany
F-BGVU	-	None	None	Airworthy	Destroyed in crash, January 1964

Mosquito Squadron (1970)
Technical Credits

Director: Boris Sagal
Screenplay: Donald S. Sanford
and Joyce Perry

Cast

Quint Munroe - David
McCallum
Beth Scott - Suzanne Neve
Air Commodore Hufford -
Charles Gray
Squadron Leader Scott - David
Buck
Flt. Lieut Douglas Shelton -
David Dundas
Wing Commander Clyde-
Penrose - Dinsdale Landsen
Flt. Sgt. Wiley Bunce - Nicky
Henson
Sqn. Ldr Neale - Bryan Marshall
Father Bellague - Michael
Anthony
Mrs Scott - Peggy Thorpe-Bates
Mr Scott - Peter Copley
Lieutenant Schack - Vladek
Sheybal
Flt. Lieutenant Bannister -
Michael McGovern
Major Kemble - Robert Urquhart

Production Staff

Producer: Lewis J. Rachmil
Music: Frank Cordell
Cinematography: Paul Beeson
Film Editor: John S. Smith
Casting: Irene Howard

Art Director: Bill Andrews
Make-up Artist: Benny Royston
Production Manager: Victor Peck

Second Unit

Assistant Director: Anthony
Waye
Second Assistant Director: Chris
Kenny

Art Department

Set Dresser: John Jarvis

Sound Department

Sound Recordist: Norman
Bolland
Sound Editor: Bill Creed

Special Effects

Les Bowie
Kit West
Brian Johnson

Stunts

Stuntman: Joe Powell

Camera and Electrical Department

Aerial Photography: Stanley W.
Sayer
Camera Operator: John Winbolt

Music

Composer & Conductor: Frank
Cordell

Other Crew

Continuity: Doreen Soan
Aerial Advisor: Air Commodore
Allen Wheeler
Unit Publicist: Alan Arnold

List of Mosquitoes used in *Mosquito Squadron* (1970) and current status where known

Serial	Type	Film Code	Supplied by	Status (1968)	Status (Current)
RS712	B.35	HT-F	T.G. Mahaddie	Airworthy	Static; on loan to EAA, Oshkosh; Owner Kermit Weeks; May be restored to fly
RR299	T.3	HT-E	Hawker- Siddeley	Airworthy	Destroyed in crash, July 1996
RS709	B.35	HT-D	Skyfame Museum	Airworthy	Static; Museum of the USAF, Dayton, Ohio
TA634	B.35	?	Liverpool Corporation	Airworthy	Static; D.H. Aircraft Heritage Centre, London Colney
TA719	B.35	HT-G	Skyfame Museum	Static	Static; IWM, Duxford
TJ118	B.35	-	MGM Studios	Cockpit Scenes	D.H. Aircraft Heritage Centre, London Colney

Other Aircraft used in *Mosquito Squadron*

Type	Serial	Role (1968)	Current status
Avro Shackleton MR. 3	WR972	Camera Plane	Presumed scrapped
Avro Anson XIX	?	Taxying	Scrapped
Avro Anson XIX	?	Taxying	Scrapped

Raid on Entebbe
(1977)

R*aid on Entebbe* may seem an odd choice for inclusion in this book, because it is not a film that is widely known. Furthermore, like *Midway* (re-titled *The Battle of Midway* for UK release) it was originally produced in 1976 as a TV movie for American television, though it received a theatrical release in the UK and Europe in early 1977.

Nonetheless, I would argue that it was the best of the three films that were made about 'Operation Thunderbolt': a hostage rescue mission carried out by the Israeli Defence Forces (IDF) on 4 July 1976. This operation (later re-titled 'Operation Jonathan' in memory of the commander of the Israeli troops involved in the assault) and its various cinematic and documentary recreations had an impact on Western Governments' policies that cannot be underestimated. It is very likely that 'Operation Desert Claw' (the US military's unsuccessful attempt to rescue American hostages in Iran in April 1980), the failure of which ultimately led to the downfall of President Jimmy Carter, was heavily influenced by the Entebbe raid. Had the American operation succeeded then it is likely that Carter (rather than Ronald Reagan) would have been re-elected President in 1980 on a wave of public euphoria, and history might have been changed.

'Operation Mikado', a mission to land SAS troopers on an Argentine air base during the 1982 Falklands War, may

also have been influenced by the Entebbe raid. The plan, which involved two RAF Lockheed C-130 Hercules aircraft (the same type used by the Israelis at Entebbe),would have resulted in the destruction of Argentina's Dassault Super Etendard strike planes, the killing of their pilots, and the blowing up of all their remaining air-launched Exocet missiles. The operation was scrapped after a reconnaissance mission in a Sea King helicopter prior to the raid ('Operation Plum Duff') was compromised.

Prior to 'Operation Thunderbolt', the standard response of Western Governments to terrorist hijackings was to give in to whatever demands had been made, resulting (in the long-term) in further hijackings. Israel, though, has always had a zero-tolerance policy towards terrorism and was the first nation to introduce plain clothed armed guards (or 'sky marshals' as they are now known) on civilian airliners. This, combined with tight security on the ground, eventually made the seizure of an Israeli airliner an impossibility. No Israeli airliner has been hijacked since 1968.

Other nations slowly copied some of Israel's ideas on airline security, most of which are now in place, and had they been fully implemented by the USA in 2001 then the 9/11 terrorist attacks would have been thwarted and the world would now be a different place.

Back in 1976, however, airline security outwith Israel was very lax, and it was especially poor at Athens when on 27 June four terrorists (two German and two Palestinian) boarded an Air France Airbus A300 with 248 passengers which had stopped on its way from Tel Aviv to Paris. Security at Athens was notoriously bad, and it was particularly so in late June 1976 as the security men were on strike. It was said that you could haul an artillery piece onto

an airliner at Athens airport without anyone noticing. Using concealed weapons, the four terrorists swiftly took over the airliner and forced it to divert to Entebbe, Uganda after a brief stopover in Benghazi in Libya. The Ugandan Government supported the hijackers and the President Idi Amin personally welcomed them.

After transferring all the hostages to the old, disused terminal building, the hijackers (now seven in number) identified all the Israelis from their passports and forced them into a separate room. Over the following two days, 148 non-Israeli hostages were released and flown to Paris. Some 94 passengers, mainly Israelis, along with the 12-member Air France crew, remained at Entebbe Airport and were threatened with death.

The hijackers warned that they would kill the hostages if their demands were not met. These included the freeing of 40 Palestinian militants imprisoned in Israel, and 13 prisoners in four other countries, in exchange for the hostages.

The Israeli government continued to negotiate with the terrorists and Idi Amin while they prepared a military solution. This involved four Lockheed C-130 Hercules aircraft flying 100 commandos over 2500 miles to reach Uganda. As even the long-range C-130 could not fly this distance and back without refuelling, tentative plans were made to refuel the Hercules at Entebbe using the Ugandans' fuel supplies and pumps brought by the Israeli force. As this would have entailed more time on the ground (and a greater risk to the aircraft), a deal was agreed with the Kenyan government whereby the Israeli strike force could refuel at Nairobi after carrying out the mission before returning to Israel via Sharm-El-Sheikh in the Sinai peninsula, which at that time was part of Israeli territory (The Sinai was eventually handed back to

Egypt as part of the peace process and Sharm-El-Sheikh is now a popular Egyptian holiday resort).

On 4 July during the hours of darkness, shortly before the deadline for negotiations expired, the first two Hercules landed at Entebbe. The initial strike force travelled towards the old terminal building – where the hostages were being held – in a black Mercedes limousine and two Land Rovers, thus simulating the appearance of General Amin making a surprise visit to his troops. The only Mercedes limousine the IDF could acquire at such short notice was an old white one which was in poor mechanical condition. It was hastily repaired and painted black using a roller. Ironically, Amin had recently started using a white Mercedes limousine though the Israelis did not know this at the time.

Almost complete surprise was achieved, and a battle ensued in which all seven terrorists were killed. 45 Ugandan soldiers who attempted to resist the Israeli troops also died, as did three of the hostages. A fourth hostage, Mrs Dora Bloch (who had been taken to hospital earlier following a choking episode), was subsequently murdered by Idi Amin's forces. The leader of the raid – Yoni Netanyahu, brother of future Israeli Prime Minister Benjamin Netanyahu – was killed by a Ugandan soldier, and five Israeli commandos were wounded.

The remaining 102 hostages were flown out of Entebbe as quickly as possible, while the Israeli troops stayed a little longer to destroy the 30 Soviet-made MiG-17s and MiG-21s of the Ugandan Air Force which were sitting on the ground and could have pursued and shot down the four Hercules. Within an hour of arriving on the ground at Entebbe, the operation was over and all the aircraft were on their way back to Israel via Nairobi and Sharm-El-Sheikh.

The reaction of the international community was mixed. Predictably the Soviet Union and Arab countries condemned the raid. Switzerland and West Germany praised the operation, with the latter saying that it had been carried out 'in self-defence'. The British government said that it was 'very pleased' with the outcome of the raid, but stopped short of issuing outright congratulations to Israel in case this offended Arab nations. Henry Kissinger, the US Secretary of State, berated Israel for using US equipment in the operation, which he said was a breach of the end user agreement. However, he privately congratulated the Israelis on their magnificent military achievement.

Soon after the raid, a series of newspaper and magazine articles appeared giving further details – though these were sometimes quite inaccurate. The mission was also the subject of several books, the most recent of which, *Operation Thunderbolt* by Saul David, was published in 2015.

Unsurprisingly, several Jewish film producers in the United States saw the opportunity to make a film about the raid. The first of these – *Victory at Entebbe,* which aired on American TV in late 1976 – was a truly dreadful studio-bound production. Though blessed with a stellar cast which included such luminaries as Kirk Douglas, Burt Lancaster, Richard Dreyfuss, Elizabeth Taylor and Anthony Hopkins, it had poor production values, making it seem like an Ed Wood film. It was made entirely on 525-line NTSC videotape, which was then transferred to film for European theatrical release. (NTSC, by the way, stands for 'National Television System Committee', and its colour process dates back to 1953 although cynics – aware of the poor technical quality of this system – have suggested that it really stands for 'Never Twice the Same Colour'.)

Victory at Entebbe was released as a theatrical feature in the UK in December 1976, and I remember seeing it with my parents at the Glasgow Odeon multi-screen cinema in Renfield Street. One thing that struck me at the time was the almost complete lack of action in the film. Stock footage of a USAF Hercules in flight (complete with highly visible American markings) was used to depict the Israeli strike force on its way to Entebbe, and the hostage rescue was over in seconds.

A few months after the theatrical release of *Victory at Entebbe*, an even longer (and consequently more tedious) version cropped up on British television. By this time a far more exciting and action-packed recounting of the mission had been made: namely *Raid on Entebbe*, which was shown in British cinemas in early 1977. Aware of the soporific nature of its dreary predecessor, the distributors advertised this film as 'The Action Entebbe Film', complete with posters depicting Charles Bronson blazing away with a machine gun against a background of fiery explosions.

Directed by Irvin Kershner, who was later to achieve fame for helming *The Empire Strikes Back* (1980), the second film in the *Star Wars* series, and *Never Say Never Again* (1983) which featured Sean Connery's final appearance as James Bond, *Raid on Entebbe* had a far more gritty and realistic feel than *Victory at Entebbe*. Kershner's production was made entirely on film using real locations, genuine aircraft interiors and naturalistic lighting.

In order to achieve the necessary realism, producers Edgar J. Sherick and Daniel H. Blatt turned to the 146th Tactical Air Wing (TAW) of the California Air Guard who had assisted in the making of many Hollywood aviation films and were sometimes referred to as the 'Hollywood Squadron'.

While the 146th TAW Van Nuys Airport facility doubled for the Israeli C-130 base, Stockton Airport in Northern California was transformed into Entebbe Airport. As it happened, the terminal building and control tower at Stockton closely resembled the old terminal at Entebbe.

The 146th TAW provided a number of Lockheed C-130E Hercules (the same type used on the raid), and these were turned into 'Israeli' aircraft by applying self-adhesive vinyl decals with blue and white Israeli Air Force 'Star of David' roundels over the existing USAF markings. No repainting of any of the aircraft was considered necessary, as the standard camouflage scheme of USAF C-130Es was similar to that used by the Israelis. Several Hercules appear as background set dressing in the Israeli air base scenes, while two of them were flown to Stockton Airport which was doubling as Entebbe.

The 146th TAW also supplied all the military vehicles used in the film which included Ford M151 'Mutt' jeeps, some of which carried M40 106mm recoilless rifles (anti-tank guns) and others the famous M2 'Ma Deuce' Browning 0.50 inch calibre machine gun. The Ford M151 was produced between 1959 and 1982. It was used extensively by the US Army until being replaced by the well-known 'Humvee' (High Mobility vehicle) in the 1980s. The 146th TAW also supplied several M113 armoured personnel carriers (APCs), some of which had mounted M40 guns. The M113 had been manufactured in the USA since 1960 and was one of the earliest APCs to have lightweight aluminium armour, making it transportable by air.

Filming took place in California in November 1976, with an all-star cast which included Peter Finch as Yitzhak Rabin the Israeli Prime Minister, Charles Bronson as General Dan Shomron, Jack Warden as General Mordecai Gur, John

Saxon as General Benny Peled, Stephen Macht as Yoni Netanyahu, and a young James Woods as Sammi Berg. The best performance in the film was probably that which was given by Yaphet Kotto, who perfectly captured Idi Amin's paranoia and egotism. Kotto is probably best known for playing the role of Dr Kananga ('Mr Big') in the 1973 James Bond film *Live and Let Die*.

Raid on Entebbe was the last film Peter Finch made, and he died on 14 January 1977 – just a few weeks after filming concluded. In March that year he would win a posthumous Oscar for his role of unbalanced news anchor Howard Beale in Sydney Lumet's film *Network*.

The first hour of *Raid on Entebbe* deals with the events leading up to the hostage rescue mission, and although there is little action there is a sense of mounting tension – helped no end by David Shire's excellent musical score. The second half of the film is much more action-packed, and deals with the preparations for the raid and its execution.

The film correctly depicts the Israeli commandos practising their assault using a mock-up of the old terminal building at Entebbe. This is entirely accurate, as the new terminal at Entebbe Airport had been built by an Israeli construction company, Solel Boneh, and IDF (Israeli Defence Forces) personnel obtained copies of the plans of the entire airport from them.

A few minor inaccuracies occur at this point in the film. The uniforms worn by the troops are similar to – but not identical to – the ones actually worn during the raid. Also, in the film the Israeli commandos are armed exclusively with Israeli-made Uzi submachine guns. The Uzi was created by Major Uziel Gal, and first saw service with the IDF in 1950. It was widely exported, making it the most successful sub-

machine gun in history. Several variants were made, including the smaller mini-Uzi and the tiny micro-Uzi.

In reality, most of the soldiers who took part in the mission chose to use captured Soviet-made AK-47 Kalashnikov rifles, because they liked them and they were very reliable. Like the Germans in WW2, the Israelis have never been shy about using captured equipment – even to the extent of fielding an improved version of the Soviet T-55 tank (the Tiran 5) which was fitted with the excellent British L7 105mm tank gun (as fitted to later versions of the Centurion tank) instead of the original 122mm weapon.

In recent years, military experts have suggested that the Israeli soldiers who took part in 'Operation Thunderbolt' would have been better off with Uzis, since a sub-machine gun is a more effective weapon for close-quarter combat. The British SAS uses the Heckler and Koch MP5 sub-machine guns for anti-terrorist operations, as does the German GSG-9 unit.

Another error in the film concerns vehicles. As previously mentioned, the Israeli forces in the film use Ford M151 'Mutt' Jeeps, when in reality the earlier M38 Jeeps were used plus two Land Rovers. There is some controversy though over what light armour was taken to Entebbe. Accounts published soon after the mission claim that WW2 vintage M3 half-tracks were used; other sources say that tracked M113 armoured personnel carriers (APCs) were employed, while some military experts have suggested that captured Soviet-made BTRs (wheeled APCs) were used, either the BTR-40 or the larger BTR-152.

Another highlight of the second half of the film is the splendidly choreographed sequence in which the Israeli Hercules are loaded with troops, jeeps and APCs prior to

their mission, to the accompaniment of David Shire's exciting score (which one critic described as 'Jewish Action Music').

Another minor technical error occurs at this point. On the real mission, two Boeing 707s were used. One was equipped as a casevac (casualty evacuation) aircraft with operating facilities, while a second was an airborne command post which remained aloft during the mission. As no 707 was available for filming, a Douglas DC-8 was used instead. The DC-8 has a similar configuration to the 707, as it has swept back wings and four underwing jet engines mounted on pods. Compared with a 707, though, it has a longer fuselage and a rounder, more bulbous nose compared with the more pointed one on a 707 (though only an aircraft enthusiast would have noticed this!). At one point in this scene, General Dan Shomron (Charles Bronson) drives past the DC-8 in his jeep and the tail number N8207U is visible, revealing that it is a US civil aircraft rather than an Israeli military plane.

The next highlight of the film is the scene where the Israeli troops assault the terminal building and kill the terrorists using their Uzi submachine guns and grenades. Nowadays SAS troopers would wear special black clothing and respirators and carry stun grenades for such an operation, but such equipment was not available to the Israeli forces in 1976.

All the terrorists are killed. In the actual operation they were also photographed and fingerprinted, though this is not depicted in the film. As the hostages are led out to the waiting Hercules, a Ugandan soldier opens fire from the balcony of the control tower, fatally wounding Yoni. General Dan Shomron (Charles Bronson) hears the shooting and orders his Jeep driver to go to the control tower as quickly as possible where the lone Ugandan sniper is despatched with a

well-aimed round from the vehicle's M40 recoilless gun. In the actual raid, the Israeli commandos didn't have any M40s and used Soviet-made RPG-7 rocket grenades to take out the control tower.

With the hostages now on their way home, General Dan Shomron orders his men to destroy the Ugandan Air Force's MiG fighters. This is one of the most spectacular scenes in the film, as the Israeli troops in M113 APCs and M151 jeeps use their 0.50 calibre machine guns and M40 recoilless weapons to take out the MiGS in a series of spectacular explosions.

The ten 'MiGs' were actually half-scale replicas of North American F-86 Sabres, one of the earliest American jet fighters, which proved highly successful in the Korean War. Sabre replicas rather than models of MiGs were used because it had originally been planned to feature a genuine F-86 in some taxying scenes. Because of poor weather at the time of filming, the F-86 couldn't fly over from its usual base but one genuine non-flying FJ Fury (the US Navy's version of the F-86), which happened to be at Stockton Airport, was hastily painted in Ugandan markings to appear in some shots though it wasn't blown up.

Raid on Entebbe was well received, and even won an Emmy (the TV equivalent of an Oscar) for its cinematographer Bill Butler, with an Emmy nomination for director Irvin Kershner and stars Peter Finch, Martin Balsam and Yaphet Kotto. But it wasn't the last film to be made about 'Operation Thunderbolt'.

Victory at Entebbe and *Raid on Entebbe* had been made as TV movies, but a more spectacular recounting of the tale with a much larger budget was planned. Hollywood star Steve McQueen was mentioned as one of the possible stars,

but the project collapsed. At this point, the Israelis took over production, with Menahem Golan as director and co-producer, Yoram Globus as the other producer, and Ken Globus as scriptwriter. This was the beginning of the Golan/Globus partnership that later bought Cannon Films to become the 'Cannon Group', which made a huge number of films in the 1980s including several with Charles Bronson or Chuck Norris in the lead. At one point the Cannon Group also owned 1,600 cinemas in Europe and the USA.

Golan and Globus aimed for a documentary feel to the production and, with this in mind, several of the real players involved in the 1976 crisis appear as themselves including former Defence Minister General Moshe Dayan, well-known Israeli diplomat Abba Eban, Defence Minister Shimon Peres, and Israeli Prime Minister Yitzhak Rabin. General Dayan's son Assi (Assaf) Dayan appears as a soldier called 'Shuki'.

No expense was spared in this production, and a full-scale outdoor set of the Entebbe control tower and old terminal building was created in Israel. Also, the MiG fighters (presumably replicas or perhaps even genuine aircraft captured by the Israelis) look like the real thing. However, production of this film took longer than expected and questions were asked in the Israeli parliament (the Knesset) about the allocation of troops and equipment to the production. The film did not receive a theatrical release in the UK until 1978. Although originally shot in Hebrew, an English language version was made available for release in the UK and USA.

Despite receiving much acclaim, the general consensus among critics at the time (and subsequently) was that it was inferior to *Raid on Entebbe*. Although *Operation Thunderbolt* was clearly the most accurate of the three

Entebbe raid films – particularly as regards vehicles, aircraft, weapons and uniforms – there was a noticeable lack of tension in the movie. The musical score in particular had an 'art house movie' feel to it, which didn't help the correct mood to be achieved. Although realised mainly with conventional instruments, at times the score lapsed into a series of electronic tonalities making it seem a bit like Malcolm Clarke's 'experimental' score for the 1972 *Doctor Who* story *The Sea Devils*. *Operation Thunderbolt* also appeared too late to make an impact, as by the time it was released many people had forgotten about the Entebbe raid.

In 1986 Golan and Globus returned to the subject of Middle East terrorism and possible military solutions with the action-packed blockbuster *The Delta Force* starring Chuck Norris and Lee Marvin (in his last screen role), which was filmed in Israel with the assistance of the IDF.

The Delta Force opens with a reconstruction of the tragic events in the Iranian desert on 25 April 1980, when the US military had to abort a proposed mission ('Operation Eagle Claw') to rescue American hostages who were being held in Tehran. After several Sikorsky RH-53 Sea Stallion helicopters developed engine problems from flying hundreds of miles in sandy conditions, the mission commander chose to pull out. At this point, a taxying Lockheed Hercules struck one of the helicopters causing a huge fireball which soon engulfed both aircraft.

The film starts with a shot of one of the RH-53s exploding. Major Scott McCoy (Chuck Norris) bravely risks his own life to rescue an injured soldier from the blazing fuselage of the chopper, against the orders of his commanding officer Colonel Nick Alexander (Lee Marvin). The Delta Force assault team then leaves the scene in two Hercules

aircraft, fitted with rockets to give them a shorter take off run, as McCoy vows to resign his commission.

The producers of *The Delta Force*, Menachem Golan and Yoram Globus, had originally intended the entire film to be a retelling of 'Operation Eagle Claw', rewritten to show what would have happened if the mission had been accomplished successfully. Colonel Charles Beckwith – who was on the real mission and was advising the producers – promptly resigned in protest, so Golan and Globus came up with a new plan: they would base the plot of *The Delta Force* on the real-life hijacking of TWA Flight 847 in June 1985, but with a different resolution in which all the hijackers are killed and every hostage rescued.

There are many connections between the films *The Delta Force*, *Operation Thunderbolt* and *Raid on Entebbe*. *Operation Thunderbolt's* opening title sequence depicts Israeli commandos practising an assault on a hijacked airliner, which starts with them hiding in baggage containers being towed by a tractor so as to approach the target unobserved. This scene is recreated with American soldiers in *The Delta Force*.

Charles Bronson, who played General Dan Shomron in *Raid on Entebbe*, was the first choice to portray Colonel Alexander. He turned the role down, and Lee Marvin played the part instead. Martin Balsam plays a Jewish hostage in both *Raid on Entebbe* and *The Delta Force*.

Israeli actor Assi (Assaf) Dayan appears in both *Operation Thunderbolt* and *The Delta Force*. In the former film, he plays an Israeli commando called 'Shuki'. In the latter his character is called 'Raffi Amir', but he looks exactly the same in both productions and one wonders if he was actually playing the same person. In *Raid on Entebbe*, US Hercules are turned into Israeli aircraft using self-adhesive vinyl decals. In

The Delta Force, Israeli C-130s are transformed into American planes using the same method.

The Delta Force is best remembered for its spectacular stunts and rousing musical score by Alan Silvestri. It did well enough at the box office to spawn two sequels. These were both rather forgettable, though *Delta Force 2* features a 'falling out of an aircraft without a parachute' sequence reminiscent of the pre-titles sequence in the 1979 James Bond film *Moonraker*.

So taking into account *The Delta Force* and its two sequels, it can be seen that the Entebbe raid in July 1976 spawned six films, three of which were direct retellings of the story and the rest at the very least inspired by the events of 1976. *Raid on Entebbe*, though, in my opinion remains the best of all the films about this historical event.

Operation Eagle Claw

'Operation Eagle Claw' was the name given to an unsuccessful mission to rescue 52 Americans held hostage in the US Embassy in Tehran in 1980. The plan was similar to 'Operation Thunderbolt', as it involved the use of Lockheed C-130 Hercules transports and the temporary capture of an Iranian air base. Unfortunately the mission failed, as just about everything that could go wrong did so. As Field Marshal Helmuth von Moltke once said, 'no battle plan ever survives contact with the enemy'.

On 1 April, three weeks before the mission, Major John T. Carney Jr flew in a Twin Otter aircraft to a disused desert airstrip in the Iranian desert (dubbed Desert One), which was to be used as a base for the American operation. Major Carney was not detected, and successfully placed a number of remotely operated infra-red lights and a strobe light

on the ground as well as taking soil samples to determine the load-bearing properties of the desert surface.

The rescue plan was much more complicated than 'Operation Thunderbolt', and was very risky. On the first night, six Lockheed C-130 Hercules carrying Delta Force soldiers and 6,000 gallons of jet fuel in collapsible bladders would arrive at Desert One, followed by eight long-range Sikorsky RH-53 Sea Stallion helicopters which had flown from the aircraft carrier USS *Nimitz*. The plan was for the RH-53s to refuel and then fly the Delta Force troops to a second location – Desert One – which was close to Tehran.

The plan also involved the capture of Manzariyeh Air Base near Tehran by a force of Army Rangers, which could then be used to fly the hostages home in Lockheed C-141 Starlifter jet transports once they had been released from captivity. They would be flown from the US Embassy to the airbase by helicopter.

Unfortunately, things started to go wrong with the mission almost from the start. An Iranian fuel truck arrived at Desert One and was engaged by US soldiers using shoulder-launched missiles. The truck exploded, and the resulting blaze lit up the desert. Then a bus filled with Iranian civilians appeared and the passengers had to be detained.

Only five of the eight RH-53s made it to Desert One because of the effects of mechanical failure and sandstorms. At this point, the mission commander Colonel Charles Beckwith chose to abort the mission and received Presidential approval for this decision via satellite phone.

One of the RH-53s had to be moved (by hovering around one of the Hercules) in order to refuel, and as it was doing so the pilot became disorientated by the sand that was being whipped up by the downdraught of his rotor blades.

His helicopter collided with the C-130, which was loaded with jet fuel. There was a huge fireball which consumed both aircraft, and eight servicemen died. The pilot and co-pilot both survived, but were badly burned. The Americans staged a quick evacuation, but had to leave behind five of the RH-53 helicopters – two of which now serve with the Iranian navy.

After the raid, the Iranians scattered the hostages to different locations throughout Iran making future rescue attempts impossible. The political fallout was considerable, as the botched rescue mission is widely believed to have led to Jimmy Carter's failure to be re-elected later that year. As if to rub it in, the Iranians did not release all the hostages till after the new President, Ronald Reagan, took over in November 1981.

'Operation Eagle Claw' was a high-risk mission which had little chance of succeeding. Indeed, it featured in one episode of *Great Military Blunders* which was broadcast by Channel 4 in 2000.

Rather like 'Operation Market Garden', the ill-fated attempt to capture several key bridges in Holland in September 1944, the whole plan was based on the assumption that there would be little or no resistance from the opposition, and even if the fatal collision between two aircraft in the Iranian desert had not happened it is likely that the plan would have unravelled sooner or later.

Operation Mikado

'Operation Mikado' was a proposed assault on Rio Grande Air Base in Terra Del Fuego during the 1982 Falklands War. The plan was for two C-130 RAF Hercules – carrying 55 SAS troopers equipped with four 'Pink Panther' Land Rovers and two Triumph motorcycles – to land at night on the airfield.

The soldiers would quickly destroy the five Dassault Super Etendard strike aircraft on the airstrip, the only planes Argentina possessed which could carry the air-launched AM39 version of the French Exocet sea-skimming anti-ship missile. They would then blow up the three remaining Exocets and kill all the Etendard pilots. The plan was approved by Brigadier Peter De La Billiere, then Director of the SAS, who later achieved fame as the commander of British forces during the 1991 Gulf War.

At this point in the war, Argentina had used up two of its five air-launched Exocets in the successful attack on HMS *Sheffield* on 4 May. The three Exocets which remained were a potent threat to the British task force, particularly as most of the British warships (and none of the Royal Fleet Auxiliaries and merchant vessels) lacked a close-in weapon system (CIWS) which could destroy incoming missiles. Two of the warships, HMS *Brilliant* and HMS *Broadsword* – both Type 22 frigates – carried the British Aerospace Seawolf point defence missile system. This system – in theory, at least – could shoot down an Exocet, but most of the British Task Force lacked any kind of anti-missile weaponry such as the American Vulcan Phalanx 20mm CIWS or the Dutch 30mm Goalkeeper system which is now standard equipment on current Royal Navy vessels.

The Hercules were to sit on the runway with engines running during the mission, and if they survived they were to transport the SAS troopers to the Chilean air force base at Punta Arenas. If the Hercules were damaged or destroyed by Argentine fire, the aircrew and SAS soldiers were to hike to the Chilean border 50 miles away after they had completed their mission.

'Operation Mikado' was preceded by a reconnaissance mission – 'Operation Plum Duff' – on the night of 17/18 May. The plan was for a Westland Sea King from HMS *Invincible* to transport a small SAS team to Tierra Del Fuego, where they could set up an observation post. Unfortunately, the helicopter had to make a detour to avoid an Argentine drilling rig. The helicopter pilot then became disorientated in poor visibility, a decision was made to abort the mission, and the Sea King landed in Chilean territory where it was set alight and abandoned. The SAS troopers and helicopter crew subsequently surrendered to the Chilean authorities and were eventually returned to the UK. However, it was clear that 'Operation Mikado' was now unfeasible and a decision was made to cancel the mission. Had it gone ahead and achieved its objectives then the sinking of the *Atlantic Conveyor* on 25 May could have been prevented. This vessel was carrying a huge number of stores for the Task Force including several helicopters, food, tents, ammunition and crucial spare parts for the Army's Rapier surface-to-air missile system.

In his book *Watching Men Burn*, Rapier operator Tony McNally claims that the malfunction of his missile system at Bluff Cove on 8 June, caused by a lack of replacement parts, was a key factor in the loss of the RFA landing ships *Sir Tristram* and *Sir Galahad*. Had his Rapier missile launcher worked as advertised, claims McNally, then at least one of the attacking Argentine A-4 Skyhawks could have been shot down, possibly preventing the carnage that ensued which included the deaths of 48 soldiers plus two crew of the *Sir Tristram*.

It is unlikely, though, that 'Operation Mikado' would have succeeded since – like 'Operation Desert Claw' – it was based on the assumption that there would be little or no

response from the enemy. After the compromised Sea King mission, the Argentines would have expected an attack on their airfields, which were well-defended and had good radar cover. Also, the SAS was first created in the Western Desert in 1941 by Colonel David Stirling specifically to destroy Axis aircraft on the ground, so this was a *modus operandi* which the Argentine forces would have been familiar with.

Rio Grande Air Base was well defended by good quality troops, whose weapons included four modern radar-controlled 20mm Rheinmetall anti-aircraft guns which had a rate of fire of 2,000 rounds per minute. Even if the Hercules had managed to avoid being shot down as they came in to land, they would probably have been riddled with bullets before the SAS troopers had time to disembark from their aircraft.

Had it succeeded, 'Operation Mikado' would have saved many British lives and made the recapture of the Falkland Islands easier. But it is likely that, had it gone ahead, it would have failed and might even have become a suicide mission for those involved.

The Lockheed C-130 Hercules: the real star of *Raid on Entebbe*

'Operation Thunderbolt' could never have been executed without the amazing Lockheed C-130 Hercules. During the Korean War (1950-53), it was clear that the WW2 vintage transport aircraft then in service were not suitable for the demands of modern warfare. Several manufacturers were asked to come up with designs for a large transport aircraft with a rear ramp to aid loading.

Lockheed's design was chosen by the US military, and the first examples entered service in December 1956. More

than 60 years later, the type is still being manufactured; over 2,500 having been built, making it the longest production run of any aircraft in history.

Many specialist variants of the C-130 were produced, including the AC-130 gunship variant which originally mounted two 20mm Vulcan fast firing cannon, a 40mm Bofors gun and a 105mm howitzer.

One reason for the success of the C-130 was the choice of engines: four Allison T56 turboprops. The contemporary RAF transport aircraft, the Blackburn Beverley, had four Bristol Centaurus piston engines and a fixed undercarriage giving it limited performance and a short service life. The RAF soon scrapped its Beverleys and replaced them with the Hercules from 1965 onwards. One of these RAF C-130s appeared as UNIT's mobile HQ in the classic 1968 *Doctor Who* story *The Invasion*, though the studio set of the interior didn't look much like the inside of a Hercules!

Raid on Entebbe (1977)
Technical Credits

Director: Irving Kershner
Screenplay: Barry Beckerman

Cast

Yitzhak Rabin - Peter Finch
Brigadier General Dan Shomron
- Charles Bronson
President Idi Amin - Yaphet
Kotto
Daniel Cooper - Martin Balsam
Wifred Boese - Horst Buchholz
General Benny Peled - John
Saxon
General Mordecai Gur - Jack
Warden
Dora Bloch - Sylvia Sidney
Yigai Allon - Robert Loggia
Shimon Peres - Tige Andrews
Captain Becaud - Eddie
Constantine
Menachem Begin - David
Opatoshu
Eli Melnick - Allan Arbus
Lt Colonel 'Yonni' Netanyahu -
Stephen Macht
Captain Sammy Berg - James
Woods
Mr Harvey - Harvey Lembeck
Rachel Sager - Dinah Manoff
Alice - Kim Richards
Major David Grut - Aharon Ipale
Gad Yaakobi - Warren J.
Kemmerling
Gabrielle Krieger - Mariclare
Costello

Mr Sager - Robin Gammell
Chaim Bar-Lev - Lou Gilbert
Mr Goldblaum - Billy Sands
Mrs Loeb - Pearl Shear
Terrorist - Alex Colon
Mrs Sager - Millie Slavin
Terrorist - Rene Assa
Relative - Barbara Allyne Bennet
Mrs Berg - Anna Berger
Israel Gallili - Stanley Brock
Mr Scharf - Peter Brocco
Uri Rosen- Fred Cordoza
Julie Darin - Lauren Frost
Mr Berg - Larry Gelman
Nathan Darin - Bill Gerber
Meteorologist - Dov Gottesfeld
Mrs Gordon - Hanna Hertelendy
Mrs Bennett - Harlee McBride
Air France Stewardess - Toian
Matchinga
Chaim Zadok - George Petrie
Delegation Member - Louis
Quinn
Amos Eran - Tom Rosqui
Jonathan Sager - Steve Shaw
Delegation Member - Martin
Speer
Air France Stewardess - Cynthia
Brian
Italian Passenger - Vincent De
Paolo
Israeli Soldier - John Eggett
Passenger - Luther Fear
Man at Airport - Martin Garner

Israeli Soldier - Robert Leh
Mr Haskell - Alan Oppenheimer
Israeli Soldier - Robert Shepherd
Israeli Soldier - Rex Steven Sikes
Airbus Navigator - Bruce A
Simon
French President Valery Giscard
d'Estaing - Robert Til

Production Crew
Producers: Daniel H. Blatt and
Edgar J. Scherick
Associate Producer: Robin S.
Clark
Original Score: David Shire
Director of Photography: Bill
Butler
Film Editing: Nick Archer, Bud
S. Isaacs and Art Seid

Production Design: W. Stewart
Campbell
Art Direction: Kirk Axtel
Set Decoration: Fred Price
Costume Design: Patty Woodard
Make-up Artist: Jack Petty
Hair Stylist: Jan Van Uchelen
Production Manager: Robin S.
Clark
Post-Production Supervisor:
Cleve Landsberg
Production Manager (Second
Unit): R.J. Louis
First Assistant Director: Mack
Harding
Second Unit Directors: Bud S.
Isaacs and Max Kleven
Property Masters: Bill Hudson
and Matt Springman

Memphis Belle
(1990)

M<i>emphis Belle</i> deserves inclusion in this book for a number of reasons. As well as being a thrilling film in its own right – and one of my personal favourites – it remains the last big WW2 aviation movie to have been made in the UK. At the time of writing (2016), 27 years have passed since the film was shot but nothing comparable has been produced in Britain since, with Peter Jackson's proposed remake of *The Dambusters* likely to be filmed mainly in New Zealand.

In addition, *Memphis Belle* is the last aviation film to be created using what might be described as traditional methods – namely real aircraft, radio-controlled models, studio miniatures and blue-screen work. All the more recent air pictures have relied heavily on CGI which, in my personal opinion, has been to the detriment of the production. One has only to compare the 'look' of *Red Tails* (2014) with that of *Memphis Belle* to see what I mean. *Dark Blue World* (2001) – which is discussed in detail elsewhere in this book – is the only aviation film which, I believe, has successfully used CGI to make the flying sequences more realistic.

Memphis Belle was the brainchild of English film producer David Puttnam, who had overseen a number of successful British films in the 80s including the Oscar-winning *Chariots of Fire* (1981). Eventually Puttnam ended up as the chairman of Columbia Pictures in the USA in June 1986, but

was fired in September 1987 when he disagreed with the current Hollywood policy of making really dumb action pictures and pointless sequels which had the sole aim of making money.

Puttnam was particularly incensed by the jingoistic and gung-ho antics of the US Navy pilots in Tony Scott's *Top Gun* (1986), the movie which really propelled Tom Cruise's career into the stratosphere, and vowed to make an aerial war movie which portrayed true courage. Originally, Puttnam was interested in making a film about RAF Lancaster bomber crews in WW2 – perhaps even a film adaptation of Len Deighton's highly acclaimed 1970 novel *Bomber*. Unfortunately it soon became clear that a film about RAF bomber crews would be death at the US box office. American audiences simply aren't interested in British war movies, as shown by the failure of *Battle of Britain* (1969) which did extremely well in the UK, West Germany and the Commonwealth countries but flopped everywhere else. In order for a British war movie to be successful in the USA, it would have to feature Americans in the cast – as was the case with *633 Squadron* (1964) and *The Guns of Navarone* (1961). This was also the reason why William Goldman, the American screenwriter of Richard Attenborough's *A Bridge Too Far* (1977), was told to 'big up' the role of US airborne troops in 'Operation Market Garden' in order to ensure it was financially successful.

There were two other factors militating against a film version of *Bomber*. One was that the action took place at night (which would be harder to depict on screen), and the other was that there were only two airworthy Avro Lancasters in the world: B. Mk I PA474 with the RAF Battle of Britain Memorial Flight at Coningsby, Lincolnshire, and

Mk X FM213 which was owned by the Canadian Warplane Heritage at Hamilton, Ontario.

Taking all these factors into consideration, Puttnam decided that a film about a US Army Air Force (USAAF) bomber crew in WW2 was a more practical proposition which would be easier to fund and have a greater chance of success. After viewing William Wyler's classic colour wartime documentary *Memphis Belle* (1944), about the first B-17 bomber in the European theatre to complete 25 missions, Puttnam realised that it could be the basis for a film. It should be emphasised that the resulting 1990 movie was pure fiction, though based on fact. The crew of the *Memphis Belle* in the movie were totally different characters to the real airmen involved, and most of the events depicted in the film never happened. For example, the real *Memphis Belle's* last mission was to Lorient, France and not to Bremen as shown.

I first learned of the proposed film in August 1988 when I picked up a flyer at the annual 'Great Warbirds' air display at West Malling in Kent. The circular announced that *Sally B* (G-BEDF), the UK's only airworthy B-17, was to be used in a film produced by David Puttnam and filmed the following year. At that time the movie was to be called *Southern Belle* and the handout suggested it would be filmed at Duxford with the Imperial War Museum's non-flying B-17 *Mary Alice* also participating as a static aircraft.

At that time, the title of the new film was indeed going to be *Southern Belle* as it was thought this would lessen the chance of legal complications. However, checks by lawyers showed that were three real B-17s with this name serving with the US Eighth Air Force during the war, and about 100 veterans still alive who had flown in these aircraft. As all the surviving crew members of the original *Memphis Belle* had

read the script of the new film and given their approval, it was decided to re-name the movie *Memphis Belle*.

By this time William Wyler's daughter Catherine – herself a film producer who had worked with Puttnam at Columbia Pictures – had joined the movie as co-producer. Her uncle was David Tallichet, who was a USAAF bomber pilot during WW2 and owned one of the world's few remaining airworthy B-17s, N3703G.

The screenwriter for the new version of *Memphis Belle* was Monte Merrick, and the director was to be 31 year-old Michael Caton-Jones from Broxburn who had previously helmed the hit film *Scandal* (1989) about the affair between Government Minister John Profumo and Christine Keeler.

As with all aviation films made in the modern era, the biggest problem was finding suitable aircraft. The film company (Enigma Productions) found that there were only eleven airworthy B-17s left: eight in the USA, two in France, and one in the UK.

As most of the flyable B-17s were in the USA, it seemed logical to make the film there, but a survey by production designer Stuart Craig showed that there was not a single airfield in the whole of America that looked remotely like East Anglia in 1943. Craig then checked out several airfields in the UK, including Predannack and St Eval in Cornwall, but still couldn't find anywhere suitable. Duxford near Cambridge (used as the principal location for the 1969 film *Battle of Britain*) could be employed as a base for aerial filming and engineering support, but couldn't be used to depict a wartime USAAF airfield as there were now too many modern structures in the background such as the huge new 'superhangar' plus numerous large, out-of-period aircraft which would be hard to hide.

236

The actual location used in the original 1943 documentary, Bassingbourn, still existed but was now unsuitable for filming as it was being used as an Army barracks and the runways had been ripped up. Eventually an RAF guard at St Eval told Craig about the former RAF station at Binbrook in Lincolnshire, which had recently been vacated by the RAF. It had been used as a base for two of the last units operating English Electric Lightning fighters (5 and 11 Squadrons) and was still owned by the Ministry of Defence, operated on a care and maintenance basis. Craig viewed the airfield and realised it would be ideal. There was a modern control tower which was still used by the RAF, but this could be easily concealed and a period watch office built in its place. There were also some modern lighting towers which needed to be taken down, but once this had been done the airfield looked much the same as it did during the war with its period C-type hangars (like those at Bassingbourn) and Nissen huts.

With a location in England now chosen, Enigma Productions planned to use the trio of airworthy B-17s which existed in Europe and fly over three more from the States. The most prominent of these Fortresses was G-BEDF *Sally B*, owned by B-17 Preservation Ltd which had originally been operated on aerial survey work by a French organisation called the Institut Geographique Nationale (IGN) based at Creil airfield North of Paris, and had been bought by an organisation called Euroworld in 1975 before being brought to Duxford where it had remained airworthy ever since.

The two French B-17Gs were F-AZDX *Lucky Lady,* owned by Jean Sallis at La Ferte Alais – a former IGN aircraft – and F-BEAA *Chateau De Vernieuil,* which was still owned by the IGN and was a working aircraft. The

Imperial War Museum's static B-17G *Mary Alice* (formerly F-BDRS) had also come from the IGN. Although it did not appear in the film as originally planned, it provided some spare parts for the airworthy aircraft and the studio mock-up of a B-17 which was built at a cost of £420,000 and used for the filming of aircraft interiors at Pinewood Studios.

The script called for German fighters which could attack the B-17s. No genuine airworthy German Messerschmitt Me109s or Focke-Wulf 190s existed in 1989, so the producers used three ex-Spanish Air Force Hispano HA-1112 MıL Buchons (the same type used to depict Messerschmitt Bf109Es in the 1969 film *Battle of Britain*) to portray the Luftwaffe fighters. These same three aircraft, G-BOML, G-HUNN and D-EFHD – which in 1989 represented Europe's entire population of airworthy Buchons – had also appeared in London Weekend Television's mini-series *Piece of Cake* (1988), which had been filmed the previous year.

The screenplay also featured aerial battles between escorting Allied fighters and the Messerschmitts. The film's main technical advisor, Roger Freeman, told the producers that in May 1943 such aircraft would have been American P-47 Thunderbolts or RAF Spitfires. In 1989 there was only one airworthy P-47M Thunderbolt in Europe, owned by The Fighter Collection at Duxford. Furthermore, it was a late-war version with a 'low back' fuselage and bubble canopy, not the earlier 'razorback' version with a heavily framed canopy which would have been correct for the period. Several airworthy Mark V and Mark IX Spitfires would have been available for use in the production, but producers David Puttnam and Catherine Wyler vetoed the inclusion of Spitfires in the film on the grounds that this type of aircraft

was associated with the Battle of Britain and its participation might confuse audiences!

Thus the Allied escort fighters which appear in the film were all North American P-51D Mustangs with 'low back' fuselages and bubble canopies, a version which did not become operational till early 1945. Five of these Mustangs (N51JJ, G-BIXL, G-SUSY, G-HAEC and N167F) were painted in olive drab camouflage and markings representative of the 356th Fighter Squadron, 354th Fighter Group (the first unit to operate P-51B Mustangs), while two others (NL1051S and NL314BG) – which only appeared in the background in some shots – retained their original natural metal livery.

Although Enigma Productions originally intended to have a total of six airworthy B-17s in the film, only two were flown across the Atlantic to appear in the production as many American Fortress owners were unwilling to accept the fees that were offered for their participation. The aircraft involved were B-17F N17W, owned by Bob Richardson, and David Tallichet's B-17G N3703G.

The first B-17 to arrive at Duxford was David Tallichet's N3703G, which arrived on the afternoon of Friday 23 June 1989. It joined B-17 *Sally B,* which was resident at Duxford, and within a few days the two French Fortresses arrived as well. The fifth B-17, Bob Richardson's N17W, didn't get to Duxford till 29 June and arrived with only three out of four engines working. The faulty number 4 Wright Cyclone engine was replaced with a low-time spare engine which was removed from the Imperial War Museum's static B-17 *Mary Alice.* This engine incidentally had originally been fitted to the RAF Museum's B-17G N5237V when it had been ferried from the USA to the UK in 1983.

Prior to their arrival at Duxford, all the B-17s were resprayed at Southend in correct 1943 USAAF colours: namely olive drab on the upper surfaces and light grey underneath. All the Fortresses were authentically weathered by the art department, with the exception of F-BEAA which portrayed *Windy City*, supposedly a factory-fresh aircraft.

As four out of the five B-17s were the later 'G' models, they had to be converted into an accurate representation of the earlier 'F'. This work involved the removal of chin turrets and waist gun windows (as the 'F' model had open waist gun positions), and the replacement of the later Cheyenne tail turret with the earlier Stinger models which were custom-built in the UK by Autokraft especially for the film.

Twin 'cheek' 0.50cal guns were fitted in the noses of all the bombers, though none of them received weapons fitted in the nose perspex dome itself (as was usual in 'F' models) since this would have entailed drilling holes in the plexiglass blister, replacements for which were hard to find and very expensive.

Some of the B-17s were fitted with working 0.50cal Browning machine guns firing blank ammunition, and this caused problems during filming as the fuselage filled with smoke every time they were fired. *Sally B* had real 0.50s fitted in the waist, cheek, ball and tail positions, while David Tallichet's B-17 had guns installed in the cheek, waist and radio room positions. *Sally B* had a specially built remote controlled ball-turret installed with working guns, while Tallichet's aircraft had a genuine wartime manned ball turret which was not in full working order.

The principal camera platform for the production was B-25 Mitchell *Dolly* N1042B, which was supplied by 'Aces High' of North Weald and had a special camera nose. When this aircraft eventually became unserviceable due to engine

problems, a single-engined Grumman TBM-3 Avenger owned by the Old Flying Machine Company was used instead, with a camera installed in the rear gunner's position. For this role, the rear fuselage and tail were painted olive drab in case it appeared in shot. Some cameras were also installed in *Sally B* for certain shots.

The plan was for three weeks of aerial filming operating out of Duxford, after which the aircraft would relocate to Binbrook for another 21 days of location work. On 30 June, a minor mishap occurred during filming when the cowling of the number 1 engine of the French B-17 *Lady Luck* came off completely, striking the tailplane in the process. Unfortunately this incident was not captured on film by any of the cameras. On landing it was discovered that a whole engine cylinder had come away. Luckily the missing cowling was discovered by police near Stowmarket and returned.

A replacement engine was needed, however, and fortunately the French contingent had one at Binbrook. It was moved to Duxford and swiftly installed on *Lucky Lady*. Regrettably there were recurrent problems with the new engine, as it had been used as a mould master to produce replica engines for set dressing while at Binbrook. This had caused a small quantity of plaster to get into the oil system, which then required repeated flushings during the film schedule. The engine continued to give problems during the rest of the film.

The film opens with a caption which reads:

'In the summer of 1943 a fierce battle raged in the skies over Europe. Every day hundreds of young airmen faced death as they flew bombing raids deep into enemy territory. Fewer and fewer were coming back.'

There is no pre-credits sequence (as was virtually obligatory in the 60s and 70s), and the titles then begin – yellow lettering over footage of rolling clouds, filmed from the nose of the B-25 camera aircraft. Yellow titles were probably used to match the USAAF code letters on the aircraft and the *Memphis Belle* logo on the 'hero' aircraft.

The first scene proper then begins at an unspecified USAAF airfield somewhere in England. A yellow caption informs us that the date is May 16, 1943 (which coincidentally was the same date that the RAF's 617 Squadron set off on their 'dam-busting' raid).

B-17 *Memphis Belle* is being repaired and some of their crew play football in the warm sunshine while a voiceover by John Lithgow (who played Colonel Derringer in the film) tells us the names of the crew as they appear on screen. The crew include flight engineer and top turret gunner Sgt Virgil Hoogesteger, known as 'Virge' (Reed Diamond), waist gunners Sgts Jack Bocci (Neil Guintoli) and Eugene McVey (Courtney Gains), tail gunner Clay Busby (Harry Connick Junior in his first film role), and radio operator Danny 'Danny Boy' Daly (Eric Stoltz).

Suddenly the first of the B-17s screams low overhead as it returns from a daylight bombing raid. The crew of the *Memphis Belle* count the returning bombers. Eventually they realise that one of the B-17s is missing. Then one of them spots a B-17 in the distance. It has been badly shot up, and is flying with its right undercarriage leg down and its left one up. For this scene, a large radio-controlled model with a 16-foot wingspan was used.

The Fortress belly lands on the runway, then skids to the left and bursts into flames. Although looking spectacular on screen, this sequence didn't go exactly as planned as the

aircraft (which was a large model being towed on a wire by a vehicle) was supposed to travel in a straight line. Unfortunately, on the day a guide wire broke and the model veered to the left injuring a cameraman.

The next scene shows the B-17 exploding with the deaths of everyone on board. For this shot, a complete fibreglass B-17 tail section was constructed by Feggans Brown – the firm which had built several replica Spitfires for the TV series *Piece of Cake* (1988) – and was blown up along with some wreckage constructed from a broken-up RAF Percival Pembroke.

Coincidentally, during filming an accident happened which – had it been captured on film – could have been used to depict this sequence. On 25 July, one of the French B-17s (F-BEAA) *Chateau De Vernieuil* veered off the runway during take off, probably due to a binding brake or wheel bearing. The pilot managed to get airborne, but just after he got off the ground one of the propeller tips struck a pile of gravel causing the aircraft to turn to the left, resulting in the port wingtip striking a tree. This caused the aircraft to crash in a wheat field. Fortunately all ten people on board got out safely before the aircraft was consumed by fire, and the only injuries were one broken leg and a fractured collarbone.

At the time, statements in the press suggested that if there had been any fatalities then the film would have been cancelled. While this may be a perfectly understandable thing to say, in the history of moviemaking there have been many cases where people have died during the production of a film and yet it has still been completed. A camera crew was killed during the making of *633 Squadron* (1964) when a light aircraft taxyed into them. Pilot Paul Mantz died during the filming of *Flight of the Phoenix* (1965) while flying the

marginally airworthy Phoenix P-1. Aerial cameraman John Jordan lost his life when he fell out of the bomb bay of a B-25 during the making of *Catch 22* (1969) in Mexico, and his colleague Skeets Kelly died when an SE5a replica struck his Alouette camera helicopter during the making of *Zeppelin* (1971) in Ireland. Four other people died in the same air accident.

In more recent times, actor Vic Morrow (best-known for the *Combat* TV series) was decapitated by a helicopter rotor blade during the filming of *The Twilight Zone* movie in 1982, Brandon Lee died during the making of *The Crow* (1994), and Oliver Reed passed away during filming of *Gladiator* (2000). In all these cases the film was completed and released, as too much money and peoples' livelihoods were tied up in them to make cancellation a realistic option.

Colonel Bruce Derringer (John Lithgow) interviews the crew of the *Memphis Belle* as they prepare for their 25th (and last) mission. He sees the opportunity to generate favourable publicity for the USAAF's policy of daylight bombing – which has attracted some criticism – by sending the crew on a war bonds tour of the United States after their last mission.

The captain of the *Memphis Belle*, Dennis Dearborn (Matthew Modine), is the first to be interviewed as flashbulbs go off, followed by his co-pilot 1st Lt. Luke Sinclair (Tate Donovan) who is an ex-lifeguard. Derringer also interviews bombardier (bomb aimer) Lt. Val Kozlowski (Billy Zane), who is studying to be a doctor and claims to have already spent four years at medical school.

Later, the crew of the *Belle* play cards in their Nissen hut. Virgil has a plan to open a chain of identical hamburger restaurants after the war and talks about this goal. The rest of

the crew discuss their next mission. Surely it wouldn't be to Germany, but rather to somewhere relatively safe like France?

That night, a dance is held in a hangar on the base. With one of the Fortresses as a backdrop (Bob Richardson's B-17F), a Glenn Miller-style band plays music while the crews dance with some of the local girls. The singer (who is miming) is played by Jodie Wilson, at that time the girlfriend of musician Keff McCulloch who composed incidental music for some 1980s *Doctor Who* stories. Jodie Wilson subsequently married the entertainer Des O'Connor in 2011.

Ball-turret gunner 'Rascal', who sees himself as a ladies man, tries to chat up local girl Faith (Jane Horrocks, best-known for playing 'Bubbles' in the BBC comedy series *Absolutely Fabulous*) using his well-tried 'this could be my last night on Earth' line, but doesn't seem to be having much success. Later, Virge unwittingly melts her resolve as he talks about how he creates hamburgers, which Faith senses is a metaphor for sexual intercourse. Meanwhile, Luke tells Colonel Derringer that he feels undervalued.

As the evening continues, Dennis wanders outside the hangar where the *Memphis Belle* sits – its perspex nose cone and cockpit windows steamed up with condensation. He talks lovingly to the plane as though it were a person, not realising that Faith and Virge are now inside the aircraft in the nose compartment. Faith lets out a yelp as she finds she is sitting on something uncomfortable – a wrench which Virge has been looking for for some time. She then takes some chewing gum out of her mouth, sticks it on the inside of the fuselage and invites Virge to make love to her.

Meanwhile, the crew of the *Memphis Belle* talk to their counterparts in the *Mother and Country,* a rookie crew flying a brand new B-17 which is going on its first mission the

next day. One of their number goes to the toilet and is sick. Danny, trying to be helpful, gives him a glass of water and his own personal lucky charm.

Colonel Derringer goes up on the stage and speaks into a microphone. He asks for three cheers for the crew of the *Memphis Belle*. There is no response. Then Clay Busby takes the stage to sing and play the piano in a rousing jazz version of 'Danny Boy'. The audience dance enthusiastically. Harry Connick Junior was already well-known as a jazz musician before he got his first acting role in this film. As the evening comes to a close, the *Belle's* navigator Lt. Phil Lowenthal (D.B. Sweeney) runs out of the hangar screaming 'I don't want to die'.

A few hours later, dawn breaks and the sun slowly rises over the USAAF air base. The crews are woken with the news that breakfast is to be at 0600 with a briefing at 0645. As the early morning sun dries the dew on the B-17s, Phil feels nauseated. He has had too much to drink the previous evening. Val takes him into the toilets and tells him to make himself sick by putting his fingers down his throat. Phil promptly vomits over Val's clean uniform. He says he feels much better.

Soon afterwards Val takes Phil to the 'chow hall', where breakfast is served including coffee, bacon and powdered eggs which 'would gag a buzzard' according to Jack. After breakfast, the crews are briefed on their forthcoming mission by their commanding officer; a raid on the Focke-Wulf factory at Bremen which manufactures the Fw-190 fighter plane. The raid will be mounted by 360 bombers and careful aiming will be essential as a school and hospital are nearby.

After the briefing, the crew of the *Belle* (all ten of them) drive to their aircraft in a single, heavily overloaded

Jeep. 65 military vehicles – including ambulances, fuel tankers and trucks – were used in this production at a total cost of £60,000, and the one in this scene was provided by Larry Carne. As the script called for mud, and the summer of 1989 was hot and dry, the Fire Brigade had to be called in to hose down the area prior to the shot.

The men board their aircraft as the ground crews polish the perspex noses and armourers check the guns. Then a Jeep drives up and an officer announces that the mission has been delayed as there is cloud cover over the target. The *Belle* crew joke that it is 'SNAFU: Situation Normal'. Actually, SNAFU stands for 'Situation Normal All Fucked Up', but the last three words appear to have been edited from the soundtrack in the video and DVD releases and TV broadcasts though they remained in the original cinematic version.

Dennis says that they will do a cockpit check while they are waiting. Meanwhile, the rest of the crew rest on the grass outside the aircraft – their frustration obvious. Virgil has an argument with 'Rascal' who keeps calling him 'Virgin' because of his supposed lack of sexual experience. Virgil says that he 'could tell him something' but refrains from revealing details of his sexual liaison with Faith during the dance.

As Clay rides on a plough, Luke tries to convince him to allow him to man the tail guns briefly during the mission, as he wants to be able to say that he shot down an enemy aircraft. Clay is initially reluctant to comply but then agrees, providing Luke gives him his dog.

As the rest of the crew of the *Belle* lie on the grass, Danny reads some poetry he has written. Several B-17s can be seen in the background in these shots but these are two-dimensional 'cut-out' paintings prepared by scenic artist Brian

Bishop. Several of these very convincing 'flats' were erected at Binbrook to greatly increase the numbers of aircraft in shot.

Suddenly a Jeep arrives, and an officer announces the mission is now 'on' with engines to be started in five minutes. By this time, Clay has agreed to Luke's request to fire his guns during the mission and says he never wanted his 'mangy dog' anyway.

All the B-17s start their engines and make their way around the perimeter track, led by a Jeep with a chequered flag. The Fortresses prepare to take off one at a time in what is probably the best effects shot in the movie. The five bombers in the foreground are actually large, realistically weathered $1/7^{\text{th}}$ scale miniatures sitting on an elevated model runway, 10 feet off the ground. Each model had working propellors, spun by electric motors, and moving crew figures operated by radio control. A heat haze was created using propane burners underneath the runway.

In the distance, the five Fortresses taking off are real, and behind them are some of the 'cut-out' B-17s. It is a magnificent shot created by effects designer Richard Conway, and was done entirely 'in camera' without any matte or blue screen work in a way which looks 'real'. If the same shot was done today, it would likely use very phoney-looking CGI.

The *Belle* rolls down the runway, and briefly we get a point-of-view shot of the airfield as seen through the windshield. Again, this is not a blue-screen shot but was filmed for real using the nose section of the B-17 mockup as it was driven down the runway at Binbrook at high speed on the back of a lorry.

As the *Belle* climbs, the crew take up their combat positions. Jack, the starboard waist gunner, talks to his 0.50 cal Browning as though it were a person and says they are going

to get 'a nice 109' this mission. The other waist gunner, Eugene, boasts that he has already shot down a 109 on a previous sortie.

Suddenly Dennis and Luke see another B-17 directly above. It looks as if they are going to collide, and Dennis has to push the stick forward to get the *Belle* out of danger. The crisis averted, the bombardier (Val) enters the bomb bay and removes pins from the nose of each bomb, thus arming them. As 'Rascal' prepares to enter the cramped ball turret, he expresses concern that it is not going to work properly as it has previously had an intermittent fault. The two waist gunners reassure him that everything will be OK.

A magnificent shot follows, depicting five B-17s crossing the English coast as seen from high above. This isn't a special effect, but was done for real by carefully positioning the B-25 camera plane high above the formation and filming down. An out-take from this sequence (with digital enhancements) was used in *Dark Blue World* (2001).

Phil (the navigator) reports their position as 5 miles SSW of Great Yarmouth, while Luke states that the temperature is now 30 degrees below zero. Meanwhile, Eugene sticks a handwritten note on the back of Jack's flying jacket which proclaims he 'couldn't get laid last night'.

Dennis tells all his gunners to test-fire their weapons by firing a few rounds each. Soon after, the escorting P-51 Mustangs are spotted at 3 o'clock high. Luke says he wishes he could be a fighter pilot, as he could do anything he wanted. The radio operator of *Mother and Country*, the new B-17 with a rookie crew, calls up Danny for advice on what he should record in his logbook. Danny tells him to write down everything until he gets more experience, when he can then be more selective. Danny takes a picture of the radio operator of

Mother and Country looking out the window, using his box camera.

Dennis informs the crew that they are approaching enemy territory and need to watch out for fighters. As an aside, he tells everyone that his family has a furniture business and they can all work for him after the war. No-one is interested.

Suddenly the first enemy fighters attack, screaming in from the one o'clock position. Six German fighters can be seen, but only the three in the foreground are 109s (actually Hispano Buchons); the others are Mustangs kept in the background so that they can't be seen clearly (a familiar cinematic trick). The defending P-51s peel off to defend the bombers, but despite their efforts one of the Fortresses is hit and plunges to earth. A second B-17, *Windy City*, is attacked. For this scene, *Sally B* portrayed *Windy City* as it was the only aircraft in the film to be fitted with smoke dischargers on both port engines plus small pyrotechnic charges on the fuselage to simulate cannon hits. The wing-mounted 20mm cannons on the 109s have realistic gunfire flashes. This was achieved using gas guns, which worked using a mixture of oxygen and acetylene gases that was ignited by a spark plug.

Windy City explodes, and the *Belle* is forced to fly through the explosion. Its cockpit fills with smoke, and guts are smeared all over the nose cone and windshield. Another Fortress *C-Cup* takes over as lead aircraft, as the crew of the *Belle* report that no chutes have been seen coming out of *Windy City*. After this grim episode, 'Rascal' cheers everyone up by telling a joke over the intercom.

At this point, the P-51 escort fighters peel off and head for home. This is a serious error in the film, as the whole point of Packard Merlin-engined Mustangs (the B, C, D and

subsequent models) was that – with drop tanks fitted – they could fly to Berlin and back.

Waist gunner Eugene can't find his lucky charm (a medal), but fellow gunner Jack finds it and apparently throws it out the window. Eugene is inconsolable, so Danny gives him his rubber band. This sequence is entirely accurate as aircrews of both sides were incredibly superstitious during the war. Guy Gibson always wore a Boy Scout wristband when he flew, and RAF bomber crews habitually peed on their aircraft's tailwheel prior to a mission for good luck.

As the *Belle* flies deeper into Germany, back at the USAAF base in England Colonel Derringer is putting up flags and bunting to celebrate the successful return of the *Memphis Belle* after her 25th mission. This angers Colonel Harriman, who takes Derringer next door and reads him some letters from the next-of-kin of deceased airman. As Derringer reads the moving letters, some monochrome German gun camera film showing Fortresses being shot down appears on the screen.

I must confess that this is the part of the film I like least of all. It seemed the producers felt that they had to get over a strong anti-war message by including this section. One of the letter writers says that she hopes in the future men can find ways other than war to settle their differences. This may be true, but diplomats had tried for years to placate Hitler through negotiation. The problem was that he kept breaking his word and occupying and invading his neighbours despite previous assurances that he would not do so, and in the end the only way to deal with him was through military force. The same applied to Imperial Japan.

There are many war films that have been ruined by including anti-war messages that are way too strong. For

example, *The Guns of Navarone* (1961) features a number of scenes where characters wax lyrical about the futility of war. Other war movies made in the sixties and early seventies expressed similar sentiments, perhaps due to public disquiet in the USA about the Vietnam War.

Meanwhile, over Germany the American formation is under attack again by German fighters. *C-Cup* is badly hit and its nose cone is completely blown off, resulting in the bombardier falling to his death. This scene was filmed at Pinewood Studios using a large miniature and a blue-screen technique.

Though not downed, *C-Cup* is seriously damaged and drops out of formation, so the *Memphis Belle* has to take over as the lead aircraft. A fighter approaches from one o'clock and opens fire. Waist gunner Jack is hit, but is relieved when he finds his harmonica has stopped the bullet. At this point Eugene reveals that he had his missing medal all along and gives it back to him.

The USAAF formation is now approaching Bremen, which is defended by 500 anti-aircraft guns. The Luftwaffe fighters retreat to give the AA gunners a clear shot. The *Belle* is rocked by turbulence caused by exploding AA flak bursts.

Dennis turns on the autopilot, which is linked to the Norden bomb sight. This means the bombardier is now flying the plane. The flak continues, and the *Belle* is hit. 'Rascal' reports 'a hole as big as my dick' in the left wing. This causes some loss of fuel, and Luke has to go to the bomb bay to transfer some gasoline from the other tanks.

The *Belle* is now a short distance from the aiming point, but Val reports that the target is obscured by smoke. Dennis says that they will have to turn around and make another run over the target. This will take them five minutes

and put them at great risk. Navigator Phil panics and tries to push the bomb release button. He is physically prevented from doing so by Val.

As the huge American formation circles for a second pass, the German fighters attack again. Luke sees his chance to man the tail guns, and asks the gunner Clay Busby if he needs more ammunition. He makes his way to the tail turret and swaps places with Clay. Soon, Luke gets his chance to fire on an enemy plane as a 109 is approaching the *Belle* from the rear. Luke fires a short burst from the twin 50s and the Messerschmitt is hit. He is elated, but is aghast when he sees what happens next. The Messerschmitt dives out of control and hits another B-17, *Mother and Country*, aft of the wing, severing the rear fuselage completely. In two sections, the B-17 dives to earth – the crew unable to bail out in time. Again, this sequence was created at Pinewood Studios using excellent miniatures filmed against a blue screen.

Luke returns to the cockpit, traumatised by what he has done, as the *Belle* approaches the aiming point for the second time. The target is still obscured by smoke, but at the last moment it clears allowing Val to drop his bombs. The other B-17s in the formation follow suit, and soon the target is plastered by 500 pound bombs. A small amount of colour archive footage from WW2 showing explosions on the ground is edited in at this point. There is relief on board as Dennis closes the bomb doors and turns for home. 'We have done our job for Uncle Sam; now we are flying for ourselves', he says.

Suddenly the 109s attack again. 'Rascal's ball turret jams and is damaged by enemy fire; he has to be pulled out and into the safety of the fuselage. The radio room is also hit and a fire breaks out. The fire is quickly extinguished, but Danny is injured with a serious abdominal wound and Val is

told to go back and take care of him. He sees the extent of Danny's injuries and admits that he can't do anything for him, as he only did two weeks at medical school before being called up.

The fighters resume their attacks and the Number 4 engine is hit, catching fire. Dennis tries to put the flames out using the extinguisher inside the engine compartment, but it doesn't work. The only option he has left is to try and snuff out the fire by diving the plane. This will be risky, as the damaged wings may break off and he will need Luke's help to pull the plane out of the dive.

Despite the risks, Dennis and Luke dive the plane. Its speed rapidly increases until the slipstream eventually extinguishes the flames. With great difficulty, the two pilots pull back with all their strength on the control columns, bringing the *Belle* out of its dive.

The *Belle* is now flying on three engines which means that it will take two and a half hours to get home. Meanwhile, the crew are arguing about what to do with the wounded Danny. As Val points out, he has serious abdominal wounds and really needs a hospital; all he has is a first aid kit. He suggests putting a parachute on him and throwing him out the plane via the opened bomb bay doors, as the Germans will then find him and take him to a hospital. The rest of the crew are not happy about this plan. They only have 10 minutes before the *Belle* is over the North Sea and it will then be too late to do what Val has suggested. The bomb doors are opened in readiness as the aircraft approaches the coast. The screen 'whites out' as the crew argue over what to do.

Back at the USAAF base, the first bombers are starting to land as the *Belle* limps slowly towards England. They have now crossed the Dutch coast, so it is too late to throw out

Danny. The plane is now flying on two engines and is losing height, so Dennis tells the crew to throw out all the guns and ammunition to lose weight. As the English coast appears, Danny hallucinates and remembers reading some poetry.

The *Belle* is now nearing its base as the number 3 engine fails. It is now flying on just one engine. For these scenes, one of the large 1/7th scale radio-controlled models was used. As these miniature aircraft required four working engines to fly, stopped motors were depicted by having a stationary propeller in front of the turning one (which didn't show up on film).

There is another problem, as the starboard landing gear leg is stuck in the 'up' position while the port leg is down. Dennis tries to raise the port leg in order to make a belly landing, but it won't budge due to an electric failure. He instructs Virge to hand-crank the starboard leg down using a crank in the bomb bay, but it is a slow, exhausting process.

At the Americans' base, Colonel Harrington sees the B-17 approaching and notices that the starboard undercarriage leg is only partly lowered. On board the aircraft Virge is still furiously working the hand crank and, at one point, nearly falls out the bomb bay. At the last moment – just as the *Belle* is about to touch down – the right undercarriage legs clicks fully down. The *Belle* bounces on the runway then makes a successful landing. It taxies onto the grass, and is immediately surrounded by a swarm of vehicles including jeeps and ambulances. As the crew climb out of the aircraft, Danny is taken to hospital in an ambulance and Clay kisses the ground. Dennis celebrates by opening a bottle of champagne.

For these scenes depicting the *Belle* in its badly-damaged state, *Sally B* was used. Its real fin and rudder were removed and replaced with a battle-damaged fibreglass replica

built by Feggans Brown. As much of the fin and rudder was missing, it was not possible to fly the aircraft in this state, so scenes showing the *Belle* in the air were created using a studio miniature against a blue screen. Very effective simulation of battle damage was applied to *Sally B* by the art department, including apparent 'holes' in the fin created using reflective mirror foil.

The film ends with a caption which explains that a total of 250,000 aircraft fought in the air battles over Europe and that 20,000 aircrew lost their lives.

Memphis Belle was released in the UK on 4 September 1990. It had originally been planned to release it in August that year, but it was held back until September in order to coincide with the 50th anniversary of the Battle of Britain. The film was shown in cinemas in the USA from 12 October 1990.

The budget for the film was $23,000,000, but it only made $27,441,997 at the US box office and so would be considered a flop. Nonetheless, the film remains a magnificent technical achievement created without any CGI and using large numbers of genuine WW2 aircraft; something we may never see again.

Memphis Belle (1990)
Technical Credits

Director: Michael Caton-Jones
Screenplay: Monte Merrick

Cast

Capt. Dennis Dearborn -
Matthew Modine
Sgt. Danny Daley - Eric Stoltz
Ist Lt. Luke Sinclair -Tate
Donovan
Lt. Phil Lowenthal - D.B.
Sweeney
Lt. Val Kozlowski - Billy Zane
Sgt. Rascal Moore - Sean Astin
Sgt Clay Busby - Harry Connick
Jr.
Sgt. Virgil Hoogesteger - Reed
Diamond
Sgt. Eugene McVey - Courtney
Gains
Sgt Jack Bocci - Neil Giuntoli
Col. Craig Harriman - David
Stathairn
Lt. Col Bruce Derringer - John
Lithgow
Faith - Jane Horrocks
Les - Mac McDonald
Singer - Jodie Wilson
S-2 - Keith Edwards
Stan the Rookie - Steven
McIntosh
Adjutant - Greg Charles
Sergeant - Bradley Lavelle
Rookie Captain - Ben Browder
Group Navigator - Mitch Webb
Lieutenant - Paul Birchard

Farmer - Bill Cullum
Cook - Eric Loren
Jitterbuggers - Cathy Murphy
and Morag Siller
Footballers - Steve Elm, Jason
Salkey and Martin McDougall
Bandleader - Greg Francis

Production Crew

Producers: David Puttnam and
Catherine Wyler
Associate Producer: Eric Rattray
Music: George Fenton
Cinematography: David Watkin
Film Editing: Jim Clark
Casting: Marion Dougherty and
Juliet Taylor
Production Design: Stuart Craig

Art Direction

Supervising Art Directors:
Norman Dorme, John King and
Alan Tomkins
Set Decorator: Ian Giladjian
Costume Design: Jane Robinson

Makeup Department

Make-up Artists: Anna Cobley
and Anne McEwen
Key Make-up Artist: Joan Hills
Chief Hair Stylist: Meinir Jones-
Lewis
Hair Stylists: Pamela Haddock
and Maureen Hannaford-
Naisbitt

Production Manager: Mary
Richards
Executive in Charge of
Production: Steve Norris

Second Unit and Assistant Directors
Second Unit Director (Aerial
Unit): James Devis
Third Assistant Director (Aerial
Unit): Antony Ford
Third Assistant Director: Cliff
Lanning
Assistant director (Aerial Unit):
Terry Needham
Third Assistant Director (Aerial
Unit): Adam Somner
Second Assistant Director: Gerry
Toomey
First Assistant Director: Bill
Westley
Second Assistant Director: Kevin
Westley
Trainee Assistant Director:
Natasha Ross

Art Department
Prop Storeman: Alan Adams
Scenic Artists: Brian Bishop,
Doug Bishop and Cloe Chloerty
Stand-By Crew: Laurence Burns
Stand-By Crew: Anthony
Caccavale
Dressing Props: Stan Cook
Art Department Researcher:
Miranda Diamond
Art Department Assistant: Peter
Dorme

Dressing Props: Bob Douglas
Supervising Stagehand: Michael
R. Driscoll
Drapes: Colin Fox
Stand-By Crew: George Gibbons
Property Master: Peter Hancock
Stand-By Crew: Brian Hartnoll
Stand-By Props: Robert Hill
Dressing Props: Brian Humphrey
Lettering Artist: Clive Ingleton
Assistant Art Director: Michael
Lamont
Supervising Rigger: Leonard
Lawrence
Supervising Plasterer: Joe Lear
Assistant Construction Manager:
Bert Long
Stand-By Props: Steve
MacDonald
Dressing Props: Dave Midson
Dressing Props: John Moore
Draughtsman: Jim Morahan
Production Buyer: John O'
Shaughnessy
Dressing Props: Gordon Philips
Storyboard Artist: Michael G.
Ploog
Draughtsman: Tony Rimmington
Stand-By Crew: Ron Seers
Supervising Painter: Arthur
Smith
Storyboard Artist: Bill Stallion
Stand-By Crew: Don Taylor
Lettering Design: Bob Walker
Dressing Props: Peter Wallis
Construction Manager: Bill
Welch

Supervising Painter: Paul
Wescott
Stand-By Crew: Alan Williams
Assistant Construction Manager:
Tony Youd

Sound Department
Boom Operator: Paul Cridlin
Sound Effects Editor: Michael
Crouch
Dialogue Editor: Martin Evans
Sound Maintenance: Richard
Finney
Supervising Sound Editor: Ian
Fuller
Sound Recordist (Aerial Unit):
Mark Holding
Sound Mixer: David John
Sound Re-Recording Engineers:
Ray Merrin and Bill Rowe
Post-Production Sound Assistant:
Sandy Buchanan
Synclavier Operator: Any
Kennedy
Dolby Sound Consultant: Tim
Partridge

Special Effects
Special Effects Supervisor:
Richard Conway
Special Effects Floor Supervisor:
Martin Grant
Senior Special Effects
Technician: Bob Hollow
Special Effects Editor: Brian
Mann
Aerial Rigs (Aerial Unit): Trevor
Wood

Special Effects Technicians:
Andrew Eio, Dave Eltham and
David McCall
Special Effects Floor Supervisor:
Steve Hamilton

Visual Effects
Blue Screen Supervisor (Model
Unit): Dennis Bartlett
Modeller and Technician (Model
Unit): Nigel Brackley, Terry
Bridle, David Eithim, Nick
Finlayson, Steve Hamilton, John
Holmes, Peter Davy, Andrew
Kelly, Brian Lince, Kaye Moss,
Ray Lovell, Roy Masters, David
McCall, Stephen Onion, Peter
Pickering, Jamie Thomas, Leslie
Wheeler and Tim Willis
Visual Effects: Nicholas Brooks
Assistant Director (Model Unit):
Mark Challenor
Electrician (Model Unit): Frank
Clissold and Ed McDermott
Director (Model Unit): Richard
Conway
Travelling Matte Coordinator:
Steve Drewett
Stand-By Crew (Model Unit):
Bill Howe, Alan Johnson, John
Addison, Keith Muir, Terry
Newvell, Wally Parker and
William Poynter
Focus Puller (Model Unit):
David Jones
Electrician (Model Unit): Stuart
King and Vic Smith

Camera Operator (Model Unit): David Litchfield

Gaffer (Model Unit): Mike McGillivray

Cameraman (Model Unit): Harry Oakes

Model Unit Trainee: Jonathan Richardson

Stand-By Crew (Model Unit): Mike Smith

Additional Photographer (Model Unit): Peter Talbot

Focus Puller (Model Unit): Keith Thomas

Blue Screen Technician (Model Unit): Ken Warringham

Optical Cameraman: Martin Body

Optical Effects Technician: Zoe Cain

Optical Effects: Craig Chandler and Tim Ollive

Optical Cameraman: Alan Church

Assistant Optical Camera: Andrew Coates

Motion Control Camera Operator: Mark Gardiner

Executive Producer (The Magic Camera Company): Antony Hunt

Rostrum Cameraman: Stuart Pitcher

Visual Effects: Janek Sirrs and Val Wardlaw

Camera and Electrical Department

B-25 Camera Plane Pilot: Dizzy Addicott

Still Photographer: David Appleby

Clapper Loaders (Aerial Unit): Steve Brooke Smith, Giles Christopher, John Foster, Nick Penn and Mark Milsome

Electricians: Fred Brown, Toby Tyler, Alfie Emmins, Alan Grosch, Stuart Reid and Steve Harvey

Camera Operators: Derek Browne, Mike Frift and Mike Rutter

Camera Grip: Peter Butler

Director of Photography (Aerial Unit): James Devis

Camera Trainees: Geoff Dibben, Kate Hunt and Natasha Ross

Camera Air-to-Air Liaison: Air Vice-Marshal Ron Dick

Gaffer: Chuck Finch

Best Boy: Tom Finch and Billy Merrell

Focus Pullers (Aerial Unit): Simon Hume, Jeremy Jones, Simon Mills and Steve Murray

Camera Grip: Ted Jaffrey

Crane Operator: Steve Leverington

Assistant Camera (Aerial Unit): Mark Moriarty

Camera Grip (Aerial Unit): Brian Osborne

Additional Photography (Second Unit): Robin Vidgeon
Video Operator (Aerial Unit): Simon Werry
Video Assist (Aerial Unit): Peter Hodgson

Casting Department
Additional Casting (USA): Owens Hill
Additional Casting (UK): Patsy Pollock

Costume Department
Wardrobe Assistants: Ken Crouch, Catherine Halloran, Philip Rainforth and David Whiteing
Wardrobe Assistant (Aerial Unit): Peter Edmonds
Wardrobe Mistress: Kirsten Wing
Advisor (Military Costumes): Bob Worth
Costume Painter: Richard Thomas

Editorial Department
Editor Trainees: Jude Andrews, Cressida Shaffer and Debbie Slater
First Assistant Editor: Nick Moore
Assistant Editors: Steve Spencer, Andy Stears, Len Tremble, Michael Trent and Bettina Woolgar

Location Management
Location Manager (Aerial Unit): Barbara Back
Location Manager: Allan James

Music Department
Orchestrators: Jeff Atmajian and George Fenton
Music Recording Engineers: Keith Grant and Geoff Young
Assistant Music Engineer: Gerry O'Riordan
Musician (Violin): Mark Berrow
Conductor: George Fenton
Musical Director (Dance Music): Greg Francis
Assistant Music Engineer: Gerry O'Riordan

Transportation Department
Transportation: Mark White

Miscellaneous Crew
Location Cashier: Andy Andrews
Title Designer: Peter Jarvis
Computer Operator: Alan Steele
Armourers: Simon Atherton and Andrew Fletcher
Aerial Coordinator: Mark Hanna
Chief Pilot: Ray Hanna
Fighter Pilots: Chris Bevan, Carl Schofield, Mark Hanna, Paul Chaplin, Rob Dean, Peter Jarvis and Brian Smith
Hispano Buchon Pilots: Walter Eichorn, Ray Hanna and Mark Hanna

P-51 Pilots: Stephen Grey, Reg Hallam, Peter John, Rolf Meum, Hoof Proudfoot, and Anders Saether

Production Coordinator: Tania Blunden

Production Runner (Aerial Unit): Tim Knatchbull

Assistant Continuity: Suzanne Clegg

Continuity (Aerial Unit): Julie Robinson

Consultant Aeronautical Engineer: Peter Brown

Providers, B-17 F-AZDX: Jean-Philipe Chivot and Jean Salis

Provider, B-17, F- BEAA: Institut Geographique Nationale (IGN)

Provider, B-17 G-BEDF: Elly Sallingboe

Provider, B-17 N-17W: Bob Richardson

Provider: B-17 N3703G: David Tallichet

B-17 pilots: Don Clark (F-AZDX), Jean-Pierre Gattegno (F-BEEA), Bob Richardson (N-17W), Keith Sissons (G-BEDF), Alan Walker (G-BEDF), David Tallichet (N3703G)

Helicopter Pilots: Peter Thompson, Marc Wolff and Jerry Grayson

Unit Publicist: Susan d'Arcy

Publicity Assistant: Jay Lance

Production Assistant: Natasha Ross

Production Accountant: Jo Gregory

Assistant Accountant: Allan Davies

Choreographer: David Toguri

Technical Advisors: Roger A. Freeman, Tommy Garcia and Bruce Orriss

Provider (Titles): Richard Morrison

Production Assistant: Julia Overton

Publicity Assistant: Rebecca West

Script Supervisor: Angela Noakes

Photographic Transparencies: Alan White

Aviation Ground Coordinator: Mike Woodley

Researcher: Art Smith Jr

List of Aircraft used in *Memphis Belle* (1990) and current status (where known)

Aircraft Type	Registration	Status (1989)	Current Status (2016)
Boeing B-17F Fortress	N17W	Flying	Extant, Museum of Flight, Seattle
Boeing B-17G Fortress	G-BEDF	Flying	Airworthy, Duxford UK (B-17 Preservation Ltd)
Boeing B-17G Fortress	N3703G	Flying	Extant, Military Aircraft Restoration Company, Anaheim, Orange County, CA.
Boeing B-17G Fortress	F-AZDF	Flying	Grounded but potentially airworthy, La Ferte Alais, France
Boeing B-17G Fortress	F-BEAA	Flying	Crashed and destroyed during filming, Binbrook 25/07/89
Boeing B-17G Fortress	'Mary Alice'	Used for Spares	Extant, IWM Duxford.
NAA P-51D Mustang	N314BG	Flying	Extant, GE Air Inc, New Iberia, LA
NAA P-51D Mustang	N167F	Flying	Airworthy, Scandinavian Historic Flight, Norway
NAA P-51 D Mustang	G-SUSY	Flying	Extant, Christoph Nothinger, Freiburg, Germany. Now D-FPSI
NAA P-51D Mustang	N1051S	Flying	Crashed 02/07/95, Malore, NY
NAA P-51D Mustang	G-BIXL	Flying	Airworthy, Robs Lamplough, North Weald, UK
NAA P-51D Mustang	N51JJ	Flying	Airworthy, Old Flying Machine Company, Duxford,UK
CAC Mustang Mk 22	G-HAEC	Flying	Crashed 10/07/2011, Duxford
Hispano HA.1112 –M1L Buchon	G-HUNN	Flying	Cavanaugh Flight Museum, USA
Hispano HA.1112-M1L Buchon	G-BOML	Flying	Crashed 25/09/99, Sabadell, Spain

Hispano Ha.1112-M1L Buchon	D-FEHD	Flying	Extant, Messerschmitt Foundation, Germany; 'Black-15'
NAA B-25J Mitchell	N1042B	Camera Ship	Extant, Jim Terry, USA
Douglas C-47 Skytrain	G-DAKS	Set Dressing	Aces High, North Weald
Grumman Avenger	N6827C	2nd Camera Plane	ITL Aviation Ltd, Palmerston North, New Zealand
Beech 18 (C-45)	G-BKRG	Set Dressing	Extant, Aviodrome, Lelystad, Netherlands

Battle of Britain
(1969)

Many aircraft enthusiasts believe that *Battle of Britain* is the greatest aviation movie ever made. Certainly the statistics speak for themselves. Including RAF museum aircraft loaned to the film company and others used for spares, a staggering 128 aeroplanes were used in the production. No film made before or since *Battle of Britain* has used that many airframes, and the fleet assembled for the film in 1968 comprised the world's 35th largest air force.

Battle of Britain is also the best-documented aviation movie in film history. A 'Making of' documentary 45 minutes long, entitled *The Battle for The Battle of Britain*, was screened on the ITV network at 10.45p.m. on Saturday 13 September 1969, two days before the film's premiere, and several mini-documentaries were filmed for the 2004 DVD release. A book about the shooting of the movie – *Battle of Britain, The Making of a Film* by film critic Leonard Mosley – was released in both paperback and hardback form in the autumn of 1969. 31 years later, aviation enthusiast and *Flypast* Assistant Editor Robert J. Rudhall wrote a book entitled *Battle of Britain, The Movie*, followed a year later by a second tome: *Battle of Britain Film, The Photo Album*. A large number of articles about the film have appeared in aviation journals, some written by Rudhall who sadly died in 2003 and was probably the world's number one expert on the film. Two conventions have been held at the Officer's Mess at

the former RAF station at Duxford (the principal UK shooting location) to celebrate the film. The first, organised by the *Warbirds Worldwide* journal, was held on Saturday 24 June 1989, and the second – hosted by *Aeroplane* magazine – was on Sunday 19 September 1999. I had the privilege of attending both events.

The movie is also credited with kick-starting the aircraft preservation movement. At the time of writing (2016), there are 55 airworthy Spitfires and 14 flyable Hurricanes in the world – far more than were available for filming in 1968 – and this resurgence in interest in warbirds is probably a direct result of the film.

The story of the creation of the film that eventually became *Battle of Britain* started in September 1965. Film producer Benjamin J. Fisz had just scored a major hit with *The Heroes of Telemark*, an action-packed recounting of Allied saboteurs' heroic attempts to destroy German 'heavy water' stocks in Norway during WW2. Fisz planned to follow this success with a film about General Orde Wingate, who had formed the 'Chindits' in Burma during the last war.

Unfortunately the project fell through because of objections from the family of the late General Wingate, who wanted a say in the script. Rather disconsolate, Fisz left his office in South Audley Street and went for a walk in nearby Hyde Park. As he did so, he recalled an incident a few years before when a Spitfire and Hurricane of the RAF's Historic Flight (as it was then called) flew over Central London. This memory – combined with Fisz's previous experience as a Polish fighter pilot with the RAF in WW2 – gave him the idea of making a film about the Battle of Britain.

Two previous British war pictures, *Angels One Five* (1952) and *Reach for the Sky* (1956), had featured sequences

set during the Battle, but they had relied heavily on black-and-white archive footage and some rather unrealistic model shots. Fisz intended that the new film should be made in colour and widescreen, with most aerial scenes achieved using a large fleet of real aircraft with as little model work as possible.

With this in mind, he contacted Group Captain T.G. 'Hamish' Mahaddie, a distinguished former wartime RAF bomber pilot who had left the RAF in 1958 to become an independent aviation consultant to the film industry. Mahaddie specialised in procuring aircraft for movies, and was involved in sourcing the four Avro Lancaster Mark VIIs used in *The Dambusters* (1955) while he was still in the RAF. He also found and purchased all eleven Mosquitos employed in the filming of *633 Squadron* (1964).

Mahaddie often worked in an uncredited capacity. He was the aviation consultant to Eon Films who made the James Bond movies, but his name doesn't appear anywhere on the credits of the early 007 pictures. He also worked on *Operation Crossbow* (1965), *Patton* (1970) and *A Bridge Too Far* (1977) plus the ITV series *Pathfinders* (1972-73), to name but a few. In his autobiography *Hamish: The Story of a Pathfinder* (1989), he mentioned that he asked for his name to be removed from the credits of *A Bridge Too Far* (1977) as he wasn't happy about the way certain individuals were portrayed in the film.

Mahaddie's immediate task was to ascertain how many Spitfires and Hurricanes still existed and would be available for filming. Eventually he found that there were 160 Spitfires left in the world, of which 109 were in the UK. Only a few of them could fly, but if funds were available then several more could be restored to airworthy condition for the film.

Eventually 34 Spitfires were used in the film. Twelve of them were fully airworthy, eight were taxyable and another eight were static (to be used as background 'set dressing'), while a further six airframes were kept in hangars and used as a source of spares for the airworthy aircraft.

One problem was that only four of the airworthy Spitfires – a Mark IA (AR213), one Mark IIA (P7350) and two Mark Vs (VB AB910 and VC AR501) – resembled those used in 1940, as they had the short noses, single radiators and three-bladed propellors of early marks. Five of the flying Spitfires (MH415, MH434, MK297, MJ772 and TE308) were Mark IXs with longer noses, twin radiators and four-bladed propellors, and some carried 20mm cannon. Three of the flyable Spitfires were Griffon-engined late-war variants (Mark XIV RM689 and two Mark XIXs PM631 and PS853). These versions had long noses and five-bladed propellors.

Modifications to the airworthy aircraft consisted of a 1940 paint scheme, the removal of cannon, and the fitting of red doped patches to the leading edges of the wings to give the impression of an armament of eight 0.303in Browning machine guns. The taxyable and static Spitfires were mainly Mark XVIs (the same type used in *Reach for the Sky*) with low-back fuselages, cannon, four-bladed propellors, clipped wings and bubble canopies, and they received extensive modification at RAF Henlow where all the RAF aircraft were gathered prior to filming. A false back, constructed using wood and fabric, was added to each of the low-back aircraft to make them look like the earlier high-back variants. A 1940-style canopy was fitted to each airframe along with a three-bladed propeller, cannon were removed, clipped wings had elliptical wingtips restored, and narrow chord rudders were fitted. The resulting aircraft, looking like a cross between a V

268

and a IX, were referred to as 'Mark Addies' in honour of the film's aviation consultant Hamish Mahaddie.

Mahaddie was less successful in finding Hurricanes, as only six could be located for the film. Three (Mk IIC LF363, Mk IIC PZ685 and Mk XII RCAF No 5377) were fully airworthy, while another (Z7015, actually a Sea Hurricane owned by the Shuttleworth Collection) could at least be taxyed. One of the three airworthy Hurricanes (MK XII RCAF No 5377) was in Canada, where it had recently been restored to flight by owner Bob Diemert who had discovered it as a wreck on a Vancouver rubbish dump. It was flown across the Atlantic inside an RCAF C-130 Hercules to appear in the film. As the Hurricane's appearance had changed little over its lifespan, no modifications were necessary to the film aircraft other than the application of a 1940 colour scheme.

All the British fighters received a 1940 'spinach and sand' livery of dark earth and dark green camouflage and sky undersurfaces. For the Battle of France sequences at the start of the film, the undersurface of the port wing of each Hurricane was painted matte black as a nod to the black-and-white camouflage applied to the undersides of RAF fighters prior to the Battle of Britain.

Totally fictitious serial numbers and squadron markings were applied to each aircraft, and code letters made of white Fablon (the 'sticky backed plastic' used in *Blue Peter*) were stuck to each fighter. This meant that codes could be changed according to the demands of filming, and different ones could be worn on each side of the airframe as was normal practice in aviation films. The code letters were white rather than the correct light grey (so as to show up better on film), but as they soon became dirty during shooting this was hardly noticeable.

The next problem was locating a suitable fleet of German aircraft. Previous aviation movies had made extensive use of archive footage and models to depict the wartime Luftwaffe, while four films made in the sixties (*The Longest Day* (1962), *633 Squadron* (1964), *Weekend at Dunkirk* (1965) and *Von Ryan's Express* (1965)) had employed Nord 1002s (the French-built version of the Messerschmitt Bf108B) to depict the Bf109 fighter. However, the Bf108 was a slow, four-seat liaison and communications aircraft with a 220hp engine whereas the 109 was a fast single-seater with a 1085hp motor, so another option had to be found.

It was at this point that one of the film's technical advisors – General Adolph Galland, a former WW2 Luftwaffe ace – came up with the suggestion that Mahaddie should get in touch with the Spanish Air Force, as they still operated Messerschmitt 109s and Heinkel 111s, albeit locally-produced versions with British Rolls-Royce Merlin 500 engines known as the Hispano HA-1112-M1L 'Buchon' and the CASA 2-111.

Mahaddie got on the 'phone to the British Air Attache in Madrid, Group Captain R.L.S. Coulson, and soon discovered that the Spanish still had 32 airworthy Heinkels. The news on the Messerchmitts wasn't so good, as they were in the process of being scrapped in favour of more modern aircraft. Eight were still left in flyable condition, with four of them due to be sold to the Confederate Air Force (CAF) in Texas. In addition, there was a pile of dismantled Buchons which could be rebuilt to provide another ten airworthy aircraft with a further six restorable to taxyable status and four more suitable for use as static 'set dressing'. In March 1966, Mahaddie put in a bid for the whole lot at a Spanish auction known as a 'sabasta' and was successful. He also

agreed a deal with the CAF to use their four Buchons in the film, plus their airworthy Spitfire Mark IX MK297, with the only condition being that the CAF would supply their own pilots for the duration of the filming.

During restoration all the Buchons were modified to resemble 1940 Messerschmitt Bf109Es by fitting dummy twin engine cowling-mounted 7.9mm machine guns plus mock 20mm FF cannon in the wings and fake tail struts. The rounded wing tips were also squared off so as to resemble an 'E' model. All the fighters were painted in 1940 Luftwaffe camouflage with two shades of green on the upper surfaces and light blue bellies and wing and tail undersurfaces. One inaccuracy, though, was that the camouflage pattern was soft-edged rather than sharply demarcated as on the originals.

An agreement was also signed with the Spanish Government allowing the use of the 32 Heinkels. Very generously, the Spaniards only asked for the film company to meet the costs of the painting of the aircraft and their reinstatement to Spanish colours at the end of filming. All other costs such as fuel and aircrew wages were met by the Spanish Government, and it is estimated that this generosity saved the film company £200,000. The producers subsequently donated £1,000 to the Spanish Air Force Benevolent Fund.

The CASA 2-111 bombers received a respray in 1940 Luftwaffe colours, and three MG15 machine guns were fitted in the nose, dorsal and ventral gondola positions. These were mostly dummy guns, but some aircraft had real blank-firing MG15s installed which were supplied by Baptys of London.

Some of the Heinkels were target-towing aircraft and – as the Spanish refused to allow the gear to be removed – a cigar shaped object can be seen under the belly of some of the

bombers in certain shots. 1,000 dummy fibreglass bombs weighted with concrete in 50kg, 100kg and 250kg sizes were manufactured and dropped by the Heinkels into the sea off the coast of Spain during the shooting schedule. Another 200 bombs were made for set dressing.

So far the film company (Spitfire Productions Ltd) had obtained a large fleet of German fighters and bombers to use in the film. One problem, though, was that certain aircraft types were almost extinct and could not be represented on film. The Air Historic Branch of the RAF owned single examples of the Junkers Ju-88 bomber and Messerschmitt Bf110 twin-engine fighter, but these could not fly and were both night-fighter versions. No Dornier 17s existed anywhere at that time, so they didn't feature in the movie either.

However, the script called for Stuka attacks on Ventnor radar station, so some means had to be found to depict this. Only two complete Stukas existed in the world, one owned by the RAF Museum St Athan Collection and another (a Ju87-B2) in the Museum of Science and Industry in Chicago. The RAF Museum example was a 1943 Junkers Ju-87G-2, work number 360043, originally designed to carry a pair of 37mm anti-tank guns under its wings. As a 'G' model it had a more streamlined canopy and nose cowling than the 'B' model used during the Battle. Nonetheless, serious consideration was given to making it airworthy for the film, so it received a 1940 paint scheme and – with the addition of a fibreglass bomb and dummy airbrakes – became a passable representation of a Battle of Britain-era Junkers Ju-87B.

Reports suggest that the restoration work got as far as engine runs but, owing to the time it would have taken to restore the aircraft to flying condition and the likely cost involved, it was decided not to proceed further. Instead,

aircraft restorer Viv Bellamy (who had created a replica Pfalz D.III for *The Blue Max* in 1965) decided to build some mock Stukas using four Percival Proctor airframes (G-ALOK, G-AIEY and G-AIAE plus a fourth whose identity is unknown). The conversion work included the fitting of a new canopy, a square tailfin, and a revised centre section to give the so-called 'Proctuka' the correct 'bent wing' of a Junkers Ju-87.

Bellamy carried out three test flights on the 'Proctuka' and soon found that it had dangerous flying characteristics. If he had carried out a classic Stuka near-vertical dive, the wings would probably have come off. As a result, the Stuka sequences were eventually achieved using large radio-controlled models.

The main camera aircraft for the production was a B-25J Mitchell N6578D flown by Jeff Hawke and Duane Egli, which was extensively modified to take several 70mm Panavision cameras. One was mounted in the nose, shooting through an optically perfect Perspex dome, while another was fitted in an enlarged and open tail turret. Other cameras could shoot through modified waist windows, while another could film through an astrodome on the aircraft's spine. There was also a camera fitted on a retractable articulated arm in the bomb bay which could shoot through 360 degrees. The aerial unit director (David Bracknell) sat under an astrodome behind the cockpit and could see instant playbacks of what had just been shot on film using TV cameras and videotape machines. This was a technical innovation which later became standard practice in the film industry. The B-25 was sprayed in a multi-coloured paint scheme, including stripes on the wings, to make it easier for pilots to formate on and this led to it being called 'The Psychedelic Monster'.

Other aircraft carried film cameras during the production. Two of the Mark IX Spitfires (MJ772 and TE308) were twin-cockpit Tr.IX versions formerly operated by the Irish Air Corps, and these proved very useful during filming as they could carry a camera in either the front or rear cockpit. TE308 was used as a camera aircraft while MJ772 was employed for pilot training. One of the Buchons (C4K-122) was also a two-seater with a single elongated canopy, and this was used in a similar way to TE308. For some scenes requiring a stationary or slow-moving aerial camera an Aerospatiale SA318B Alouette II helicopter G-AWAP was used, and cameras were also fitted inside one of the Heinkels for certain sequences.

Despite the large number of airframes that had been acquired for the production, a large number of full-size fibreglass replicas of Spitfires, Hurricanes and Messerschmitt 109s were required for set dressing, and these were constructed in two tented workshops at Pinewood Studios. Eight Hurricane, seven Spitfire and six Messerchmitt 109 replicas were built for the production, and many of these survive to this day in various locations. A single Heinkel He-111 fuselage was also created. The Hurricanes were particularly realistic, and hard to tell from the real thing. The Spitfire replicas had a flaw, as the undercarriage was raked too far forward. Some of these Spits were fitted with lawnmower engines to spin their propellors and could be taxied. Some more flimsy replicas of Spitfires were also created for scenes of them being blown up.

The film was originally scheduled for production in the summer of 1967, but on 23 September 1966 the Rank Organisation – who had originally funded the production – pulled out of the film. By this time Harry Saltzman (who had

produced the Bond films with Cubby Broccoli) had joined Benjamin Fisz as co-producer, and he immediately started looking for a new backer. Talks with Paramount Pictures came to nothing, and by the end of 1966 the film had been shelved. However, by the following year a deal had been struck with United Artists to finance the film, with production to commence in the Spring of 1968.

The original director for the project was Lewis Gilbert, who had helmed many war films including *Reach for the Sky* (1956), but he had to decline eventually because the delay in production meant a clash with his existing commitments. His place was taken by Guy Hamilton – who had previously directed *Goldfinger* (1964) – using a screenplay written by James Kennaway and Wilfrid Greatorex (replacing the original choice, Sir Terrence Rattigan), based on the book *Narrow Margin* by Derek Wood and Derek Dempster.

Filming was to start at Tablada and El Corpero airfields near Seville in Spain on 13 March 1968, and after two months the unit would relocate to the former RAF Duxford close to Cambridge. Duxford served as the main base for the flying unit, and also played the part of three different airfields. Other former RAF airfields used in the production included North Weald, Hawkinge, Debden, Kenley, Northolt and Bovingdon.

A single Spitfire Mark IX MH415 was fitted with a long-range fuel tank and flown to Spain by Viv Bellamy to obtain the necessary shots of a Spitfire flying through large German formations, and when the film unit left Spain for England in May 1968 it took all 17 airworthy Messerschmitts (one having crashed during filming in Spain) and two of the Heinkels with them, the Spanish having agreed to sell two of the planes.

The film opens with a shot of a single Hawker Hurricane flying against a background of white clouds. A caption reads 'France, May 1940' as the Hurricane makes a victory roll over a column of refugees. The aircraft's Rolls-Royce Merlin engine cuts out momentarily, and it emits a small puff of black smoke as it flies inverted for a few seconds. The crew of a British Daimler armoured car (which didn't enter service till 1941) accompanying the column are unimpressed. 'Who the hell's he trying to kid?' says one of them. This scene was filmed in fields near Pinewood Studios.

The Hurricane lands at a nearby RAF forward airfield and taxies to a standstill. Squadron Leader Colin Harvey (Christopher Plummer) immediately berates the pilot, Jamie (James Cosmo), for his unnecessary victory roll which could have put his plane at risk. However, the British pilots have even more important matters on their mind as news arrives that the Germans have broken through at Sedan and will arrive in 30 minutes.

Three more Hurricanes land, including one which is piloted by Squadron Leader Skipper (Robert Shaw) – a character clearly based on 'Sailor' Malan, the South African RAF ace. Skipper and Harvey realise the situation is hopeless, and the only option is to fly their Hurricanes to Abbeville near the French coast before the Germans arrive.

This scene was shot at the edge of Duxford airfield and made good use of all six Hurricanes that were available to Spitfire Productions, plus several fibreglass replicas. The fake chateau background was a partial-scale 'flat' built on scaffolding.

The British pilots race for their Hurricanes, and Skipper tells the driver of a Bedford QL fuel bowser to get it out of the way as 'they will go with what they've got'.

Harvey then orders an RAF Sergeant to burn all the unserviceable aircraft to stop them falling into the hands of the Germans. The Sergeant is played by Reg Thomason, who appeared in many TV series and films in the 60s and 70s, often in non-speaking roles.

The Hurricanes start up and begin to move forward. French pilot Jean Jacques (Jean Wladon) looks on apprehensively, as he knows he faces an uncertain future. Then one of the British pilots suggests he squeezes into his Hurricane's cockpit and the two of them take off for safety. As the last airworthy Hurricanes depart, the RAF Sergeant instructs his men to splash petrol over the 'lame ducks'. Just as he is about to set fire to the British fighters several Messerschmitt Bf109s arrive and strafe the grounded Hurricanes, which explode in a spectacular fashion. This is one of the most realistic sequences in the film, as the burning Hurricanes look very like the real thing with the wooden framework underneath the fabric covering appearing very authentic, although the inner steel tubular structure of a genuine Hurricane is not depicted.

The next scene is set in the Air Ministry buildings in Whitehall, and was filmed at the actual location (which would now be called the Ministry of Defence) on a Sunday. Air Chief Marshal Dowding (Laurence Olivier) walks down a long corridor as a voice over (by Olivier) reads the content of a letter he has just sent to the Permanent Secretary of State for Air (Harry Andrews), warning him not to send any more fighters to France as it has now become a lost cause. The civil servant is angered by the letter, saying that he will have to show it to Churchill. 'That's why I sent it', says Dowding.

In Dunkirk, a large number of German vehicles and troops are entering the town. This scene was shot in Spain

using vehicles supplied by the Spanish Army. The convoy is led by an American M37 105mm self-propelled gun, based on the M24 Chaffee tank, which entered service in 1944. Also visible are two American M3 half-tracks modified to look German, and some M35 Reo trucks painted in Wehrmacht markings.

An impressive tracking shot follows (filmed at Huelva beach), showing all the vehicles and guns left behind by the British Army at Dunkirk. Those in the foreground were real trucks and cars found in Spain, while two-dimensional cut-out 'flats' were employed to depict vehicles in the far distance. The scene is a *tour de force* of art design, as no miniatures, matte shots or glass paintings were used and everything was done 'in camera'. As the camera tracks over the desolate landscape, Churchill's famous words are heard on the soundtrack, as reported on the BBC Home Service: 'What General Weygand called The Battle of France is now over. The Battle of Britain is about to begin'.

At this point, the title sequence begins with a dramatic head-on shot of a CASA-352 (Spanish-built Junkers 52) in German markings flying over the sea on its way to a German air base in Northern France. It is interesting that the final title of the film was *Battle of Britain* since all the way through production it was referred to as *The Battle of Britain*.

The Junkers lands, and the Inspector General of the Luftwaffe – Field Marshal Milch (Dietrich Frauboes) – and his colleague Field Marshal Albert Kesselring (Peter Hager) get into a Mercedes Staff car and inspect squadrons of Heinkel bombers at two neighbouring airfields as the titles are displayed. The title music track by Ron Goodwin is the stirring 'Luftwaffe March', though in later years it was

renamed 'Aces High' at the request of the RAF Band who liked playing it!

After the title sequence there is a brief scene where the German Ambassador to Switzerland, Baron Max Von Richter (Curt Jurgens), is called in to see Hitler in Berlin. Some days later, Von Richter arrives at the British Ambassador's residence in Switzerland with a message from Hitler: allow Germany to have a free hand in Europe and the British Empire can survive. Britain's situation is hopeless, as their Army has left behind all their equipment on the beaches at Dunkirk. The British Ambassador to Switzerland, Sir David Kelly (Ralph Richardson), tries to remain calm but eventually loses his patience, pointing out that 'the last corporal who attempted to cross the channel came a cropper' (a reference to Napoleon).

Eventually Von Richter leaves, and Sir David Kelly confesses that he did something unforgiveable for a diplomat – he lost his temper. He also concedes that much of what Von Richter said was true – Britain isn't ready to repel an invasion, there isn't much time... and it is running out!

The next scene is set in an unnamed RAF airfield in South East England just after the Dunkirk evacuation (it was actually filmed at the former RAF North Weald). A caption reads 'June 1940' as a Spitfire flies low over the wooden dispersal huts, circles, and comes in to land. But something is wrong, as the inexperienced pilot is about to touch down without lowering his undercarriage. In the nick of time an airman comes out of a caravan and fires a flare pistol in front of the Spitfire to warn the pilot of his mistake.

The pilot opens up the aircraft's throttle, accelerates away, climbs and then circles round again to make a successful (if bumpy) landing with the undercarriage down. A rather

shaken pilot, Simon (Nicholas Pennell), taxies the aircraft to the dispersal area and then shuts down the engine. 'Undercarriage lever a bit sticky, was it, sir?' says Flight Sergeant Arthur (Duncan Lamont) rather sarcastically.

Unfortunately for Simon, his dodgy landing has been witnessed by the aggressive Squadron Leader Skipper, leading to some classic dialogue:

'How many hours have you done on Spits?'

'Ten and a half.'

'Then make it eleven before Jerry has you for breakfast!'

The two pilots take off, and Skipper attempts to teach the youngster the basics of combat flying such as looking around him all the time, anticipating the enemy's moves, and never flying in a straight line in the combat area. Simon fails miserably. Soon on his tail is Skipper, who simulates a machine gun attack by screaming 'taka... taka... taka... taka...' into his microphone. It is clear that Simon is in for a hard time as he tries to reach the lofty standards of his highly experienced Squadron Leader.

The film then cuts to a meeting of RAF controllers in II Group, covering the South East of England, as Group Captain Hope (Nigel Patrick) outlines the system for dealing with enemy aircraft and the problems they face. One of the controllers, Squadron Leader Tom Evans, is played by Bill Foxley – a real-life member of the 'Guinea Pig Club', RAF airmen who suffered burns in combat and were treated by plastic surgeon Archibald McIndoe at the Royal Victoria Hospital in East Grinstead.

Meanwhile, on the French coast a squadron of German Messerschmitt pilots are visited by senior Luftwaffe officers. They enjoy lunch outdoors in brilliant sunshine. Morale is

high, and they are itching to get into action against the British.

The next scene is set on a French airfield where Luftwaffe crews are being briefed on their forthcoming attacks on British airfields. Back in England, the British Minister (Anthony Nicholls) is in Dowding's office studying a map. He remarks that the German forces seem to have paused, and that Hitler is apparently sightseeing in France. The Minister points out that the RAF has 650 fighters and that Lord Beaverbrook – now in charge of aircraft production – has promised that the factories can produce 100 new fighters a week. Dowding replies that the Luftwaffe has 2,500 planes.

The Minister then mentions radar, and says that Dowding must be trusting in radar and praying to God. Dowding replies that the opposite is true: he is trusting in God and praying for radar. Nonetheless, the RAF will have to down four enemy planes for every one of their own shot down if they are even to keep pace.

The action then shifts to an RAF base (actually Hawkinge, though it is not mentioned by name), where a young Kiwi pilot, Charlie Lambert, is asking his CO – Squadron Leader Canfield (Michael Caine) – for permission for a test flight to check that a new oil pressure gauge is working. Canfield reluctantly agrees. Incidentally, Caine's appearance in this movie was largely because he was under contract to Harry Saltzman at the time.

Meanwhile, Squadron Leader Harvey is off to Scotland to train some novice pilots, departing in his 1934 MG PA sports car. On the way, he stops at the 'Jackdaw Inn' to meet his wife Maggie (Susannah York) who is a Section Officer in

the WAAF. By the way, the 'Jackdaw Inn' is a real pub on the A260 near Denton.

An instrumental version of a contemporary hit *A Nightingale Sang in Berkeley Square* plays in the background as the couple discuss a current issue between them. Colin wants Maggie to apply for a posting in Scotland, but she does not want to do this. As Squadron Leader Harvey leaves the pub, some Local Defence Volunteers (who later became knowns as the 'Home Guard') arrive at 'The Jackdaw' for a pint.

In the meantime, a lone Hurricane lands at Hawkinge. It wears the codes 'OK-1' and is the personal aircraft of Air Vice Marshal Keith Park. These were the actual codes of the aircraft flown by Keith Park during the Battle. Park has arrived to find out how the Squadron is doing. Within minutes he works out that a pilot is missing.

'What is it this time? Undercarriage check?' says Park.

'Oil Pressure check.'

Park then asks Canfield the missing pilot's name. 'Lambert', he replies.

There is a quick cut to a shot of an RAF pilot's dead body floating in the English Channel supported by his lifejacket. To the accompaniment of some dramatic music from Ron Goodwin, a Messerschmitt flies overhead and returns to base.

The pilot, cigar-chomping Major Falke (Manfred Reddemann), clearly based on General Adolf Galland, is ecstatic at his latest victory and asks his batman Gerhardt to run a bath. His fellow pilots rib him and tell him that if he is not ready in five minutes they are going to Boulogne for dinner without him. As Falke has a quick bath, the other pilots discuss the merits of the Spitfire and one says he thinks

it is faster than the Messerschmitt. Just before Brandt is due to depart for Boulogne, he receives word that he is to report to Wissant with Major Fohn (Paul Neuhaus).

A little later, as the Luftwaffe pilots head to Wissant in a VW Kubelwagen they are forced to stop at a T-junction before they can turn right onto the coast road. A large column of vehicles pass in front of them, including trucks and four heavy articulated lorries carrying invasion barges. The Luftwaffe men realise that invasion is imminent.

The next scene is set at 0715 on 10 August 1940, the day the Germans called *AdlerTag* (Eagle Day). At a Luftwaffe bomber base, the pilots are briefed on their targets: 'Manston, Biggin, Kenley, Hawkinge, Dover'. Simultaneously, the pilots of the escorting Bf109s are being told details of their mission. They are reminded that the limited fuel capacity of their 109s means they can only spend 30 minutes over their targets. One of the German fighter pilots is played by George Roubicek, who played Captain Hopper in the classic 1967 *Doctor Who* story *The Tomb of the Cybermen*.

The Heinkels start up and taxy to the runway. As they do so, Spanish Air Force roundels can be seen showing through the Luftwaffe paint on the upper wings. The bombers take off in groups of three (with Freddie Young's photography making them seem menacing), followed soon after by the Messerschmitts.

At Ventnor radar station on the Isle of Wight, an RAF corporal arrives on his bicycle as the operators start to pick up plots indicating that a large German formation is heading for South East England. One of the radar operators is played by Maureen Lipman. In 11 Group Operations Room, Air Vice Marshal Park realises that something is building. He wonders if the Germans are intending to attack British

convoys in the English Channel, but is told that none are expected till the next day.

Back at Ventnor radar station, the situation is tense and the on-duty officer declines an offered cup of tea. 'Not now corporal, not now', he says as a large formation of Junkers Ju-87 Stukas approach. The first shot of the Stukas (26 in total) was achieved with studio miniatures, thereafter $1/8^{th}$ scale radio-controlled models were used. Ventnor radar station was a large outdoor set with only the bottom part of the radar towers built to save money. A large miniature of the station was also constructed at The Mound near Dover, and this was used for the sequence where the Stukas dive-bomb the target.

The Stuka bombing sequence was probably as realistic as it was possible to make it in 1968, bearing in mind the non-availability of any real, flying Junkers-87s and the failure of the 'Proktuka' project. The model Stukas drop their bombs at the lowest point of their relatively shallow dives, rather than releasing them in a near-vertical plunge, using an extending bomb cradle to ensure that they miss the propeller, probably because that was the best that could be achieved using radio-controlled miniatures.

Meanwhile, 54 Squadron led by Canfield has been scrambled and arrives over Ventnor as the Stuka attack is in progress. The squadron peels off in 'vics' of three and attacks the Stukas, leaving Yellow Section to watch out for the fighters. Almost immediately the Spitfires are on the Stukas' tails and blast them out the sky with bursts of machine gun fire. While trying to evade attack, two Stukas crash into one another (this was actually an accident during the model filming but looked so good it was kept in). Others explode in a spectacular fashion; a highly realistic effect achieved by fitting

284

a condom filled with petrol inside each model, which was detonated by radio control and filmed with a high-speed camera to 'slow down' the explosion. Although the shots of the actual bombing of Ventnor were filmed in England, the rest of the radio-controlled model footage was lensed in Malta because of the need for clear blue skies and good weather. Another reason for the move to Malta was that (unlike in the UK) there was no radio interference from taxi cabs on the island.

About 100 radio-controlled model aircraft – Spitfires, Messerschmitts, Hurricanes, Stukas and Heinkel 111s – made of fibreglass were created for the production, and at the end of filming in Malta all but three were burnt on a huge bonfire to save the cost of transporting them back to the UK.

Another of the Stukas is hit, and crashes next to the radar towers in an excellent miniature shot. Despite the RAF pilots' successes, Ventnor radar station has been put out of action and the RAF is now depending on the Observer Corps. A shot follows of an Observer Corps post near Dover which records '100 plus Heinkels escorted by 109s at 12,000 feet heading inland'. At North Weald, the 'phone rings at a dispersal hut and the pilots scramble for their Spitfires.

Back at Duxford, a lookout answers the 'phone and then activates an air raid siren as Group Captain Baker (Kenneth More) walks in front of the hangars and complains to Warrant Officer Warwick (Michael Bates) about the state of the place. 'Muck and filth everywhere', he says.

He then berates Section Officer Maggie Harvey for the WAAFs' habit of sharing slit trenches with male colleagues, and their use of gas mask containers (which look like haversacks) as handbags. As Baker is continuing his rant, some bombs explode in the distance and he and Harvey run

for the nearest slit trench. Duxford is plastered with bombs, and one of the hangars is blown up.

This was one of the most controversial aspects of the filming at Duxford. Originally the big explosion was planned for 21 June 1968, but the explosives failed to detonate at the first attempt and the pyrotechnics experts, Cliff Richardson and Glenn Robinson, had to reschedule the event for the following day. This time all the gelignite exploded as planned, and with careful editing work the sequence appears to have been filmed in one take.

Meanwhile at North Weald, the 'phone rings in the dispersal hut. There is an urgent message for the squadron to scramble again. Initially Squadron Leader Skipper doesn't believe what he has been told, as their Spitfires are still refuelling after their recent sortie, but as bombs start falling on the airfield he realises there isn't a moment to lose. The inexperienced pilot Simon stands bemused, not knowing what to do, but Skipper soon puts him right.

'Don't just stand there – get one up!'

The Spitfires taxi out for take-off as bombs fall around them. Some of them are hit on the ground and one of them swerves into a bowser, causing it to explode. This effect was achieved by steering one of the taxyable replicas using wires attached to two Land Rovers, but unfortunately there are two technical errors in this stunt. First of all, the Spitfire apparently has squealing tyres even though it is taxying on grass, and secondly the bowser explodes before the Spitfire hits it.

Eventually five of the Spitfires get airborne and start climbing with Simon (Red Two) lagging behind, causing Skipper to tell him to close up. Skipper calls Cowslip (Ground Control) on the radio for instructions, and is told that the

'bandits' are now 20 miles to the East, heading South-East. The section of Spitfires turn to port in pursuit of the raiders, but unfortunately Simon becomes disoriented and separated from the rest. Almost immediately he is bounced by a Messerschmitt which comes out of the sun at his six o' clock position – exactly the dangerous scenario which Skipper had warned him about earlier – and shoots him down. The Spitfire dives to earth out of control and explodes.

Back at Duxford there is chaos. A hangar lies in ruins, two wrecked Spitfires lying amongst the debris. Section Officer Harvey is clearly stressed by what has happened and fumbles with a packet of cigarettes. She puts one between her lips and lights it. Almost immediately she is reprimanded by Warrant Officer Warwick: 'Put that cigarette out! Can't you smell gas? The mains are gone!'

Harvey snaps back at him: 'Don't you yell at me, Mr Warwick', and decides to become just as nasty as him. She orders some airmen to 'get some stretchers... and fast!'

Back at the 11 Group Control Room, Wing Commander Willoughy (Robert Flemyng) suggests that the RAF could pull back their fighters North of the Thames to conserve their strength. Park replies that that is exactly what the Germans want. Meanwhile at Duxford, the RAF is rapidly recovering from the earlier bombing raid. The mess is being cleared up, Spitfires are being repaired, and a catering van is giving out food and hot drinks.

In Berlin, the Luftwaffe chiefs are jubilant as they believe that almost half the RAF fighter force – 300 aircraft – has already been destroyed, forcing the RAF to move reserves from the North of the UK to South East England. They believe this will leave the North of the country undefended, and they plan to attack it using bombers flying from Norway.

A large force of unescorted Heinkels is sent out over the North Sea to attack targets in the North East, but as they approach the coast Spitfires appear led by Squadron Leader Skipper. In reality, these German bombers weren't unescorted on these Northern raids as they were accompanied by long-range twin-engined Messerschmitt Bf110 fighters, but as none were available for filming this detail was left out.

'Help yourself, boys; there's no fighter escort', says Skipper over the R/T as the Spitfires pounce on the slow, vulnerable Heinkels. Many are shot down and plunge into the sea. These scenes look impressive, and were achieved by running large Heinkel models down wires from the Alouette camera helicopter which was being used as a launch platform – though in one shot, the model's guide wires are highly visible.

Eventually, the British pilots have to break off the combat and return to base as they are low on fuel. One pilot does a victory roll over the airfield. At a subsequent debriefing, the same pilot (Peter) is dismayed that he has only been awarded 'a third of a kill' as two other pilots have claimed the same aircraft. Skipper congratulates him on his shared victory, pointing out that he 'used to blast away and never hit a sausage', but berates him for his 'idiotic' victory roll, pointing out that if his controls were shot up he could have ended up being 'spread over the field like strawberry jam'.

At Dowding's HQ at Bentley Priory, an RAF Officer (John Savident) reads a report on the Northern raids which reveals that the RAF has shot down 23 German bombers without loss and prepares to take it to Dowding who has gone downstairs to the Operations Room.

As Dowding descends the stairs he discusses the current shortage of pilots with Air Vice Marshal Evill (Michael Redgrave), who informs him that Fighter Command will be loaned six pilots from Coastal Command and the Fleet Air Arm, five from the Fairey Battle Squadrons and thirteen from Army cooperation, but that the Government is reluctant to weaken the light bomber squadrons too much in view of the risk of invasion. There are also the Polish and Czech squadrons, but Dowding doesn't want to use them because of language problems. So far the Germans have been losing two aircraft for every RAF plane shot down, a ratio which is unsustainable for the British. As Dowding enters the Ops room, he is handed the figures on the Northern raids which cause him to chuckle.

The air battles continue. Skipper's squadron attacks a large formation of Heinkels, and Sergeant Pilot Andy (Ian McShane) hits one of them. Suddenly a large formation of yellow-nosed Messerschmitts bounces the Spitfires, causing Skipper to tell his squadron to break right and climb.

Major Falke tries to draw a bead on one of the Spitfires, but it manoeuvres out of the way. There is a marvellous shot of the view through his gunsight as he tries to bring his guns to bear. This is not a special effect, but was done for real using a Panavision camera mounted vertically in the front seat of the two-seat Buchon and filming through a 90 degree angle using a prism, with the aircraft being flown from the rear cockpit. The same method was used to obtain gunsight footage from inside a Spitfire using TE308, one of the two Tr.IXs.

Andy gets behind a Messerschmitt, but another gets on his tail and opens fire. A colleague shouts a warning over the R/T, but it is too late. Andy's Spitfire dives to the ground, its

engine smoking, and disappears from view as the crew of a burning Heinkel jump out. Most of the bail-out sequences in the film were real. For scenes showing German crews departing their Heinkel, a device like a child's slide was fitted inside the fuselage of one of the Heinkels. Other parachute jumps were made from a De Havilland 86 Rapide and the Alouette camera helicopter, while the two-seat Spitfires were employed on several occasions for such sequences – sometimes carrying a real parachutist in the rear cockpit or else releasing a dummy fitted on the port wing root.

Back at North Weald, 'Rabbit Squadron' has now landed and ground crews are trying to clear up the mess caused by the recent bombing. Skipper is incensed to see some captured Luftwaffe bomber crews being led off. 'Where are you taking these vultures?' he says. 'Officers to the Mess, NCOs to the guardroom,' replies the RAF Corporal. Skipper loses his temper and tells the airman that the German prisoners should be made to clear up the mess.

'What about the officers, sir?' asks the airman.

'Give them a bloody shovel!'

This was one of two scenes that General Adolph Galland objected to, though it was kept in.

One of the RAF fitters working on a Spitfire's Browning machine gun in a nearby hangar has witnessed Skipper's outburst, and comments that he hates Jerries. 'You'll hate me in a moment if you don't get that gun fixed', comments Flight Sergeant Arthur.

Skipper is concerned that he only has eight serviceable aircraft for the following morning (he should have 18), but Arthur points out that five are write offs, one has a wrecked undercarriage, and two aircraft have gone missing. The fitters have been working for 48 hours without a break.

At this point Andy turns up. 'Where have you been?' barks Skipper.

'Learning to swim,' he replies.

Skipper criticizes him for his poor tactics. 'Never fly straight and level in the combat area for more than 30 seconds', he says. This in fact is one of Sailor Malan's famous 'Ten Rules of Air Combat'. Having had his say, Skipper gives him a lift home.

Meanwhile, Squadron Leader Canfield surveys the devastation at his airfield caused by German bombing. He is told that the squadron is to be moved to a new temporary location at the South Downs Flying Club.

The next scene is set at the flying club, and was filmed at Duxford. Several Spitfires are sitting on the ground with their engines running. Canfield is impatient to get going, and (over the radio) tells his controller that his engine is overheating and so is he. (This was a genuine problem with the Spitfire, as its Rolls-Royce Merlin engine had a tendency to overheat rapidly on the ground as the radiator was partly obscured by the starboard undercarriage leg.) A moment later, an airman fires a flare pistol and the squadron rolls forward. A beautiful shot follows – taken by a low-flying Alouette camera helicopter – of the squadron getting airborne.

Ground Control then contacts Canfield and tells him to steer 192 degrees, as 20 plus bandits are approaching at Angels 20 (20,000 feet). The squadron is then bounced by Messerschmitts, and Canfield's Spitfire is hit and explodes.

Concurrently, twenty plus Heinkels approach Duxford at 8,000 feet. In the underground control room, everyone dons tin hats. Shortly afterwards, the bombing starts and several ceiling beams fall onto the plotting table. An aerial shot then

follows of Duxford being plastered by German bombs and almost completely obscured by smoke. The concrete runway at Duxford can be seen in the left of the shot even though it is playing the part of a grass airfield.

At the South Downs Flying Club, Jamie lands his smoking Spitfire. He jumps out, distraught, and reports that Canfield is dead as his aircraft blew up in mid-air. Later, Air Vice Marshal Keith Park arrives at an airfield in his Hurricane (the scene was actually filmed by the old hangars at North Weald), dismayed at what has happened. He blames 12 Group, which failed to arrive on time.

That evening, Air Vice Marshals Park and Leigh-Mallory have a meeting with Dowding in his office, where the whole concept of 'Big Wings' is discussed. It is interesting that in the 1956 film *Reach for the Sky*, this tactic was depicted as a good idea. Twelve years later, the newer film offered a more balanced view and presented both sides of the argument.

The meeting depicted in the film never actually happened, but is probably justified on dramatic grounds as it explains to the audience the arguments that were going on behind the scenes. Leigh-Mallory supported the concept of 'Big Wings' of up to five squadrons, which had been suggested by Group Captain Douglas Bader. He believed that all that mattered was shooting down the enemy in great numbers. However, Keith Park held a different view. He felt that 'Big Wings' took far too long to form up, and the enemy had often departed before they arrived on the scene. In this classic scene in the film, Leigh-Mallory says that he would rather hit 50 aircraft after they had hit the target than 10 before, while Park replies that he wasn't getting 50 – in fact, he wasn't even getting 10.

Dowding then offers a different perspective: the real issue is that RAF Fighter Command is short of 200 pilots. The RAF is fighting for survival and is losing.

'We don't need a big wing or a small wing', he says – 'we need pilots'. As an air raid siren sounds, he bids his two commanders good night.

As night falls, Colin Harvey and his wife Maggie are preparing for bed in a hotel. Maggie has taken off her skirt and is displaying her legs in suspenders as she drinks some wine. It is obvious that she intends to seduce her husband. A radio in the bedroom is playing the popular song 'A Nightingale Sang in Berkeley Square'.

Later, after the couple have made love and are lying in bed, they hear the sound of bombs dropping nearby. A group of Heinkel bombers has got lost due to navigational error and has dumped its bombs on a London suburb (this actually happened on 24 August 1940). Maggie thinks it is a big joke, but her husband is aghast that the Germans have started bombing the capital. She then promises that she will put in for a posting to Scotland.

The next scene is set the following day at a Luftwaffe bomber base in northern France. The commander of the Heinkel formation, Major Brandt – who accidentally dumped his bombs on London – is severely reprimanded by his commanding officer, who points out that attacks on London are forbidden by the direct order of Hitler. He informs him that he and his navigator have been ordered to report to Colonel Schroder in Berlin.

Later they arrive at Berlin-Staaken airport in a Junkers 52/3m, while another in Lufthansa markings is parked in the background. They are surprised to discover that no blackout is in operation. As they are driven into the centre of Berlin, they

are amazed to see British aircraft picked out by searchlight beams as they bomb the city even although Goering had previously given an assurance to the German people that that would never happen. As Goering had himself said prior to this episode, 'If ever a bomb falls on Berlin you can call me Meier'. This scene was filmed in San Sebastian, using hundreds of Spanish extras in period costumes.

The next day in Berlin, Adolf Hitler (Rolf Stiefel) addresses a Nazi Party rally with characteristic aggression. He is furious that the British have bombed Berlin and promises reprisals:

'If the RAF drops 200, 300, 400 bombs then the Luftwaffe will drop 2,000, 3,000, 4,000 bombs. If they attack our cities, we will wipe them out', he says.

A few days later on 7 September 1940, Goering arrives at the Channel coast in his special train and is met by Kesselring. He visits Cap Gris Nez and looks at the English coast through binoculars. Suddenly, a huge fleet of Heinkel bombers escorted by Messerschmitts flies overhead. Every available German fighter and bomber was used in this scene, but the apparent numbers on screen were multiplied by special effects expert Wally Veevers, giving the impression of hundreds of aircraft heading towards England. Goering is delighted at this spectacle and pretends to be deafened by the noise.

'If we lose now, we deserved to have our asses kicked in', he says.

Later, Skipper's squadron is patrolling over Southern England but can find none of the large numbers of German aircraft that have been picked up by radar. Skipper cannot understand where they have gone. Instead of attacking

airfields, the Germans are now heading north-west to London and there are no British fighters in their way to stop them.

One German Heinkel pilot cannot understand what has happened to the RAF. 'Wo is Die RAF? (Where is the RAF?)', he wonders.

The huge formation of bombers flies up the Thames, heading for London. Shots showing just two Heinkels were achieved using real aircraft (G-AWHA and G-AHWB) which had been flown to Britain in May 1968 after the completion of the Spanish segment of filming. Other scenes featuring multiple bombers were achieved by special effects expert Wally Veevers, using cut-out colour photos of the aircraft stuck on glass and then added to the background footage using a matte technique.

The Germans drop their bombs on the docks, and further sorties are mounted at night. The next scene shows the warehouses at St Katherine Docks in flames. As it happened, these old buildings were due to be knocked down for redevelopment of the area, and the producers were fortunate to secure their use in the film. The billowing flames were achieved using large numbers of propane gas burners fitted behind window openings, and genuine Thames fire boats were used to achieve authenticity.

As the Blitz continues, Sergeant Pilot Andy arrives in a taxi looking for his family. He is relieved to discover that they are all safe and well in a nearby rest centre in a Church hall. These scenes of a devastated London were filmed in Dragon Road in Camberwell SE15 in May 1968. This was another area which was due to be knocked down for redevelopment, and the Greater London Council was quite happy to give permission for the buildings to be demolished for scenes in the film. Large numbers of car windscreens were brought in and

broken to depict the glass strewn in the streets for these scenes.

Andy meets his wife (Isla Blair) at the rest centre, and gives his two children a couple of model Spitfires which he has built for them. One made of wood appears to be about 1/32 scale, while the second smaller model looks like an Airfix 1/72 scale model of a Spitfire Mark IX (many of which, incidentally, were used in the planning of the aerial scenes along with an Airfix B-25J Mitchell). As Andy relaxes with his wife, an air raid warden arrives asking for volunteers to help in trying to free some trapped casualties in a nearby bombed house in Shaw Street. This mission proves fruitless as the victims are dead and, as Andy returns to the rest centre with his uniform covered in dirt, he discovers that it has been hit by a bomb and his family have been killed.

The next scene is set in Squadron Leader Skipper's house. It is early morning and Skipper checks on his wife (Sarah Lawson) and three children, who are sleeping. He wakes Andy, who is now staying with them. The two pilots leave the house to travel to the airfield in Skipper's car. There is a minor 'goof' here, as the front door looks quite modern as does the white plastic bell push.

Meanwhile in the 11 Group control room, Park is concerned as a Polish Hurricane Training Squadron is in the vicinity of some German bombers. He orders them to return to base, as he considers them a liability. High above South East England, Squadron Leader Edwards (Barry Foster) receives an order to take his Polish Squadron back to their airfield, but it is too late as one of the pilots has spotted a group of Heinkel 111s. One by one, the Hurricanes peel off to attack until eventually Edwards is left on his own and has to join them. This scene apparently features six Hurricanes, but

only the trio of aircraft nearest the camera are the genuine article; the other three in the background are Hispano Buchons painted in RAF markings. Interestingly, in this sequence there is a close-up, head-on shot of a Hurricane firing its eight machine guns, which is the only one in the entire film. This was achieved at Pinewood Studios using a full-sized Hurricane replica, which was oddly proportioned so as to appear in normal perspective when filmed at close range with a Panavision camera.

The Poles prove to be highly aggressive and competent pilots, and they devastate the German formation bringing down many bombers. Later on the ground, Squadron Leader Edwards rebukes them for their lack of discipline in the air (with the aid of a translator). But then he gives them some good news: the squadron is to become fully operational forthwith. There is a loud cheer.

At Bentley Priory, Dowding receives the news about the Poles' success and admits he was wrong. Both Polish squadrons are to be made operational, as well as the Czechs and Canadians. As dusk falls, Dowding and Park stand on the balcony and view the glow of a burning London in the distance. They admit that nothing can be done at present to counter the night bombing. But with the Germans turning on London, their fighters will only have ten minutes' fuel over the target. Plus, for the first time, the German raiders will come within range of 12 Group and its 'Big Wings.'

The next day, a massive air battle takes place over London and the 'Big Wing' participates. A Polish pilot bales out of his stricken Hurricane and lands in a field, where he is threatened by a farmer with a pitchfork who thinks he is German. Large numbers of German aircraft are shot down, and one Heinkel limps back to France with one engine

smoking. German soldiers look on apprehensively as it flies low over some invasion barges. One of these vessels is fitted with aero engines and propellors, which is entirely authentic.

The next shot shows the same Heinkel after belly landing on a French airfield. Emergency crews extricate the injured and dead crew members using crowbars. Many articles about the making of the film have claimed that this scene was shot in the UK using a full-sized Heinkel replica, but in fact it was shot in Spain using a real (but non-airworthy) CASA 2-111.

Goering meets some of his pilots to discuss the latest turn of events, and tells them that from now on the fighters will stay close to the bombers. Falke points out that this will result in them losing all their advantages of height and speed. After his tirade, Goering asks Falke if there is anything he needs. Falke replies that he would like 'a Squadron of Spitfires' (an actual quote from Adolph Galland).

As Goering leaves on his special train, Kesselring gives him a Nazi salute. This was the second scene which enraged Adolph Galland, as he was adamant that there were 'no Nazis in the Luftwaffe'. He threatened to walk off the picture unless the scene was cut. Eventually the dispute was sorted when the producers contacted Field Marshal Milch, who was still alive and confirmed that the scene was accurate.

Over London the air battles continue. One Spitfire is hit by return fire from a Heinkel, but the pilot – Pilot Officer Archie (Edward Fox) – bravely attacks again with success. Smoking badly, the bomber flies low over Admiralty Arches in Central London and crashes into Victoria Station where it explodes. These scenes where shot using a special effects technique credited to the late Les Bowie, in which monochrome photographs of buildings taken by a large format

camera were blown up to a huge size (sometimes as big as 20 feet by 30 feet) and then pasted to large sheets of hardboard or plywood, which was then cut out to match the outline of the building. In some cases the windows could be cut out as well. Usually the black-and-white photo was hand-coloured using paints, though in some cases it was left as a monochrome print.

To create the effect of a building being blown up, a small flash charge was set off in front of or behind the flat (sometimes both). This was the method that was used to create the effect of the church being blown up at the end of the *Doctor Who* story *The Daemons* (1971) and the exploding stately home in the penultimate scene of *Day of the Daleks* (1972), as well as the destruction of 'Chateau De Charlon' in *Mosquito Squadron* (1970).

The shot showing the smoking Heinkel disappearing behind the Admiralty Arches was filmed at the former RAF Bovingdon, using a real Heinkel and huge flats erected on scaffolding. For the scene of the Heinkel diving on Victoria Station, two different flats were used: one for the foreground, and the other for the mid-distance. To achieve the desired effect, a model Heinkel was run down a wire behind the foreground flat and a small explosive charge was then detonated.

The next scene is one that I found very moving when I first saw the film in October 1969. A temporary plotting room has been set up in E.J. Prize and Sons, a local bakers, to take over the role of the one destroyed in a recent German bombing raid. Group Captain Baker enters the building with his colleague Squadron Leader Tom Evans (Bill Foxley), and introduces him to Section Officer Maggie Harvey saying that

he knows her husband. Harvey is initially shocked by Evans' obvious facial injuries, but quickly recovers her composure.

'How is Colin?' says Evans. 'I haven't seen him since my little escapade with the burning Hurricane.'

In real life, Foxley was a WW2 RAF navigator: a prominent member of 'The Guinea Pig Club' who had sustained severe hand and facial burns in March 1944 when his Vickers Wellington bomber crashed during a training mission. The aircraft caught fire and, although Foxley exited the aircraft safely through the astrodome, he went back inside in a brave but unsuccessful attempt to save a colleague. As a result all of his face below his eyebrows was destroyed, as was his right eye, and his left cornea was left with severe scarring. He required 29 operations to repair his face, and his hands were left with stumps for fingers. In Leonard Mosley's book *Battle of Britain. The Making of a Film*, Susannah York revealed that she wasn't that interested in the film until she met Foxley and realised the risks that fighter pilots took in 1940.

After meeting Evans, Harvey is called to the 'phone. It is her husband Colin, asking if she has put in for the posting in Scotland. She admits she had forgotten all about it.

Now it is 15 September, recognised as the climax of the battle and now celebrated as 'Battle of Britain Day'. Squadron Leader Harvey's Spitfire is hit, and his gloves catch fire as his plane dives out of control. Soon his cockpit is ablaze as he tries to get out. Eventually he bales out of his Spitfire, just before it explodes and his parachute opens. But it is obvious that he has been badly burnt.

The rest of his Squadron returns to base. Peter knows that Harvey was hit, but definitely saw him bale out. At the Parade Ground at Duxford, Section Officer Harvey is met by

Group Captain Baker as three Spitfires fly over. He doesn't say anything, but his grim expression tells her all she needs to know.

'It's Colin,' she says.

'He's not dead, Maggie.'

'Is he badly burnt?'

'They can do wonders nowadays. It's just a question of time.'

Baker then tells Harvey that he will arrange a new posting for her so that she can be close to him.

Meanwhile, in the absence of Squadron Leader Harvey Peter has taken over Red Section. Two new pilots arrive, but one has only done ten hours on Spitfires, the other seven. Peter tells them to 'stick to him like glue and keep your eyes open'.

At the 11 Group plotting room, Winston Churchill has arrived. All fighter reserves have now been committed to the massive aerial battle. The camera pans slowly upwards from St Paul's Cathedral to reveal a clear blue sky filled with contrails as hundreds of aircraft do battle over the capital. There is a chatter of machine gun and cannon fire as Sir William Walton's 'Battle in the Air' music starts.

The saga of the musical score to *Battle of Britain* is a story in itself. Originally Sir William Walton was commissioned to write all the music, but three weeks before the premiere the producers changed their mind and asked Ron Goodwin to score the entire movie. One of the problems with Walton's score was that he only wrote 20 minutes of music, not nearly enough for a soundtrack album.

Walton was extremely upset at the producers' decision, and wondered why they simply hadn't asked him to write some more music. His good friend Laurence Olivier became

involved in the dispute, and threatened to withdraw his name from the credits if Walton's score wasn't used. Eventually, an agreement was reached with the producers in which Walton's music was used in the 'Battle in the Air' sequence towards the end of the movie, with Ron Goodwin's score used for the remaining sections. Some prints of the film also include some of Walton's music at the very end, as I shall explain shortly.

For years, Walton's music for the film was thought to be lost, but in 1991 a copy of the master tapes was found and the subsequent CD release of the film's soundtrack includes both scores. The 2004 DVD release of the film has the option of playing the movie with the Walton score.

My own personal view is that the Ron Goodwin score is the better of the two, but there is no doubt that Walton's music perfectly fits the 'Battle in the Air' sequence which includes many grim shots of pilots trapped in their blazing aircraft, windscreens becoming coated in oil, etc. One of the highlights of this segment is a long shot where a pilot (actually a dummy) bails out of his Spitfire and the camera follows him down for what seems like ages, yet his parachute fails to open and it becomes obvious that he is falling to his death. This sequence was actually a technical error during filming, as the parachute was supposed to open, but it looked so good they kept it in.

After this stirring montage, the next scene is set in the Luftwaffe fighter pilots' mess where there are many empty places at the dinner table. The pilots eat silently, reflecting on the loss of their colleagues, as some Heinkels take off against the sunset.

Back in the UK at Duxford, RAF fitters push another repaired Spitfire out of a hangar as they see the red glow of a bombing raid on the horizon. At Aldwych Underground

Station, hundreds of civilians are sheltering from the bombing and are listening to the latest news on the radio. 165 German aircraft have been claimed as destroyed that day, with RAF losses being 30 fighters lost with 10 pilots saved.

Dowding gets a 'phone call from a British Minister who says that the Americans are doubtful of British claims. Dowding replies that he is not interested in propaganda. If he is right, the Germans will stop; if he is wrong, they will be here in a week.

At North Weald, a Bedford MWD truck arrives at the dispersal area with several pilots. The pilots are sitting about waiting for the scramble. Suddenly the 'phone rings. Everyone looks on nervously as an airman answers the 'phone. Tea is ready. One anxious pilot goes to the loo to be sick. In the 11 Group operations room, Park is told that the Germans are 'late today'.

Over in Northern France, German soldiers are dumping their lifejackets and returning to their barracks. Goering is furious with his pilots, saying that they have betrayed him. At Bentley Priory, Dowding goes onto the balcony, the relief on his face evident. The RAF has won the Battle of Britain. Incidentally, there are three different versions of this ending in circulation: one with the Goodwin score, another with Walton's music, and a third version with a combination of the two.

Battle of Britain had its premier at the Dominion Theatre, Tottenham Court Road at 8.45p.m. on Monday 15 September 1969. It received much critical acclaim and did good business in the UK, Germany and the Commonwealth countries. It was a flop in the all-important USA market, as Americans are generally disinterested in British war movies.

At the time it was one of the most expensive films ever made, costing $17million with $2m of that being extra funding that had to be sought prior to filming. The film came in well over budget, and the main reason for the great expense was that the very costly aerial filming involving a huge fleet of aircraft went on for about six months – far longer than intended – because of terrible weather in the UK in the summer of 1968. The weather was so consistently bad that, in August 1968, the aerial unit had to relocate to Monmartre in the South of France with nine Spitfires and three Buchons to complete the dogfight sequences over the Mediterranean.

Battle of Britain received its first television showing on BBC 1 on Sunday 15 September 1974, exactly five years to the day since its premiere in London. It has been shown many times since and has had several VHS, DVD and now Blu-Ray releases. It is highly unlikely that we will ever see a film of this type (which used a large fleet of real aircraft) again, and many enthusiasts consider it to be the greatest aviation film ever made.

Battle of Britain (1969)
Technical Credits

Director: Guy Hamilton
Screenplay: James Kennaway
and Wilfrid Greatorex, based on
the book *Narrow Margin* by
Derek Dempster and Derek
Wood

Main Cast

Senior Civil Servant - Harry
Andrews
Squadron Leader Canfield -
Michael Caine
AVM Keith Park - Trevor
Howard
Baron von Richter - Curt Jurgens
Sergeant Pilot Andy - Ian
McShane
Group Captain Baker - Kenneth
More
ACM Sir Hugh Dowding -
Laurence Olivier
Group Captain Hope - Nigel
Patrick
Squadron Leader Harvey -
Christopher Plummer
AVM Evill - Michael Redgrave
Sir David Kelly - Ralph
Richardson
Squadron Leader Skipper -
Robert Shaw
AVM Trafford Leigh-Mallory -
Patrick Wymark
Section Officer Maggie Harvey -
Susannah York

Warrant Officer Warwick -
Michael Bates
Wing Commander Willoughby -
Robert Flemyng
Mrs Andy - Isla Blair
Squadron Leader Edwards -
Barry Foster
Farmer - John Baskcomb
Pilot Officer Archie - Edward
Fox
Assistant Controller - Tom
Chatto
Squadron Leader Evans - W.G.
Foxley
Jamie - James Cosmo
Sgt Pilot Chris - David Griffin
Senior Air Staff Officer - Jack
Gwillim
French NCO - Andre Maranne
Peter - Myles Hoyle
Minister - Anthony Nicholls
Flt Sgt. Arthur - Duncan Lamont
Simon - Nicholas Pennell
Skipper's Wife - Sarah Lawson
Ox - Andrzej Scibor
Pasco - Mark Malicz
Jean Jacques - Jean Wladon
General Osterkamp - Wilfrid von
Aacken
Bruno - Reinhard Horras
General Jeschonnek - Karl-Otto
Alberty
Boehm - Helmut Kircher
Major Brandt - Alexander
Allerson

Major Fohn - Paul Neuhaus
Field Marshal Milch - Dietrich Frauboes
Colonel Beppo Schmidt - Malte Petzel
Brandt's Navigator - Alf Jungermann
Major Falke - Manfred Reddemann
Field Marshal Albert Kesselring - Peter Hager
Reichmarshal Hermann Goring - Hein Reiss
General Fink - Wolf Harnisch
Adolf Hitler - Rolf Stiefel

Rest of Cast

Dubbing of Voices - Nikki Van der Zyl
Albert - Paul Angelis
Radar Officer - Graham Armitage
Old Lady - Hilda Barry
Pilot (Fohn's Crew) - Nicky Beaumont
Grace - Kate Binchy
Air Observer - A.J. Brown
Pilot (Falke's Crew) - Gunter Clemens
Policeman - John Comer
Tactical Records Officer - Basil Dignam
RAF Officer - Eric Dodson
Soldier - Harry Fielder
Alistair - Gareth Forwood
Edith - Paddy Frost
RAF Cpl. Ernie - Brian Grellis

German Staff Officer - Michael Guest
'A' Station Pilots - Barry Halliday, Stuart Hoyle and Karl Paul Hansard
ADC to Hitler - Vincent Harding
WRAF Cpl. Seymour - Pat Heywood
General Staff Officer - Desmond Jordan
Air Observer - Geoffrey King
Andy's Taxi Driver - Jack Le White
Wendy - Illona Linthwaite
Radar Operator - Maureen Lipman
Workman - Reg Lye
Lac Arnold - David McKail
Pilot (Fohn's Crew) - Harold Meister
Civilian - George Merritt
Pilot (Falke's Squadron) - Hilary Minster
Pilot (Falke's Squadron) - Ingo Modendorf
Replacement Pilot (Red Section) - Richard Morant
British Embassy Valet - Richardson Morgan
Boy Watching Archie Landing by Parachute - Steve Morley
Boy - Christopher Morris
Air Observer - Geoffrey Morris
German Sergeant Pilot - Douglas Nottage
German Pilot - Hugo Panczak
Kelly's Butler - Clifford Parrish
Lady Kelly - Eileen Peel

'A' Station Pilots - David Quilter,
Clive Scott and Chris Tranchell
WAAF in Plotting Room - Pam
Rose
Messerschmitt Pilot - George
Roubicek
RAF Officer - John Savident
Old Lady - Kathleen St John
ADC, Intelligence - Frank
Sussman
RAF Pilot - Nick Tate
RAF Sergeant - Reg Thomason
Peasant Boy - Paul Tropea
Peasant Girl - Rosetta Tropea
Air Observer - Michael
Trubshawe
Charlie - Alan Tucker
German Pilot - Peter Wesp
Air Raid Warden - Alister
Williamson
Rescue Worker - Fred Wood

Production Crew

Producers: S. Benjamin Fisz and
Harry Saltzman
Associate Producer: John Palmer
Music: Ron Goodwin
Director of Photography: Freddy
Young
Film Editor: Bert Bates
Casting: Maude Spector

Art Direction

Supervising Art Director:
Maurice Carter
Art Directors: Bert Davey,
William Hutchison, Jack

Maxsted, Gil Parrondo and
Lionel Couch

Makeup Department

Chief Make-up Artists: Eric
Allwright and George Frost
Hairdresser: A.G. Scott

Production Management

Production Managers: Claude
Hudson and Agustin Pastor
Production Supervisor: Sydney
Streeter
Production Manager (Aerial
Unit): Bernie Williams
Unit Production Manager: Denis
Johnson Jr

Second Unit and Assistant Directors

Second Unit Director: David
Bracknell
First Assistant Director: Derek
Cracknell
First Assistant Director (Second
Unit): Terence Clegg
Second Assistant Director: Mike
Gowans
First Assistant Director (Aerial
Unit): Garth Thomas

Art Department

Storyboard Artist: Colin Grimes
Chief Draughtsman: Brian
Ackland-Snow
Draughtsman: Terry Ackland-
Snow

Chief Draughtsman: William
Alexander
Draughtsman: Dennis Bosher
Set Dressers: Timothy Bryan,
Vernon Dixon and Tony
Reading
Sketch Artist: Andrew Campbell
Assistant Art Directors: Roy
Dorman and Frank Wilson
Trainee Scenic Painter: Michael
Guyett
Painter: Julian Martin
Scenic Artist: Peter Melrose
Assistant Art Directors: Tony
Rimmington, John Siddall and
Alan Tomkins
Construction Managers: Ken
Softly and Gus Walker

Sound Department
Sound: Gordon Everett, Donald
C. Rogers and Gordon
McCallum
Sound Editors: Ted Mason and
James Shields
Sound Maintenance: Ron
Butcher
Assistant Sound Editors: Ron
Davies and Pat Gilbert
Boom Operator: Ken Reynolds

Special Effects
Ray Caple
Cliff Richardson
Glen Robinson
Wally Veevers
Nick Allder
Ian Scoones

Wally Armitage
Alan Barnard
Ron Burton
Colin Chilvers
Peter Dawson
Rodney Fuller
Jimmy Harris
Peter Hutchinson
Garth Inns
Malcolm King
Jack Mills
Robert Nugent
William Plampton
John Richardson
Brian Warner
Roy Whybrow

Visual Effects
Camera Assistant: Martin Body
Model Handler: Richard
Conway
Carpenter (Model Aircraft and
Cockpits): William Creighton
Special Photographic Mosaics:
Alf Levy
Assistant Modeller: Roger
Turner
Optical Effects: Ronnie Wass
Model Art Finisher: Brian
Wilsher

Stunts
Rick Lester
Nosher Powell

Camera and Electrical Department

Director of Photography (Second Unit): Robert Huke
Stills Photographers: David James, Keith Hamshere and Bob Penn
Aerial Photographers: Skeets Kelly and John Jordan
Electrician: George Pearman
Camera Operator (Second Unit): Chris Anstiss
Focus Pullers (Aerial Unit): Robin Browne and John Morgan
Clapper Loader: Trevor Coop
Camera Operator: Dudley Lovell
Focus Puller: Mike Rutter
Electrician: Jack Thetford

Casting Department

Casting (Germany): Carl Fox-Duering

Costume and Wardrobe Department

Wardrobe Mistress: Brenda Dabbs
Wardrobe Supervisor: John Wilson-Apperson

Editorial Department

First Assistant Editor: Timothy Gee
First Assistant Editor (Second Unit): Andy Smith

Music Department

Conductor: Ron Goodwin
Composer (Additional Music): William Walton
Music Recordist: Eric Tomlinson

Other Crew

Title Designer: Maurice Binder
Aerial Directors: David Bracknell and Quentin Lawrence

Technical Advisors

Hans Brustellin
Franz Frodl
Adolf GallandPeter Townsend
Tom Gleave
Ginger Lacy
Douglas Bader
Robert Stanford-Tuck
Robert Wright
Claire Legg WRAF
Hamish Mahaddie
Sqdr. Leader B. Drobinski

Other Crew

Dialogue Director (German): Carl Fox-Duering
Model Aircraft Operator: Chris Olsen
Continuity: Elaine Schreyeck
Continuity (Second Unit): June Faithfull and Joan Kirk
Continuity (Aerial Unit): Josephine Knowles
Technical Flying Advisor and Sketch Artist: John Blake
Director of Publicity: Derek Coyte

Unit Publicist: Larry Belling
B-25 Pilots: Jeff Hawke and
Duane Egli
Hurricane Pilot (Canadian Mk
XII): Bob Diemert
Hurricane Pilots: Dave Curry
and Tim Mills
Spitfire Pilots: Lefty Gardner,
R.B. Lloyd, Gerald Martin, M.R.
Merret, Tim Mills, Lloyd Nolen,
Connie Edwards, J.M. Preece,
D.J. Spink, S. Sgt. J. Momer and
Mike Vickers
Production Secretary: Janet
Turner
PR to Harry Saltzman: Adrian
Gaye
Assistant to Producer: David
Haft

List of aircraft used in *Battle of Britain* (1969) and current status where known

Aircraft Type	Serial No. or Civil Regn.	Supplied by	Status (1968)	Status (2016)
Hawker Hurricane				
Hawker Hurricane Mk. I	P2617	RAF	Static	RAF Museum, Hendon
Hawker Hurricane Mk. IIC	LF363	RAF	Flying	Flying, BBMF, Coningsby
Hawker Hurricane Mk. IIC	LF571	RAF (Gate Guardian), Bentley Priory	Static	Extant, RAF History Museum, Manston
Hawker Hurricane Mk. IIC	PZ865	Hawker Siddeley	Flying	Flying, BBMF, RAF Coningsby
Hawker Hurricane Mk. XII	G-AWLW	Bob Diemert	Flying	Destroyed in hangar fire, Hamilton, 15/2/93
Hawker Sea Hurricane Ib	Z7015	Shuttleworth Collection	Taxyable	Airworthy, Shuttleworth Collection, Old Warden
Supermarine Spitfire				
Supermarine Spitfire Mk.1a	AR213	Allen Wheeler	Flying	Airworthy, Spitfire The One Ltd
Supermarine Spitfire Mk. Ia	K9942	RAF	Spares Source	RAF Museum, Cosford
Supermarine Spitfire Mk.IIa	P7350	Gate Guardian RAF Colerne	Flying	BBMF, RAF Coningsby

311

Aircraft Type	Serial No. or Civil Regn.	Supplied by	Status (1968)	Status (2016)
Supermarine Spitfire Vb	BM597	Gate Guardian RAF Church Fenton	Mould Master	Airworthy, HAC, Duxford
Supermarine Spitfire Vb	BL614	Gate Guardian RAF Credenhill	Taxyable	RAF Museum, Hendon
Supermarine Spitfire LF.Vb	EP120	Gate Guardian RAF Wattisham	Static	Airworthy, The Fighter Collection, Duxford
Supermarine Spitfire L.F.Vb	AB910	RAF BOBF, Coltishall	Flying	Flying, BBMF, RAF Coningsby
Supermarine Spitfire Vc	AR501	Shuttleworth Collection	Flying	Airworthy, Shuttleworth Collection
Supermarine Spitfire IXb	MH434	Tim Davies Elstree	Flying	Airworthy, OFMC Duxford
Supermarine Spitfire H.F. IXb	MH415	Rousseau Aviation Dinard, France	Flying	Warbirds Flight Club, Scone, Australia; Restoration to fly
Supermarine Spitfire LF.IXc	MK297	Confederate Air Force	Flying	Destroyed in hangar fire, Hamilton, 15/02/93
Supermarine Spitfire LF.IXc	MK356	Gate Guardian RAF Locking	Static	BBMF, Coningsby
Supermarine Spitfire Tr.IX	MJ772	Samuelson Film Services	Flying	Airworthy, Fighter Academy, Herringsdorff
Supermarine Spitfire TR.IX	TE308	Samuelson Film Services, Camera ship	Flying	Airworthy, Aspen, Colorado

Aircraft Type	Serial No. or Civil Regn.	Supplied by	Status (1968)	Status (2016)
Supermarine Spitfire FR.XIVc	NH904	Bunny Brooks Garage, Hoylake	Spares Source	Palm Springs Air Museum, CA
Supermarine Spitfire F.XIVc	RM694	Manchester Tankers Ltd	Spares Source	Stored, High Wycombe
Supermarine Spitfire F.XIVc	RM689	Rolls Royce Ltd	Flying	Crashed, destroyed 27/06/92
Supermarine Spitfire LF.XVIe	RW382	Gate Guardian RAF Leconsfield	Static	Crashed, destroyed 03/06/98
Supermarine Spitfire LF.XVIe	SM411	RAF Wattisham	Taxyable	Museum of Aircraft & Astronautics, Krakow
Supermarine Spitfire L.F. XVIe	SL574	RAF Bentley Priory	Static	San Diego Air & Space Museum
Supermarine Spitfire LF. XVIe	TB382	Gate Guardian RAF Hospital, Ely	Taxyable	BBMF Coningsby, Spares Source
Supermarine Spitfire LF.XVIe	TB863	Pinewood Studios	Spares Source	Airworthy, Alpine Fighter Collection, NZ
Supermarine Spitfire LF. XVIe	TD248	Gate Guardian RAF Sealand	Spares Source	Airworthy, Spitfire Ltd, Duxford
Supermarine Spitfire L.F. XVIe	TE356	RAF Bicester	Taxyable	Evergreen Aviation Museum, Oregon
Supermarine Spitfire L.F. XVIe	TE311	Gate Guardian RAF Tangmere	Taxyable	BBMF, Under Restoration

Aircraft Type	Serial No. or Civil Regn.	Supplied by	Status (1968)	Status (2016)
Supermarine Spitfire LF.XVIe	TE384	RAF Syerston	Taxyable	San Martin, CA, USA
Supermarine Spitfire L.F. XVIe	TE476	Gate Guardian RAF Neatishead	Taxyable	Fantasy of Flight, Kermit Weeks, Florida
Supermarine Spitfire PR.XIX	PM651	Gate Guardian RAF Benson	Static	RAF Museum, Cosford
Supermarine Spitfire PR.XIX	PM631	RAF, BOBF, Coltishall	Flying	BBMF, RAF Coningsby
Supermarine Spitfire PR.XIX	PS915	Gate Guardian RAF Leuchars	Static	Airworthy BBMF, RAF Coningsby
Supermarine Spitfire Pr.XIX	PS853	BOBF, Coltishall	Static	Airworthy, Rolls-Royce Heritage Flight
Supermarine Spitfire F.21	LA198	197 Squadron ATC Worcester	Static	Kelvingrove Museum, Glasgow
Supermarine Spitfire Mk. 24	PK724	RAF Gaydon	Spares	RAF Museum, Hendon

Hispano HA.1112M1L (used to portray Messerschmitt Bf109Es)
All supplied by Spanish Air Force

Aircraft Type	Registration/ Serial No.	Status (1968)	Status (2016) where known
Hispano HA.1112M1L	G-AWHD C.4K-126	Flying	Bought by Boschung Global
Hispano HA.1112M1L	G-AWHI C.4K-106	Flying	Steve Rister, Batavia

Aircraft Type	Registration/ Serial No.	Status (1968)	Status (2016) where known
Hispano HA.1112M1L	G-AWHG C.4K-75	Flying	Airworthy, Messerschmitt Foundation, Germany; DB605 engine fitted
Hispano HA.1112M1L	G-AWHE C.4K-31	Flying	Airworthy, Spitfire Ltd., Jersey
Hispano HA.1112M1L	G-AWHF C.4K-61	Flying	Ground Looped, 21/05/68
Hispano HA.1112M1L	G-AWHH C.4K-105	Flying	Extant, Richard Hanson, Batavia, USA
Hispano HA.1112M1L	G-AWHC C.4K-112	Camera Plane Two seater	Air Leasing, Sywell; Restoration to fly
Hispano HA1112.M1L	G-AWHT C.4K-169	Flying	Air Fighter Academy Heringdorf, Germany; Converted to two- seat Bf109G-12, DB605 engine, Now D- FMVS
Hispano. HA.1112.M1L	G-AWHS C.4K-170	Flying	Auto & Technik Museum, Germany; DB605 engine fitted, Static
Hispano.HA1112.M1L	G-AWHR C.4K-152	Flying	Bought by Boschung Global Ltd
Hispano HA.1112.M1L	G-AWHO C.4K-127	Flying	EAA Airventure Museum, USA
Hispano HA. 1112.M1L	G-AWHP C.4K-144	Flying	Crashed & Destroyed, 19/12/87
Hispano HA.112.M1L	G-AWHN C.4K-130	Flying	Erickson aircraft collection, Madras, Oregon

Aircraft Type	Registration/ Serial No.	Status (1968)	Status (2016) where known
Hispano HA.1112.M1L	G-AWHM C4K-99	Flying	Air Leasing, Sywell; Restoration to Fly
Hispano HA.1112.M1L	G-AWHL C.4K-122	Flying	Museum of Flight, Seattle; DB605 engine fitted, Static
Hispano HA.1112.M1L	G-AWHK C.4K-100	Flying	Airworthy, Historic Flying Ltd., Duxford, UK
Hispano HA.1112.M1L	G-AWHJ C.4K-100	Flying	Kalamazoo Aviation History Museum
Hispano HA.1112.M1L	C4K-30	Spares Source RAF Henlow	Bought by Boschung Global Ltd
Hispano.HA.1112M1L	C.4K-107	Taxyable	Crashed, Sabadell, Spain, 25/09/99
Hispano.HA1112.M1L	C.4K-111	Cockpit Shots, Pinewood Studios	Boschung Global Ltd.
Hispano HA.1112.M1L	C4K-114	Spares Source RAF Henlow	Static. Western Canada Aviation Museum
Hispano HA.1112.M1L	C4K-121	Taxyable	Unknown
Hispano HA.1112.M1L	C.4K-131	Taxyable	Airworthy, Eric Vormezeele Braaschatt, Belgium
Hispano HA.1112.M1L	C.4K-134	Taxyable	Wittmundhafen, AFB DB605 engine fitted.
Hispano HA1112.M1L	C.4K-135	Taxyable	Airworthy, Messerschmitt Foundation, Germany D-FMBB
Hispano HA.1112.M1L	C.4K-154	Spares Source RAF Henlow	Boschung Global
Hispano HA.1112.M1L	C.4K-172	Taxyable	Cavanaugh Flight Museum, Addison, Texas

CASA 2.111 (used to portray Heinkel He111s)

Aircraft Type	Registration/ Serial No.	Status (1968)	Status (2016) where known
CASA 2.111B	G-AWHB B.21-157	Flying	Stored, Norfolk, England; Owned by Flying Heritage Collection, Washington
CASA 2.111B	G-AWHA	Flying	Deutsches Museum, Germany (Static)
CASA 2.111B	B.21-20	Studio Shots	Extant, Austria (Interior)

In addition to the CASAs listed above, another 30 were used in flying sequences in Spain. A few other non-airworthy CASA 2.111s were present at Tablada airfield in Spain, and one was used in a crash sequence towards the end of the film. In addition to those aircraft listed above, another nine complete CASA 2.111 airframes (plus one cockpit section) exist today at various locations. At least some of those aircraft will have participated in the making of the film in some capacity. Details are given below:

Aircraft Type	Registration/ Serial No.	Status (1968)	Status (2016) where known
CASA 2.111B	B.2-82	Flying	Auto und Technik Museum, Sinsheim
CASA 2.111B	B.21-103	Flying	IWM, Duxford
CASA 2.111F	T.8-97	Flying	Museo del Aire, Madrid
CASA2.111D	B.2H-118	Flying	Musee de l'air, Paris, Le Bourget
CASA 2.111B	B2.H-109	Flying	Luftwaffen Museum, Germany
CASA 2.111D	BR.21-14	Unknown	Flugaustellung Hermeskiel, Germany
CASA 2.111B	B.21-22	Flying	USAF Museum, Dayton, Ohio
CASA 2.111B	B.21-27	Flying	Cavanaugh Flight Museum

Aircraft Type	Registration/ Serial No.	Status (1968)	Status (2016) where known
CASA 2.111B	B.21-39	Flying	Flying Heritage Collection, Washington
CASA 2.111 (Nose)	Unknown	Unknown	Camarenilla Airfield, Spain

Other aircraft used in making of film

Aircraft Type	Registration/ Serial No.	Status (1968)	Status (2016) where known
CASA 352L (Junkers 52/3m)	T.2B-176	Airworthy	Training Services Inc. Virginia Beach
CASA 352L	Unknown	Static	Unknown
Percival Proctor	G-AIEA	Parts	Scrapped
Percival Proctor	G –AIEY	Flew as 'Proctuka'	Scrapped
Percival Proctor	G-ALOK	Parts	Scrapped
Percival Proctor	Unknown	Parts	Scrapped

Camera Aircraft

Aircraft Type	Registration/ Serial No.	Status (1968)	Status (2016) where known
B-25J	N6578D	Camera Plane	Reevers Warbirds Australia; Restoration to fly
Sud-Air 318C Alouette II	G-AWAP	Camera Helicopter	Crashed, 26/06/83

Museum Aircraft

Aircraft Type	Registration/ Serial No.	Status (1968)	Status (2016) where known
Junkers Ju87G-2 Stuka	494083	Pattern aircraft for R/C models	RAF Museum, Hendon

The RAF Historical Branch also offered a Messerchmitt Bf109E, Messerschmitt Bf 109G, Junkers 88 night fighter, Messerschmitt BF110 night fighter and a Heinkel He 111 for possible (static) use in the film, but these were not used in any capacity.

Fibreglass replicas

A number of full-scale fibreglass replicas were built for the film and details are given below:

Type	Serial Number	Current Status (2016)
Supermarine Spitfire	N3289	Unknown
Supermarine Spitfire	N3289	Kent Battle of Britain Museum, Hawkinge
Supermarine Spitfire	N3313	Kent Battle of Britain Museum
Supermarine Spitfire	N3313	Believed extant
Supermarine Spitfire	P8140	Believed extant
Supermarine Spitfire	P9340	Believed extant
Supermarine Spitfire	N3313	Torbay Aircraft Museum
Hawker Hurricane	P3975	Extant, Delabole, Cornwall
Hawker Hurricane	L1592	Torbay Aircraft Museum
Hawker Hurricane	L1592	Kent Battle of Britain Museum
Hawker Hurricane	P3059	Unknown
Hawker Hurricane	P2640	Extant in New Zealand
Hawker Hurricane	V7767	Gloucestershire Aviation Collection
Hawker Hurricane	V7467	Midland Air Museum
Hawker Hurricane	P3059	Kent Battle of Britain Museum
Hawker Hurricane 'Panavision' replica (distorted perspective)	?	Kent Battle of Britain Museum
Hispano HA.1112.M1L Buchon	'14'	Kent Battle of Britain Museum
Hispano HA.112.M1L	'14'	Midland Air Museum
Hispano HA. 1112.M1L	1480/6	Kent Battle of Britain Museum
Hispano HA.1112.M1L	1480/6	Unknown
Hispano HA.1112.M1L	6357	Torbay Aircraft Museum
Hispano HA.1112.M1L	6356	Kent Battle of Britain Museum
CASA.2-111 (Fuselage only)	-	Lincolnshire Aviation Heritage Centre, East Kirkby, UK

Notes

As you can see, many of these replicas have survived. Some have been restored. In particular, some of the Hispano Buchons have had new cowlings fitted to replicate the appearance of a Bf109E. It is likely that a 'Panavision' fibreglass replica of a Buchon was created for head-on shots of it firing its guns, but it does not appear to have survived.

The Ones That Got Away
A Look at Some Proposed Aviation Movies which Never Happened

Ｉn this book I have discussed my ten favourite aviation films, and in some cases have described the difficulties that were encountered in bringing them to the screen. But for every flying film that has seen the light of day, there have been others that have been proposed but never produced. In other cases, aviation films have started production but have remained unfinished because of soaring costs.

Of course, it is not just aviation films which have suffered this fate. Movies in any genre can sometimes be started and then abandoned. A good example would be Alexander Korda's version of *I Claudius* (1937), which was never completed. Much footage from the aborted production still exists and has turned up in documentaries and on YouTube. There are also films which have been proposed but have never entered production. John French in his biography of Robert Shaw, *The Price of Success*, mentioned that only *1 in 70* commissioned screenplays are ever made into films.

In 1959, Irish film producer Kevin McClory collaborated with Ian Fleming, Ivor Bryce and Jack Whittingham to produce an original screenplay (*Longitude 78 West*) which later became *Thunderball*. It was originally intended be the first James Bond film, but in the end the producers elected to start the franchise with the simpler (and cheaper) *Dr No* (1962). A year earlier, Fleming had infuriated McClory and Whittingham by bringing out a novelisation of

the *Thunderball* screenplay which did not credit them. A court case followed, which resulted in the rights to *Thunderball* being passed to McClory. Later, Bond producers Harry Saltzman and Cubby Broccoli made a deal with McClory to produce *Thunderball* in 1965 as part of the official Eon Films' Bond franchise.

A clause in the 1963 legal settlement meant that the rights to *Thunderball* passed to McClory after ten years, and so from 1975 onwards he attempted to make a new version of the film. One such project in 1975, called *Warhead*, involved both Sean Connery and Len Deighton, but the film never got made. Eventually, a remake of *Thunderball* did appear in 1983 called *Never Say Never Again*, with Sean Connery reprising his most famous role.

Despite this film only being moderately successful, McClory announced his intention to make further Bond adventures, all of which were opposed by Eon's legal department. McClory even approached Pierce Brosnan in the late eighties about playing Bond in the rival series. At that time, Brosnan had just lost the role of Bond to Timothy Dalton because the producers of the TV series *Remington Steele* insisted he make a further series. Brosnan declined the offer to make a rival Bond picture, but McClory continued to be obsessed with idea of making another remake of *Thunderball* right up until his death in 2006. The legal ramifications of the 1963 court case were only finally settled in 2013, which explains why SPECTRE and Blofeld have only recently reappeared in the franchise.

Thus many films are never made because of legal objections, and others due to lack of funding. When you add on the great costs involved in making an aviation movie –

such as the vast expense of operating vintage aircraft – then it is no surprise that many promised films have failed to appear.

In the chapter on *The Dambusters*, I have mentioned Peter Jackson's proposed remake which may or may not see the light of day. Interestingly, Jackson has a special interest in First World War aircraft and owns a collection of WWI aeroplanes including two of the replicas constructed for *The Blue Max* (1966). He has previously expressed a desire to remake this film, particularly as the 1966 original departed considerably from Jack D. Hunter's original novel and featured some inaccurate aircraft such as thinly-disguised Tiger Moths.

It is also remarkable that no-one has ever made a feature film based on Richard Hillary's autobiographical book *The Last Enemy* (1942). Hillary was an RAF Spitfire pilot who was shot down and badly burned during the Battle of Britain and became one of Archibald McIndoe's 'Guinea Pigs', undergoing a large number of skin graft operations to treat severe burns to his face and hands. Despite his injuries, Hillary returned to flying duties as a night-fighter pilot. He flew Blenheims and Beaufighters and was tragically killed during a training flight in 1943.

In 1956, Peter Graham Scott (who later produced the 1971-1980 BBC series *The Onedin Line*) directed a TV adaptation of *The Last Enemy* for ATV. Though it was a largely studio-bound production, the Air Ministry supplied a single Spitfire for aerial scenes. Hillary was played by actor Pete Murray, who later became famous as a DJ and presenter on *Top of the Pops*, while John Breslin (well-known to *Doctor Who* fans as Captain Munro in the classic 1970 *Doctor Who* story *Spearhead From Space*) was cast in the supporting role of Peter.

No TV or film adaptations of the book have appeared since. Around 1989, there were reports in the media that both the BBC and ITV were preparing their own rival productions of *The Last Enemy*, and that a cinematic version was also planned. In the event none of these three projects ever appeared, allegedly due to objections from the Hillary family, and instead ITV made a series called *Perfect Hero* (1991) starring Nigel Havers as a burned Spitfire pilot who later became an instructor.

It is also surprising that Hollywood has never made a film about the 'Flying Tigers' – or the American Volunteer Group as it is more correctly known – other than the rather poor 1942 John Wayne film which largely employed rather unconvincing and inaccurate wooden replicas of Curtiss P-40s for ground scenes. In the mid-1990s, *Warbirds Worldwide* journal reported that a film about the AVG (which was due to be shot in Mexico) had been abandoned. Witnesses reported seeing hangars full of replica aircraft which were subsequently scrapped.

In more recent years there have been reports that two different films about the 'Flying Tigers' were in production; one directed by John Woo and the other starring Tom Cruise, himself an aviation enthusiast and the owner of a North American P-51 Mustang fighter. Cruise had starred in *Top Gun* (1986), one of the most popular movies of the eighties. For years, a sequel to this movie has been rumoured with Cruise perhaps playing the role of chief flying instructor, but so far it has not appeared.

Tom Cruise was also supposed to star in *The Few* several years ago. This film about Billy Fiske, one of seven Americans to fly in the Battle of Britain and the only one to

die in combat, was to be directed by Michael Mann but was subsequently cancelled.

This has not been the only film about the Battle of Britain which has failed to appear. In 2013, reports appeared in the media that respected film producer Robert Towns – best-known for *Chinatown* (1974) – was writing the screenplay for a new film about the Battle. Some accounts of the proposed new film expressly stated that it was a remake of the 1969 film directed by Guy Hamilton.

In 2010 at the 'War and Peace' Show at Beltring (a huge outdoor exhibition of military vehicles), a replica glass fibre Hurricane used in *Battle of Britain* (1969) was on display at a stand run by an organisation called 'Their Finest Hour'. This outfit subsequently claimed that it was looking into the possibility of producing a new film about the Battle, but no more has been heard about this project.

A remake of *633 Squadron* (1964) has also been suggested. About a decade ago there were reports that a new version of the music from the film was to be commissioned for use in a remake, but there has been no news since. Rumours about a new version of *633 Squadron* (or another similar movie featuring Mosquitoes) resurfaced in 2012 when D.H. Mosquito F.B. Mark 26 KA114, the first of its type to fly since 1996, took to the air in New Zealand. The company which handled the rebuild (Avspecs) hopes to restore a few more derelict Mosquitoes to airworthy condition.

Incidentally, the star of *633 Squadron* – Cliff Robertson – has appeared in a few aviation movies. One called *I Shot Down the Red Baron, I Think* was filmed in Spain and Ireland in 1970, but was never completed. 14 cans of aerial footage are said to exist from this uncompleted production.

Another film which remains unfinished at the time of writing is *Destroyer*, based on Captain David Hart-Dyke's book *25 Days in May* about the exploits of HMS *Coventry*, a Type 42 air-defence destroyer, during the 1982 Falklands War. *Coventry* successfully shot down at least three Argentine aircraft with her Sea Dart missiles, but was then herself sunk by bomb-carrying Douglas A-4 Skyhawks on 25 May 1982. At one point it was intended that Colin Firth would play Captain Hart-Dyke, but he is no longer involved in the project.

Some filming was carried out with HMS *Edinburgh*, the last operational Type 42 destroyer, in 2013, and some scenes have also been shot at the Malta Film Services water tank. But nothing more has been heard about the film for three years.

A similar fate seems to have befallen a proposed film about the early days of the SAS in the Western Desert during WW2 (which would just qualify as an aviation film, because it would have featured attacks on Axis airfields). It was announced in the media more than a decade ago with filming to take place in Morocco, but it has yet to appear.

A new version of *The Final Countdown* (1980), about an American aircraft carrier – the USS *Nimitz* – travelling back to 6 December 1941 due to a 'Time Storm', has also been proposed. In this revised version, the action was to take place off the coast of Japan rather the waters near Hawaii, but no more information on this production has appeared in the last few years. There have also been rumours about a new version of *Midway* (1976), known as *The Battle of Midway* in the UK. The original was a TV movie in the USA, but was released as a theatrical feature (in 'Sensurround') in the UK in February 1977.

Hopefully at least some of these films will eventually be made, for one thing is certain: aviation films will continue to be made as long as there are people who want to see them. As I was completing this book in the summer of 2016, news emerged that several genuine WW2 aircraft were to be used in a new film about the Dunkirk evacuation which was to be directed by Christopher Nolan and released in July 2017. I am keeping my fingers crossed for some spectacular footage of air battles.

References

The Internet Movie Database (**www.imdb.com**) and Wikipedia (**www.wikipedia.com**) were used as reference sources for every film. In addition, the following books, magazines and websites were used as reference sources:

The Dambusters

Filming the Dambusters by Jonathan Falconer. Sutton Publishing Ltd. 2005. ISBN 0 7509 37122.

Flying Film Stars by Mark Ashley. Red Kite books. 2014. ISBN 978-1-906592-15-8.

After the Battle magazine. Issue No 10. 1974. ISSN: 0306-154X.

Dambusters by James Holland. Bantam Press. 2012. ISBN 978-0593066768.

Dam-busters. The Amazing story of Operation Chastise. Aeroplane Monthly Special. 2013. ISBN 978-1-907426-83-4.

Dambusters. The Most Daring Raid in Aviation History. Mortons Media Group Ltd. 2013. ISBN 978-1-909128-21-7.

Salute Dambusters. 70th Anniversary Special. Key Publishing Ltd. 2013.

Aeroplane (magazine) '70th anniversary of the famous dams raid', May 2013.

Memorial Flight. Spring 2013 issue. No 59. Dambusters 70th anniversary edition. Published by Lincolnshire Lancaster Association.

Reach for the Sky
All My Flashbacks by Lewis Gilbert. Reynolds and Hearn 2010. ISBN 978-1904674245.

After the Battle magazine. Number 35. Published by Battle of Britain Prints International Ltd. ISSN: 0306-154X.

Flying Film Stars by Mark Ashley. Red Kite Books. 2014. ISBN 978-1-906592-15-8.

The Flight of the Phoenix
Broken Wings. Hollywood's Air Crashes by James H. Farmer. Pictorial Histories Publishing Company 1984. ISBN 0-933126-46-8.

Aeroplane Monthly. May 2016 issue. *The Flight of the Phoenix: Fifty Years On* by Simon Beck.

Simon Beck's website: **www.C82packet.com**

633 Squadron (& Mosquito Squadron)
Warbirds Worldwide. Journal 29. 'The Filming of *633 Squadron*' by Gary. R. Brown. June 1994 issue. ISBN 1 870601 38 6.

Mosquito Survivors by Stuart Howe. Aston Publications. 1986. ISBN 0-946627-04-5.

Mosquito: A Celebration of De Havilland's 'Wooden Wonder'. Key Publishing Flypast special 2009. Article on *633 Squadron* by Daniel Ford. ISBN 978-0-946219-18-6.

Mosquito: Britain's World War Two Wooden Wonder. Kelsey Publishing Group 2012. Article on 633 Squadron by Francois Prins. ISBN 978-1-907426-59-9.

After the Battle magazine. Published by Battle of Britain Prints International Ltd. Number 18. 1977. Article on *Mosquito Film Stars* by Gordon Riley. ISSN: 0306-154X.

Air Pictorial magazine. September 1963. Vol 25. No 9. Article on *633 Squadron* by Graeme Weir.

Cinema Retro. Vol 9: Issue 26. 2013. *Chocks Away!* Article on making of *Mosquito Squadron* by Howard Hughes.

Flying Film Stars by Mark Ashley. Red Kite Books. 2014. ISBN 978-1-906592-15-8.

The Blue Max

The Blue Max by Jack D. Hunter. 1964. ISBN 0-7351-0456-5.

Delta Papa. A Life of Flying by Derek Piggott. Pelham Books. 1977. ISBN 0-7207-0979-2.

Making' The Blue Max': **www.historynet.com/making-the-blue-max.htm**

Dark Blue World

Flying Film Stars by Mark Ashley. Red Kite Books. 2014. ISBN 978 -1-906592-15-8.

'Making of' documentary and director's commentary on DVD of film.

Tora, Tora, Tora

Flypast Magazine No 125. December 1991 issue. Article on making of *Tora, Tora, Tora* by Scott Thompson.

After the Battle magazine. No 53. 1986. Published by Battle of Britain Prints International Ltd. Article on making of *Tora, Tora, Tora.*

After the Battle magazine. No 113. 2001. 'The Day of Infamy on Screen'. Article covers both *Tora, Tora, Tora* and *Pearl Harbor.*

Aircraft Illustrated. December 2011 issue. Published by Ian Allan Ltd. Article on Commemorative Air Force's 'Tora, Tora, Tora' Flight and surviving 'Tora' aircraft.

The Aircraft Spotter's Film and Television Companion by Simon D. Beck. McFarland and Company, Inc. North Carolina, USA. ISBN 978-1-4766-69494.

Director's commentary of DVD of film.

Article on making of *Tora, Tora, Tora*. **www.daveswarbirds.com/tora/frames.htm**

Raid on Entebbe

Broken Wings. Hollywood's Air Crashes. By James H. Farmer. Pictorial Histories Publishing Company. 1984. ISBN 0-933126-46-8.

Operation Thunderbolt by Saul David. Little Brown and Company. 2015. ISBN 978-031-6245418.

Exocet Falklands. The Untold Story of Special Forces Operations by Ewen Southby-Tailyour. Pen & Sword Maritime. 2014. ISBN 978-178-3463879.

Memphis Belle

Flying Film Stars by Mark Ashley. Red Kite Books. 2014. ISBN 978-1-906592-15-8.

After the Battle. Number 69. 1990. 'The remaking of *Memphis Belle*.' ISSN 0306-154X.

Aeroplane Monthly. September 1989. Article on forthcoming film *Memphis Belle*. ISSN 0143-7240.

Warbirds Worldwide. Numbers Ten and Eleven. 1989. Filming *Memphis Belle*. ISBN 1 970601 09 2.

Sally B News. Issue 18. Spring/Summer 1989.

Sally B News. Issue 19. Winter 1989/90.

Sally B News. Issue 20. Spring/Summer 1990.

Battle of Britain

Battle of Britain, The Movie by Robert J. Rudhall. Ramrod Publications. 2000. ISBN 0-951832-9-6.

Battle of Britain Film, The Photo Album by Robert J. Rudhall. Ramrod Publications. 2001. ISBN 0-9538539-3-4.

Battle of Britain: The Making of a Film by Leonard Mosley. 1969.

Flying Film Stars by Mark Ashley. Red Kite books. 2014. ISBN 978-1-906592-15-8.

The Battle. The Journal of the Battle of Britain Film Society. No 1. 1991.

Aeroplane Monthly. October 1999. 'Echoes of The Battle of Britain' by Tony Harmsworth.

Aeroplane Monthly. October 2009. Article on new photos from *Battle of Britain* by Peter R. Arnold.

Flypast magazine. September 1989. Articles on *Battle of Britain* by Francois Prins and Robert J. Rudhall.

Flypast magazine October 1989. Article on *Battle of Britain* by Francois Prins.

Flypast magazine. September 1999. Article on *Battle of Britain* by Donald MacCarron.

Flypast magazine. August 2009. Article on *Battle of Britain* by Francois Prins.

Airfix Magazine. February 1969. *Battle of Britain* film previewed.

Warbirds Worldwide. Nos. 5 and 6. 1988. Articles on *Battle of Britain* by Robert J. Rudhall.

Photoplay Film Monthly. October 1968. Preview of *Battle of Britain* film.

Photoplay Film Monthly. October 1969. Article on *Battle of Britain.*

The Big Screen scene. Showguide. September 1969. Article on *Battle of Britain.*

Wingspan Magazine. July/August 1988 issue. Articles on Vivian Bellamy including work on *Battle of Britain.*

Air Pictorial. September 1969. Article on *Battle of Britain* film.

Souvenir programme from *Aeroplane* magazine's *Battle of Britain* film celebration at Duxford on September 19, 1999.

Index

336

E

G

345

H

I

J

351

N

O

Q

R

S

360

X

Illustrations

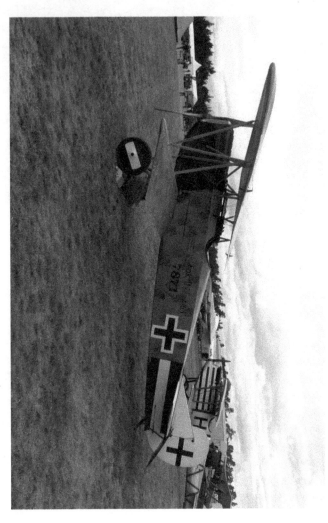

(Reproduced by kind courtesy of the private photographic
collection of Simon D. Beck.)

A Fokker DVII Replica ZK-FOD used in *The Blue Max*,
pictured at Omaka Airfield, New Zealand in April 2015.

Boeing B-17G N3703G being prepared for use in *Memphis Belle* at Duxford on 23rd June 1989.

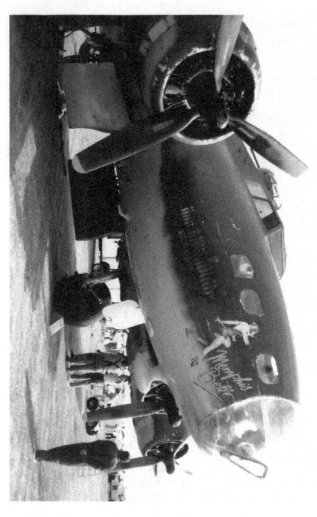

(From the private photographic collection of Colin M. Barron.)

Another shot of B-17G N3703G at Duxford
on 23rd June 1989.

(Image by the United States Air Force. Reproduced by kind courtesy of the private photographic collection of Simon D. Beck.)

A Fairchild C-82 Packet as used in *Flight of the Phoenix*.

(From the private photographic collection of Colin M. Barron.)

De Havilland Mosquito B.35 TA719 under restoration at
Duxford in June 1989. Formerly owned by the Skyfame
Museum, it flew in *633 Squadron* and had a static role in
Mosquito Squadron.

(From the private photographic collection of Colin M. Barron.)

Boeing B-17G G-BEDF 'Sally B' at Duxford in June 1989,
just prior to the start of filming of *Memphis Belle*.

(Image by Fairchild. Reproduced by kind courtesy of the
private photographic collection of Simon D. Beck.)

A Fairchild C-82 Jet Packet.
Note the jet engine on top of the fuselage.

(From the private photographic collection of Colin M. Barron.)

Three P-51D Mustangs and a Hispano Buchon at Duxford in June 1989 for the filming of *Memphis Belle*. The aircraft in the foreground is Spitfire Mark IX MH434, which was used in *Battle of Britain*. In 1989 this aircraft was painted as a PR Blue photo-reconnaissance aircraft.

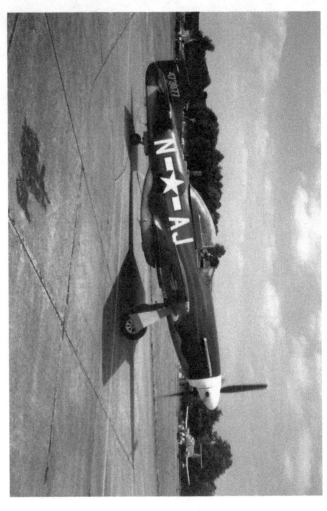

(From the private photographic collection of Colin M. Barron.)

P-51D Mustang N167F at Duxford in June 1989 for the filming of Memphis Belle.

A Pfalz D.III replica ZK-JPI, used in *The Blue Max*.
Photographed at Omaka airfield, New Zealand
in April 2015.

(From the private photographic collection of Colin M. Barron.)

B-17G Fortress 'Sally B' at Duxford, prior to the filming of *Memphis Belle* in June 1989.

(From the private photographic collection of Colin M. Barron.)

Two of the Hispano Buchons used in the filming of
Memphis Belle at Duxford, June 1989.

About the Author

Dr Colin M. Barron was born in Greenock, Scotland in 1956, and was educated at Greenock Academy (1961-74) and Glasgow University (1974-79) where he graduated in Medicine (M.B. Ch.B.) in 1979. He worked for the next five years in hospital medicine, eventually becoming a Registrar in Ophthalmology at Gartnavel General Hospital and Glasgow Eye Infirmary.

In December 1984 he left the National Health Service to set up Ashlea Nursing Home in Callander, which he established with his first wife Sandra and ran until 1999. He was the chairman of the Scottish branch of the British Federation of Care Home Proprietors (BFCHP) from 1985 to 1991, and then a founding member and chairman of the Scottish Association of Care Home Owners (SACHO) from 1991 to 1999.

Colin has a special interest in writing – his first non-fiction book *Running Your Own Private Residential and Nursing Home* was published by Jessica Kingsley Publishers in 1990. He has also written around 150

articles for various publications including *This Caring Business*, *The Glasgow Herald*, *Caring Times*, *Care Weekly*, *The British Medical Journal*, *The Hypnotherapist*, *The Thought Field* and many others. He was a regular columnist for *This Caring Business* between 1991 and 1999.

Colin has always had a special interest in hypnosis and alternative medicine. In 1999 he completed a one-year Diploma course in hypnotherapy and neuro-linguistic programming with the British Society of Clinical and Medical Ericksonian Hypnosis (BSCMEH), an organisation created by Stephen Brooks who was the first person in the UK to teach Ericksonian Hypnosis. He has also trained with the British Society of Medical and Dental Hypnosis (BSMDH) and with Valerie Austin, who is a top Harley Street hypnotherapist. Colin is also a licensed NLP practitioner. In 1992 he was made a Fellow of the Royal Society of Health (FRSH). He is a former member of various societies including the British Society of Medical and Dental Hypnosis - Scotland (BSMDH), the British Thought Field Therapy Association (BTFTA), the Association for Thought Field Therapy (ATFT), the British Complementary Medicine Association (BCMA), and the Hypnotherapy Association.

Colin has been using TFT since early in 2000, and in November 2001 he became the first British person to qualify as a Voice Technology TFT practitioner. He used to work from home in Dunblane and at the Glasgow Nuffield Hospital.

Colin has also had 40 years of experience in public speaking, and did some training with the John May School of Public Speaking in London in January 1990.

In May 2011 his wife Vivien, then 55, collapsed at home due to a massive stroke. Colin then became his wife's carer but continued to see a few hypnotherapy and TFT clients. In late July 2015 Colin suffered a very severe heart attack and was rushed to hospital. Investigation showed that he had suffered a rare and very serious complication of myocardial infarction known as a ventricular septal defect (VSD) - effectively a large hole between the two main pumping chambers of the heart.

Colin had open heart surgery to repair the defect in August 2015, but this first operation was unsuccessful and a second procedure had to be carried out three months later. On 30th November he was finally discharged home after spending four months in hospital. Unfortunately he also developed epilepsy while in hospital which meant he has had to give up driving for at least a year.

As a result of his wife's care needs and his own health problems Colin closed down his hypnotherapy and TFT business in April 2016 to concentrate on writing books and looking after his wife.

His interests include walking, cycling, military history, aviation, plastic modelling, and reading.

For more details about Colin and his work, please visit his website at: **www.colinbarron.co.uk**

The Craft of Public Speaking

By Colin M. Barron

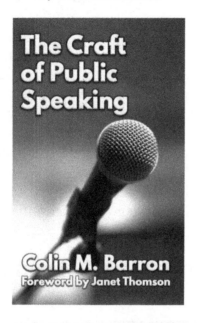

Public speaking is one of the most important skills in personal and professional life. Yet too often this key ability is neglected, leading to presentations which are dull, uninspired and poorly delivered.

The Craft of Public Speaking examines some of the crucial aptitudes which are fundamental to delivering an effective presentation for listeners. These include preparation, structure and rehearsal, in addition to some of the more overlooked aspects of oration such

as the use of visual aids, adding humour, and dressing for success. As well as discussing how to deliver effective live addresses in public settings, the book also covers interview techniques for TV and radio along with how to organise seminars and conferences.

Dr Colin M. Barron has delivered hundreds of lectures and presentations to audiences during a long career, giving speeches on a wide variety of different subjects over many years. In *The Craft of Public Speaking*, he shares the essential knowledge that you will need to become a truly successful public speaker.

For more details about *The Craft of Public Speaking*, please visit the Extremis Publishing website at:

www.extremispublishing.com

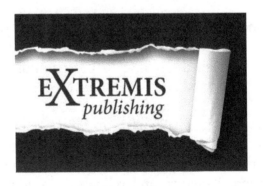

Also Available from Extremis Publishing

The Spectrum of Adventure
A Brief History of Interactive Fiction
on the Sinclair ZX Spectrum
By Thomas A. Christie

The Sinclair ZX Spectrum was one of the most popular home computers in British history, selling over five million units in its 1980s heyday. Amongst the thousands of games released for the Spectrum during its lifetime, the text adventure game was to emerge as one of the most significant genres on the system.

The Spectrum of Adventure chronicles the evolution of the text adventure on the ZX Spectrum, exploring the work of landmark software houses such as Melbourne House Software, Level 9 Computing, Delta 4 Software, the CRL Group, Magnetic Scrolls, and many others besides.

Covering one hundred individual games in all, this book celebrates the Spectrum's thriving interactive fiction scene of the eighties, chronicling the achievements of major publishers as well as independent developers from the machine's launch in 1982 until the end of the decade in 1989.

Also Available from Extremis Publishing

An Innocent Abroad
The Misadventures of an Exchange Teacher in Montana: Award-Winner's Edition

By David M. Addison

An Award-Winning Book in the 2015 Bookbzz Prize Writer Competition for Biography and Memoir

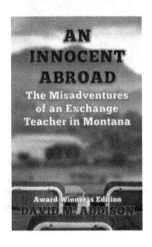

When, in 1978, taking a bold step into the unknown, the author, accompanied by his wife and young family, swapped his boring existence in Grangemouth in central Scotland for life in Missoula, Montana, in the western United States, he could never have foreseen just how much of a life-changing experience it would turn out to be.

As an exchange teacher, he was prepared for a less formal atmosphere in the classroom, while, for their part, his students had been warned that he would be "Mr Strict". It

was not long before this clash of cultures reared its ugly head and the author found life far more "exciting" than he had bargained for. Within a matter of days of taking up his post, he found himself harangued in public by an irate parent, while another reported him to the principal for "corrupting" young minds.

Outwith the classroom, he found daily life just as shocking. Lulled by a common language into a false sense of a "lack of foreignness", he was totally unprepared for the series of culture shocks that awaited him from the moment he stepped into his home for the year – the house from *Psycho*.

There were times when he wished he had stayed at home in his boring but safe existence in Scotland, but mainly this is a heart-warming and humorous tale of how this Innocent abroad, reeling from one surprising event to the next, gradually begins to adapt to his new life. And thanks to a whole array of colourful personalities and kind people (hostile parents not withstanding), he finally comes to realise that this exchange was the best thing he had ever done.

This award-winning book, the opening volume of the *Innocent Abroad* series, charts the first months of the author's adventures and misadventures in a land which he finds surprisingly different.

www.extremispublishing.com

For details of new and forthcoming books
from Extremis Publishing,
please visit our official website at:

www.extremispublishing.com

or follow us on social media at:

www.facebook.com/extremispublishing

www.linkedin.com/company/extremis-publishing-ltd-/